Starting and Succeeding in Your Own Photography Business

STARTING
and Succeeding in
YOUR OWN
PHOTOGRAPHY
BUSINESS

By Jeanne C. Thwaites

Writer's
Digest
Books

Cincinnati, Ohio

All photos copyright by Jeanne Thwaites.

Library of Congress Cataloging in Publication Data

Thwaites, Jeanne
 Starting and succeeding in your own photography business.

 Includes index.
 1.Photography—Business methods. I. Title.
TR581.T48 1984 770'.68 84-2336
ISBN 0-89879-112-X

Design by Janet Czarnetzki.

This book is for my son
DANIEL

INTRODUCTION

In 1965, faced with earning a living after a divorce left me coping on 35 cents a day for several months, I had two options: I could be a secretary or start a photographic studio, hopelessly underfinanced. During the latter part of my marriage, I had become obsessed with photography and decided to give it a chance for two years. I've never regretted the decision for more than a few days at a time!

My thirteen-year marriage had been to a brilliant English Chartered Accountant (a Certified Public Accountant in the U.S.), whose specialty was finance. I had become very interested in his clients and in money; how it works, why some people succeed and others fail. I saw it was not by accident that some don't make it; people unintentionally program themselves for failure. We all know how to make money—it isn't difficult—but we can't be bothered to take the necessary steps or make the sacrifices.

When Jeanne Thwaites Photography was born it was necessarily a small studio and it has stayed small. I gave the public what I didn't see in other studios, what I call the gourmet product. I noticed that the great portrait photographers worked for magazines, not studios, and that people did not have vibrant portraits in their homes. Instead, they had almost-lifelike pictures, the kind I call franchise photography. So I decided to offer San Luis Obispo a choice: franchise photography or mine!

In the early years, my fluctuating income terrified me. But I was able to keep going and work my business up from the meager $200 I had when I started (plus $275 per month child-support for my three children who lived with me), because I understand how money works. I'm not hung up on money. I don't think it's what life is all about—I think of it as a game. It works very simply; you learn the rules and you use the rules to outdo the other players. You win or you lose!

Why I Wrote This Book

When I first looked through the books on photographic studios, I found that writers dwelt on how-to photography, not how-to money, as if the money part was simple. The money just arrived in your cashbox and you put it in the bank. On the other hand, books on business seemed geared to much larger companies than mine.

"Why," I asked a Certified Public Accountant, "is there no information on how to run a small business?"

"The libraries are full of such books."

"I'm not talking about that kind of information; everyone talks in such large figures."

I told him that I had attended a seminar called Tax Shelters for the Small Business and the first words the instructor uttered were, "If you are netting less than $50,000 a year, this class will have nothing for you."

To my surprise no one left the room.

During the lunch hour I conducted a secret poll of the twenty-two business people attending. Three refused to participate, but all the others admitted they made less than $50,000, and we laughed conspiratorially when I showed them the tally. That's why we were there; we needed help! If we had $50,000 free and clear after paying our bills, we'd have spent some of it to let an expert work out our tax shelters.

"What about people who aren't earning $50,000 a year?" I asked the CPA after lunch. "The ones who started with nothing, as I did?"

"They learn from the school of hard knocks," he said. "The 'street smarts' that used to be handed from parent to child, aren't taught in college business courses."

And so the idea for this book took hold, although I didn't actually write it for several years. Meanwhile, I gained a lot of experience running my own studio. Although there seemed no end to the things that went wrong, perversely enough, I actually enjoyed the trouble. I needed to know what the problems were so I could supply the solutions in my book!

During this time many studios were folding; photography always has a high casualty rate and the economic recession made things worse. But I met many out-of-business photographers willing to talk specifics and I took advantage of that. Some told me they'd put on a show of success but actually, most years were lean; the bad times ate up the profit from the good. Others just couldn't take the strain of having to please a person on such a sensitive matter as his or her own image. What was saddest was that many of these photographers had become bitter about the entire industry and hadn't touched a camera in months; some had sold all their equipment, and weren't even taking pictures for fun anymore!

These photographers amazed me with their innocence. They obviously knew very little about business and had depended on what they learned in school or read in articles, information that should have been taken with a grain of salt. They seemed shocked when I mentioned that certain unscrupulous writers frequently make up facts to fit their theories and some publishers don't bother to check the truth of these statements.

Small business doesn't work the way it may seem—even to knowledgeable writers or teachers of business courses. There is no certainty at any time, no smooth increase of funds, no miraculous time when you can crow, "I'm there!" One day you may be handed fifteen checks, another none.

I wanted my book to provide information on the areas of business that are hard to find out about, because people always have the urge to withhold their special little secrets. And because photographers already get too much Pollyan-

naish advice, I've made no effort to whitewash the facts. I hope your experiences will be wonderful compared to what I tell you could happen; instead of feeling that you might do as well as I have, you'll know you can do better!

Secret of Success

Decision-making is the key to the whole thing. The owner of a photography business is confronted with many decisions every day. A simple decision may be, "Should I order a new file box or read a magazine?" Some are more critical: "Should I rework that bid or call the customer's bluff that he can't pay the price?"

As you get stronger financially, the decisions become more complex—involving, for example, a choice of investments, the possibility of expansion, or whether to take on a partner. Mistakes become more expensive, although you have more money to absorb them. But often the little decisions, put together, will make or break us.

How simple it would be if a customer wanting to order ten reprints from a studio made an appointment, arrived on time (checkbook in hand), and said, "Make me ten 8x10s of the portrait you took last month, the order number is 84345."

It is more often something like, "What would an 8x10 cost? I'd like ten but maybe eight would be enough . . . do you think 8x10 is large enough? Would that be too big? Do you think it would be vain to give a picture of me to all my family? Maybe a smaller picture . . . a 5x7? There is another one I like but I left the number at home . . ."

"I would try to sell him more and larger prints!" I hear you saying!

It's not always so easy.

You might lose that customer entirely with one wrong word. He'd walk out to "Think about it," and the next day a relative might offer to copy the proof (illegal, of course, but widely done) or someone might talk him into giving fruitcakes as gifts instead of photographs.

Price could also be critical. One customer may be prepared to pay whatever you ask, the other determined to stay within a tight budget. To tie up the order you have to be interested not just in that customer, but in his family—and he has to know it!

In this book, I've used examples of many such decisions; I've described where I went wrong, and where I guessed right. My own experiences, however, do not comprise all of the text. I have listened very carefully to successful men and women, asked questions, tried to pull out from their knowledge and experience information photographers can use. Sometimes, as I photographed people, I was openly pumping them for information!

This book is longer than I initially intended. Before I knew it I'd collected more than 500 business tips and anecdotes! From this mass of information, I've selected only what I felt we can use.

The small studio operator is a stubborn individual. Determined to do what he wants, where he wants, he's often ignorant of how money works. Such a small operator or freelance photographer knows he's doing a good job, but usu-

ally has a nagging suspicion that he's not reaching his financial goals. It's been a long haul of working feverishly to stay in the same place, and suddenly he's sick of eating hamburgers and watching for the sales.

If you see yourself in that person, making a respectable gross only to see it trickle away, this book is for you. And if you're a photographer who's starting out underfinanced, keep reading! Before tackling anything new, it's a good idea to have the whole picture clearly focused in your mind. *Starting and Succeeding in Your Own Photography Business* gives you a detailed map for doing just that. Even if you are already successful, there are lots of specific tips on becoming more so.

Adapt my advice to fit yourself. Take only what you need and forget the rest!

Table of Contents

TIPS: Good Advice Can Come Free. The Name You Go By. Sixteen Decorator Tips. Toys. Six Steps to Instant Order. Thirteen Ideas to Save Purchasing $$$. How I Spent a Little and Saved a Whole Lot.

PART TWO: Taking Care of Business

Papers. Pens and Pencils. Catalogs. Forms. Tips on Business Forms. The Cheapest Deals I've Found. Use the Local Stores. Don't Lose Those Calls. Listen to Your Customer. Thirteen Customer Gripes. Trouble-Shooting Your Business Operation. Rainy Days. Make a List. Year-Round Schedule. How to Cope with Misfortune.

PART ONE
Ready, Set, Go!

The first nine chapters of this book are intended to stretch your mind—so you'll realize what your resources are and think of all your potential sources of business. Then you can choose the markets for your work intelligently, always considering your own aptitudes and vision of your career. Part I also contains the information you need to begin setting up your photography studio—common sense rules of money so you can finance this enterprise without getting in over your head, a list of minimum necessary equipment, tips on choosing the best location, ways to assess your style and take stock of your "photographer's personality." In a chapter on portraiture, which is my specialty, I've described some of the little tricks that have worked for me and might for you, too. I've also included information on various sidelines you can use to build your business—while you make extra cash!

1
Money Sense—The Bottom Line for Any Small Business

This book is about money.

It is specifically directed to the photographer who now earns less than $50,000 a year and to whom customary financial "business-column" advice, therefore, does not apply. That advice is usually geared to people with much higher incomes.

How can it make sense to talk about management development, test solutions, and business communications if you panic at the thought of $50 for a single ad?

If, for example, you are grossing in excess of $50,000 a year and you still feel "poor," perhaps you are. Even though you are in an enviable position with your healthy gross, the cost of operation—and perhaps your personal expenditures—is swallowing your profit.

You don't have to look far for a quick solution to your problem. Stop spending money!

Your gross income actually has nothing to do with your real financial success; if it costs $50,000 to make $50,000 the profit is a big zero dollars. But increase that $50,000 income or decrease the $50,000 expenses and you have a profit—money left over after you've paid your bills. What you own less what you owe is called your net worth, and this, *not* how much you earn, indicates your true financial picture.

An efficient business increases its owner's "net worth" each month and gradually puts him into a financial position to take advantage of fluctuations in the economy. However small that business may seem to outsiders, or even to the owner himself, it is a huge success.

In my third year of business I ruefully discussed my financial position with a friend who was a business consultant. I felt a failure, but he pointed out that each year since I'd opened the studio my income had doubled. I wasn't a failure at all!

Looking at business this way helps put your own operation into perspective—you don't need to adopt someone else's goals as your own. You can make your own rules; set your own pace.

But to succeed in business you must have money sense—"common sense" about financial matters. Money is what your business is all about. Your talent as

3

a photographer is not in question. All too often the talented fail and the untalented succeed.

Let's Talk Money

To understand money it must be real to you, like blocks or rocks or marbles. You can only get so many blocks of a certain size into a specific box. No matter how you try, you can't exceed that limit.

Money sense is knowing, for example, that if you're taking a loss selling toothpaste for $1 a tube, it would be stupid to advertise it on sale for 95 cents. The more business you do, the more you'll lose. Maybe you could make a profit selling soap instead.

Money sense is knowing that if Mark asks you to give him $10 to tell you how to make $1 million, he is hoping to fine one hundred thousand suckers who, at $10 a head, will bring him $1 million. If he already had a million he wouldn't need your $10.

Money sense is knowing that when Mr. Evans tells you his yearly income he's conning you. What possible reason could he have for confiding that information? All you know now is that Mr. Evans wants you to believe he earns a certain sum, so ask yourself, "Why would he want me to believe that?"

Money sense is also called business acumen and to develop it you must move slowly and test your hunches. Whatever advice you receive from others, including me, you must listen to your own sixth sense of what is right for you. No advice from experts can replace the certain knowledge you have from time to time that you're facing an opportunity to make a smart move. When it happens, gamble and do it. There is always a margin for error, so don't dump all your resources at the same time. Keep your eyes and ears open. The time may come when you should *not* be taking senior portraits but borrowing to buy the house next door.

Money is a Solid Commodity

If you want to get a good perspective on how to handle your money, think of it as something tangible, for example, bricks.

Suppose you buy 100 bricks and each costs $1. Would you take two of those bricks and throw them into the garbage can? Probably not. But you'll say, "It's only $2" when it's money you're talking about. Why is your attitude to money and bricks different?

Suppose you decide to build a wall and you buy 1,000 bricks (at $1 each). Those bricks are stacked in a square of about twenty-five high and forty wide. Every time you make a $10 error at the studio, you take ten bricks off that pile.

You see that pile eroding and know the wall will have to be made smaller, so you had better stop using up the bricks unless you really have to. Set a goal, collect 1,000 bricks ($1,000) and build yourself a wall. Then start collecting for another wall. Don't expect to have enough bricks for the wall though, if you keep tossing them in the nearest wastebasket.

Some people never grasp the meaning of money. That pile of bricks or money will just not grow unless you hold on to what you have, and find a way of adding to it.

4

So act with caution in your payments and purchases, and keep an eye on your capital (that pile of bricks).

Now that you are collecting bricks you can see that if someone offers you forty bricks for a pile of rocks you have no use for, you would be smart to take it. If you paid $30 for those rocks and you know their retail worth is about $60, take the profit you are offered. Forty new bricks will add a few inches to your wall; the pile of rocks isn't doing a thing but sitting there. Think of the work, and maybe money, you would have to invest to get the $60 the rocks are worth.

So take the profit!

Separating Good Advice from Bad

If thinking about money is not one of your favorite pastimes and you don't know where to start, the obvious place is by clearing your mind of all the *junk* you've read and absorbed, or which has been pushed on you. The "junk" is advice that at the time seemed a little "off" but was believable nonetheless.

The most extreme pseudo-advice comes in advertisements. Have you sent for any get-rich-quick publications to see if they could really make you rich? I did out of curiosity, and the only ones that were not out-and-out frauds were those that suggested I overcome my feelings of inadequacy by repeating my goals as if I already had them. "I own a $100,000 house," was suggested as one slogan to repeat, the theory being that if I said it enough I would get one. I actually tried this and on the third day I found I no longer wanted a $100,000 home because I already lived in one and had been living in one all along.

(You see, real estate in San Luis Obispo has skyrocketed and my very modest home which is in the same building as my studio is now worth well over $100,000, just because of the value of the land.)

I decided to switch my goals and repeat instead, "I am very thin." After two days I must have believed it because I forgot to tell myself how thin I was, although the scale has never budged a half pound in support of that belief.

It struck me that this method of getting what you want used to be called prayer and it was presumed—a theory contrary to common sense which I can't help believing—that a supreme being gives a hoot if our businesses or diets are thriving.

I do not believe that repeating, "I am a millionaire," as I rise each morning will make me one, though it might lift my spirits if one of my customers has just left town without paying me. It also sounds like a lot of fun to list goals and read them each morning, something a photographic magazine suggested as a sure pathway to success. I haven't met one truly wealthy individual who would take it seriously if you asked if this was how he got rich. He owes his success (ask his long-suffering family) to being obsessed with making a buck and to a comprehension of how money works.

How's Your Arithmetic?

Bookkeeping and making money are two different things. Both can be learned.

The subject was composition in photography and the teacher said, "Some

5

of you will never need to study composition, because you have what is called a 'good eye.' You'll automatically arrange a picture so that it is well balanced and visually pleasing. Those without a good eye can achieve exactly the same thing by learning a few rules."

So it is with money sense. If you are asking yourself, "Could I ever learn to be as good a businessman as someone who is instinctively smart with money?" the answer is "yes." Because we are dealing with a very specific substance in money, the rules by which it works are basic. It's not like painting a picture; it's like putting bricks in a row.

I've listened to very convincing lectures on the cause of some people's mental blocks of anything that smacks of mathematics and there is evidence that this is learned as a child and can be *unlearned.*

I would think so, considering that almost anyone can learn to drive a car well, a skill which is not that easy.

Simple bookkeeping, which scares many people witless, is actually a simple matter. It may seem a waste of time to learn it, but exactly as in the case of driving a car, you soon find you're automatically doing all the right things and can quickly make up your own solutions to new problems when the basics are no longer a mystery.

Once you no longer fear bookkeeping you will be able to forget about that side of your business except when you are putting the figures into your books or collecting them for your year-end or quarterly accounts. But if the tax season comes up and you've neglected the office bookkeeping, you'll think, "What do I do now?" The whole job will have become a puzzle taking lots more time to unravel than it would have if you had your records in order.

Many businesses hire a bookkeeper, but at the beginning a small operation doesn't need one, and probably can't afford one either. The money can usually be spent better elsewhere.

But even as you grow, if you decide on a bookkeeper, you will have to oversee your accounts. The person who handles your checks has ample opportunity to steal and if you don't know what's going on it's more likely to happen. If you read the newspapers you'll know that judges, lawyers, accountants, friends, and relatives, have all been known to dip into someone else's kitty. These were people that someone trusted, someone probably just like you. Even if your bookkeeper is highly ethical, you are still responsible for mistakes in the books—it is *your* business. If he makes accidental errors, at the very least you'll have a false view of how things are going.

The best part of bookkeeping is that it is easy to learn even if you were a straight-D student in math! In Chapter 16 I break it down into some very easy steps.

Keep It Simple

"Money" experts write complicated articles on finance but they need not frighten us. They write for other experts, not for us, and they disagree among themselves, further confusing the issues. If you put it into photographic terms, such writers are like the photographer who must have forty different types of pa-

per to make one print. He explains that a choice of forty papers is necessary to get the optimum from each negative. As an advanced photofinisher or maker of salon prints, this might interest you, but to a studio photographer the forty grades of paper are unnecessary. He may not need more than one b&w multi-contrast paper and a good photo lab.

Have you heard the money experts discuss interest rates? By the time they have computed the differences between stocks, second trust deeds, different savings and loan accounts, banks, treasury bills, and money market funds, I am so confused I don't even want to think about money. The idea of how much money I must be losing overwhelms me!

By keeping your thoughts simple, you can come up with the same information and quickly figure for yourself the best deal.

You want to know whether it is worth moving your savings into a higher interest account; how a certain percentage-per-year applies directly to you. First, multiply the amount of money you have to invest by the interest and divide that figure by twelve. You are now reducing your interest to your profit per month.

Do this first with the interest you are earning now. You will notice I ignore the "percent (%)" in calculations. I use common sense to tell me where the decimal point should go.

Let us say you have $500 invested at 5 ½ percent per annum. You now make 500x5.5 ÷ 12, or $2.29 per month.

The interest you could be getting is 15 percent—or 500x15 ÷ 12, which is $6.25.

If you switch to the higher interest account you will make $3.96 more each month (which we shall call $4 because it is easier to play with).

Now, if you didn't read all that because it contained figures, go back and do so, because it is very simple. Just take it from the top, one line at a time.

And what you have to consider is this: Is it worth switching accounts for $4 per month?

Remember, money is like bricks . . . whichever way you look at that $4, it remains $4 and is not very much. So if the amount you have to invest is $500, you might just forget about it and try to talk every customer who enters the studio into spending just $4 more.

But if you have $5,000, you now increase your value by $40 per month, so it's worth walking to the bank to make a switch.

It's Easy to Make Money

Deep down we all know how to make money; that we don't is because our hearts aren't in it. Instead our hearts are in what money can buy or envying others their fortunes. So we dream of winning a sweepstakes.

The sweepstakes people are very good at making money, because giving it away is one way of making it. They know for sure that we'll buy their product after we've sent in our tickets, but we have only a 3 million-to-1 chance of winning.

Right now I am writing this book, which is a lot harder than making money other ways. If I let my mind drift to the most certain way I could make a good chunk of money, I'd say it would have to be in real estate because the houses

are not moving right now, students are always looking for places to live in our college town, and people will pay anything for a piece of property with a low interest loan.

So why don't I do it? I have to admit I don't primarily write for money, I do it for fun. I'd rather write this book, because the idea fascinates me and I feel it is needed.

If It's So Easy to Make Money, Why Isn't Everyone Rich?

Many of us prefer to read success stories than live them. We have other interests—we want to play with our children, go the the beach, wander through the stores, whatever. It is only when we *don't* have enough money that we become concerned that our car is five years old while the neighbor's is new. Although it sounds easy to spend thirty minutes a day working on becoming rich, we soon forget to . . . it's like taking thirty minutes to exercise each day. It's easy to think about doing it but few people are that organized.

We also back away from success. Until someone pointed this out to me I had no idea I, too, had this problem. In my case it was the childhood feeling that femininity and success were in conflict.

If you panic when things go upward rapidly, ask yourself why. It could be that you feel you are selling out, that you were worth more when you were not "up for sale." Or is it that you don't want to have to keep up the pace? You could also be programmed not to succeed. Ted is a carpenter, his father was a carpenter. Bert is an architect, his father was an architect. If Ted and Bert switched places they would be in jobs right for their talents, but Ted was not programmed to think of a "high achievement" career and Bert was.

If you have been programmed to think of cash-money as the only real evidence of riches, you may be looking for dollar bills in a backyard full of rough diamonds.

A rich person is the one who can afford, or already has, what is needed. If the need is food, then the person with the loaf of bread, or the price of that loaf, is rich. The person with the $200 radio or the $15,000 automobile is not.

When food is so plentiful we can just pluck it off the trees, then car ownership becomes more important. On a deserted island it may be the man with the shortwave radio who has wealth but the young man who has the strength to climb the coconut trees has even more.

Those who rigidly accept ideas of what it is to be rich—other people's ideas—can become frustrated and deplete their own power. Talent, know-how, beauty, the ability to reason, are worth cash in the bank, and the people who have them are often so busy earning a living where these attributes are not a prerequisite that they start out thinking themselves worth less than they are. As photographers we see young people who could easily make it in modeling if they had confidence in themselves. Instead they decide to wait on tables, explaining that they get very good tips!

I know photographers who use exactly the same reasoning. As an example they get hung up on their high prices instead of their net profit per year. If they sell one 16x20 for $200 they might make $160 profit. Now why can't they see that two 16x20s for $150 each makes $220 profit?

The Three Phases of Business

There are three phases of making money in the photography business or, to put it bluntly, there are three phases in business where lack of money sense can bring you down.

Phase 1. Creating a Demand for the Product

Potential customers must be made aware of the kind of photography you do and where it's available.

How often do you open a magazine, pass a shop, hear someone talking, and from those almost accidental encounters develop a habit of buying a certain product? Every product you buy more than once has, in fact, been "sold" to you in some way—first by creating a desire for it and then by fulfilling that desire so efficiently that you continue to buy it.

Photography is no different. Once a person decides to hire a photographer and that photographer delivers a successful job, the customer, his colleagues, family and friends may all become aware that professional photography is desirable—worth paying for.

If you are a very talented person who is turning out a large number of pictures, some people will find you eventually, but you need more than admirers, you need customers prepared to pay for your work and the speed with which you become successful is directly affected by how efficiently you make the public aware of where you are and what kind of photography you do. So the moment you decide to start you own studio you should be considering and following up on every opportunity that presents itself to make yourself known.

Phase 2. Efficiently Operating the Business

The organization of a studio should allow for business to be carried out in a calm and unhurried manner so that you can take in other employees, handle any amount of work and not go into chaos when faced with a crisis.

A studio should look busy but never rushed. This happens when there is an accepted, correct way of doing things—a method. Employees can cause chaos if they come into a studio which doesn't force them into a methodical way of handling customers, orders, and everything else.

This methodical way of handling things gives customers a feeling of security and makes them feel safe when giving you their money; they spend more and you save more because you are not wasting time.

How well you organize your operation will determine your net profit—how much you keep of every dollar you make. How an owner spends money on the studio will also have a major effect on his success or lack of it. You have to spend money both to attract business and take care of it, but if you can cut the waste to a minimum you keep more of each dollar you earn. It is always astounding to me that if I decide to spend just one less dollar a day, I have a savings of $365 a year.

Phase 3. Investments

In a successful business not all the money made by Phase 1 should be spent on Phase 2—there should be some left over. To put this surplus in a box under your bed, or even in a safe, is not a very smart thing to do.

If you must horde, choose something that increases in value faster than cash—which actually decreases in value unless it is represented by rare coins.

You could choose diamonds, gold, or the works of great artists—buying when the value is down and through reputable dealers unless you yourself can tell the real thing from a fake. If you plan to keep your savings like this, insure them, although safe deposit boxes at a bank are an insurance in themselves.

Other kinds of investments are:

1. *Bank accounts.* To put money in money, i.e., banks or savings and loan accounts, keeps it safe. The institution makes money by lending your money for high interest and then gives you a bit of that interest, sometimes a small bit.

2. *Speculative ventures.* These include real estate, first and second trust deeds, the stock market, and such things as horse racing and poker games. The smart speculative investment does not go down the drain entirely if you guess wrong, and it increases your worth much faster than savings accounts.

Of the three phases of business, Phase 1 is by far the most important.

If you neglect Phase 2 you may lose all the momentum created by Phase 1.

If you neglect Phase 3, you'll never be really rich because you can only make so much money working any job initially designed to merely bring in a steady income.

The Schizophrenic Photographer

As this book is about money, you might presume I equate money with success. I have never felt them to be the same thing. At times most photographers consider the chasing of money a very boring job.

I am sure you will recognize yourself in this rather schizoid approach to money, a part of the inevitable dual personality of the artist in business.

One side of you despises the coldness within you that puts a price tag on your talent; the other side despises the softy that feels that way.

Here are some other business people who must endure from a similar personality split to succeed: actors, architects, athletes, research scientists, show animal breeders, writers.

They, like the businessman photographer, must integrate the parts of the mind that are rational (intellectual) and irrational (creative).

There are also some people who become very successful without thinking about money very much. A person who is obsessed with making a dream a reality finds his money needs take care of themselves. People like Albert Schweitzer, Mother Theresa, and Albert Einstein come to mind.

However, as you are reading this book, it is safe to say you are more like me than them!

Goals

Goals are not so much a matter of wanting a Mercedes Benz or a $100,000 house—if you had the money for them you'd probably be using it for something else. The prime goal of a small business is to find a way to bring in a constant cash flow that will sustain it through good times and bad.

Attaining this goal enables you to be your own boss. You do what you enjoy most for a living and you reap the benefits therefrom. You do this in two steps:

1. Find a market for your product.

2. Sell this product at a price that will bring in sufficient net profit.

If this is not specific enough, break it down further. If you are considering the market for your photography, consider one market and then move toward it:

1. Do something about it today. Today, not tomorrow.

2. Don't rush it.

3. Start at the point which is closest to you—the easiest point.

I learned these three very important rules, which apply to all jobs, from a gardener. I had hired him to dig in our overgrown garden when I lived in England as a young married woman. After a year of yard neglect we found a jungle had grown up around our home. I didn't know how to return it to order.

So I put a notice in a store window, "Wanted: gardener. Two hours, twice a week. Two shillings six pence an hour," and went home to see if there would be any takers.

Mr. Wells applied the next day and he was so old I thought no one else would employ him, so I did. He was also ingenious because he later told me he had taken the ad out of the window to prevent anyone else from applying!

In the days to come I saw him wandering around our backyard not unlike a snail in pace and shape. Sometimes he hunched over one plant, but never for long. He would soon move on lugging his burlap sack containing his shovel and other tools.

One morning two months later, I looked out of the kitchen window with sudden surprise. There, apparently overnight, was as stunning a garden as I had ever seen. I rushed out and shouted, "It's beautiful!" and Mr. Wells rose from where he was picking at the rock garden and beamed.

Arbors of roses, now in full bloom, arched above the paths bordered with miniature daisies and at the back of the property ripening vegetables grew in neat rows. There was no weed that I could see, no leaf with holes—the bugs had packed and moved away.

"How did you do it?" I asked the old man. "How did you make it happen so quickly?"

"I only know one place to start any job—that's at my feet," he told me. "If I look at the whole thing I'd never get going so I just start to dig where my feet are!"

As you see he began:

1. Right away.

2. Slowly.

3. At the closest point.

Whenever a task overwhelms you, think of Mr. Wells and start at your feet.

TIPS

How Lucky Can You Get?

If a business fails it is rarely because of luck, but because of the lack of business acumen on the part of its operator. It is not "bad luck" if you take

on a $700 rental and cannot keep up the monthly payments—it is bad judgment of your earning capacity. It is not bad business luck if your son breaks his leg the day you are booked to photograph your first wedding (though it is great personal bad luck, particularly for your son). If you did not anticipate that something could happen to keep you from an appointment, it was again, bad judgment.

Take advantage of good luck and try to turn bad luck around. When you take on a job that depends on good weather, consider: What do I do if it rains? What if my car breaks down? What if . . .? What if . . .? Things go wrong for other people, why should you be the exception?

I have an uncle who started buying up very large homes in Ceylon (now Sri Lanka) during World War II. As the owners of these homes began rushing from the island expecting a Japanese invasion, he reasoned:

1. I don't want to leave Ceylon.
2. If the Japanese take over the country, I'll be their enemy as I am a British subject and will lose all my money.
3. If the Allies win the war and I own these houses, I will be very rich.

The Japanese didn't invade Ceylon and the Allies won the war and my uncle was "overnight" the owner of an enormous fortune in property. He could never understand people who called him "lucky."

Compulsions

To be in business is to be a bit of a gambler, but when gambling becomes a compulsion the handwriting for failure is on the wall. Panic and elation should not distort reason.

Consider the slot machine gambler. Charles runs into a streak of bad luck and panics; instead of calling it quits when he reaches his limit, he borrows money to try to recoup and never does.

The parallel is the photographic studio that puts $1,000 into a sideline the owner has heard made a fortune for another studio. When it doesn't sell, the owner advertises heavily in the newspaper, and when the public still shows little interest he turns his attention to other forms of advertising: radio and television. He won't accept defeat, and throws away good money earned from solid photography.

Edgar is also a slot-machine gambler. But he has a terrific streak of luck and wins steadily, making a lot of money. Then he hits a losing streak but says, "It won't last," and so goes on playing until he has lost what he won.

Again, a photographic studio could fall into the same trap. Its owner decides, for example, to do "old time portraiture" and the money flows in. He doesn't have to work hard—word-of-mouth does his advertising for him. Abruptly the public tires of the gimmick but he won't let go. He notices sales are down and decides to stir up more interest with advertising. Soon he has a closet full of period costumes but no business. As he has neglected other forms of photography he is back where he started.

Beware of Trends

Each business needs a solid foundation independent of trends.

Joe, a manufacturer of children's clothing, told me a story that illustrates this. One of his competitors had to close his factory and file for

bankruptcy. This man, Matt, received a huge order from Woolworth's and had to put aside his regular orders to take care of it. He delivered the merchandise on time but to his surprise received no other orders from the same chain; the "trend" for that garment was passing, he was told.

But he had put off his old customers and they now had new suppliers. His business never recovered.

That same year Joe himself also received an unusually large order from another chain store. He purchased machinery, hired help to take care of this single order, and made very little money.

"But now I have a new warehouse and excellent new machinery I hadn't been able to afford before," he said, "and my regular customers were not affected."

This new machinery gave his business greater capacity so he was able to take on more small orders—the base of his business had widened. If he received another trendy order he might have to buy *more* machinery to take care of it, because this new base could not be interfered with to make room for a sudden one-shot order.

If Joe acted with common sense then why hadn't Matt? Matt had merely forgotten that any large order is still only one order and also that trends change.

Don't Listen to the Competition

Never follow advice from someone who has any reason to profit if you fall on your face.

You think I'm cynical?

Reverse the situation; do you care about the survival of the studio down the street? You mean you wouldn't feel a twinge of pleasure if you heard it has closed from lack of business? Now why do you think that studio owner is any nicer than you are?

Even if your competitor's advice sounds very good there will be a hidden ingredient he isn't being frank about. When a photographer tells you he averages $1,500 a wedding doing it his way (a much higher average than your own), is he talking about three weddings or forty-three. If your customers are cautious about spending money during the same period of time, why aren't his? And then lastly ask yourself, "Why is he telling me this?"

I used to think that photographers were the all-time greatest liars because of the stories they told me. When I talked them over with photographers who were not in competiton with me, these stories seemed even more far-fetched. But I have talked with many small business people who were not photographers and apparently it is a big game . . . it is accepted that within one's own trade one should lie a lot.

As one dog breeder told me frankly, "When it's cash-sales we lie downwards, when it's a gross figure, we lie upwards."

I sent a young assistant, Monica, to a meeting at the high school because the teacher who edited the yearbook wanted to talk to all the studio photographers. Monica told me that the teacher asked each photographer how many seniors of this school he had photographed the previous year.

There were about 250 seniors who graduated but when the figures were totaled the photographers' total count was 450 seniors!

And these photographers did not even handle all the senior portraits.

There were two out-of-town studios without representatives present and freelancers as well.

"I tried not to laugh," said Monica. "Of course, I lied too. I didn't want anyone to think you were doing less well than they were."

She had added twelve seniors to our total!

I have known a small-town studio photographer for some years and he told me some years ago, just after his retirement, that he had photographed 300 weddings before calling it quits. Three hundred weddings in twelve years sounded about right because the first years would have been slow and the average of twenty-five weddings a year was fair. Recently, he was back in town and invited me to supper with some of his friends. He told them he had photographed "more than a thousand weddings" before retirement. I caught his eye but he didn't smile; he'd been lying so consistently that he no longer remembered the truth!

How to Gauge Your Business's Success

Try as you might to photograph six weddings a month, you average only five. Mr. Jones has eight staff photographers and would like to average fifty weddings but the figure he achieves is twenty-eight. You may feel envious of his twenty-eight weddings but you are only 17 percent short of your goal against his 44 percent short. You can rightly take credit for the bigger success.

A photographer who was a guest at a wedding where I had been hired to do the photography, boasted of the number of wedding jobs he handled. I almost felt intimidated until I realized he was free to be a guest that day; I wasn't. I felt even better when the bride told me he had offered to take the pictures at no charge—but she felt "safer" with me.

It is hard to ignore a feeling of failure when someone is hitting you over the head with his success.

A young photographer told me he was horrified to hear a certain studio made $100,000 a year. He had been in business longer and didn't come close to that gross. But the owner of that studio had a wife, adult son, and one other employee working for him. That meant his income had to be split at least three ways to take care of the management, besides his own living-wage.

When I saw the change in this young man—from depression to elation thanks to these comparisons—I decided not to discuss my income with anyone else *ever*.

I would advise you to do the same. Only you can gauge how well you have done, and do that by your own standards.

Points to Ponder

1. A $1,500 print order is just one order.
2. Capitalize on an upswing; don't sit back and say "I made it!"

A real success is someone who can ride out the low times and not be deceived by the high times.

3. The success of your business depends on how many profitable orders you get and how many people think of you when they decide to have photographs taken. The total dollar volume of these orders is an indication of how much money there is around, not how well *you* are doing.

4. If the photography business is booming and your business increases

25 percent over last year, but the average rate of increase of other studios in your area is 30 percent, you are going backwards. If your studio increases business by 7 percent and all other studios are up 2 percent, you are doing very well. If business is really bad and all other studios are down from last year and doing 4 percent less business, you are doing very well if you are down only 1 percent.

It is difficult to find these figures as photographers exaggerate their incomes, but the Small Business Administration and other government agencies can supply statistics. Reliable sources at camera stores and photo labs may share comparative data. Eastman Kodak representatives also have a very accurate idea of studio prosperity and I have found them to be honest and impartial. Write to Kodak, Rochester, New York 14601.

Three Places to Go When Business is Off to See if Others Are Suffering Too

If only you could just drop into another studio and ask, "How's business?" But, alas, photographers are reluctant to admit a downward trend to the competition.

Here are three sources I seek out when I want information on our local trends:

1. The jewelers, the caterers, and the flower shop owners. All three are luxury trades, not unlike our own.

2. The camera store owners. Their employees sometimes pass along gossip about other studios.

3. People who work in places which have a line on all businesses: insurance agencies, accounting firms, lawyers, banks.

Listen to Yourself

Learn not to slavishly follow anyone's, even your financial adviser's, advice. We all know dead people who would be with us today if they hadn't listened to their doctors; sometimes lawyers and CPAs end up in the poor-house.

When you need advice, particularly about your money, watch and listen and don't hesitate to say no. You are the one who earned it, so your money means more to you.

If you read the newspapers you'll learn that even the wealthy who think they are paying for the best financial advice don't always get it.

An example of this is Ken, a successful executive, who started a sideline business to lessen the income tax he was paying. He needed to deflect his large salary into both depreciation and deductions. To start the new business he bought a new automobile, a computer, a copy machine, and furniture for the room of his house where he would be handling the sideline.

His product was certain "data" which the computer would sort; it would be copied on the machine and offered to businesses that needed it.

"You cannot deduct the computer or copier until you have offered the data for sale," said the accountant who prepared his tax.

"Hell, I can't," said Ken, "I don't have a product to sell until the computer has been programmed and that takes time."

So he changed his accountant, and found he was right. And that's how he saved thousands of dollars.

2
Getting It All Together Financially

The bad news is that nine out of ten businesses in the U.S. don't make it, and more than half of those fold in the first two years.

But the good news is that there's no need for you to be on the casualty list.

When a business fails, outsiders can easily spot the cause. Try it yourself. Jolly's Restaurant has just put up a "For Sale" sign. You've eaten there yourself. Come to think of it, their bad luck does not surprise you at all.

Why? Take your choice: The service at Jolly's is poor; the food is unappetizing; it is not a very clean place; or the prices are too high (or too low) for the menu.

We, the customers, know why General Motors cannot sell its cars, why the neighborhood toy store has called it quits, why one clothing store is doing so much better than the other.

So to succeed, we need only apply to ourselves the rules we judge others by.

The two main reasons behind business failure are lack of an appealing product, or of the business knowledge to turn a profit from a product.

This book is not about your "product," which we know is photography. (You must decide how to do it, present it, and what your style will be.) No, it is about the second necessity for success; competence in business.

I run a small studio in a small town and most of my work is portraiture. If you are a commercial photographer in Chicago or taking "instant" pictures from a stand in Miami Beach, your problems are actually not unlike mine. You have to make money, and then try to make that generate more money.

In this book I will suggest that you necessarily emulate my own method of coping, which is low overhead, moderate prices, and high quality. I try not to give my customers a reason to go elsewhere. I'm also very competitive. I want my pictures to be the *best* and I want them in people's homes where everyone can see them. They can't take them home if they can't afford them.

You must create a base that is right for you, then by applying some simple rules of money, reverse the odds for business success so that they are now in your favor.

For example, if there are ten reasons businesses fail, and you can eliminate eight of them from your studio, there is very little chance of your not making it.

16

The Rules of Money

Ask any expert the chief reason so many businesses fail and his reply will be, "under-financing."

Think about that!

Of course the chief reason is under-financing; so is the second, the third, and the eighty-fifth reason. Businesses fail because they do not have the money to continue to operate. If a business closes for any other reason, it is that the owner chooses not to continue, because of boredom, health, retirement, etc.

How Much is Enough?

How much money do you need to start a business? If possible, enough to pay overhead for at least one year. It's ideal if you have two years covered. More than that is gravy.

There are exceptions.

I, for instance, started with just $200.

Three times in the first year I was down to 35 cents. This was so unpleasant that I even considered suicide. When I hit those low points, I always gave myself just one more week to survive and extended the deadline when necessary. Then, when that deadline came, I extended it another week!

One day I realized it had been two years since I had said, "Just one more week!" and I took that to be a signal that I had arrived.

This rather low-key beginning taught me one thing, that the experts are often wrong. You don't have to fit any formula to reach a particular goal, just get started. The reason I kept at it was that I was certain I was successful—I just wasn't making much money!

Set Realistic Goals

Instead of setting a financial goal for one or two years, e.g., "I will make $25,000 in the first twelve months, $40,000 in the next twelve," just plan on staying in business during that time. If you have done this and are not in worse financial shape than when you started, your business will now have grown roots.

These roots should not be disturbed (by changing the place of business, etc.), unless the tree is definitely in need of better soil. If you are moving to an equal location, then you will have a setback; expect it. Replanting any tree sets it back.

A flourishing studio has just been put up for sale. It started at an average location, moved to a fantastic location, then the rent rose astronomically so it moved again to another average location.

It could have survived if the owner had acted as if he were starting from the beginning, but he was used to an excellent gross and wasn't prepared to pull in and weather the slow times for a while.

A business that shows any sign of instability, such as a relocation, causes the public to take a step back. Even people who divorce are amazed to find that

17

this very personal decision affects their business, though it has no effect if the public learns of the fact after the divorce.

The customer isn't making a moral judgment, merely facing the fact that if your studio is liquidated because of a property split, his company may be looking for another photographer for its brochure (or his daughter for her wedding).

Having enough money now is, therefore, only one goal a studio owner faces. He must, at the same time, work to establish a front that inspires confidence.

Count Your Assets

As far as money is concerned, you have to start somewhere and the logical place is to count what you have. When the total count is in, you'll know if you have enough . . . enough money to survive one year. During that year you will be mostly putting down roots; all money that comes in from the business will be a bonus. The real fruits from the business will come in later.

As I've said, you could get lucky. If your studio fulfills an existing need in the community, then you might find yourself rushed off your feet with orders right away. But if you are merely like the rest of us it is still not so bad. The longer you can hang in, the more the odds will turn in your favor.

So make two lists:
1. What I Have.
2. What I Will Need.
Under "What I Have" there will be three categories:
1. Instant Cash
2. Convertible Assets
3. Loans

1. INSTANT CASH
List all places where you can lay your hands on cash immediately or almost immediately:

Checking accounts . $ _____
Stock market . $ _____
Piggy bank. $ _____
Money from rental properties $ _____
Regular income
 (include alimony, child support, etc.) . . . $ _____
Spouse's salary. $ _____
Interest dividends . $ _____

2. CONVERTIBLE ASSETS
Add assets that you are sure of but which will take a little more time to convert into cash (up to four months).

Equity in your home or any place you could mortgage or remortgage for cash in hand . . .?

Salable real estate $ _____
Family treasures $ _____
Musical instruments, jewelry, and other
 substantial luxury items $ _____
Items that could be sold in a garage sale
 (conservative total estimate)............ $ _____

One way to come up with a realistic estimate of the last three items is to make a few phone calls to stores that sell them. But first look through a catalog (Sears & Roebuck is the standard most people use) and see if any items are listed there. When you have found an item of equal value to yours, ask yourself, "If this chair costs $48 new, what would I pay for it in its present condition?" The answer will probably be between $5 and $12.

Jewelry—precious stones, gold, silver—usually increases in value, as do some musical instruments and antiques. Save yourself the expense of an expert appraisal. Phone a dealer, ask what it would cost to buy such an item, and divide that amount in half to get your selling price.

3. LOANS

Include sources certain to make cash available to you.

Banks where you are in good standing for a
 personal loan......................... $ _____
Mom.................................... $ _____
Uncle Marty............................ $ _____
Best friend Harry....................... $ _____
Ex-spouse (some have loads of guilt),
 spouses, new playmates,
 or any soft touch $ _____

The grand total of all three columns will tell you how long you can last if not one customer walks through your door the first year.

Count Your Costs

Now prepare a list of your expenses, i.e., expected yearly overhead—month-by-month. (If it seems easier, make the columns out for your monthly totals and multiply them by twelve.)

These figures will fall under two headings:
1. Home
2. Studio

1. HOME

Mortgage or rent $ _____
Taxes $ _____
Utilities................................ $ _____

Insurances.............................. $ _____
Automobile $ _____
Outstanding Loans....................... $ _____
Food.................................... $ _____
Clothes $ _____
Other obligations $ _____
.................... $ _____
.................... $ _____

2. STUDIO

Mortgage or rent $ _____
Utilities................................ $ _____
Advertising (at least $50 a month) $ _____
Business licenses $ _____
Taxes $ _____
Insurance.............................. $ _____
Miscellaneous $ _____

If the total of these two columns (your expenses) exceeds the total of the first three columns (your assets), you are not adequately financed, and will have to find a way to bridge the gap.

A difference of $2,400 ($200 a month) is a signal for you to review the list and make some changes. What if you buy all your clothes second hand (garage sales, thrift stores, etc.), or don't buy any clothes for awhile? How about cutting food costs? Do you need so much insurance? Could you or another family member get an evening job, and make $200 a month at it?

If you have more money than you need, go through the list and cut out from the loans what you can. What you have left will be the money you can either spend on luxuries (that first year), save, or apply to a second business year.

You may not stick to these figures that closely (or at all), but it will give you a very good idea of your financial position.

You will not, for instance, borrow money from anyone if you can manage without it, but one excellent way to prepare these figures is to make a few phone calls to people who might lend you money. Swallow your pride, call some close friends, business acquaintances and family (never forget family), and ask for small loans.

"Uncle David, please do not hesitate to say 'no,' but if I were to need money in my first year of business, would you lend $200? You would? At what interest? No, there's no need yet, but I want to look into my financial position very carefully."

If you were Uncle David how would you react to that phone call? Probably a lot better than if you heard, "Uncle David, I need money for the rent this month. Could you lend me $200 to tide me over?"

You'd be surprised how many good friends you have who would be happy to lend you money, maybe lots of it. Hold on to those friends by repaying every cent they have the goodness to lend you.

You may have some trouble, as I did, getting these "friendship" loans in writing.

I have borrowed from friends twice and both times they refused to sign an agreement. I gave them promissory notes, regardless.

You can buy a promissory note form at a stationery store or write your own version, in this format:

"I, Jeanne Thwaites, promise to repay John Smith $500 (five hundred dollars), at the rate of 10 percent per annum, payments of $50 per month to commence May 1, 1984."

Leave space for your signature and the date.

You must of course discuss the loan first, so that you both agree to the terms. Don't presume you know:

- The amount.
- The interest, if any.
- The method and time of repayment.

Many a friend has borrowed from someone for whom he has done a lot of favors, only to find that his old buddy is a calculating old buddy.

One accountant told me he asked a friend of his, a realtor, to lend him $1,000 when he started his own business. The realtor friend said, "of course," and then presented the accountant with a payment book which showed that he would be paying higher than usual interest.

You see, accountants can get stuck too.

If you borrow from a friend or relative and bring up the subject of interest yourself, you may find the loan increased. Uncle Joe says, "Well if you are paying me 10 percent on the money, it doesn't have to be $200; I could lend you $700."

When dealing with friends be open, fair, and businesslike. Normally, you return personal loans in a lump sum within an agreed time. But don't take this for granted. If the time limit seems too short, ask if it could be extended. If you have agreed to return so much each month and can't make it, call up the lender and tell him why and apologize. Then tell him when you expect to be able to get back on schedule.

Collateral

Sometimes you will be asked to put up "collateral" to "secure" the loan. Or you may wish to put it up anyway as a sign of good faith. Collateral is an item that either becomes the lender's or that he is free to sell, taking what is owed him and returning the rest to you, if you welsh on the deal.

As an example, a pawn shop might lend you $300 against an item worth $900. If you don't pay, the item is forfeited and the owner can sell it and keep the proceeds.

The person who holds your collateral—if it is something concrete you give into his safekeeping—is required to take "reasonable care" of it. He can't just put it on the coffee table and say "oops" if it is broken or stolen when you come to claim it. The item is still yours, not his.

It may be that you are entirely confident of coming into a certain sum of money, and you can borrow now knowing you can pay back. You may have an inheritance in probate or you may have sold property that is in escrow.

Even if you don't need more money, this is a good time to borrow just to establish credit. If you borrow from your bank this year, and pay it back on time,

you will already be an established "good risk" next year when you plan to expand your studio.

Remember, the bank wants to lend money; that is what banking is all about.

After you have evaluated your financial position, you are able to figure how long you can survive with *no* business. If you must borrow money, borrow the minimum amount needed to tide you over.

If Your Financial Position is Weak

You have, perhaps, enough free and clear for six months. Think of how quickly you could cash in on your convertible assets, starting with the easiest ones to dispose of, or the ones you would miss least. For example, you can give a garage sale in a week, but putting the half acre in Florida up for sale will take longer.

Before going into business is the time to explore the possibility of taking a bank loan—even if you don't need one. Talk to the bank manager; perhaps a business loan can be arranged if you need it.

Wherever you bank you should be on greeting terms with the manager. I learned this early from my father who always went with us to help with our first accounts. He asked to speak to the manager and introduced us to him. The first time he did so, the manager said, "I wish everyone would do this, I like to know our customers."

Know Your Bank Manager

It becomes important for all business people, particularly the smaller ones, to have someone to ask for advice on money matters. This person should not have an axe to grind, nor should he profit by the advice he gives you.

The logical person to go to is your bank manager. He is, however, human like the rest of us, and it's important to get to know him before you need him. This man (or woman) is not only trained in finance, but knows the community. And why shouldn't he? The bank's customers *are* the community. If you are a person to him, not just a number, he will be able to help you over and over again.

If the manager at your bank is a cold fish who shows no interest in you, then I would suggest you bank elsewhere. However, I have only once found this to be the case; most managers are delighted to meet their customers and take a concerned interest in them.

The way to introduce yourself to the manager of your bank is simple. Just walk in, ask if you may speak to the manager, and when asked what your business is, say you need advice.

Even if you have no specific advice to ask, just introduce yourself, tell him you might have to consult him in the future over your business and its financial situation, and that's all.

Then when you go into the bank again, be sure that you speak to him personally from time-to-time.

Your bank manager's advice is valuable because:

1. It is free.

2. Money is his business.

3. You can go directly to him if you have any kind of trouble with a clerk or need any explanation of your monthly statement.

4. If you have to take out a loan you will be dealing with someone who is not a stranger. He will put you in touch with the loan officer, but you can return to him if you aren't satisfied.

5. A bank manager can help you when you run into sticky situations involving other business people. He can tip you off if you would be better off not doing business with someone. Listen carefully because these cautious people don't come right out and say, "He's a crook."

6. You can find out the trends of other businesses. If you hit a low spot (or a high) you can determine whether your studio's success is unusual or just a reflection of the general rise and fall of the economy. This is very comforting if you have a long slow period on the heels of a very lucrative one. You may find, as I have, that sometimes the bank manager needs your advice. (I have been asked for advice on where to stay in Europe, what camera to buy, and even for a confidential opinion on the possible dishonesty of someone.)

Once your bank manager (or bank president) knows you, if you want a quick credit reference you can say,

"Call my bank, ask for the manager, Mr."

Here's an example of how useful this is. I ordered a printer for my computer and it hadn't arrived in a week. The company has its head office on the east coast and had taken my check on a Saturday. I figured the check would not clear for a few days, so on the Tuesday (rather than the Monday) following that weekend, I transferred funds to cover the check. Meanwhile the company had phoned my bank to get authorization for the check and the bookkeeper had told them there were insufficient funds.

All this cleared up immediately when I told the sales office that they should have called the manager of my bank, not the bookkeeper. "He would have authorized it" and he did. He has before, and I have sometimes phoned to tell him I have written a large check and when I would have the money in to meet it.

Obviously, it is important to be entirely aboveboard with money if you want someone at your bank to back you up. In fact, if you are suddenly short of money—but expect some in the near future—with a good record you can go directly to the manager of the bank (in these cases I go to the president), and take advantage of something you really need at a good price, rather than wait.

A Word of Warning

If you are underfinanced be realistic. The answer is NOT to depend on your ability to work twenty hours a day. Illness, a family crisis, all kinds of problems may arise and then you'll start falling behind.

The answer is to turn your leisure time into dollars, not to give it up. So don't stay home all day, every day. Parks, beaches, many zoos, and concerts are free and it can be fun to seek them out and enjoy them.

Your creative energy must be spent on your business, bringing it in, maintaining it, and planning. Whatever you do, look after your health and don't push yourself too hard.

Money-Saving Options

The underfinanced new businessman has two things he must do as quickly as possible:

1. *Stop spending money.* Stop charging, stop buying newspapers, stop eating in restaurants, start using up everything you have been storing for a "rainy day." That day has arrived.

2. *Start buying cheap.* If you have to buy, never pay top price for anything. If you can't get it at a thrift store, buy wholesale.

Your children should fall into line too. Never mind what their friends have or what they themselves used to have, it is "family for the family" now and the kids' help will be needed.

And do all this with a feeling of fun and adventure or you will be so depressed you'll give up the idea of a studio for good. Get your family hot with your enthusiasm. It's going to be fun, remember?

TIPS

Saving $$$ in a Bank Account

When you're struggling to make a living, there are some interesting savings to be made by choosing your bank with care.

A local branch of a California bank opened in San Luis Obispo and advertised that the people who banked there in the first week would receive "free" accounts. We rushed to join.

Now years later friends ask, "Why didn't you tell me about it?" Of course, I did, but they didn't listen.

A "free" account allows a customer to write checks to any balance, even $1; other accounts require a minimum balance, such as $200, which is money frozen in that account, earning no interest. If you dig into that $200 you pay a fee. You may also pay a "per-check" fee, which is waived with a free-account.

More recently savings and loan associations have started checking accounts. Most of them give "free" services and do not even charge for the cost of the checks if you are over 60 years of age. If you are, take advantage of this because as your balance rises, you can put the surplus into the highest interest account you qualify for.

Other savings accounts ask for a minimum balance, $500 or $1,000 and, as this balance earns less than ordinary passbook savings, it is not as good an idea as it sounds.

If you want to get better than passbook interest on your savings account, open two accounts and switch all but a $5 balance from one account to the other on or before the ninth of each month. Interest is paid from the first of the month on money deposited up to the ninth, so you will get nine days more interest because it will "overlap."

Say you have $1,000 in one account and move it to another on the ninth. That $1,000 earns interest to the ninth in the first account, and when you put it in the second account it earns interest from the first again.

24

In one year you can get 108 days more interest!

Work out—or have a friend do it for you—whether this type of juggling of accounts will do better than a money market savings account at higher interest. Remember not to tie up money too long in an account because the penalty for having to use that fund before it matures may bring down the interest to where you haven't benefited at all.

Piggy Banks

It's hard to save when we have our backs against the wall and the piggy bank works as well as any other method, particularly a Piggy Savings Account that earns interest.

If you have to save for a particular contingency (vacation, property tax, etc.), start a separate account for the fund. It costs no more than to have one account, and it can be fun.

The piggy-bank saver puts aside specific income for that fund:

1. All income from passport pictures.
2. Ten percent from wedding reprints.
3. All quarters, dimes, or $100 bills.
4. All income from people with gray hair.

One friend of mine puts all his loose change into a bowl (his piggy bank) and when the bowl is full, he has several hundred dollars he feels he never had before!

Another puts all her money won playing bridge into an account for luxury clothes.

A great piggy-bank account is an investment fund. There it sits, getting fatter and fatter. Then, when a chance comes along to make a "killing," you have the money.

Start your Piggy by opening a savings account. Then delegate a box or vase or sock to take care of the day-to-day accumulations. Set yourself a goal. When you have saved, say $20, you *must* stop what you're doing and deposit that money.

The day will come, sooner than you imagine, when the sum of all your Piggy accounts will total more than the minimum a bank allows for a high interest account (usually $2,500). So you now open a single high-interest account and transfer your money there.

Now that you have this account you must not throw away that old passbook. Every time you put money from one into your high-interest account, you note the amount in the old passbook so you still have a record of how much money you have been saving under that category. There are restrictions on high interest accounts, so before you make any move, have a bank clerk go over them with you so you choose the one that has the greatest advantages to you.

This may sound a very primitive way of saving to you, but you may need to play these games to get moving!

Borrowing Money

A trick I learned from my CPA husband was to borrow money when I don't need it and pay it back quickly. For a few dollars I can buy myself credit this way. If I really *do need* money, I can then go down to the bank and borrow without trouble because I have proved myself to be a good credit

risk. It is the person who says, "I've never borrowed a cent," who can't get a quick loan.

A bank needs to lend money. It survives by borrowing money from one person to lend to others.

The usual procedure—if you want to borrow money from a bank—is to put up something against the loan, or "secure" it. That's how mortgages work. Someone lends you money and you put up your house. If you don't pay him back, he can sell your house and take what he is owed, so his money was never really "risked." If the sale produces less money than the balance owed on the loan, the lender is in trouble, which is why financial institutions are cautious and never lend to the full value of the house.

The unsecured loan is harder to get. Here you borrow money without security, the bank gambling that you are a good risk and charging more interest because of this gamble. The unsecured loan is what you want to work up to because you want to be able to walk into a bank and borrow money on your name alone.

Your initial bank loan could be small and short term and, if possible, unsecured. Be sure that you will pay no penalty if you pay it off early. It can be matched by sufficient funds in your savings account. Three months later, pay it back in full so for $20 interest (on a $500 loan at 16%) you have bought yourself credit.

Next year do it again but raise the amount, maybe to $1,000.

The Perils of "Adequate" Financing

"Adequate financing" can make one lazy.

As a woman who was once married, I have seen how dangerous it is for a person to come out of a marriage without a need to work. Usually that person, let us say a woman with a large financial settlement and alimony, starts a little business, makes a mess of it, eventually runs out of money, and only then sits up and applies her intelligence and talent where it can help her.

Another example of this is children of wealthy people trying to run a business alone. They just don't have the discipline of knowing that tomorrow's dinner won't be there unless they get up and move today.

Let's say you have decided to start a studio. You have $60,000 in cash in the bank; you own your home (even if you have one or more mortgage payments on it); you have no debts other than the running expenses of your home and automobile; and your children (if any) are provided for (perhaps by child support or inheritance).

You are not going to be as cautious as someone with $10,000 in the bank. Nor will he be as cautious as someone with only $1,000.

Yet your problems are much the same. You still have to create a business with enough money coming in to give you a solid profit over the running expenses.

$60,000 is a fair chunk of money; if you have a bad month, you can shrug it off. But suppose you are a photographer without that nest egg. You will use the time available in that bad month to generate extra income to survive, or devise ways to promote the business—ideas which may not pay off right away. You really have no choice but to pour your energy into the business and economize where you can, knowing that you are generating an incoming cash flow that may take months (or even years) to fully manifest itself.

Thus the underfinanced photographer may actually build his business faster than one who is lulled into a feeling of security because of considerable cash reserves. And $60,000 could work against you instead of for you, unless you pretend that money isn't there. Or assume that it is something you are keeping for your old age, or to pay for your child's college career or another worthy cause. Or use that money! Make it really help you.

Invest the $60,000 to generate the highest interest you can get, let's say, 10 percent ($6,000 a year). Earmark the $6,000 for certain improvements to your business: upgrade the physical look of the place, purchase additional equipment, or pay for your vacation (plus an assistant to keep an eye on things when you are away). What you are doing is turning that $60,000 into a real asset.

Working After Hours

Any owner-operator is going to have to work long hours sometimes and it's impossible to *always* hold your work to a normal work day.

If you are enthusiastic about your business (and/or hungry for it), you find yourself working evenings, getting up early, and using weekends as another time to work. It's fun at first because you are trying to get off the ground and what does it matter if the work comes on Sunday or at 9 p.m., as long as it comes?

Whatever conflict it causes in the family, you must make your loved ones understand that they must back you up when you say to a customer:

"Yes, do call me at home!"

"I'm free this Sunday; let's do it then."

"I'm always in town on Thanksgiving."

Holidays are times when families get together, and some of my most lucrative orders have resulted from such sittings.

If you find yourself thinking, "I need time for myself," remember that you could have had lots of time if you had taken a salaried job. Now you have to take time for yourself when it is available, and that may not be on conventional holidays but days when others are working.

Later on when things flow more smoothly and money is coming in without too much effort, reverse this. Don't become someone who can't relax.

Your checkbook will tell you when it's time to make the change. If you can afford to relax, then take that time and do it.

Develop a Second Career

A wonderful tip given to me, and which I have encouraged my children to follow, came from Doris Olsen, a great reporter friend of mine who started her career as a newspaper printer.

In her family every member learns a trade, no matter how lofty their career dreams . . . I wish I had thought of that when I was growing up.

No matter how high her family rose in the corporate or other fields, they hung loose because they could stop it all and become carpenters, mechanics, etc. It gave them self confidence.

During the Depression several of them needed their trades. Doris is very proud of her abilities as a printer. In fact you hear more about that from her

husband than her Polk prize and the fact that she has been nominated for a Pulitzer in two categories.

You may never need to use that second skill to earn a living but it does help psychologically to have one. I am sure you know as many people as I do who have no solid skill at earning a living, and they are always complaining about how badly the world has treated them. If they would instead learn some skill, even following an existing hobby to a higher level, the doors would open. As an example, no sooner did I take a class in computer programming than I began to get opportunities that I could use, if I wished, to launch yet another career. I have to insist, "My computer is my toy," to keep it on an amateur level. But it is a great comfort to me that I have a new marketable skill.

When you play at your hobby—whether it be fishing, organizing youth football, reading or climbing mountains—learn this subject very well. If you want a breather from the small-business world, you can always earn money at your hobby and get a different perspective on life. It is only when your studio is everything that you'll find yourself getting a bit manic.

You also will be happier and healthier, and relatively free of the stress that brings so many busy people down, if you know this is not the only kind of work you can do.

Twelve Legal Ways to Buy the Same Thing

If you asked a movie star what it cost to redecorate a room she will say, "$50,000 at least." If you asked me, I'd say, "About $400." I have a friend who can change the look of a place entirely without putting a cent into it.

If there is something you need, consider the ways you could get it.

I gave myself an exercise. Lucy wants to buy a coat and it costs $435. How many ways can she get it? (Without going into high finance!)

First, she can buy the coat with money; second, she can get it without. If you have been yearning for something you can't afford, you might sit down and figure how many ways you could get it and perhaps you too can get it for nothing.

Here are ways Lucy could get what she wanted:

1. She could steal the coat!
2. She could charge it and not pay for it.
3. She could get a friend to buy it for her.
4. She could get the store owner to give it to her.
5. She could start saving and wait until the coat was on sale and buy it at a reduced price.
6. She could find out where the coat was manufactured and go directly to that source and see if they would sell it to her.
7. She could pay the full price at the store.
8. She could trade something she has for the coat.
9. She could trade a service for the coat—work at the store perhaps—until it was paid for.

There are some other ways she can get a coat that is "almost as good" if she doesn't mind lowering her sights somewhat.

10. She could make a coat just like it.
11. She could ask someone who owes her a favor to make it for her.
12. She could ask someone who loves her to make it for her.

13. She could get a similar coat at a thrift store.

14. She could find someone who is tired of a very similar coat and wants to dump it, sell it, or give it away.

The list could go on endlessly: She could mug the wearer, blackmail someone, and so on. But the fact is that she doesn't have to get what she wants the expensive way.

Coping with Temporary Poverty

When I was a kid someone in our circle moaned about his lack of money, and my father asked his best friend if this man was really short.

"Yes, poor Walter," said the friend, "he's down to his last hundred thousand again!"

To Walter that was poverty indeed.

Because I was born wealthy, when I found myself without funds and about to start a new career (photography), I felt I was playing at poverty.

I know a lot of people who started out without money—that is, as children they were poor. Today they are very wealthy but don't *feel* wealthy. "Rich" or "poor" seems to be a state of mind.

I think it is much easier to feel rich (playing at poverty), and you might like to try it. If you hit a desperate moment, pretend you are a millionaire experimenting on how it feels to be poor. Look at it, enjoy it, play at it, and come out of it wiser but unharmed by the ordeal.

One way to do this is to try to keep certain luxuries in your life at all times. Mine was my car, which I used without considering the cost of gasoline, repairs, etc. I also surrounded myself with small luxuries like good soaps. And I often sent myself flowers—pots of flowering chrysanthemums, always cheap in the grocery stores and one of my favorite flowers.

I've discussed this method of coping with poverty with others and one young woman told me she tried it and it worked right away.

"I don't look at the pineapples and mushrooms and buy apples and carrots; now, I buy pineapples and mushrooms," she said. "I used to think pineapples were too expensive for me, and then I'd go to a cafe and have a cup of coffee for the same price."

A friend with four children says, "People think I've never traveled, but I have. When I clean the floor, I'm actually lying on the beach in France!"

So next time you are feeling poor and a little desperation—and I do know that feeling; the pain is almost unbearable—think of something rich to do. Plan a trip to somewhere, perhaps Spain, call the travel agent, and check out the first class fares (or would you prefer a cruise)? Ask about the weather, what clothes you should take, and the cost of the hotels. If that makes you feel good, you will have tricked your mind into enjoying poverty. The heaven of it is that you don't have to go to Spain. You can make all the preparations for nothing from your armchair.

It costs nothing to walk through the most expensive hotels, to enjoy their gardens, to sit in the lounge. Parks are free, so are beaches, many museums, galleries, libraries, churches, and wandering through the finest department stores. In California it costs nothing to visit the wineries and taste their award-winning wines. Each state has such special places intent on attracting tourists. Enjoy these good things and let them lift your spirits.

3
The Complete Photographer

You are ready to be a studio operator when you can handle any photographic situation that comes up. That's the ideal. However, if you waited for this moment you would be waiting still. But you do have an above average competence with:

- The camera
- The subject you will now be paid to photograph
- Many of the problems you can expect to run into day after day

If you also have one photographic skill that is above average—whether it is photographing food or buildings or babies—then the hard part is over. You'll quickly pick up the rest.

The one exception to the last paragraph is landscape photography. There are few exceptional landscape photographers (but many who think they are). Waiting for a beautiful sunset, pointing a camera at it, and clicking the shutter is very inadequate training for satisfying a critical customer.

Photographic Expertise

What would you do if:

- Your flash failed?
- It rained when you were expecting sunshine?
- You woke up with a fever and were due to photograph an anniversary party?
- Your car broke down on the way to a job?
- The lab lost your film?
 etc., etc., etc.

There is no definite answer to any of this, except that you can hardly shrug it off and say, "Too bad, they'll have to get someone else."

Would you use the same settings for:

- A black person and a white? (No.)
- A sunny day in the snow, the woods, the desert? (No.)
- An automobile for the manufacturer, and a sculpture of the identical automobile for the artist? (Probably not.)
- A horse and a human? (Sometimes.)

And if you made a wrong decision, would you correct it without letting the

customer know, or retake the sitting? (Whichever is easiest, considering first the customer's convenience and then your own.)

More questions:

- Can you photograph an interior without bringing your own lights? Can you do it with one light?
- Do you know all the current Kodak films available?
- What would you do if you were offered a job but didn't have the equipment you needed?
- Which lens would you use for someone with a long nose?
- Are you changing your f-stops to change the depth of field?
- Can you take an outdoor picture to look as if it were taken indoors and vice versa?
- Can you photograph a chair, an apple, an elephant?
- What are the requirements of the American passport picture?
- What format and film type will a printer require to provide your customer with post cards, brochures or catalog pages?
- How would you photograph a group of fifty-six people?

These questions are not designed to test you but to make you aware of the variety of problems you will meet and to guide you to the answers, if you do not know where to find them.

You can't wait forever to be ready, but a good indication of whether you *are* would be the public's attitude toward your work. You don't need praise alone. When someone offers to pay for your services, rather than for the film, it's an indication that the time has come. The turning point for me was when a rancher said, "Please charge me because then I can order freely what I want."

What Is a Photographer?

We are nondenominational. We come in two sexes, a variety of colors, races and religions; we are heterosexual, homosexual, and maybe even asexual—though I haven't met any of those, yet! We span all ages.

One of my sons was an excellent photographer at nine years, handling the camera with considerable dexterity, composing pictures carefully and clicking the shutter at exactly the right moment.

Julius Schulman, the great architectural photographer, is a vigorous man in his eighties with a work schedule that seems incredible.

We are often very ordinary. Our ability to click the shutter at the right moment *alone* separates us from other businesspeople. We are artists with strong opinions about our own taste—fascinated with visual images and mechanically minded, with a love of technical things.

The self-employed photographer is also likable because he is enchanted with other people. A portrait photographer loves other people's faces, whereas the obsession of most people is their own faces. A commercial photographer gets excited about people's ideas, products, and interests because these are the subjects that will test his skill.

My friendship with Boris Dobro started when I saw him staring at me at a large dinner party. Later he apologized for making me uncomfortable, saying he

had been wondering how he would photograph me. Now I do the same thing to others. But I was very intrigued with the old man who never took his eyes from my face. It made my evening!

I know a commercial photographer who can go into a house and after a few minutes in each room remember every detail in that room. Naturally, this endears him to the people who chose those items and he has garnered many return invitations, inevitably leading to business.

A photographer can use this naturally likable quality to bring in business, but you can also use it to regain energy when you're feeling deflated. If you feel down, walk around the block, drop in at the local coffee shop, wander around a drug store. Taking in all those sights will revitalize you because you are a visually stimulated person.

Business Expertise

You may not have business experience, but don't neglect to develop business skills that will help you.

Basic business methods are easily learned, but if you can get some on-the-job training, that is, work for someone else, you'll be doing it the easy way.

If you decide not to take this shortcut, follow my simple bookkeeping and filing methods (see Chapters 13 and 16) and adapt them to your needs. Once you earn enough money, pay someone to do it for you if you still hate to work with figures.

The Photographer/Businessperson

Self-employed photographers must be more aggressive, competent, understanding, tactful, and resilient than the average person. They must also be self-motivated, innovative, stubborn, and optimistic in a job they can do for life.

When amateur photographers get into discussions with me (and I include photographers who may be professional teachers), "The only real difference between you and me," I say, "is that I *have* to come up with the pictures."

If you already have or would like to have your own photography business, you now *have* to come up with the pictures. You have decided to waive the security of the paycheck for the more dangerous life of being paid per job and it will take resilience, for some jobs will not pay. There are, I have found, people who work at cheating others.

But now you'll also know the pleasure of landing a lucrative job, sometimes by luck alone, and earning $1,000 for a simple half-day's work—and that money is *all* yours.

You can be as eccentric as you like and there will be no boss to correct you. My hours are ten to five because it takes me a full hour to wake up. Decide on hours to suit yourself, decor to suit yourself. You are in charge. How sweet it is!

Stubbornness

I asked a Small Business Administration official, "What makes a successful small businessman?"

"Stubbornness," he replied. "I see it year after year. I think: *That one will be bankrupt before the year is out,* and then there he is, five years later, trying to get a loan to put in *improvements.* Most of you are already out of business but don't have the sense to know it!"

Optimism

We're like the girl who told me that she had finished last in a 100-meter swimming race at her school and that night dreamed she had won at the same distance in the Olympics. To run a successful small studio, you'll have a manic optimism—you won't believe you're licked no matter who says you are.

That optimism takes many forms. Time and again you'll hear a self-employed person say, "It's a gamble but I'm going to take it because if I lose I know I could start again and get back to where I am now."

Humility

On the other hand, we all need *humility.* Nothing is worse than a know-it-all businessman who won't admit he could be wrong, or that he isn't as good as someone else. There is nothing wrong with knowing when you're best, but you can't be best all the time and at all things.

I have not met one photographer (who was any good) who wasn't aware that disaster could be just around the corner. Even Boris Dobro, a photographic genius, told me that every time he picked up a camera, he was convinced he was going to have a dud day!

By contrast, a young photographer refused to show me a contact sheet. Only an album of selected 8x10s would do because he felt they demonstrated his competence. I refused to hire him.

Later he told me that he had lined up several Christmas portrait orders. "I'm taking the business from under your noses," he told me. So I was not the only photographer who passed on him!

After Christmas it was another story. He gave up photography for good because of the complaints. He lashed out at the public. "Vain bitches," he called the women.

If you approach each job with caution and humility, you won't make his mistake . . . that of thinking he was so accomplished he didn't have to make an effort.

Eating Humble Pie

Whenever I feel I've got this business licked, something will happen to bring me down and make me humble.

How would you like to: Be booked because "all the other photographers are busy," or "all the other photographers are closed today" or hear "We came to the wrong studio by mistake?"

Recently I received this backhanded compliment: "I sure wish they'd hire you to take the driver's license pictures!"

And a lesson in anonymity was taught: "I didn't know you were a photographer, I just see you on the street."

I never laugh at these people. I'm afraid they'll take their business elsewhere!

Self-Motivation

You've got to be driven from within. The ability to work long hours is a necessity to any owner-operator.

One of the three wealthiest men in our town is in his late sixties and admits to putting in consecutive twenty hour days even now. Yet his father and grandfather were wealthy men.

"If you can't work," he says, "you'll never get anywhere, but money behind you helps."

I still work twenty-three days at a stretch, two or three times each summer.

In my first self-employed year, I sat in front of the TV every evening spotting black and whites for my first book and for stock agents; that was back in 1966. Every day was a repetition of the day before. I took pictures, developed the film, and printed and spotted the 8x10s. I couldn't wait to get started again each day.

The summer of '67, I took the kids to the San Diego Zoo and found I had forgotten what to do when I wasn't doing photography! I could take pictures at the zoo, but sitting beside the motel pool and swimming from time to time made me restless. I had to get my camera.

Yet my parents used to deplore my lethargy. I did jigsaw puzzles and moaned if I was asked to help someone. As a housewife, too, I could find little to do but sit around.

It was only when I found work I liked that I became obsessed with it.

When you have that kind of enthusiasm for the job, go with it. Don't hold yourself back. I now have dual obsessions, both photography and writing. When friends ask, "Don't you rest?" I say, "I'm all rested up from my youth."

Like the many, many businesspeople I have spoken to who survived the initial years, I am very proud of the long hours I put in. Actually, to think of it, it was no strain at all. And because it was no strain, it was often possible to have more outside interests. I kept taking everything on, and friends kept dumping things on me because they, who were less busy, never had any time. I was doing what I wanted to do and in the evenings I just went on doing it. It is called self-motivation.

A Self-Motivation Test

Imagine that you are shown into an empty room.

You will be left entirely alone, no one will watch you.

In the room you'll find just one bucket and several rubber balls.

While you are there you must throw the balls into the bucket.

You can stand anywhere, there is no score and no one will know if you got even one ball in.

Now close your eyes and imagine the scene. How close to the bucket will you stand?

The test is a way of figuring your self-motivation. The further you stand from the bucket, the more you like to test yourself and the stronger your self-motivation is.

When this test was put to me I said I would stand far enough away to make it a game, and then move farther and farther away as I became more skilled.

George Hasslein, who has become a legend in his field by creating the largest architectural school in the country out of a four-professor department in an engineering school, replied that he would open the door to the room and, leaving the bucket at the other end, would back out of the door and *start* throwing!

A retired friend said, "I'd stand over the bucket and be *sure* I got them in." She didn't want more challenges.

But however self-motivated you are you can't keep up an abnormal pace indefinitely.

Self-Discipline Works Both Ways

Eventually you have to slow down; age demands it. You have to get off the treadmill, interrupt your forward momentum, fall in love, or lie in a hammock. Your interest might shift for awhile (as mine did to writing). You could buy a new home and become fascinated with remodeling it, get excited about a sport, or travel. What about disaster? Illness, death (someone else's!), an earthquake, a fire—any of these could bring you temporarily to a halt.

This is where the money management of your business holds you together. No matter how hardworking you are, your business should become financially self-perpetuating as soon as possible and ideally, you should have an investment to back you up.

Retirement

The professional photographer doesn't really have to worry about retirement if he keeps stress down and doesn't hit the bottle. Both are sure ways to end up on a life-support machine.

A successful young customer and I were discussing social security a few years ago and I said one day I would make additional provisions for retirement.

"When will that come . . . your retirement?" he asked.

"Oh, I don't know, one day," I replied.

"But when? Will you be 60, 70, or 80?"

"Everyone retires sooner or later," I said.

"No," he answered. "They don't. Some people never retire and you're one of them. You'll just go on doing photography and writing books and then one day you'll die."

When Boris Debro died on location at eighty-two, I thought about that! I hoped it would happen to me that way. If you can't think about retirement, you probably won't need it. Don't worry about an infirm old age. Fear of something has a nasty way of making it a reality.

The previous year Boris and I had taken some pictures together.

"In the morning," he told me, "I look at myself in the mirror and say, 'How can a mind as alert as yours exist in a body that looks like that?' "

He knew he would not last long, "I've had a call from St. Peter," he told me long before.

One year before his death I heard Buckminster Fuller talk to an audience of architectural students and he held them spellbound for four hours. He was eighty-seven. The only concession he made to his age was to ask for a chair after an hour on his feet. His talk was unprepared, he said, because it was more exciting that way and allowed for interesting thoughts to come up as he went along!

His wife of sixty years sat beside me through the lecture and chuckled at his jokes as if she had never heard them before. She never once dozed off.

They had flown into L.A. from India the evening before and taken a plane to San Luis Obispo the morning of his lecture. After he spoke we had a late (11:30 p.m.) supper, and at 1:30 a.m. Mrs. Fuller said she was a little tired from the long day so they returned to their hotel. Later that morning this incredible couple caught an 8 a.m. flight back to L.A. so Bucky could take a mid-day plane to Chicago!

It is interesting to note that Buckminster Fuller was self-employed.

The Reward

One day for fun I made a list of the kind of people I might never had known if I hadn't had to photograph them. It has enriched my life considerably to have met these people—kind of like living a book of short stories.

Here is part of that list:

A man whose name is on a can or bottle in just about every kitchen in the country because the product is owned by his family.

A Nazi from the Third Reich. "Hitler is a much-maligned man," he insisted. No, I didn't throw him out, I took his money!

Patty Hearst.

Several national sports heroes.

The president of a country.

A prime minister.

A man with three personalities (like the *Three Faces of Eve*).

All kinds of crooks, politicians and other professionals!

Aristocrats with long titles.

Prostitutes with long records.

Some of the most beautiful people in the world. And, as the ad says, *many more.*

I wasn't successful when these people walked into my life; they just did. But if I were a bookkeeper in a supermarket I'd never have known who they were.

All kinds of personal intrigues have also enlivened my world. Husbands and wives hide their extramarital affairs from each other, but not from the photographer they both employ.

Three customers on separate occasions have offered to arrange a "hit" if I didn't like someone; in my life before photography, I thought those things only happened in fiction. (No, I didn't take them up on it!)

The camera has also given me a way to move through other people's worlds without their questioning my presence.

I can travel alone, not always the wisest behavior for a woman in certain countries where an unattached female had better have a reason to be there, or

she is considered either "loose" or a husband-hunter.

These advantages of being a photographer have stayed in my memory, outweighing the times when things went wrong. I can remember the times of agony, before I took equipment failure in stride. After every job I used to become a basket case until I saw the results of my work and knew it was "all right," and if it wasn't, I would have nightmares about it.

Fortunately, that insecurity passes, and I have come to accept that everyone has equipment failure sooner or later.

Looking back, there is no pain—only amusement at the catastrophes and delight at everything else!

TIPS

On Teachers of Photography

High school and college photographic classes are often taught by photographers who haven't tried to sell their work. If your experience is from a photographic class you may be surprised how much information is left out and that some nonsense is left in.

The man who taught me photography, as an example, did not realize that his use of a waist-level finder made his standing subjects loom into the picture. And because his "eye" was not original, he taught us that there was no such thing as originality. It had all been done before!

Two of my photographs were printed on the Miscellany page of *Life* magazine in the 1960s. In each case I deliberately took unsharp pictures as well as sharp, noticing that *Life* used a snap-shot look on that page. I suspected it was a deliberate choice, giving an accidental look to the "double take" pictures.

Sure enough, both pictures printed were from the unsharp negatives, although *Life* had the sharp ones, too.

I have fought this point with college teachers of photography who insist that no one would buy an unsharp picture. How do they get into the magazines then? It is the subject of the picture that sells it rather than the technique, though the finest magazines get *both* from their contributors.

Teachers who are real photographers occasionally ask my advice *just because* I have the street knowledge of the business. They pass to me information from their ex-students who are out "in the world," which initially made me aware of how much nonsense I was getting from other sources.

When a teacher talks, listen and take what you need, but don't always believe.

Fourteen Agonizing Experiences

Before you feel sorry for yourself because you've goofed, you may like to know you're not alone.

1. *The Case of the Darkroom Lights*

I went into the darkroom to develop four rolls of film, a separate black and white sitting on each. I closed my eyes, unrolled the film and put it on the reels, dropped it into the tank, and opened my eyes to find I hadn't turned the lights off.

2. *The Case of the Sodium Sulphite*

Sodium sulphite added to the developer will make finer grained negatives. I measured out the sodium sulphite and developed the film and came up with a blank roll. I had bought sodium *sulphide* by mistake.

If you ever make this mistake you'll know it by the smell. Sodium sulphide smells like rotten eggs!

3. *The Case of the Double Exposures*

I exposed a roll of 120 and then ran it through the camera again backwards coming up with *two* dud rolls.

4. *The Case of the Missing Roll of Film*

I was photographing a dance and used my Nikon for the single shot of each couple for the usual "prom package" coverage. When I got into the car after the dance I found that one roll was missing. That meant thirty-six couples would have no pictures.

What had happened was that one of the dancers had a camera and saw my roll of film on the table, thought it was his, and put it in his pocket. By the time I chased it down it had been developed and cut so I had to pay for the pictures to be printed individually. The college students who had hired me had also all gone home for the summer. I noticed they didn't hire me the following year!

5. *The Case of the Photographic Dream*

I dreamed I arrived at the wedding and had left my flash unit back at the studio, so the next morning when I turned up at a church to photograph a wedding, I somehow got my dream mixed up with reality and rushed back to the studio to find I had the flash with me all the time!

6. *The Case of Everything Going Wrong at Once*

I was hired to photograph a wedding 200 miles away and decided that one backup unit was not enough. I took three of everything. Just as well.

While the couple were at the altar the camera body malfunctioned. The best man was at the altar, my backup cameras were in his car and he had the key in his pocket.

As soon as possible after the ceremony, I got started again, and then a set of ni-cad batteries went dead. I changed those and a lens jammed. I changed that and the new batteries went dead. Finally during the reception the third set of batteries went dead and the best man ran down to the drugstore for more. As soon as he got back with them, another lens jammed!

That was, by the way, the last time I used ni-cads!

7. *The Case of My Only Flash Unit*

When I started photography I took only one flash unit to the first wedding I photographed. It was all I had. As the bride entered the church on the arm of her father the flash failed and never did function again.

I muddled through somehow and when the bride bought an 8x10 of every picture I took, I discovered that you don't need flash. It just makes a job easier.

8. *The Case of the Angry Bridegroom*

A bride's father called me and flew into a rage. He thought my pictures were in "bad taste."

I was startled, to say the least. "In what way?" I asked.

Apparently he thought the picture of his daughter and son-in-law kissing was disgusting.

I thought it was pretty funny until the bridegroom himself turned up at the studio with a brown paper bag; in it were all the wedding pictures torn into small pieces! When he saw my face, he grinned, "Don't worry," he said, "*WE* loved them. I tore them up so that dirty rat would stop talking about *his* money." And then he ordered them all again!

9. *The Case of the Missing Deposit*

I turned up at the church to photograph what I was now calling my "nonpaying job."

"Are you the official photographer?" someone asked me.

"I am," I said.

"The official photographer has arrived!" he yelled and everyone clapped.

I had come to love this family although they seemed intent on not paying me.

"What is this word 'deposit'?" asked the elderly Mexican mom.

" It's . . . it's good faith money!" I told her.

"Well," she said frankly, "I don't have it. When you come to the church we'll give you money."

"It is customary," I tried again, "to give upfront money to the photographer."

"It is not my custom," she smiled warmly, "because I have no upfront money."

I cannot resist people who are genuinely kind and nonmaterialistic. They can talk me into anything, and so there I was at the church.

During the service a man approached me and whispered, "You want upfront money?"

"Sure!" I whispered back.

"Here," he said and he gave me two dollar bills.

Yes, they did pay the whole bill eventually, but only when they had seen the pictures!

10. *The Case of the "Blinkers"*

At one wedding I photographed I managed to catch eight closeup portraits—that is, eight different people—with their eyes shut. Every person in the family seemed to have a nervous twitch in the eye.

As some of these people *had* to be in the album I decided to put all these pictures together—four on one page facing four on the other—rather than scatter them through the pages or pull them entirely.

This turned out to be everyone's favorite page!

Apparently they were used to pictures of themselves with their eyes shut and thought I had done it deliberately, to make them laugh.

11. *The Case of the "Most" Beautiful House*

"You won't miss it," said the owner, "it is the most beautiful house in that block. Just get a picture of the front of it."

I went out and it was indeed beautiful, a stunning old home with gables and a good-looking garden.

When I showed her the pictures, she was outraged. I had photographed the wrong house.

12. *The Braces Case*

A boy I photographed assured me that his braces were "him." His mother arrived two weeks later, fuming. The braces were to come off the

following week and I should have waited!

13. *The Case of the Foggy Film*

One of my worst experiences happened when I photographed youth baseball. The lab phoned me to say that a whole roll of film was unsharp (six teams). I never did figure that one out, but the following year the lab called *again* with the news that again a whole roll was fogged! (I found out the cause of *that*. My son found an old roll of film in my glove compartment and put it in with the others!) It came as no surprise to me that I wasn't called on to photograph youth baseball again!

14. *The Multiple Disaster Case*

An unusually beautiful album was finally presented to the bridal couple despite the fact that everything went wrong. (I had used an enormous amount of film however, when I realized it was just not one of my days.)

For starters, I thought the wedding was scheduled an hour later than it actually was (someone phoned me so I got there fifteen minutes before altar time). Then I kept forgetting to change f-stops in the church so I had to reenact all kinds of action that had happened. I also left a swirl filter on the lens unintentionally for twenty exposures. People kept stepping in front of me, ruining what good shots I managed to get; I put a 220 roll of film into the camera which was set for 120 film. And I locked my keys in the car!

Business Lunches

I worked for a large engineering corporation for two years before I was a photographer and learned a great deal about salesmanship because it was my job to keep statistics on the salesmen.

My records showed that each salesman's success was in *direct* relationship to how many times he took a customer out to lunch. These salesmen were selling the tools needed to run and repair the enormous machinery that our company manufactured and they merely checked in at the different corporations and took managers out to lunch to discuss their needs.

Each of our salesmen was supposed to turn in five lunch expense slips a week and list the name of his guest or guests and their business affiliations. If someone turned in only three slips for a week, his monthly average was *always* off and he'd be hauled in front of the manager to explain why.

Our top salesman was not at all aggressive; he was just a sweet, friendly man who loved talking and eating and he made a great deal of money.

Our salesmen also made it a point of knowing our *competitors* by name. If another engineering company decided to give a posh dinner for a construction firm that had picked up a large government contract, our spies would let us know where it was to be and at what time! Two of our salesmen would then happen to drop by that restaurant when the dessert was served, go over and greet their "friends" in the host firm and buy the after-dinner drinks. There was no way for the others to escape; the host would have to introduce our men to their guests and, at the end of the party, guess who would be best friends with the construction executives.

Although I kept records on the "parts" salesmen, we had salesmen in every part of our business. Even if we lost a large job in a foreign country, our men would be there whether it was in Saudi Arabia or Tibet, buying drinks and picking up the meal tabs! And often our top executives would fly

over for a few days to do some entertaining when our competitor's machinery started giving trouble.

That all this paid off was evidenced when *Fortune* magazine rated the top fifty companies in the U.S. one of the years I worked for the company. It was in the top ten of those making the most profit per capita.

The most successful photographers I have met are definitely gregarious. They don't have to have an excuse to eat out, they do it all the time, and they are rarely alone.

They don't have to be told to "sell" their business, they do it instinctively. Their interest in their work closes the sale.

I know my own love of being with other people has been very helpful to me, particularly starting as I did with nothing. I often end up very good friends with my customers, and the reverse happens: Friends become my customers.

Taking people out to lunch was not something I did for business reasons, until I remembered how it had worked in the company where I had been a secretary. But looking back, so many of my major jobs have come from people who know me socially, either directly or by recommendation.

The photographer who is rather shy must remember that not everyone is comfortable socially, and that good manners do not come naturally. They are learned.

About Looking the Part

An insurance salesman who is told, "You don't look like an insurance salesman," is delighted. It is a compliment because the prototype salesman is not a terrific physical image to emulate (smiling, ingratiating, insincere).

A photographer who is told, "You look like a photographer," should be delighted, because it sounds like a good person to be. (Artistic, yet practical, interested in all visual things.)

A photographer who looks like an insurance salesman is therefore doing it wrong!

Larry Simon (I used to call him "Central Casting" because he looked exactly the way an architect should look) told me he worked on his look because it was extremely important for clients to see him as their own image of an architect. He is very successful today, not just because of his image, but also because he has enormous talent to back it up.

This "image" problem is particularly difficult for me because much of the time I couldn't care less how I look. But I feel it is vital. I must emphasize that what you *don't* want to look like is an ad for polyester; you want to look as if at least, once in a while, you make an effort to buy quality clothes that really fit.

For Women Only

Repeatedly (invariably by women) I am asked my feelings about entering a predominantly male profession. The fact is, I never thought about it. Nor did I give a second thought to competing with men when I studied photography. If they took a better picture, they won; if I did, I won.

We have not as yet achieved in this country an entirely comfortable relationship between males and females. It is as exhausting for me to have to deal with women who feel perpetually put upon by the insensitivity of

men as it is to deal with the men who are insensitive.

I realize my own Oriental upbringing in a country where a woman is considered intellectually equal although physically vulnerable may have made my own experiences as a woman in business slightly different from those of American-born women. I do, however, find it frustrating that American women have to prove to most men that they are equal citizens rather than to be given this right automatically.

I must make it clear, therefore, that what follows is my own opinion; maybe it's not what I *ought* to feel, but it's what *I do* feel. Another woman would probably come to different conclusions, given the identical situations.

Does a woman photographer do as well as a man in business? Once your reputation is established, it doesn't matter what your sex is. I do less commercial work than I should and I am sure it is because I am a woman. To get this work I'd have to really go out there and fight for it. I make that up on portraiture, which is my first love—here I did my initial footwork, and getting myself known was pretty easy. A female portrait photographer seemed a natural. If there was a difficulty it was in getting enough people to prefer a portrait that didn't try to be exactly like every other they had ever seen; to go for my particular style.

When I had a male assistant I noticed that a different type of work came into the studio through him. I hadn't realized there was a certain macho type I wasn't attracting, men who do business only with other men until something out of their control comes up to break this habit. This assistant was addicted to drinking at bars. As long as he was a social drinker he brought in good business from male drinking acquaintances. When he started boozing really heavily, in fact became a drunk, no more orders materialized.

Many male customers, of course, see me merely as a photographer, someone they hire to get a particular job done and often these are my most loyal boosters. Women too, by the way, may choose a photographer just because he is a man, just because she is a woman. You win some, you lose some.

How to Get Depressed, or Competitive Jealousy

More destructive to your business than what someone else can do is what you can do to it.

Jealousy is such pure poison to a professional business person that it can destroy his entire joy in what he does. Being jealous and being competitive are two different things. Jealousy is always destructive; competitiveness can be constructive.

The new *Rangefinder* arrived a few days ago. The first article I read is Don Feltner's and he discusses how his ad was left out of the Yellow Pages in 1981 and how he overcame the problem by restructuring his ads and prices and has promoted his studio since to bigger and better things. When I put the magazine down I was acutely depressed.

Don Feltner's ability to handle such a calamity with cool intelligence left me feeling incompetent.

If *my* ad were left out of the Yellow Pages, I'd consult a lawyer and gripe.

Do articles about other people's competence leave you feeling ready to give up and take up another job?

I read the article after a particularly good week, one in which I noticed

that the previous month I had made more money than the whole of 1966, $1,800 more! I also had three wonderful compliments from customers, any one of which would have left me flying for a week.

Yet I have never been a jealous person, so what I feel for Don Feltner is not actually envy at all because I couldn't change places with him and I know it. But I feel "less" in some way.

Such feelings can have a great deal to do with your ultimate success or failure. If your business becomes nothing but a series of downers, there is no purpose whatever in continuing.

It's easy to say, "don't be jealous," to a jealous nature, but that doesn't necessarily help. Instead, let's consider how to handle jealousy.

1. Every time another photographer succeeds it means that the public interest in photography is rising, the pie becomes larger . . . a pie in which you have a slice.

2. What is the photographer you are jealous of doing right? If it is something you can copy, do it. If not, store the information away.

On the other hand, if a competitor is jealous of *you*, don't feel threatened. Take it as a compliment.

In England a book called *One-Upmanship* created a delighted uproar when it was published. In it the author told others how to make other people insecure! Suddenly people became aware that they had become victims of others' one-upmanship or had been doing it themselves. And they realized that in an effort to keep ourselves "up" we create an atmosphere in which someone else might well feel "down," and sometimes we do it deliberately so that no one knows how scared we are.

But it also showed that when someone says something—even by accident—that makes you feel "less," then you can get back to feeling the way you were by taking yourself back mentally to where you were before you heard that remark.

The Wide Receiver

Every time one studio grabs a job intended originally for another studio, it learns something *not* to do.

In fact every job is a job taken out of someone else's pocket. A sad fact of life is that we succeed at the expense of someone else. So we become competitive—or if we don't, we go down the drain unless a combination of luck, talent, and money makes it possible for us to ride out any storm. We can't depend on that. All we can do is see that the jobs we do get don't find their way into someone else's studio, and that the jobs we pick up because we happened to be there at the right time, don't go back to the studio they were intended for.

Every new job is a center of a snowball, one that will finally put us in that enviable position, a business that generates new business automatically.

Here are some instances when I was able to take other studio's customers from under their noses:

1. *Weddings.* If a photographer blows a wedding he should somehow make it good to the customer. That all studios do not is evidenced by the number of times I have had to retake other photographers' bridal sittings. After the couple have seen their album, they come to me to somehow get pictures they can send their friends.

What I want to know is why the photographer who photographed the wedding in the first place wasn't willing to take more pictures just to keep me away from that family.

2. *Unpunctuality.* "We're all dressed up," said the mother of a family whose work I do now, "and the photographer hasn't showed. Can you do the pictures *now?*"

Not only have I photographed other events for this family, but they have recommended me to their friends.

The original sitting was a gift from one of their family, so they didn't even have to pay for it. But they still preferred to use someone more reliable and pay the bill themselves.

3. *Rudeness.* A photographer had developed a snappy way with his customers, and I owed my first jobs to him. A number of people he'd been rude to came to me. One of our wealthy local families did not go back to him because their teenage daughter heard him saying to a friend, "I hate teenagers."

4. *Rigidity.* A photographer who says to the bridal couple, "That's not tradition, it's superstition," when they want to wait until *after* they are married to be photographed together, has lost weddings to other photographers as well as myself.

There is no way that a thinking couple is going to meekly say "you know better," to that kind of nonsense. The fact is, it is their wedding.

5. *Manner.* A number of times I get a job because someone else's manner has upset the customer. This can work in the reverse. How do I know if my own manner is upsetting someone? I ask. After I have completed a job I sometimes sit down with a customer I feel I have developed unusual rapport with and discuss how I could better serve the needs of the customers. What did I do wrong and what right? Occasionally out of these little talks I get some really good ideas.

It is difficult to come up with a mother-and-child picture that avoids a stereotype. Here, the expression of the child is carrying one's imagination beyond its conventional setting.

A Picture Portfolio: **Portraits**

Sensuality is not nudity. I have
a large collection of nudes, yet
this picture is more sensual
than any of them. Her skin is
tanned and the rest of the pic-
ture is in neutral shades. It is
one of those poses that young
women ask for; its appeal is
not just to men.

The child I was photographing
was perched on a stool in front
of the backdrop when I turned
and saw this lovely picture on
the sofa. Very carefully, we
moved them in front of the
backdrop, and I was able to
get the picture before the child
became aware of the camera.

Here mother and daughter were photographed for no reason except to decorate their wall with my work.

The double exposure of Joy, the mother, is in light browns and white. Her hair is very fair, and she has exceptionally light blue eyes and wears no makeup. Women look at this portrait a lot and like it. (Print size is 16x20.)

Cynthia, the daughter, is wearing a kimono of many colors (mauves, blues, and gold) with plum-colored tights under a purple satin skirt. She is not dressed up: she wears exotic clothes all the time. Like her mother, she wears no makeup. Young women often ask to be photographed in what is now known as Cynthia's pose. (Print size is 30x40.)

These portraits of high school seniors show my feeling about pictures of men of any age. They should be simple, they should not be over-retouched, and they should show the style of the man. Notice that the "full-length" shots are actually three-quarters, and that a foot is placed to bring the body forward. Men of all ages tend to lean back. Any full-length portrait, like a statue, should never appear to be toppling.

These two pictures (below and upper right) are from the series
10 Moods of Janice, photographed within one hour. They show
that the camera tells only the story its operator wants it to.

Here is Janice's own favorite.

Here is a picture I use to demonstrate that age doesn't need to be softened.

4

Gearing Up—Basic Equipment for Studio Photographers

You can't take pictures without a camera, that's for sure. But how much equipment do you really need? If you are desperate, of course, you'll start as I did with too little, but I have compiled a bare minimum list that I would have liked to have back then.

1. Two medium format camera bodies.
2. Three different focal length lenses and one backup lens of the length used most (105 mm for Mamiya TLR [twin lens reflex]).
3. Two electronic flash units with auto sensors.
4. A tripod.
5. Two cable releases—one for backup. (They can get lost easily on location.)
6. As many filters as possible for the lenses, also lens shades, and any accessories available.
7. A black light-tight changing bag.
8. Something for the subject to sit on and for an object to be placed on.
9. At least ten rolls each of black-and-white negative film and color negative film.
10. A few rolls of color positive film.

Add everything else you can buy as you need it, and that includes a light meter. Your electronic flash tells you what settings to use. For available light you can easily follow the instructions that come with any film of the speed you use. A studio photographer doesn't do very much work at low light levels and sooner or later you can pick up a good light meter.

If you don't have a second camera body even an Instamatic is better than *no* backup camera. Borrow or rent a camera if you have to, but don't do a job out of your studio without a second camera and film to go with it.

"What would you do," asked one of my students "if you took two cameras on a job and both jammed?"

"I would borrow, hire, think of some solution. But what I would *not* do is worry the customer with my troubles."

I told him of a time when this happened. Only then I had no time to get my backup camera.

As Mary and Dave were about to leave their restaurant reception and came

running to their car through a shower of rice, I found my lens had jammed.

I looked around and saw a guest with a camera and said, "I'm the photographer, my camera died, please take the pictures," and he went to work.

As the newlyweds drove away, I thanked him and asked if I could buy his film and send him copies of his own pictures on the same roll. As amateurs do, he refused because he had five exposures left!

"I'll send you the pictures," he promised and I gave him my card.

"If you lose it," I told him, "send them to Mary and Dave."

Eventually my work was ready. Mary arrived to pick it up and I told her why the last part of the celebration was missing. "One of your guests took the pictures," I said. "Have you heard from him? It was a Lewis Snyder."

"Oh, was that what happened?" she replied. "I did get pictures from a Mr. Snyder. They came to me care of the restaurant. Who is he?"

Mr. Snyder had not been a guest at all. I had approached a stranger! But he was a nice stranger for he had sent no bill.

I didn't borrow the man's camera myself for two reasons: 1) I would be appalled if a stranger asked for my camera, and 2) the young couple was *running.* Even if he had offered me the camera I'd have said, "No, it will be quicker if you take it," as each camera model has its own idiosyncrasies.

Of course, I was lucky. Mary may well have missed those final shots of her wedding. But I wouldn't have been unlucky. I would merely have goofed if I hadn't tried.

The 35mm Camera For Studio Work

Few studios build their methods around 35mm for several reasons:

1. The print bargains usually exclude 35mm film. Many labs insist that 35mm be put through at custom prices only.

2. The 1/60 second setting for flash hopelessly overexposes outdoor pictures, and even if you can stop down enough you have too much depth of field. (Most of us use a flash-fill on outdoor portraits.) If your 35mm is synchronized for flash at this speed it just doesn't do the job. "What about cutting the film speed by using neutral density filters?" you might wonder. If you are trying to "simplify," you won't want to. Say you are using a skylight filter and a soft spot filter, as well as two neutral density filters. That's eight surfaces to collect dust—besides the lens.

My Cameras

The Mamiya twin lens reflex, the mainstay of the studio, is the heaviest camera that I can tote around comfortably.

I have five camera bodies, including my very first bought used in 1960: Two c.22s, one c.33, two c.330s.

I also have four eye-level viewfinders, besides the five waist-level viewfinders that came with the cameras.

All the camera cases, lens cases, and protective covers are never used. I wrap the cameras in towels or other soft fabric and the extra lenses in soft lens

pouches. I don't want to unpackage cameras every time I use them.

(Cameras are advertised with "handy" carrying cases. Pros call these "unhandy" carrying cases.)

I have eight lenses for the Mamiyas: one 65mm (both this lens and the 55mm that I sold are unpleasantly soft toward the edges), one 80mm, three 105mm, one 135mm, one 180mm (my first lens), and one 250mm.

I also have a Yashica t.l. (twin lens) and 80mm lens for backup wedding work, mostly to lend to photographers who work for me. This is actually not my camera. It is on loan from a friend who never uses it.

The Nikon F is my "personal" camera, the one I take when I am traveling. All over the world I find Nikon and Nikkormat owners who will lend me equipment I need, if I lend mine.

I prefer this Nikon to the newer models (the newer built-in light meter I find too slow). In fact, I had to rush out and buy it when I heard it was being discontinued.

I travel with only the 135mm lens and a p.c. (perspective correcting) 35mm lens. I don't even take the macro zoom with me anymore, though when I did I was always lending it to friends. The p.c. lens (straightens buildings, etc.) is such a treasure that everyone wants to try it and will naturally lend any of their equipment to do so!

Backup for the Nikon is an old Yashica 35mm, a lucky purchase many years ago. The color and quality of the lens is exceptional.

View Cameras

Both my Speed Graphic and my Toyo have Polaroid backs. I also have a passport adapter (takes two pictures at once) for the Graphlex (Speed Graphic) but have never used it.

Both these cameras only take 4x5 film, although they can be adapted for roll film if necessary; I do not have adapters.

The Speed Graphic is actually a press camera, not just a view camera. The difference is that with a view camera the only way you focus is through the ground-glass panel at the back. You've seen the old-time photographer (or maybe a movie of him) disappearing under a black tentlike cloth to focus. He isn't protecting light-sensitive film but trying to get a sharp image without room light interference. Some cameras have snap-up shades so you don't need a tent.

The photographer slips in a film pack behind the ground glass, slides out the guard in front of the sheet of film to be exposed and takes the picture. He then replaces the guard upside down before removing the film pack—so he now knows that particular sheet of 4x5 film has been exposed. He must reverse the pack for a second exposure, and he must use a new film pack for a third exposure.

The awkwardness of all this is considerable. You must load all the film packs in advance in the dark, one sheet of film to each side.

Polaroid has made a nice film pack which works a bit better, using a strip of 4x5 (in their usual variety of direct process materials in both color and black-and-white one b&w pack gives you both a negative and positive simultaneous-

ly). The pack contains a continuous double strip of paper which is perforated and sealed. Instead of removing the film pack from the camera after each exposure, you merely pull the strip out leaving the pack in place. As you pull the strip a capsule of developing chemicals is squeezed so they are released. Wait a required time (from fifteen seconds to one minute depending on the film), then pull apart the two sheets of paper for your picture.

A *press camera* has these same methods of running film through the camera but here the focusing can also be done the normal way by looking through a viewer, not the back of the camera through the lens. A press camera can, of course, be used as a view camera if you find that more convenient.

The advantage of using 4x5 film is primarily in commercial photography where you want a high quality reproduction and minimum blowup.

This seems as good a place as any to mention that if your negative will not enlarge to the size you want, make an 8x10 print of it, copy that on fine-grained 4x5 film, and blow that up. A lab will do this for you.

Electronic Flash

I've been through a lot of these and usually bits fall off them before they begin to malfunction. I usually have boxes of flash units with broken shoe connections, etc.

I always have several 202 Vivitars, besides a Vivitar 283 and 273. I also have two Ultima mini-strobes that refuse to quit, though I notice they are no longer in the Spiratone catalog from which I bought them. These little strobes use only two penlite batteries but the same f-stop as the Vivitars.

All the strobes have sensors (are automatic).

My main studio strobe used to be a Sun Auto 611. I usually use it with an umbrella.

I recently bought two M90 Speedotron light units with a D402 power supply. I bought them for a job where I needed broad, even lighting (used with umbrellas), and a flash that recycles speedily and gives me an f-stop of 11 or better. I am crazy about this light outfit, with its modeling lights (enables you to see the effect you'll get if you wish) and the fact that you can cut down the power, too.

Other Accessories

I keep my inventory down, always selling or giving to a charity auction anything I don't use a lot. The exceptions are my view cameras, which would be too costly to replace.

One essential accessory for me is the L-bracket, useful for gripping the camera from the side and carrying the flash. Be sure you get one that will fit your particular camera, e.g., my Mamiya brackets cannot be used for any other cameras because there are special fitting holes in the Mamiya to match up.

I wouldn't be without the heavy unipod which goes from my camera to the leather belt and fisherman-type pouch at my waist, so the weight of the camera is taken off my arm and shoulder. I designed it myself, and it's something I'm really proud of.

The belt is worn over a many-pocketed apron designed for me. There is a place for anything I might need: film, business cards, pencils, cable release, filters, battery packs. The hem turns up to provide more large pockets and the pockets on the hips are deep and angled so exposed film can't bounce out (a problem I've had with other aprons when a job forced me to climb and jump down). I have learned to pin an extra car key into the apron.

Beg, Borrow, and Steal

Buying new equipment is lovely but no way to save money. The way I look at it is that I can have more if I buy cheap. (I have put the word out that I am looking for a particular camera or lens, and seen it walk through the door days later.)

One such windfall was the perspective correcting lens for my Nikon ($100); another, a Mamiya 330 camera body ($25). And I have received several gifts of old cameras, "I found this at the back of the closet. Can you use it?" That was how I got my Speed Graphic.

Another steal was a nice set of filters from a customer who informed me that she had found "little circles of colored glass in my father's camera box. If you know what they are you can have them."

Buying Used Equipment

1. Ask why the owner is selling. You don't want a camera with too much mileage on it, or one for which extensive repairs are needed.

2. Know the approximate retail price for that item. You should try not to pay more than half-price for the same item used.

3. Never give the seller any idea why or how you are making judgments or how much you have to spend. Suppose, for example, you are buying a used Minolta. You ask if the seller bought it new or used. To his "New," you respond, "Good, I don't want to buy a camera that has been bought and sold before." Mistake. Now when you look at the Canon, he's not going to tell you if he bought it from a friend.

4. Many professional photographers ask absurd prices for their equipment, and I've noticed they (unintentionally, I hope) misrepresent it, e.g., "This is the flash unit most large studios use." It is the same name but an archaic model.

5. Professionals also subject their equipment to great wear and, I myself will practically give an item away if I have been using it regularly. I would never buy a camera or lens from a pro unless it was almost new. It would be like buying a car with 100,000 miles on it.

6. Make an offer. Unless the price is irresistible (then don't waste time haggling), leave your phone number and, if it is an expensive item, make that offer subject to a camera repairman's examination of it.

7. Try an "as is" offer, that is, ask that the item be discounted if you take it as is (without being examined by a professional).

8. Try a trade. Does he want your lawnmower as partial payment? How about your second vacuum cleaner?

9. Ask if there are any accessories that come with the camera. Those "little pieces of colored glass" I mentioned before, or "metal rings" (adapters). Also ask about the manuals. They are surprisingly expensive to buy and, if the equipment is old, may even be out of print.

10. While you're at it, ask if he has anything else for sale. He may have cable releases, tripods, and other items you can't have too many of.

11. If you want one lens but the seller wants to sell camera and lenses as a unit, make an offer for the lens you want and leave your name and phone num-

ber. The only reason to buy the whole package is that the price is so good that you can quickly sell the surplus items . . . and come out ahead.

12. Keep away from used electronic flash units you can't test and also ones which work off their own nickel-cadmium power packs. Some old units have built-in packs that must be charged through an AC adapter. The only problem is, they never hold the charge.

13. If you lose a piece of equipment you really want, don't waste any time worrying about it. Bargains turn up regularly; just start all over again and you may find an even better buy.

Cameras—Best Buys

If you want to buy only new equipment, buy in another country! It is cheaper to buy the camera and pay the duty, so if you know someone going abroad ask him to pick up what you want. Otherwise, write to Peter Chew's, Box 1964, Singapore, and ask what something costs. I have found Chew's to be absolutely trustworthy. Hong Kong and Singapore are usually the cheapest places to buy cameras (ask around).

I took a used Pentax and two medium length lenses around the world and, as I didn't like the camera, I sold it in Calcutta when I was offered an incredible price for it! (The new Pentzx is much easier to focus and I really like it.) Apparently people there are in need of cameras. I accepted a check on an American bank for the Pentax and as my next stop was Singapore, I took the check to Peter Chew's hoping they would cash it but not really expecting it. They did! I bought a Nikon F and one 50mm lens (new) and received $200 in change! That was a terrific price, my friends in Singapore assured me, which is why I am so hooked on Peter Chew's. Since then they have mailed me equipment, and it arrived quickly and in perfect condition.

There are probably other places where you can get a good deal abroad, but Hong Kong and Singapore are the places you hear talked about, and I've been to both places myself. However, if you do have a friend who has returned from a trip, or who is going on one, be sure to ask him to check the local regulations about buying photographic equipment and the prices.

What you will be looking for is a "free port," where merchandise is not taxed by the local government. That tax is ordinarily so high that it far exceeds the cost of bringing in the item and paying customs charges, if any. Certain camera manufacturers that have franchises in this country do not allow that financial advantage by insisting that cameras imported independently be charged at the going U.S. retail price.

You must be careful sending money abroad; be certain the dealer is reliable. I would never import from Hong Kong because the camera stores I visited there, though cheap, seemed specifically geared to fooling the tourist.

At one store, I asked if they stocked Mamiyas and was assured they did. Then we sat, and we sat, and we sat. The store owner treated us to soft drinks, and every time we rose to leave, we were assured the camera would be there in a few minutes. Forty-five minutes later, someone produced a Mamiya, which my friend bought. The camera has worked well, and was brand new, but there is no

way I would mail money to that store!

In the U.S. the number one marketplace of used (and new) equipment is Shutterbug. It is advertised in most photo magazines, and contains column after column of classified ads for photographers. Shutterbug is a good place to sell your equipment too. I know a woman photographer with a small studio in northern California who bought, through an ad in Shutterbug, a Bronica with three lenses and every accessory she needed for it, for a bargain price. I was very envious.

It is also an excellent place to look for comparative prices, if you wish to sell or buy equipment. You will find not just one listing of the item you are interested in, but many.

Other places to look are the Sunday papers in your own city, or of the nearest major city. Also, as I have said, ask your local camera stores to keep an eye out for something specific you are looking for.

The first place to look is the place nearest home. I always recommend that all purchases possible be made in your own town. You are wise to keep money within the area where you hope to get it. (If you see a new item advertised outside your state or town at an exceptional price, offer to buy it at your local camera store if it can come close to that price.)

A photographic flea market is less easy to find, but the bargains there are really incredible. Dealers will have tables of all the junk they have been trying to get rid of, and it may not be junk to you. It is also an excellent place to meet the dealers all in one place, so you can compare not just their merchandise, but their personalities. At such a flea market I found the truly wonderful repairman John McQuatters, who fixes my cameras now.

The places where you buy used equipment are the places to sell your own. I have had the best luck just placing a classified ad in the newspaper. Be sure to take the name and phone number of anyone who feels your for-sale item is overpriced so you can get back to him later if no one else buys it. I usually price my items so low that they sell instantly; people rush over and buy them! I like a bargain and I like to give a bargain.

TIPS

More Tips on Equipment

1. If you don't have a piece of equipment, accept the job that needs it and then buy it.

2. If you don't think that a $600 piece of equipment is worth buying for a $200 job, rent it.

3. Keep it simple. Decide on a camera to build your methods around. Then you can pick up accessories that fit it and you don't have to keep buying special equipment in different sizes.

4. Let camera stores know if you are looking for something special so that when it comes in secondhand they can take it in trade to sell to you.

5. Don't buy something because the salesman tells you it will save you money. Will that $850 passport camera *really* pay for itself in a year?

6. Don't buy equipment that is likely to become obsolete right away. Every year a new instant camera debuts. If you need one, pick up the cheapest until you know for sure which models will become standbys.

7. Periodically check your equipment to see if it is all there and in good working condition. A studio owner needed his view camera for a commercial job—as a portrait photographer he rarely used it. He found that it had been stolen, but had no idea when.

8. If you don't need a piece of equipment, sell it or give it to a charity and take the deduction.

9. Never lend equipment.

10. Never lend your car if you have only one.

11. Buy filters in the largest size you need and buy adapter rings so they can be used on all lenses.

12. Cut down the kinds of film you use by sticking to one ASA as much as possible. I find I don't have to think on the job—I can figure the exact settings if I use 100 to 160 ASA. If I occasionally move to other film, I make my calculations from that point.

13. Don't waste good camera performance on a bad lab. Switch labs if their performance changes.

14. If you can find a simpler way to do something, do it. You don't need two lights if one can work as well. Experiment from time-to-time (I do this when I have to waste a half roll of film to get the first half to the lab), and see if you can come up with a modification of an old technique.

15. Be on a constant lookout for a good camera repair person. One photographer, I know, keeps his camera repairman's phone number in his wallet. If someone tells you of a reliable repairman write that name and phone number down instantly.

16. If you see something you wish you had in the studio—a special chair or stool, perhaps—borrow it. Most people are complimented if you ask. You can give it back after a few weeks or months.

17. If you know someone who is a do-it-yourselfer, tell him or her about your particular need. Often that person will give you an idea that you can quickly adapt. One young man I was photographing mentioned that the wires leading to the lights were all over the floor.

"I trip on them a lot," I told him.

"Why don't you hang them from the ceiling?" he asked.

It was a perfect solution. (Use the screw-in hooks sold to hang swag lamps.) My son Michael showed me how to drill a hole into the upper/inner edge of a wood box and slip a nail into it when I want its hinged cover to stay slightly open.

18. A quick backdrop is a new bedsheet (one I used for years cost $2.50) stretched across any surface and stapled. A blanket is a great backdrop. Sheets and blankets come in many colors you can play around with and if you make a mistake, just return them to the beds.

19. Pillowcases have their uses, too. They make ideal protectors if you have to carry a lot of framed pictures up to 16x20 in size. If you don't have enough, slip every other picture into a pillowcase. For the larger pictures, make similar open bags from old sheets or fabric.

20. Make your own camera accessories. Nowhere are we as overcharged

as for camera equipment. If a ball and socket costs 99¢ in the hardware store, it will cost $7.99 in a camera store.

Here are a few nonphotographic items I've adapted for studio use: A strip of foam rubber on the inside of your lens shade will hold a filter in place; floodlights can be placed in $3 clamp-on fixtures; ceiling track used for hospital curtains will carry a backdrop around the room any place you want it.

When you need an accessory, wonder first, "What will do the job as well?" If you can't come up with an idea, go to the largest hardware or home improvement store, and look around.

21. Don't look for camera bags in camera stores. Look for them in the sporting goods outlets that sell equipment for fishermen. People who fish apparently don't spend much on containers for tackle. This is the place I find soft pouches for lenses. I found lovely ones for $1.69—which I gave to my photographer friends—and boxes of all kind for cash, tools, etc.

22. There are a few nonphotographic items you carry in your camera bag because you'll find a use for them, sooner or later: safety pins, rubber bands, string, scissors, a small notebook and pencil, and Band Aids. Include masking tape for marking a spot on the floor. Throw in some nail polish. (Colored nail polish is the best way to mark a notch on a tripod, which camera has the color film, which lens is damaged—and the mark doesn't come off until you want it to.) Don't forget to pack a pair of socks. It's amazing how often your feet get wet on outdoor jobs.

23. Your equipment is only a projection of yourself, so don't blame it if you are making mistakes. Have you, too, seen the work of two photographers using the same camera (one is sharp, the other is not)?

Nineteen Ways to Foil a Burglar

There are two kinds of thieves, shoplifters and professionals. They come in three ways:

1. Through the front door during business hours.
2. Through doors or windows when the studio is not occupied.
3. Through the roof.

So you must protect your studio on all three fronts.

Here is my list of how to keep robberies to a minimum:

1. There is little you can do about shoplifters except *watch them*. Make it difficult. If you are obviously watchful you will deter thieves; if you are obviously careless they will steal you blind.

Many large studio owners find that the loss of small frames and bric-a-brac is part of the game, played while they are locking up cash, camera equipment, etc.

Do not leave customers alone for long unless you are certain they can be trusted. Many thieves dress very well to put the storekeeper off.

2. I had an unusual burglary at night—one that seemed to fit the shoplifter category. Only wedding pictures were taken; wedding pictures and frames that were suitable for such pictures. Albums of pictures were gone and a couple of albums seemed to have been dropped on the thief's way out.

In addition, nothing was tossed about; drawers that were opened had been searched without disturbing the contents, and certain piles of photographs had been moved carefully from one place to another.

When several frames of one kind had been taken, one had been left for

me! And the window had been jimmied, but the thief had jumped over a pile of pictures by the window without knocking them down. Also, a typewriter, adding machine, and things more easily disposed of than pictures were not taken.

I decided eventually it was someone with a bride fetish or someone who was starting a studio and wanted some pictures to show his customers!

I learned from this experience to secure windows (the kind that lift) by drilling ¼-inch holes through the frame and pegging them.

I also learned from the police that if they dusted the place for fingerprints, there would be considerable damage to the rest of my work. So I had to let it go.

3. When you move to a new studio, look at the place coldly and consider how you would break in if you wanted to steal something from it.

4. Fragile doors can be kicked in regardless of their style of locks. Replace a door if placing your shoulder against it sharply makes it give.

5. It would take a great deal of time to describe the different locks and bolts available for doors and windows—and more are invented each year. Visit a locksmith, look at what's available, and ask him to explain how they work.

6. Don't make it easy for a burglar to leave. Most come through a window and if they can just open the door and walk out you make things much easier. If they had to leave by the window they might have to take less with them. A door should lock indoors and out.

7. The most efficient alarm rings at the police station as well as making noise on the premises. If you can get one that rings at your own home, it is even better. Time and time again you hear of the alarm being turned off at the police station because it was presumed to have been accidentally triggered. One friend of mine had such a burglar alarm and he arrived because a neighbor phoned him. (This man lived next to my friend's studio.) The police never did arrive; they just turned the alarm off.

This friend repaired the window (on the roof) where his burglar had entered. He reset the alarm and bolted iron bars across the space. The following night the burglar returned but could not break-in. Again the alarm sounded and this time the police arrived and found signs of someone having tried to force the bars apart.

8. Any studio that lets a burglar work undisturbed stands a better chance of break-ins. My studio where the adjoining roof met the window was such a case; a studio that is a house which stands alone is another.

9. The best deterrent I have found is a small metal plate outside each window and door saying that the building is protected by an electronic alarm system.

A businessman who had had a break-in had self-stick metal labels printed to that effect and gave them to all his friends, including an artist who had had a break-in. He tells me that those who put the labels on their windows have had no burglaries.

10. Dogs are the best protectors of property, but they're not for everyone—for obvious reasons. I keep two who guard my studio/home and do a terrific job. Our large dog Theo has only to look at someone to stop him from doing whatever he's doing! His little friend Rufus barks if he's startled, so they're a great combination. A large, ferocious-looking dog that does not bark is more frightening than one that does.

And, since the dogs are watchdogs for the studio, all their expenses are deductible.

If you want a watchdog you don't have to have a dog that is ferocious, but one that merely looks it. You don't want an adorable-looking dog. You also must keep those dogs *away* from your customers so that the word doesn't get out that they are good-natured slobs. Get a dog of a natural protective nature, rather than a fighter. A German shepherd is an obvious choice but you don't have to get a purebred, either. Just go to the pound and pick up a puppy of a suitable breed. Theo is Rottweiler/shepherd.

11. Don't ever keep a dog that is dangerous. "Protective" is a dog that is not going to let someone walk in unless you say so; "dangerous" is a dog that will pursue a stranger and attack him. If your dog is dangerous have him destroyed, however fond you are of him. Imagine the lifetime of trouble you could create for an innocent person and yourself, if he were ever to viciously attack.

Obviously you can't lock a dog in a department store complex, but if you have a studio that stands alone, let your dog protect it. (If we are out, we allow the dogs the run of the premises—inside and out.) On four occasions we have had proof that our dogs have stopped intruders trying to enter by the windows.

12. There are two things that are known to deter burglars: noise and light. Turn on the lights! Light the front of the studio, the inside, anywhere you feel light will stop someone from getting in without being observed. Lights serve a dual purpose: They prevent break-ins and they draw attention to your studio if it overlooks a thoroughfare.

13. If a neighbor knows you'd do the same for him—and sometimes if he doesn't—he will alert the police (or you) if he suspects someone is breaking in. It only makes good sense to go out of your way to get to know your neighbors.

14. Let's say you feel you have inadequate protection but cannot do anything about it right away. There are still ways you can protect your belongings safely. One is to hide all but a single camera, the one that you can safely afford to lose.

15. A burglar is often after something specific. He has made it his business to know where that thing is. He will pick up anything else that is easily available, of course, but it is important that you don't advertise where you keep your more valuable equipment. Never let your equipment be visible from the street and if it is not in use, put it away. If you have a basement or an attic, put it there.

A young couple had their TV set stolen while they slept. To their amazement the burglar had put a ladder against the window closest to it, came in and, took just the TV. They realized, too late of course, that when the TV was turned on at night, it could be seen from the street.

16. There are three places a burglar looks first: top drawers, laundry hampers, and in the toilet tank. Presumably, the sloppy people choose the first, the cautious the second, and the devious the third place.

A burglar expects to be in a house three minutes only, so he is not likely to hang around unless he knows for sure that you are out of town.

Be careful to:

• Leave no signs that you are away—no newspapers on the porch, no mail sticking out of letter boxes, no *"Back Sunday"* notes taped to the front door.

• Leave no keys under flowerpots, on door ledges, or under outdoor mats and other obvious places.

• Leave nothing of value in top drawers. Leave nothing of value where

someone can just pick it up. Leave no sign indoors that you will be away for a few days.

- Have a timer on your lights indoors or outdoors, so they can be turned on and off automatically. If you have lights that can be turned off and on by sunlight, there is a very inexpensive adapter that turns a light on when it gets dark and off again when daylight comes.
- If you use a door chain, be sure it is not long enough for someone to reach around and cut it.
- Leave the bathroom door ajar and the light on.
- If you have something particularly valuable, perhaps you should not keep it at your studio at all.

17. In addition, don't *let* a customer steal from you . . . make it difficult by getting a suspect out of there. Call the police and check on someone who looks suspicious.

18. If one evening you intuitively feel uneasy about your studio, stop by and see if your fears are founded. I know two people who did that and surprised a burglar!

5
Your Very Own Studio

Ideally, you should inherit the perfect studio in downtown Manhattan with fifty feet of windows at street level. However, if you're like most photographers, you do not have such benevolent relatives and must pay your own more modest way.

No matter where you live, give thought to both your customers and yourself when deciding on a location. Think of this as a long-term decision, as though your next twenty years will be spent doing business in the same spot.

The Ideal Location

An ideal location gives you access to the customers you want, and a place of business that you truly enjoy.

If you wish to appeal to the mass market, for example, you should have a location where people will probably fall over you, right in the mainstream—a shopping mall or other much traveled area. A location at a major crossroad would also work.

The advantages of setting up somewhere close to established, heavily grossing businesses (major chain stores and restaurants) are:

• Your business will not suffer if you lose some customers, because they will be quickly replaced by others.

• You can use your neighbors in a joint effort to stimulate business in slow times (joint advertising).

• Any large store near you will stimulate your business every time it places an ad that brings shoppers in for a sale. You will have to advertise very little (you may not have to advertise at all).

It is a mistake, however, if you are moving into a shopping center, to expect to be able to make any overhead, any rent, just because of the foot traffic. The proof is the number of stores that go out of business in large shopping centers.

However, if your appeal is not to the mass market, you may be looking for a more exclusive clientele, or one that expects to pay above average prices. (Some very expensive stores do well in shopping centers. One costly photographic chain uses a "magic" 300,000 population figure as a gauge. If there are fewer than 300,000 people in the area, the chain will not open a store in that center.)

You may specialize and neither expect nor need heavy foot traffic.

Even so, the location of your studio will have a lot of bearing on your speed of success. In some cases the actual direction of a building could affect your income. We've all made decisions not to go to a particular store just because of the location. Wind, parking problems, dirt, safety, noise, and smell are some reasons for our negative reactions.

If you are considering setting up business in your home county, you will know which sites to avoid. But if you want to start a studio in a place you haven't lived, then don't make a hasty decision; what's normal in one state may not be acceptable in another. You need different criteria, too, for city or country sites. A New York friend used to be appalled that I would leave my Arroyo Grande home/ studio unlocked. He was also amazed to hear that I canceled portrait sittings if it rained. In New York the residents take bad weather in stride. In San Luis Obispo they act if there has been a death in the family.

In choosing the person to consult about location, find an extroverted, intelligent, aware businessman (hairdressers would be a good choice; they hear all the gossip and dispense free advice for the hell of it). You don't want to prod someone who says, "I'm not a photographer, how would I know?"

Reasons for Choosing One Photographer Over Another

A mistake I made in my early years in the business was to think that customers choose a photographer by talent alone. I expected photographers who were more talented than I to make more money and those less so to make less.

But I found that customers make their decisions quite haphazardly. They might like you, they might like your children, they might make the decision by price. Mostly they happen to be passing by, which initially brings them to you and not the photographer next door. After that they might recommend you, but again it may not be on the quality of your work but because you are nice! I am a bit embarrassed to find that many of my customers come to my studio merely because they find me comfortable to be with!

But even in my most innocent days, I did not expect people to know I was there until I told them.

I realized that a person might go to a photographer because he has heard or seen the name; he knows where the business is located; or a specific photographer's work has inspired him to have photographs taken—something he would not have done otherwise. Even so, he may *then* go elsewhere.

I am sure I'm not alone in having taken on a customer who originally thought I was someone else. Aware of the mistake, he will stay because it saves time or because he now prefers *my* work.

It's just like the time I waited for one-and-a-half hours outside the wrong candy store on Avenue of the Americas in New York.

"You can't miss it," my friend had said, forgetting its name.

I did miss it. She was judging the store by its delicious product which made it the "only" candy store to her, and I was judging it by the size of its windows. Both stores were on the same side of the street and on the same block!

Your superior product may get overlooked in the same way. You must, there-

fore, be certain that your studio does become known to the public.

Don't be like the young singer from abroad whom I recently photographed and was furious because he had so few bookings and that when he did get an offer, it was for too little money. He has a very beautiful voice, and I could understand his frustration.

"I will not sing for these people," he said, "because they do not appreciate someone like me!"

I persuaded him to take *any* booking for a while, because, "They don't know anything about you. Do you think people would come to my studio if I just told them how great I was? I have to show my work, and then if they like it they will come."

You can't just sit there and sulk if people do not find you. At least get out there and attract people to your work. Take your first step after investing in a place of business: Make yourself known.

Questions to Ask When Choosing a Studio Location

1. Will my business be easily visible and if not, how will I compensate for this?

2. How will a change in weather affect this location? Will customers have to swim to it after a heavy rain?

3. Does the city plan to change this area? (Call up city hall and ask them.) Cities have created agonizing distress to businesses just by rerouting traffic, and they have the right to obliterate streets or seize property to make way for other improvements. You may be reimbused but there is considerable inconvenience and/or financial loss.

4. Who will my neighbors be? Neighbors can move, of course, but if you are in a commercial district flanked by businesses that have already been there several years, that's unlikely. Each area develops a style of its own and as a newcomer (a rather small newcomer), some of their style may rub off onto you. Do you want it to?

5. Would it be safe to come to this neighborhood at night?

6. Can I protect my studio here when I am not in it?

If the location you had originally liked produces a number of problems you hadn't anticipated, consider the outlying areas. If you're patient, you will find that "best buy" and you might save more by waiting a couple of months than by making the decision right away. Options are always limited but they change from day to week to month. If you narrowly miss one good deal, there'll be another.

A young couple told me they decided to buy and found their dream place, in Berkeley. At $80,000 for a two-storied building it seemed a steal in that very expensive city. But as they came down the steps, having decided to purchase the property, four tough teenage boys were leaning on the wall at street level with tire irons in their hands; their grins were challenging.

The husband said, "There went our dream!" They eventually bought a more modest place for a higher price in a better area.

Don't Give Up

Persistence often pays off. One couple who owns a small gift shop walked down a main shopping street, as they often had before, wishing they could afford to rent there. But this time they saw an old bar being cleaned out and walked in and leased it on the spot. A death in the family forced the owner out. He didn't want to hang around trying to wrest the highest dollar in rent; he just wanted reliable tenants.

To Buy or Rent, That is the Question

Before choosing your location, decide how you'll pay for your studio. This will be the costliest part of your overhead initially. (Eventually your lab fees will rise to astronomical heights, but you'll have the business to cover them.)

My first studio was really no studio; I just worked from my home and did the darkroom work in the bathroom. My enlarger table was wheeled in and out.

I then moved upstairs in a large downtown building in San Luis Obispo. I had one room costing $25 per month (darkroom in a closet); you can't do much better than that. As I expanded I rented two more rooms ($75 total), utilities were included, and when I was asked to pay for the electricity, I complained!

The rents in our town rose rapidly until I was paying eight times my original rent, so I bought a Victorian cottage in a business district for $51,000 and converted it into a studio. Out of habit I have a darkroom (a combination of bathroom and closet), though I only print about once a year these days.

When I mention the specifics of my business, you must consider whether they would apply as easily to you where you live and work. Few people would start with as little as I did but if you are among those few, I want you to know it can be done.

Keep Your Overhead Down

If I've learned one thing it's to avoid the immovable overhead of a costly rent or mortgage month after month that can drain a business into oblivion.

There was a study in England of nine self-made millionaires, all under thirty, who had made it big in a country where you move quickly into a 90 percent tax bracket. That is like having to make $10 million to keep $1 million (in pounds-sterling, that's the equivalent of making $20 million to keep $2 million). In every case the man (there were no women) had started with a good idea and one room in a low rent district. With almost no overhead, the profits could be ploughed back to generate more money.

I've heard so many successful American businessmen talk of exactly the same thing. "Overhead can kill you," said one whom I asked for tips for new studio owners. "It doesn't matter what your business is. Unless you have no worries about money, keep your overhead down. That means low rent and payroll."

More Advantages of Low Overhead

I found that my $25 a month studio gave me a chance to both write and do

photography, so in my early studio days I was able to take the time to broaden the base of my business.

My overhead was so low in those days that for four years I spent a full 10 percent of my *gross* having pictures of my work printed for exhibition. I put these in banks, restaurants, albums, where they made up somewhat for my "invisible" location, yet did not drain me as much as a continuing constant overhead would have done.

I sometimes made as little as $500 a month. Deducting 10 percent for exhibition prints and $25 for rent, that still left me with $425, a large percentage of my income for my other expenses. There were other months when the work came in fast and furious, taking the pressure off the very slow months, and giving me a chance to catch up with some luxury living I'm addicted to!

The exhibition prints too were often bought by my customers, never many of them, but always enough to cover the cost of printing all of them.

Renting

If it is impossible to buy a studio in the right location (you don't have the money or need it for something else or need a temporary studio), and you do not want to work out of your home, you must rent.

There are some real advantages to renting. If the market is right, it's cheaper. Property may not be moving and there are areas where the owners bought so cheap originally that many properties are available for rent at extremely reasonable prices.

Also, in a city, many photographers would be wise to look at the rentals available and forgo the advantages of buying for the much greater advantage of having a superb location.

An additional advantage of renting is that one can walk out when a move seems sensible. There is no sale to be arranged, no mortgages that may have to be negotiated; you just give notice, pack your bags, and leave. This could be the difference between being able to take advantage of an unusually good piece of property suddenly coming up for sale or rent, and having to let it go to someone else who has the required financing.

How Much Rent is Reasonable?

To find whether you can afford a particular rent, consider how many orders you would have to take in to pay the rent; how much of your time will be spent working for the landlord alone? Add to the actual rent figure all the extras you will *have* to pay at this location: utilities, telephone, business licenses, and upkeep (occasionally renters are required to pay a percentage of the upkeep of shopping centers and this figure may include advertising).

If you are a commercial photographer guess at an average profit per layout and make a *low* estimate of your potential market. Most portrait photographers make a good living from weddings. If the profit from just one wedding a month will pay the rent, you've got the perfect overhead. If you'll need four weddings to do the same thing, however, look for another place.

Ours is a luxury business in that people do not need to have photographs of themselves and commercial photography is almost dead in many smaller towns. These are tough, unchanging facts that you can't ignore when working out the overhead you can handle.

In addition there'll be certain times of the year when the public thinks "photography" and others when it doesn't—the most noticable of the "nots" being income tax time (between January and April).

When a salaried worker receives a shock from her accountant and wails, "I've already paid $3,000. Why do I owe another $700?" having a pretty picture taken for Mom is the last thing on her mind.

Your income may take care of a particular rent in the good times, but you may still have to borrow against future income when there's a slack. That's living dangerously. If you run into a slow year instead of just a slow season, where will the money come from?

Evaluating Your Chances

Let's imagine that you think you've found the perfect studio; it's more than you intended to pay but it *is* in a busy shopping center. You expect people will wander in all day, so you'll do a lot of business and not have to advertise. Don't forget:

1. You'll have to work harder to handle this increased traffic. Instead of one or two deadlines, there'll be days when a small calamity could become a crisis.

2. You'll need to hire help.

3. You'll have a new problem—pilferage.

Are you capable of coping; do you even want to? Here are some more questions.

How did you get the chance to rent this perfect location? Did someone go out of business? If so, why?

Perhaps it's a new development. In that case you might not be able to wait out the time it takes for the public to get in the habit of shopping there. In a city or even near a city, people often pour into new shopping centers. Find out the public reaction to the last one that opened.

Big businesses can handle initial slumps but the small shops are quickly replaced by other small shops until the cost of the rent and the amount of business level out. Our first shopping plaza here was a disaster that went through a number of larger stores in its first years. The reason it didn't thrive was that the parking lot was windy! Now we are used to the wind—we ignore it and shop there a lot!

Let me lay some further high rental caution on you. Our town has 35,000 people and nine portrait photographers share the business, whereas ideally there should be one photographer for every 50,000. You must find out what the figures are in your own area and estimate how much photography *could* come your way.

You'll find your competition in the Yellow Pages of the phone directory; that's where most people looking for a photographer turn first. In the Yellow Pages you'll also find advertising agencies, architectural firms, schools, travel

agencies (for passport pictures), and other sources of customers. Make a few phone calls to see which photographer they are using and find your major competition.

You could be working in the most beautiful building in the finest location but you still can't get more business than is available. Whichever way you look at it, there are still only 35,000 people in town and only a few will be getting married and not all of those will hire a photographer. The same applies to baby pictures, family groups, etc. You may get a *bigger* slice of the pie than anyone else, but it remains the same pie from which nine other slices must be cut.

Don't Count Chickens that Are Not There

A simple error in choosing a location is to believe that $30,000 profit in one location will become three times more in a location when you pay three times the rent. It is also a mistake to think that a physically larger studio will make proportionally more business.

We are talking about a single pie and you may be getting all the slices that can be cut out of it right now.

A local store I shall call Peter's sold pottery and inexpensive imported gift items and did very well. The owner started another store in a neighboring town of similar population and this one was even more successful. Both stores were crammed with baskets and pretty things that literally overflowed onto the sidewalk. Customers jostled each other as they hunted for bargains and helium-filled balloons attracted the children.

It was difficult for the clerks to work because of the clutter and when a large drug store became vacant, Peter's owner decided to rent it for $1,400 a month. I remember saying to another store owner in the same block, "Imagine the number of baskets and pots he'll have to sell to take $1,400 off the top!" In addition, he had to hire more store clerks.

But now Peter's was just another large store, the bargain basement atmosphere was gone, and when the rent became a real problem, the owner had to buy on credit. His suppliers stopped delivering merchandise when he couldn't pay. The store began to look empty and the successful branch in the other town had to bail it out. Eventually both stores collapsed and could not even sell their name because they showed a loss.

There's an important rule here: If you are going downhill and do want to sell, do it when someone can still buy your name and use his credit to save the firm's reputation. Your name won't sell if it is a detriment to the location.

Three or four doors from Peter's was a store in a similar situation. But that owner began to see very quickly what a mistake he had made in taking on more overhead than he could handle. He sold the store before it was in real trouble and the new owner, an experienced buyer and manager, changed the merchandising just enough to make it pay.

When property values soared, there were many such disasters in our area because the owners of the stores couldn't see that no matter what the value of their stores, we still had a small-town population that could only buy so much merchandise.

On the other hand a photographer, Alfred, was renting a studio in a terrific location and his landlord raised the rent. He could afford the $400 new rent but saw the handwriting on the wall and moved to a town where there were only two photographers. He bought a studio and hasn't looked back.

My Own Delusion of Grandeur

Just before all this happened I decided that small-town living was not doing justice to my great photographic talent and decided to move to San Francisco's Bay Area, specifically a wealthy little town called Tiburon! I found a great downtown location and went home to think it over.

A professional man with an office in Tiburon happened to be in San Luis Obispo a few weeks later and we had lunch together. When he came to my studio I poured him a glass of wine and talked about the move.

I was sitting at my 7x3 desk (a piece of plywood held up by two bookcases) on a high chair that doubled as my stepladder. Around me, as usual, were piles of photographs, many stacked against the walls; my orders were thumbtacked onto a huge board. (My method of business has caused some funny comments from other photographers, but my customers put up with it.)

"Do you realize," said my friend, "that you couldn't work like *this* in Tiburon?"

I thought he meant I would have to be tidy.

"Why not?" I asked, "Nobody seems to complain, provided they like the pictures."

"Oh, you can have the same decor," he said, "But you'll no longer be able to sit around doing what you want, such as having a glass of wine with me before lunch. Do you realize how hard you will have to work just to pay your overhead? You can't just walk out and leave a notice on the door; you'll have to have a good receptionist. You'll get three or four times more customers and that means that much more work.

"When you visited Tiburon, what did it cost you in loss of business here? Didn't you say you went to Asia this year? Imagine if you were *there,* what it would cost you to take a few weeks off. How will you pay your overhead?"

I realized then why I had been stalling the realtor who was handling my "dream" studio. My friend was right, I could certainly have moved and occasionally made more money, but with my lifestyle I needed a low overhead operation.

Which is why I am still here!

CHEAP ADVICE

If you decide to rent ask, as I did, someone who has been in business in the same area for several years what he thinks of your chances for making the rent. The person *not* to ask is a competitor.

The Lease

If you get a good deal you may also want to protect your rental with a lease. A lease enables you to stay where you are at the same rent for a certain number of

years; even if the building is sold you can't be evicted.

In a booming area landlords are often unwilling to lease to renters who are paying a moderate rent. A landlord might decide to fill up his building or shopping center with businesses, and then put the rent up bit-by-bit, easing out those people who can't handle the overhead. In an area which does not expect to move up sharply, a landlord is eager to have a tenant he can forget about for several years.

A lease should be renewable and usually contains a clause to the effect that after two or more years, the rent may be raised a certain percentage. A lease should protect *both* parties.

A fact of life is that if property rises steeply and you decide to *buy* a studio before the lease is up, the landlord may welcome a chance to break the lease! If property decreases in value, the landlord may still release you from the lease if you can find someone else to take your place. A renter, therefore, has little to lose in signing a lease . . . provided he can handle the rent *now* or very soon.

Not All Landlords Go to Heaven

Most landlords do go to heaven. They have learned that a good relationship with their tenants is beneficial all around and if they have a good tenant they'll bend over backwards to keep him. A good tenant is one who pays on time and doesn't lay waste to the property.

But here are two stories about tenants who, fortunately, had the law to protect them from their landlords.

Steve had rented a small store for six years and his landlord decided he should now sign a lease. Steve agreed and did so, paying a first and last month's rent as requested. He gave the papers and the check to the landlord in person, and the man pocketed them.

Meanwhile, the landlord decided to do something else with the building.

When Steve found his check had not been cashed, he asked why and the landlord replied, "What check?"

"The check I gave you with the lease."

"Lease?"

The landlord then told Steve that his rent was in arrears and he should look for another place at the end of the month!

Steve called a lawyer and was adviced that when someone has been in business in a certain location, as Steve had, for several years, the landlord could not get rid of him with only a month's notice *even* if he was in arrears for a month. Three months' notice would be minimum, and maybe a month or two more if he had difficulty relocating.

Steve had kept a copy of the lease—proof that the landlord had, at least, offered him the option. But now the lawyer advised he should write a new check and put it into a savings account under his landlord's and his own name. And he should mail the man a copy of the passbook entry.

In his letter Steve wrote, "In future, I will pay my rent into this account until you are prepared to accept it personally as before."

And he started to look around for a new location.

The second landlord story involves a renter, Bill. Bill's water heater exploded one night and hot water poured from it. He phoned the fire department which came right over and syphoned the water into the sink. Bill's apartment was on the second floor so the possible damage to the apartment below was what panicked him most.

Instead of thanking him, Bill's landlord evicted him for not calling him *before* the fire department! Bill phoned the housing authorities and found that a landlord may not evict a tenant for doing something *legal*. Nor could he punish a tenant for making a complaint.

A tenant could, for example, catch his landlord stealing and call the police, but the landlord could not evict him. He could not now evict Bill until some time had elapsed after the water heater incident and then would have to prove cause. Laws differ in each state; look into yours.

If you ever get in a spot where you know you are being taken to the cleaners don't just stand there complaining. Ask a lawyer or a trusted friend what to do and DO IT.

Facts About Landlords

A landlord is no different from anyone else. He is either honest or dishonest.

Don't believe his promise unless you are certain that this is a person incapable of dishonesty. Even so, it's amazing how forgetful someone can be!

Get it in writing.

"Every two years I'll have the rooms repainted," he says.

"Thank you so much," you answer joyously and write that out, without delaying five minutes, and ask him to sign what he just said.

"I'll have my attorney draw up something," is usually a clue that it was an empty promise. He's merely trying to stall. He can say later, "My lawyer doesn't think . . ."

And you can say, "*My* attorney says that a simple handwritten agreement is as strong as any legal document—there's no need for you to pay for a lawyer."

One good way to get a signature on an agreement is to make it a double agreement. If the landlord suggests *you* do something, agree and ask that you give him an agreement to that effect in writing:

"I, John Doe, agree to lock the building every evening when I leave the premises and Carey Smith (the landlord) agrees to have the interior walls painted every two years starting 1985."

I insist on written agreements on important matters even with my children—to get them into the habit of being businesslike.

I say, "Of course I trust you but what if one of us drops dead?"

Rental Cautions

1. Read all agreements carefully before signing them. Ask about any clause you do not understand and *do not sign* until you have no questions.

2. Have a third party witness all oral agreements. These are legally binding but usually difficult to prove. Later, go over the specifics of the conversation you

might want this witness to recall one day. If necessary have him write down what went on (or do it yourself), and file that where you can have it handy.

3. If you are one of many businesses in a shopping complex, be quite sure you are aware of your obligations to other tenants. Also, find out what insurance your landlord carries so you do not duplicate it. He will, for instance, be covered with fire insurance and should provide you with a *waiver of subrogation.* As he is protected anyway, it costs him no more to assure you that you will not be held responsible if a fire starts in *your* business and spreads to others.

4. If you wish to be the only photographer in the complex, receive an assurance in writing that this is so. Many photographers do prefer this, but it is something to think about and may not be wise. I happen to believe that the more businesses of one kind there are together, the more the public is turned on to that kind of business. A general guide is to question whether your work can hold up against competition. If you do not have something special to offer, (even lower prices or longer business hours) keep away from the competition. My own experience has proved this.

Rick, a photographer, moved right next door to me and we became instant friends, and pretended more rivalry than we felt. Rick picked up some jobs, mostly commercial, from some of my customers who presumed Rick (a man) to be a better commercial photographer, and me (a woman) to be a better portraitist! And it worked in reverse—I scooped up portraiture from him. We developed the habit of discussing our wins and losses, and the winner for the week took the loser to lunch.

On one occasion we both had aerial photography to do in the same area and decided to rent a plane together to halve our costs. I arrived first and persuaded the owners of a small plane to give us a free ride in exchange for pictures of themselves and their plane, and then found there was only one passenger seat available. When Rick arrived I told him the bad news.

He was looking depressed so I said, "I'll take your pictures for you," and that's what happened, not that I didn't regret it! My stomach heaved as I hung what seemed to be upside-down—the best angle to get a great view, the pilot said. Then after getting my shots, I had to pick up Rick's camera and turn upside-down all over again.

The final blow was when "his" pictures made better sales than mine did!

After Rick moved in my business picked up; when he left it slipped some.

Later another photographer who became a friend set up twice a year across the street at a local store and offered, "One 8x10 Portrait of Your Child in Living Color—95¢!" (Remember the days?)

"Across the street," he told me he was saying to mothers, "is the greatest child-photographer in the *world!* But she can't give you the deal I can. You can't afford her prices but you *can* afford mine!"

I was so delighted at his compliment I didn't realize he was making more than me—so much more that he offered me a job for more than I was making!

But I thought of a way to get even.

"If I'm so great," I told him one day, "I should take your portrait; you'd be stupid to miss the chance," and I charged him full price.

He says he then changed his slick talk to, "Across the street is the greatest

photographer in the *world*. I myself have had a portrait taken by her; I can afford her prices but can *you* . . .?"

Can you see how I benefited from this? He was there only two weeks, twice a year. I was there all the time and all his customers now knew favorable things about me.

5. When renting among other businesses make friends with the tenants. When a problem comes up then you can work it out amicably.

A noisy dance studio moves next to you. How much noise is reasonable?

One renter habitually leaves the communal front door unlocked at night.

One tenant is openly using illegal drugs.

There's a problem you'd like the landlord to fix, (a shabby hall rug, dangerous wiring, rats).

Mature adults are supposed to sit down and discuss such problems and usually can, but if a single tenant gets touchy, going to work can become hell for all of you, and that's important to remember when *you* feel like sulking. If someone complains about you, and he has a point, apologize and mend your ways.

Here's a time I blew it. I received a complaint about my matte-spraying in the communal hall. The spray lingered in the air and eventually the staircase became matte and even the wall-to-wall rug lost it's shine! I apologized a *lot* when it was brought to my notice and felt lucky not to have been handed a bill for the damage.

At that same studio a new tenant decided that we should have "tenants' meetings" to air our grievances. If you are there to air grievances, you can be sure a lot of them will come to mind. We persuaded him that it was better to downplay our grievances and try to act like a family.

6. There's a fine line between being easygoing and a sucker. A good way to avoid being taking advantage of is to make it clear that you will be very nice *except* when ripped off.

For some years, as an example, I was one of the only tenants in the building who had a phone. At $25 per room per month, we had some poverty-level tenants. My phone soon became the communal phone. We were a friendly bunch, always doing things for each other, so I didn't object to the phone calls, but one morning a fellow tenant came in and made eight consecutive phone calls. Before he left I light-heartedly gave him a bill for $5 for "loss of time."

The amount was small enough to upset him, although he didn't pay and I didn't press it, but he got the message. He never used my phone again.

7. Take pictures! Twice photo evidence has helped me in tenant situations.

Once a fellow tenant told me that the manager of our apartment building had a habit of being very nice to tenants and then later accusing them of causing damage that had been there in the first place. So I photographed every defect in every nook and cranny of the place, gave the film to a friend to develop, and had him date and seal it after making a contact sheet. When I later appeared in Small Claims Court (I had to sue to get my $275 cleaning deposit back), my photographic evidence was all I needed to win.

The other time photographic evidence carried weight was at my old studio. My window looked onto the roof of another shop and that roof began to leak. The owner accused me of putting a plant shelf in such a position that I was responsi-

ble. I had photographs to show that the shelf had been installed before I moved in. If I had been the new owner, I would have been responsible; as the new renter, I was not.

8. If you want to make an improvement to your studio most landlords will happily pay for the materials. In an apartment I rented the landlord was quite startled to find that in a colorful mood I had painted some of the woodwork red and some orange and that in a bathroom we were featuring *purple*. The old-fashioned claw-foot bath was purple and so was the toilet seat and he had paid for all the paint. It was no accident that when I asked him to pay for the paint I didn't mention the colors.

9. In a rental, anything you nail onto the wall becomes the landlord's and you may not take it when you leave unless he agrees. When putting in my darkroom, I therefore made sure it was collapsible.

10. A good time to make structural changes in a rental where you have a lease is when the building is up for sale—before, if possible. If you want to put a door in a wall, partition a room, etc., a landlord who has refused his permission may change his mind now.

When a landlord is only interested in the resale value of property, he will accept anything that doesn't detract from it. Be sure that there are no local regulations against the changes.

If you are not now aware of the laws that protect both tenants and the landlord, do some digging. If a disagreement occurs then you are forearmed.

"The law is tipped in favor of the tenant," one landlord told me, "but, fortunately, few bother to check when we tell them something."

Obviously, if you have a friend who is a landlord you can get some good advice on your rights.

Working Out of Your Home

Before discussing the home-studio I must point out that in the section on renting you may find pointers which will apply here and to buying a studio.

So go back and read it, if you didn't!

The home-business has some advantages and problems. Initially when I went into business, I worked from my own home. I happened to be there; it seemed the simplest solution. We were in an R.1. (residential single-dwelling) area, but no one told me I needed a license until the city sent me a bill and asked me to pay a business tax which I did.

The zoning laws are not just a means of labeling certain sections of each city; they also restrict areas to specific types of occupation. If my neighbors had complained about me being in business in an R.1. zone, I would have been in trouble in Arroyo Grande. In San Luis Obispo, a neighbor's complaint wouldn't have been required; the city itself would have told me to cut it out.

Most cities require that someone wishing to do business from his home in any R-zone petition for a variance. He must file to have an exception made in his case and this exception may not be made. Other cities will allow no variances at all. If you have a home in a residential district in such a city, you will not be able to run a business from that address, period.

There are occasional legal ways around this. A person might be allowed to receive business mail (mail orders perhaps) in a residential zone, but not be allowed to receive customers or even business telephone calls in that zone. An example is a local business where we have to write, enclosing a check, for computer disks, and receive the order by mail. It takes three days, although I could get to that address in five minutes from my home.

Occasionally you see a photographer advertise with a telephone number and here again he may be able to install a business telephone at his home address but not receive customers. He will then visit any caller to show his portfolio and discuss prices. I've heard of successful photographers who do weekend weddings only this way but have never met any personally.

I have been told by business owners who have moved from a business location into their homes that they do less business this way and that is why they do it. They *want* less business. Age and infirmity are two reasons for pulling in.

Some customers, of course, will visit you at your home-business but others will not. These are people who do all their buying at shops, those who fear that going into a home where they do not know the people might set up a dangerous situation, and those who do not equate working at home with success. They want to hire a successful (to them this means a more reliable) photographer.

When I moved from my lovely home in a town where I was well known into my modest little upstairs studio in a town where I was not, I was astounded at the instant increase of business. When I realized how important location was, I at once made an effort to be even more "visible."

During the first week in my second-story $25-per-month location in San Luis Obispo, I made more than I had in the previous month out of my home. My sole advertising effort, which was responsible for that increase, was to distribute some little wooden plaques painted black and white reading:

<div align="center">

JEANNE THWAITES PHOTOGRAPHY
now at
846 Higuera Street, S.L.O.

</div>

I added my phone number.

My children went to all the stores and asked if they could put the plaques in the windows.

Business increased even further when, in that first month, I persuaded the other tenants that we should paint the building a good-looking (though somewhat bright) pink, obliterating the brownish beige that made it invisible. We did it on a Sunday so no one could stop us. The building became so visible that a store-owner on the ground floor complained, but fortunately our landlord refused to evict us all, and as we instantly became "too tired and too busy" to repaint, it was pink for years.

Zoned Out

If you are already in business in a particular zone, that is, you have a license to be in business there, you will rarely be required to move if the law is suddenly

78

enforced or the zoning is changed. It will be the new businesses that will be denied permits to carry out their trades and saying "I don't know" is not a valid excuse. E.g., Having done business for more than a year from my home, I would have been allowed to continue there indefinitely.

Before moving in to a new location, don't presume that just because you are buying a place to live in you can work from there. A phone call to city hall should settle the matter quickly.

The zoning laws work in this way: You may always carry out a business (or live) in a zone that is *less* restrictive than the zone you qualify for. For example, an industrial plant may do business in a M.1. (manufacturing) zone but may not in a R.2. (two residences per lot) or C.N. (neighborhood commercial) zone. But you may have a residence in any of the three zones. That is to say you can upgrade the neighborhood, not downgrade it.

Therefore, if you wish to work and live at the same place, move to a zone that allows photographers, because you can certainly have a residence there.

As I said before, if a zone does not allow a photographic studio where you wish to start one, you may apply for a *variance*, making you an exception to the rule. Your planning department will advise you about the likelihood of being granted one.

A variance is a term used when the zoning law is to be relaxed in a certain case. (E.g., a particular zone may not allow photographic studios but if the photographer petitions city hall for a variance, it may be allowed.)

A use permit, on the other hand, is a permit to use the location for a use already permitted by the zoning. You don't always need a use permit; check with city hall.

Pros and Cons of Working at Home

The pros:

1. You can get up later! You don't have to walk to work or drive.

2. If you live at your business, then you can do home chores if you feel like it. You can work in the yard, cook, or chop firewood to relieve tension.

3. If you want to get away from the studio and have no other help, it is nice to have a family member (such as your teenager), watch things even if he/she does homework at the same time.

On the other hand, the cons:

1. Because you don't have to go out, you may find yourself becoming less active.

2. Traveling time can release tension. I know people who live ten miles from their businesses, just so they have time to clear their heads before taking on the family.

3. A "home" job you really enjoy might distract from work. If there are things that need doing on the home front, don't *neglect* your business by dealing with them during the day.

4. Many friends will feel less inhibited about dropping in on a person working at home, cutting down on your productive hours.

5. If you have children, you may find them a nuisance after school.

6. If your spouse prefers not to help at the studio, (perhaps you have young children and someone has to watch them), you can expect irritation when you insist on keeping to business during business hours.

Buying a Studio

To estimate the financial advantage of buying against renting, consider whether or not the money invested could grow better elsewhere. Usually it could not. Buying is, therefore, a smart move.

There Are Bargains

There are still houses and studios to be bought for no money down. The very day that a friend told me that he had decided not to buy a "real deal" for $100,000—a five-bedroom home in a business district—for no money down, another friend insisted that 20 percent down was the least any seller would take.

I paid $51,000 for my studio, a small house of two bedrooms, two bathrooms, a cellar, two enclosed porches, a kitchen, a living room, two fairly large outside buildings—one with electricity, a garage, and a 50x145 lot. At that time the nearest comparable property was selling for $70,000.

My son just bought a house for $85,000 in Berkeley in an area where the houses start at $120,000. The older owners had found their dream apartment and wanted to move in right away.

My first studio at $25 a month in a downtown (though upstairs) location was a setup I thought could not be bettered. But it so happened that a housing boom was coming and I would have gained financially to have bought, no matter the bargain my rent seemed. But back then I needed every penny I could lay my hands on and buying later still gave me a house that in three years was worth more than twice what I paid.

"If only I had . . ." solves nothing. You must try to think positively from this moment on.

There are three main reasons to buy rather than rent:

1. If you own your own place, the only person who can get you out of there is the holder of a mortgage you haven't paid.

2. With every monthly check you increase your net worth, for some of that goes toward the principal due.

3. If property rises in value, you don't have to sell your home to get the cash out of it; you can remortgage. And you can buy other property using this money as a down payment. Your mortgaged property also becomes easier to sell, if you decide to do that. Most buyers of property prefer to buy where there is an existing loan.

You can see that you should put down the *least* money you can on a purchase, though enough to ensure that you can handle the payment, a combination of principal and interest. Sometimes it is necessary to find someone to take a second mortgage on the property so you have two monthly payments instead of one. Again, this is a *good* place to be if you want to sell.

Realtors

Here are three realtor tricks that were played on me; there have been many others. (If I listed those I've been told about it would take the rest of the book.)

1. A house was for sale so I went over to look at it. The realtor showed me around and told me that the rental unit at the back was bringing in $350 a month and that there were two assumable loans on the property, one at 9 and the other at 11 percent.

I spoke to the owner.

The rental at the back brings in $300 a month and there are two nonassumable loans, one at 9½ percent and the other at 12 percent.

2. A realtor encouraged me to purchase a house for the studio although it was in a zone that did not allow photographic studios.

"I promise you, you'll get a variance," he insisted, "you have my word."

I spoke to the planning department and was told that no petition for a variance would be possible. All realtors had been informed that there would be *no* exceptions allowed on this particular street.

3. I put money down on this one. Then I noticed the escrow instructions. (Escrow is the halfway house in a property deal. The escrow company holds the money until the deal is completed and then divides it. It also investigates the title so you know you are buying something that's free to be sold.) The fine print read, ". . . the buyer understands that there can be no development of this land at this time." I later learned it was subject to landslides and was to be used for grazing cattle only. Eventually, I got my money back.

Interest Rates

When purchasing property, remember you can barter on the interest rates; you don't have to accept what's offered unless it is from a lending *institution* (bank, mortgage company, etc.). Figure out what is best for you or talk to an accountant or a smart friend who is already successful in business.

Rules for Buyers

1. Look at the property very carefully and check the city zoning. There is always a line where the zoning changes. Be quite sure you fall on the side of the line you want. Just because a gas station is on the corner doesn't mean you can set up a studio in *this* house.

2. Find out the local restrictions as to building. It costs nothing to go to the city or county office, whichever controls a particular piece of land, and talk over its future with someone.

3. A planning *department* and a planning *commission* are not the same thing. The former is a government department that enforces certain rules. The latter is a group of citizens appointed and/or elected to review complaints and petitions and make the rules.

The planning commission is like Congress where the laws originate. The planning department is the regulatory office that enforces them.

4. Check the size of the property, and consider where your customers will park and how the location will serve you.

5. When considering the pros and cons of purchasing a property remember that from now on the repairs are on you, the utilities are your full responsibility, you may be required to put in curbs at your expense, and you will have taxes to pay. You also take on any liabilities that exist. E.g., your tree's roots ruined the neighbor's garage four years ago. You, not the previous owner, are liable.

6. If it strains your budget to purchase the property, get the place making money for you. Put up your shingle saying you're in business even before the studio is ready, because we are one of the few professionals who can work *anywhere*. The world is our backdrop.

7. What is done *can* be undone! If you agreed to something when you bought a piece of property that you now feel was unreasonable, you can petition your planning commission to reconsider the matter. (Obviously, this does not apply to the deal you made with the previous owner of the property who is now *out* of the picture.)

Let's say I agreed to put in a particular improvement on a piece of property, in return for which I am given a permit to do business as a studio. Later I find I can't afford that improvement. I can now (and I have in fact done so), go back to the planning commission and say, "I can't afford it. What now?" In my case I had an alternative plan and they accepted that.

You Don't Lose Your Equity

When buying a piece of property, all the same things apply as when renting. The exception is that you have an "equity" in the property, which means the right to redeem it. Say you can't pay on that property, but you have paid $12,000 on the principal. The holder of the mortgage can wait a certain time and sell it. But he can only take what is owed to him from the sale; the rest reverts to you. You can also come up with the entire amount of back payments during that "grace" period and continue as before.

Some buyers have found it to their advantage to allow the bank, as an example, to foreclose and sell the property, rather than hang around and do it themselves! One described to me how this worked for him.

"Our home was in San Jose," he said "and I was paying $350 per month on the mortgage. I was offered a job in Texas and found that I could buy the house I wanted for $1,500 down. So I stopped paying on my San Jose house and borrowed $1,500 on a short-term loan (four months). We did not have to leave San Jose for four months and when we did, we just moved and left the house there. Later, we received the balance due us after the bank sold the house and took what we owed them."

I suppose my reluctance to recommend the above is just that I would hate it to be done to me! There doesn't seem to be any hitch, though. My friend got the loan and he put up the house as collateral. The bank foreclosed, the house was sold, and the balance was due him.

Like Money in the Bank

Once you have the place where you will do business as a studio, you have a tangible asset.

If you were to leave the photography business then this asset could be cashed in. The fact that you were doing photography at this location makes it a particularly attractive one for another photographer and that person can be asked to pay you hard cash just for that location.

When you notice a "business for sale" it usually does *not* mean that the *location* is for sale but the business name, customer goodwill, tools and other property you would need to purchase to start up in that business. The business name can also be sold without the studio appurtenances. What isn't mentioned is that you also may be buying ill will.

As an example, say the previous photographer was an alcoholic. Inevitably, that would have hurt some jobs. The memory of customers will be that the photographer at your address is unreliable. Or say the photographer was selling girlie stuff to magazines, legitimate but Playboy-style. The local newspaper has written him up enthusiastically, but *you* are after a family clientele. There'll be parents who won't let their girls near you.

A determined advertising campaign can help some, but sooner or later someone will say, "You're letting him photograph your *daughter?* He's the man who . . ." You may never get a chance to defend yourself.

An Objective Look at the Studio

Having made the decision about the location of your studio, and then found it, and moved in, you must now very coldly assess it.

One way is find any other store, restaurant, professional office, etc., that belongs to a specific business person. Let us say you decide on a clothing store. Write down the addresses of three or more such stores and drive to them. Now look at them from the outside and try to make a judgment—just from the impression you get—of the type of product you'll get in that store.

Now when you come back to your own studio you can be objective. You'll see that you can make judgments from the way a place looks. And were all those stores equally easy to find? Did their signs jump to your attention? Did you have to look for the street number?

It is obvious that some businesses are practically invisible and others are not. Now what you have to do with your location is to make your business visible in it. You don't want customers to say, "I've passed this way every day for months and have never seen your sign." You want them to say, "I notice your sign every time I pass this way, and I've always wanted to drop in."

Can you see the building? Can you see your name on or outside it? If the building you buy is drab or dirty, paint it. A coat of paint is the cheapest, most effective facelift. The people who can own student-housing rentals have told me that much of the elaborate preparation for interior painting is not necessary; as one said, "Just dust off the walls. Don't wash them—paint the dirt out." However, if the paint is peeling, you do have to sand and scrape it off.

Water-based paint is always easier to handle. If you're going to have a cheap job done, make it into a family job and do it fast and get it over with. Otherwise get someone who will guarantee the work.

When we painted the entrance to my old studio building pink (we painted the staircase red), it was to draw the eye to it. For years I had passed that old building and never knew that there was an upstairs. The entrance was Victorian embellished stucco, the most imposing on the block, but it had been painted to tone it down. It was invisible.

We succeeded almost too well in drawing the public's attention to that entrance, because very soon people would come and sit on the wide carpeted staircase that led to where I worked. Shoppers got tired and there was nowhere to sit downtown, so the younger shoppers gathered on the stairs and it soon was difficult to get past them.

The "upstairs" tenants, of which I was one, had long discussions on how to get rid of these people. What worked best was a notice saying, "The carpet has been dyed recently and the color may come off on your clothes. Sit on it at your own risk."

It had not been dyed, but worked best of all the notices we tried.

In my new neighborhood the problem was the same: The house I bought as a studio was invisible. But painting it a bright color was not the solution, as an ugly brick warehouse next door had been painted turquoise blue, I needed to separate from it by looking classy, not brassy, and it wasn't easy. My modest "carpenter-built" cottage was far from classy, so I settled on making it adorable instead. And I made mistakes.

I originally wanted off-white and coffee trim and still have that paint in the cellar. Eventually I decided on a cement brown with a colorful front garden and a strong sign on the building itself to draw the eye.

My door started out dull yellow (the color when I arrived). Then I tried red, pink ("an ethnic pink" the painter called it!), bright blue, and even zebra-striped (black and white).

It is now the color of the house.

While you are painting the outside of your building you will be advertising it; the sight of other people working is an eyecatcher! While work was being done on my present studio, every store I went to seemed to know the location, "Isn't that where they're working on the driveway?" kind of thing.

When I bought plants for the flower bed last year, the cashier asked, "Isn't it time to change the color of the door again?"

Good advertising!

A cheap facelift to a business is landscaping. If you have a yard make it work *for* you. I have two rules for buying plants: They must be beautiful or edible! Because I use my yard for photography, what I buy for it is deductible.

My obsession with look was foisted on me by an architect friend who endlessly nagged that I would see the results in my receipts.

He worried about the lettering on my sign, the size, the color, etc. Apparently there is a group of people who have studied graphic arts, and are repelled by sloppy lettering.

He also showed me that when you turn a house into a business, you must

take down all "visual" barriers which tell the passerby, *"Keep out!"* He insisted I remove a small white fence which ran the length of the sidewalk.

The floor, the curtains, the awnings, every part of the building was thought out carefully, and I didn't spend much money either, but shopped for the best deals.

Your Location is You

Imagine how dull it would be if we went into every home and everyone had identical taste. It would be equally dull if everyone dressed the same way. Whatever you decide for your studio's look must be yours and yours alone—remember that this place of business where you will build a career must be a place where you are happy. If you love what you do and where you do it, the joy you feel in your work will spread to your customers and everyone you meet.

We have all been into offices where even the owners seem uncomfortable. A chrome-and-glass designer-decorated business may seem exactly right for one person, yet I've seen them staffed by uptight people who I am sure would be happier with something less extreme. A chaotic office, too, where there are no facilities to put the many piles of books and papers away, may be presided over by a furious executive who would be much happier in uncluttered surroundings.

The place where you do business must not just be a good buy (or rental); it must be pleasing to you and at least have the potential to become a place in which you can relax rather than wish to escape from. If you are comfortable, your customers will be comfortable, and they will not expect your decor to mirror their own tastes.

I happen to know this because it is the route I took. Looking back, I based most decisions about where to work on *my* preferences. I have had opportunities, particularly in recent years, to move my studio into spectacular locations, but I couldn't do it because I am perfectly happy where I am.

Consider how both things you can and cannot change about your studio might come to irritate you in ways that you did not at first anticipate. It's possible to prevent them if you think carefully beforehand.

An example of something you cannot change is a fixed environmental factor or variable factors that are nevertheless beyond your control.

My daughter rented a basement apartment when she was in college at Penn State. She began to suffer extreme depression and came to realize it was because she hated to come home and have to turn the lights on no matter what time of the day it was. To this day she shudders remembering that "terrible dark underground place," which didn't seem to bother her husband at all.

Before I bought my present studio, I was able to avoid getting caught in the same trap. Offered a prime low-rent, long-lease location underground in a shopping mall, I was initially thrilled. Only when I went over to finalize the deal did I realize that I would go crazy if I had to stay underground all day every day.

The other business owners down there, however, seemed happy and some have rented the same spaces for years and were the original tenants when the building opened many years ago.

Examples of changeable annoyances *outside* your own control are the kind

of neighbor you have—you might not like the smell of a fish-and-chip take-out next door, the sound of automobile engines being revved up or dogs whining at a veterinarian's or pet shop—or even being a tenant where the air conditioner or heater is controlled by a manager who likes different temperatures than you do.

Examples of changes that can and should be made (as soon as possible) are any of the decor nuisances you might find when you get into your new building. A color can be painted over, rugs can replace vinyl flooring, and storage units can be put in where they don't now exist. Sometimes, too, neighbors can be persuaded to change something for your convenience. For instance, I eventually persuaded two neighbors to allow me to cut down my boundary hedge so my building could be seen more easily. Both these hedges had been planted on their property, not mine. One refused for a full year until he saw how much healthier the twenty-five-foot hedge became when it was reduced to five feet.

Similarly, barking animals can be controlled or moved to where you can't hear them, thumping on your ceiling can be stopped, and someone can be asked to wash the sidewalk at a time when your customers won't slip on it or bring their wet footprints onto your floors.

Don't just consider replacing something you don't like with something you do, set about creating an environment that is you—your personal style, your "Look," in a very positive way.

Three tips when considering *your* look:

1. You must like it, really like it. If you don't, change it.

2. You must like the color scheme. They must be colors you feel happy with. Avoid being influenced by a so-called expert. If he thinks pink and red are terrific and you want blue, have blue! Any color combination can work if it's handled right. Look at nature.

3. Be strong-minded and in your decor don't include gifts from your friends unless you really feel they add to the place. Take them home and use them there, or hide them.

You'll find that your customers will get a feeling that you care about them and how *they* look, if you care about how your studio looks. Whether you have a gorgeous decor, a place that looks like a warehouse, or a simple little studio is not the issue. What's really important is that your studio doesn't look overdone, like a dump, or drab.

TIPS

Good Advice Can Come Free

Over the years you'll meet people who are experts in various fields. Keep a record of their names and call them if you need advice. When you can't afford to pay for advice, then you have to be practical and find a way to get it anyway!

Many professionals in business detest giving free advice, but there are others who will do so. Even lawyers sometimes do not charge for the initial consultation if they believe they have not helped. The only time you really

need to hire a lawyer to represent you is when you have exhausted the opportunities for free advice and/or an appearance in court is necessary.

I have had very good luck in getting free advice. When I needed advice I never beat around the bush. I blurted out that I just didn't have the money to pay for it. Most people helped on the spot, some going to considerable trouble—and often expense—to get me the information I needed.

Here are some sources of free help:

1. Any of the professional bodies that exist to help others at no charge. Always start at your city hall or county courthouse and find out what local organizations of this kind exist.

Other places to get free legal advice on tenant rights (or any rights), or at least to be told where it is available are: local librarians, the District Attorney's (D.A.'s) office (county government), the City Attorney's office (city government), the Housing Authority, and any consumer protection group.

If you're a woman or belong to a minority group, there are usually organizations just to help you.

Once you find the help you need, keep the name of the person you speak to and all other names that come up, on a card that is part of a card index file.

I use a "flip" type index file, where all such information is filed by subject so I can get to it quickly.

E.g., under COUNTY GOVERNMENT, one card might read:

> D.A.'s Office 555-6543
> Christine Evans (D.A.) Ext. 40
> Ray Jones (ASST. D.A.) Ext. 43
>
> D.A.'s Secretary—Martha Smith

2. If you do someone a business favor, remind him of it when you need one. Set it up if necessary. When he says, "You've been very kind," reply, "Someday, you can do me a favor."

3. Hobbyists are delighted when you ask for advice. A person who loves taking his car apart will be the person to turn to when the front falls off yours.

4. Someone who is well read on a subject—e.g., a teacher or a student—is a person to approach when you need advice.

5. Secretaries and administrative assistants are fonts of information on the work they handle. They don't have to divulge company secrets to tell you something. For example I might call to a construction company and say, "I'm going to put in a new garage, and is this something a carpenter can handle or do I need a licensed contractor?" I might even get a frank opinion on the particular carpenter I intend to use or the recommendation of someone else for that job.

Secretaries are sometimes wiser than their bosses, better educated and more objective. Secretaries in escrow companies and banks know about money, legal secretaries about law (and lawyers).

Most secretaries give advice freely but I like to repay such favors by picking up the tab for a meal or making a gift of some photography.

6. The very rich. They don't need money and if you ask their advice they will give it, if they'll talk to you at all! If you can get past a secretary to the boss, he's usually delighted to help.

7. Lastly, someone who has been fired from a particular consultant's office is usually delighted to be able to take business away by giving you the advice you would have got (if you had been a regular client).

The Name You Go By

Possibly the dumbest thing I ever did was to go into business as Jeanne Thwaites. ("Jeanne" pronounced "J'an,"—rhymes with "pan." "Thwaites" pronounced "Thw-ay-ts"—rhymes with "gates.") If customers can pronounce even half of it right, I'm in luck. Yet I was determined to be a photographer under my own name and that was it. If you are like me, skip this section.

For the rest of you, naming your studio should be a lot of fun if its name is not already established—e.g., you have not bought a studio already named.

Even if you have, you must decide whether to change the name or leave it as it is. Here are my suggestions:

1. Change the name now, if you are going to do it at all. You need to establish your studio identity as soon as possible.

2. Keep the name if it is a definite *plus*. If you have bought a studio whose reputation is one you are very glad to have—even if you can see ways of improving on it—you'll get a lot of business, as many people will not be aware of the change of ownership.

3. Keep *part* of the name if you want to be connected with the old studio and at the same time want your own identity. E.g., Photography Plus, could become Photography Plus by John Smith, or Smith's Photography Plus.

4. Change the name if you want to convey as strongly as possible that you are a new owner or if you are eager to establish your own name as the owner.

If, on the other hand, you are the first person to establish a studio at a location you have two choices: your own name or a name other than your own.

Your Own Name

1. If your name is unusual, don't be frightened of using it, though you might adjust it somewhat, as movie stars do. Eddie Franciskovich could become Eddie Francis or Eddie Kovich or even Eddie Frankovich.

One factor to remember is that although an unusual name is difficult to remember, once it is remembered it is not easily forgotten.

2. If your name is a common one, dress it up. John Smith could become Jonathan Smith, or Smithie's.

The reason you want to get away from John Smith is that it is so common it will be easily forgotten. "I think his name is Bill Jones or something."

3. If either your first or last name is distinctive *and* has an attractive, easy-to-remember sound, consider using that one name alone, e.g., Alexander, Penelope, Floyd, Drummond, Lambert.

4. Sound your name out, and give it a good balance. Richard Rapp has a nice sound to it; Ricky Rapp sounds like a child; Rick Rapp sounds abrupt; Richard alone sounds too ordinary; Rapp alone sounds abrupt and

a bit punishing ("rap" as in "he rapped his knuckles").

5. If you are a woman, you might consider seriously whether you want everyone to know that. In my own case it never entered my head to hide the fact, but there is no question that, at times, it has lost me business. Whether I would have lost that business when a customer thinking I was a man discovered I was not, is difficult to gauge.

A Name Other than Your Own

Let's say, for whatever reason, you don't want to use your name. You would prefer your studio to have a name that reminds the public of photography.

1. The closer to the beginning of the alphabet the first letter of your studio name is, the better the business you will get from the Phone Directory listings—e.g., Alpha would be better than Zebra; Golden Dawn better than Sunset.

The woman who told me about this was married to a man whose job allowed him to spend only a few years in each city. On arrival she would rent any available space on the street level of a main shopping area, go into business under a name starting "AAA" (one of her enterprises was "AAA Pet Grooming"), and rapidly build to where she could sell the business as a package for a tidy profit.

"We couldn't lose," she explained. "While the business ran at a loss, it worked as a tax loss for my husband's high salary. When it ran at a profit, it brought us a very high sale price."

2. AAA Pet Grooming told people exactly what was going on in that shop. If you are not going to use your own name, then let your studio name do the same for you—e.g., Alpha Photographs, The Photographic Image, Fashion Photography, rather than Sunny Times, Hearts and Flowers, etc.

When considering the sound of a word in your name, divide up the alphabet into the sounds that attract you (or do not). Certain letters or letter combinations suggest crispness (k, p, cr); others, tranquility (m, n, s), etc.

If you are considering names and are not quite confortable with the ones suggested by family and friends, you can keep a good idea by removing one word and replacing it with one that sounds better.

"Moods" may be too mmmm. What you may be looking for is a crisper sound ("pep")?

3. Watch for any double meanings in your choice of studio name and also a suggestion of someone or something unpleasant, even if that is just a local dislike of a much-used word. For example, in a *small town* it wouldn't be wise to start a studio called Paradise Studios if John Doe, the owner of Paradise Salad Bar, has been in the local papers for several months because he gunned down his entire family.

If you are already in business under Paradise, no one would give it another thought. If you are just moving in under Paradise, though, there is a possibility that someone would feel there is a connection. So ask local people what they think of your proposed studio name before having a sign made.

In a large city, no one would imagine a connection. There are probably many other businesses named Paradise.

Sixteen Decorator Tips

1. Decorate with colors that look well against you and the clothes you wear. If you're the tweedy type, browns go well with you. Dark people look wonderful against white, and blondes against beiges. If you've chosen a neutral base for the studio, the accent colors could be your favorites.

When someone enters your studio, he isn't looking at himself but at you. So your studio should be *your* frame.

2. Whatever colors you choose, include something black and something white in each room. When a room looks dull, all it may lack is a white and/or black to bring out the best in the other colors.

3. Large studios with several rooms allow you to loosen up with decoration. Take advantage of the space to let your customers move around freely and sit comfortably.

4. An arrangement of display pictures must fit the size of the wall and the room. Remember that pictures are easiest to see at eye level.

5. Look intently at the photographs you display. Customers will think their work will look like those pictures. You can't afford to display pictures of people who are neither well known nor good looking. If there's a display picture of an unknown, unphotogenic man, you can be sure that Paul Newman would walk in and think that's what he'd look like if you took the picture.

This is perhaps the most common error of studio photographers: they display pictures of people they like rather than those who are gorgeous.

6. When you find yourself getting bored by a particular picture, retire it for a while. An idea that might have seemed great at one time can lose impact. If the picture is a portrait you feel you'll never really be happy with, try to sell it—or give it—to the person it is of.

On the other hand, don't dump pictures just because they're old. If they still give you pleasure, they'll give other people pleasure, too.

7. Never distract customers from your work by dragging in things that are more fascinating to look at. Books or magazines you happen to be reading and ornaments that do things are an example. We were recently given a tank of tropical fish that I'd love to have in the studio but can't because it would be like running a movie. There's drama in that tank!

8. Children love to visit toys they think of as "old friends." These younger customers come in the second time and make a beeline for the toy they played with last time. Don't throw away those old favorites unless they have really outlived their usefulness. A child would prefer to hear a toy was given away than thrown away.

9. Good smells boost sales. Potpourri, brownies, and furniture polish are such smells. Mint, lemon, and coffee are great smells that come cheap. Incense is often overpowering. Remember, you don't want your customers to fall asleep; you want them to relax.

10. Don't keep house plants in your studio unless you're going to take care of them. No flowers are better than half-dead flowers. People who love flowers (like me) hate to see them neglected.

11. Keep everything clean, particularly bathrooms. Don't leave a bathroom without checking to see that the sink and toilet are spotless, the mirrors without smears, and the wastebasket empty. A studio bathroom should house a few items of makeup, a curling iron, hair dryer, etc. I find the paper towels last longer if hung vertically and I provide hand cream.

12. Every so often go through the rooms and bring them back to their initial order. Do it once a week, once a month or every three months, but *do it.* If you've collected ornaments you can now put into retirement, do so. You might bring out something new, or something you haven't had space to display—a special bowl, a piece of furniture, a cushion—something that'll give a fresh look to the room.

13. It's fun to have some little acknowledgment of holidays—Santa or poinsettias at Christmas, a pumpkin at Thanksgiving, and a bowl of colored eggs at Easter. Sterile decor is for nonvisual people; don't be frightened of putting a little life in the place.

14. If you want to tell a passerby that you're not open to business, soften the blow. "Sorry to have missed you—Please call again" sounds a lot kinder than "Closed."

15. Repaint the walls of your studio on a regular schedule—every four years or so—whether or not they seem to need it. Don't paint the ceiling unless it really needs it (too much work), just the walls and woodwork.

16. Studio owners I've talked to say that a complete renovation of a studio pays for itself in increased business. If you have the money and are considering it, consult an expert before going ahead. You may not need advice on color or arrangements, but there's so much to know—about quality, what *not to do,* what new materials are available—that you might as well start with all the options.

If you decide to go ahead alone anyway, consider the view from each window or door. A window that looks onto a magnolia tree is so much prettier than one that sees only the neighbor's automobile.

Toys

I've learned not to have too many toys at the studio. Their main purpose is to divert the kid's attention, not to entice him into the toy box, refusing to leave.

Far and away the best toy I have is a bowl full of fabric mice with removable handmade clothes. They were designed by my sister, Barbara. Boys and girls alike love them. Who says boys and girls are alike, though? The boys often remove all the clothes and put them in one pile, and then all the naked mice in another pile. The girls usually talk to the mice or pretend they're talking to each other.

There are also some small windup toys that are fun.

When the children come back with their parents they say, "Where are the mice?" and they've been talking about them all day . . . how they were going to see them again.

All children who return with their parents get a surprise present, what I call a "lucky dip" because they don't know what they'll get. These little gifts are all things I find at garage sales, which I really don't need. They're wrapped and put into a large bowl. The kids who've been here before head for the bowl.

There are also sugarless candies for the children and in the refrigerator I keep chocolates shaped like cars, eggs, etc. You can see I get a bit carried away with the kids.

I've found it's better not to have:

1. Any large toy that has edges. Cars and trucks are fun at home, but if a child slips on one at the studio, gone is the good mood in a flood of tears.

91

2. Anything frightening. Some kids love them but others will scream. I have a hand puppet, a beautifully carved old man, but many small children hate him.

3. Anything breakable. Parents will stand by and let their children smash your toys. I used to have two jack-in-the-boxes until a doctor's family arrived and tore the jacks out of them while their mother was paying her bill.

4. Anything "cliché." The toy phone I had many years ago started off a local rash of child-making-phone-call pictures. Or maybe they were there first, but everywhere I looked I kept seeing pictures with toy phones.

5. Anything valuable. The mice have held up best, but the toys do eventually get destroyed and then I let some small child take them home.

Six Steps to Instant Order

To create instant order in a messy studio:

1. Throw everything you can into drawers or boxes; you can tidy them later.

2. Dust off all the surfaces.

3. Use a dustpan and brush to go over areas of the floor that are less than knee-deep in clutter.

4. Close all doors and drawers and pull curtains so they hang tidily.

5. Fluff up the cushions.

6. Set out a fresh bowl of fruit, a bowl of fresh flowers, or an arrangement of *anything*.

Thirteen Ideas to Save Purchasing $$$

1. *Buy cheap* when the item is disposable.

2. *Buy quality* when the item is permanent.

3. *Buy secondhand "quality"* whenever possible. The exception is when something old costs *less* new!

- Rare items sometimes increase in value, as with antiques of any kind. You can buy a good new camera cheaper than an antique camera.
- Electronic items. A $150 calculator will be sold for $50 if it is used, but a new $8 calculator may work as well.

4. *Buy beautiful.* It is worth spending extra dollars for lasting visual pleasure.

5. *Buy at garage sales.* All you have to do is keep in mind what you need and when you see it, buy it. Make do until that moment. A gold-framed 36"x48" mirror that really dresses up the studio retails for $250. I bought it for $35 in a garage sale; another mirror of the same size without a frame (for the studio bathroom) cost only $3. When you are at a garage sale tell people what you do for a living; sometimes they'll come in for photographs!

6. *Buy at the hardware store.* Hardware fixtures and pipes and fittings can be turned into elegant items that are sold for considerably more at a specialty store. A towel rail I made from a dowel, white plastic plumbing pipe, and sprinkler heads cost $6 in materials. The cheapest seven-foot towel rail I could find elsewhere costs nearly $200, and mine looks better.

Have you seen the furniture put together by plastic plumbing pipes and elbows?

You don't have to follow *Family Circle* or *Popular Mechanics* directions; make it up yourself.

7. *Buy for nothing.* After years of people telling me, "If I knew you wanted a tripod" (or whatever I had just bought), "you could have taken mine. It's been sitting in my closet doing nothing for years." I finally learned to tell my friends what I was looking for before I bought it. Even if they don't have one, they can sometimes come up with a place or a person who wants to get rid of theirs.

We've never bought *one* piece of wood for the stove, which is the only heating for the entire studio. We pass the word that we'll take donations, and if I see wood being hauled away, I'll ask if it's going to be dumped and if it is, could they dump it at my place? As a matter of fact I have enough wood now for several years!

8. *Buy only what you can't make.* I joined an adult woodshop class when I started my studio to make the things I couldn't afford to buy. Now I still save a lot of space and money by making the exact item I need, instead of making do with what the stores sell. I have the lumber yard cut the pieces to size. I learned in woodshop to make a drawing and list of what I need before I start work. When you order the cut pieces you do pay for the cuts, but you pay only for the square footage you need and if the lumberyard makes a mistake on a cut, you don't pay for the piece (you'd have to if *you* made the mistake).

Lumberyard people depend on repeat business, so they go out of their way to serve customers. A lot of the time I don't pay to have wood cut up, sometimes they deliver for nothing, and once one of the men borrowed a particular tool from a customer just to get a particular job done for me.

9. *Extravagance is fun.* Once in a while buy something you feel you *have to have.* The reward will be years of pleasure, so it's a cheap way to buy a feeling of luxury.

10. *Use and beauty.* If you cut out all your possessions that are neither beautiful nor useful, you won't miss them. If you find the place getting cluttered and want to clear out the white elephants, put each to that test. If it is useful, keep it. If it is really beautiful, keep it. All the rest must go!

11. *Don't buy tacky.* If your taste runs tacky, enjoy it only at home. I have somewhat tacky taste. I love those little pitchers shaped like cows and turtles, and egg cups that look like chickens and mushrooms. I love gaudy Christmas tree ornaments, Easter bunnies, and chocolates in boxes shaped like hearts. But you'll never see these in my studio!

No one will be put off by elegance but some will be put off by gaudy taste. I know people who disdain certain photographers just because of the frames displayed in their windows.

If you wonder whether your taste is tacky, there is an easy test. If people whose taste is generally respected give you patronizing smiles, the kind that say, "I love you, so *anything* you do is fine with me," (when you show them the lamp shade you made out of egg cartons), your taste is tacky.

Here is another test. If you still like the decor that turned you on when you were seven and the same kind of things impress you, you've probably grown up in every area except this one—your taste.

If you like mirrors that have gold veins, fake flowers, plastic cushion covers, nylon net, and pale pink writing paper with cute sayings at the top, your taste is probably a bit tacky, so indulge it at home where you have only yourself to please.

12. *Save time.* Do you drive across town to save thirty-five cents? Stop doing it. Buy everything in one store and risk an extra dollar in cost. An Arroyo Grande doctor/housewife with children and animals decided to clip coupons, look at ads, and buy at the cheapest possible places for one month as an experiment. She made a note of what she spent and then the next month, just bought what she needed at the closest place.

The total of savings for the entire month was $10.

The loss of time was fifteen hours.

Only if you're right down to basics—walking instead of driving, doing anything to save a buck—should you bother with niggling little economies. Otherwise time is your most valuable commodity. You can't afford to waste fifteen hours saving $10; you could bring in more money in one of those hours if you spent it on the phone trying to drum up a few orders.

13. Read *Mother Earth News.* If you feel poor, read this great periodical and get an emotional lift and good ideas at the same time. How can you feel you can't afford to buy a house, when you read of how one man built a home in lumber country, using only ends of wood picked up for the asking at the sawmills. (Total cost: $50 for nails!) Another built a home for $500. He made it underground and the roof was made of Styrofoam covered by asphalt.

Several times I have found ads in *Mother Earth News* and *Organic Gardening* for items I have been looking for, but was previously unable to find exactly what I wanted, e.g., an electric shredder for plant clippings. Some local nurseries denied there was such a thing (gas-powered is usual). I don't like gas-powered anything—too much work starting it and pouring the gas in. I also found in one of the ads a paper shredder for making mulch. This one is hand operated and works like a dream. My friends are amused as I crank out strips of newspaper.

These items are all business expenses, of course, as my studio garden is used for photography!

How I Spent a Little and Saved a Whole Lot

A couple of years ago I thought of a way to save myself some money and should pass that on.

In our county, Paso Robles is a town with scorching summers and freezing winters, a climate I like a lot. It had one photographer. I wondered if I could move my home to Paso, and then had a plan. I would start a branch studio there and when it became established, move there and run the Paso studio as my center. My San Luis studio thirty miles away would become the "branch."

Only it was going to cost a *whole lot.*

I thought about it for days and came up with a solution. I must first test my market.

To start, I got a business phone number in Paso to make the people up there aware that there was a new photographer in town. I timed this to coincide with the new phone directory so the new number would be in the Yellow Pages. The phone number was put through an answering service, which transferred the calls directly to me; all the customer had to do was stay on the line.

I gave myself a three-month test period and at the end of that time

found that all of those customers would have come down to my studio in San Luis anyway!

Of course, a phone number is not the same as hanging out a shingle, but it does give some indication of what's out there.

My total investment was only $200 for the answering service, installation of the phone, monthly charge on the phone, and gas to go to Paso Robles and photograph the people who hired me.

Imagine what it would have cost the other way for rent of studio, redecoration, securing the studio against burglars, payroll, telephone, utilities, gas for driving there, city taxes in Paso Robles, additional equipment, etc.

6
Style is of the Essence

Once you go into business you must find a way to make yourself distinct from your competitors. You *are* distinct from them; you are your own person with your own photographic style. If you can accept this, you will have a much clearer idea of how to advertise, what prices to charge, and where to look for your customers.

You already have a particular type of picture you can do better than average, and therefore, whether or not you are aware of it, you have already begun to specialize.

For example, you may be good at dealing with hordes of small children, each dressed in an identical uniform. This can be a lucrative field (school and sports photography). Or can you photograph an apple pie so that the viewer becomes hungry at the sight of it or arrange a fashion shot so that someone will actually want to buy that garment?

Besides your inclinations and talent is another consideration—from which social or economic level will your clientele come? This too is probably decided already, given the kind of person you are and the people you find it easier to be with.

People who are comfortable with your work and the way you dish it up will gravitate to you. For example, how important you consider the garnish—and how important the ingredients—will set you apart from other photographers.

Some years ago when I was looking at the work of a very talented photographer, I said to a trusted friend, "Darn it, he is probably better than I am." He kindly replied, "You are entirely different photographers. You both know what you are doing, but you are more likely to appeal to visual gourmets, and he to socialites." I was enormously complimented by being considered a *gourmet's* photographer!

I was never very good at the kind of photography I initially set out to do. I intended to be what I now call a *fast food* photographer, one who works cheap and fast and does a great deal of simple, I.D.-style portraiture. The moment I allowed myself to accept that I was in the *gourmet* category, I had found my niche.

But I might instead have tried a *Beverly Hills* type operation and decided the *Family Style* approach took less effort.

A Photographic Smorgasbord

I divide photographic studios into four types as if they are restaurants; it is much easier to think of us this way! Someone might say to me, "What kind of photography do you do?" If I say, "I try to provide a gourmet product," he will know exactly what I mean; my work is geared to the discriminating viewer with sophisticated tastes. I am not trying to be *good enough* but *excellent!*

Here are the four main types of restaurants:

1. *Fast Food* . . . the instant satisfaction provided by speedy service that can be given with the limited menu available. McDonald's, Kentucky Fried Chicken, Taco Bell are the restaurant equivalents.

2. *Family Style* . . . a more varied menu, but again it is short-order cooking, frozen vegetables, nondairy creamer. Travel across the country and you'll find this restaurant in any town under the name of Howard Johnson's, Denny's, etc.; as you'll find the same portrait studio, with its rustic frames, velvet liners, and offers of "portrait packages." It's the difference of padded booths instead of molded plastic chairs; meals served at the table instead of cafeteria style; and dishes and silverware that are not disposable that separate this restaurant from fast-food operations.

3. *Gourmet* . . . in all sorts of little hole-in-the-walls dedicated chefs turn out meals with their personal touch. You may get these meals on unmatched china, and the chef may elect not to serve the particular item you came for that day because he cannot get the exact ingredients he wants, but his pride in his work is obvious, and he takes every mistake he makes very personally.

4. *Beverly Hills* . . . luxury plus. Yet it is the public relations expert, not the chef, who is really in charge. If something doesn't pay, it will be removed from the menu for that reason alone, regardless of its merits. You go here for quality, not for individuality.

Each of these types of restaurants serves a need of the public, as does each of the styles of photography. When considering *your* studio style, consider what will be most comfortable for you. However, I suspect there will be no real choice; it has already been made. While dreaming of your studio, you have been dreaming of it a certain way. You are the one who knows best what will be most comfortable for you.

I did not expect to run a gourmet type studio because I was reluctant to risk a lack of understanding from the general public. So I decided to provide something very simple and cheap, something that couldn't be criticized. Then I prolonged each sitting until I was satisfied and mulled over the final prints until they seemed perfect. All this took so much time that I made no money. I was "waiting" on customers, instead of "moving" them through.

Fast-Food Photography

If this is your bent, you *have to* undercut the other photographers and turn out a quick, cheap product. You must, therefore, be located where your potential clientele will practically fall over you. Efficiency and speed will be your calling cards, and those who work for you—and you yourself—must not hang around

wondering if anyone wants what you have to offer; presume they will. If you're doing it well, there's a lot of money in it.

Some fast-food photographers travel, using a brand-name store (Sears, Penneys, etc.) to bring in their customers.

Even if your operation is conspicuously advertised by its very location, you have to run seasonal specials, coupons and discounts. And you need a good business mind and a feeling for the needs of the man on the street. It is almost impossible to run this as a one-man operation; a good financial head must keep an eye on the business seven days a week.

The photographer who travels must be capable of back-breaking, nonstop work; handling a large number of people, most of whom are clutching very small children; and coaxing these infants out of black moods and then do a good sales pitch to sell more prints.

A fast-food photographer sometimes specializes in passport pictures, IDs, inexpensive portrait packages, and often processes film for the public too. This works well as a sideline to a camera store. The photographer is anonymous and may not be recognized in the street, but the name of his operation is as well known as his is not.

Quick-Photo, Photopix and Quickpix are the kinds of names that alert the public to such an operation. When a new gimmick appears, this is where the public should find it, so keep up with the trends. Old-time photography, photo buttons, photo T-shirts, school pictures, and instant prints are naturals that will bring the public's attention to you, but don't be disappointed when you venture into something more personal like weddings and portraits. People will grumble—regardless of what they paid—if they see their own pictures looking more mass-produced than their best friend's.

Family-Style Photography

If there is only one photographer in town, this will usually be his style of operation. The prices of such photography vary according to the whim of the owner, and also how much "price fixing" goes on among the local photographers.

A particular area will become "expensive" suddenly or over the years. This doesn't seem to have anything to do with the other local costs, except that you can automatically expect to pay more where the overhead is *very* high (a studio in Manhattan has to charge to cover its overhead).

This apparent "price-fixing" is not necessarily premeditated. If one photographer decides to double his charges and continues to do good business, the other photographers will be quick to follow. If, however, an expensive photographer flounders (he has priced himself out of the market), then others may panic and lower their already reasonable prices, thinking it is a sign that the business itself is hitting a downtrend.

An example of this difference in pricing of the same family-style studio is Ventura, a town in Santa Barbara County, the county directly south of San Luis Obispo where I live. The family-style studios there charge quite a bit less than in our county. Those photographers don't know why the public will pay the prices they are charged up here.

Yet there is plenty of money in Ventura. It is a scenic and very active town with some industry and at least 20,000 more people than the city of San Luis Obispo.

When I came to San Luis Obispo, photographers charged moderately. Then our family-style photographers started raising thier prices competitively and the public paid the higher prices which are high to this day.

The family-style studio should have the best chance of survival because the public knows its product. The barriers are already down. Even so, it is here that Eastman Kodak's estimate of a "50 percent survival chance in the photographic studio," takes its big bite.

I've noticed that individuals starting such studios, or buying out studios whose owners are retiring, don't have a very good chance of survival if their thoughts are only on the money they'll make. Again, it is like a restaurant with the same family-type customer; you can run a place efficiently but if you don't make it fun for customers to go there, they won't.

The family-style studio should be the safest because it has the built-in markets. It has traditionally catered to the continual need for portraits of families, weddings, school children and babies. Such photographers also do some commercial photography, restoration, and Little League and other sports pictures.

The professional magazines, e.g., *The Professional Photographer, Rangefinder, Studio Photographer*, slant their articles to these studios' needs. Such magazines depend on the family-style photographer for their readership, and the articles describe other studios' operations for emulation. The emphasis isn't on great photography, but on practical advice for increasing studio income.

If you can find a small town without such a photographer (whose residents are having their pictures taken, but going out of town for them), then you start with an advantage. It's worth looking for such a place.

If you can afford big-city high rents until your studio supports itself, you will also have a built-in market. The residents will need photographs sooner or later (doesn't everyone?) and of that very large number of studios probably already doing the job, 50 percent will be on the way out! You needn't be one of them if you avoid their mistakes. When one moves out, you can move right in.

Whether you choose a city or small town, find a place where the population is moving in, not away. You can get these figures by finding comparable population figures—what was the population ten years ago; what is it now? Here's a question realtors can answer, phone several. Phone a realtor in a city about 200 miles away, and you may learn a lot about the population trends for your area. The local realtors may bend the truth to sell a studio!

Many family-style operations are run by husband and wife teams and where they differ from the gourmet or Beverly Hills photographer is in the sameness of their product. They rarely have a highly individualized talent. This doesn't seem to be because of the collaboration, but because of the nature of some couples— pa and ma are looking for a business to run together and this is it. These businesses seem to work at optimum level as long as ma and pa stay together.

Such a studio owner (or owners) is soon a familiar face around town and if

he stays in business in the same place, several generations of the same family are his customers. The success and failure of these studios therefore are affected by the reputation of their owners.

This studio is the most threatened when other studios with similar products move in. There's nothing to do but sit it out, expecting some customer loyalty. It is, in fact, dangerous to appear threatened by these new faces, but taking a parental attitude works well, "Oh, you mean the new kid?"

If this studio has provided the only photographer in town and has been charging astronomical prices, then it may well find itself in trouble if others move in and undercut it. We're talking about different prices for the *same* merchandise. It is, therefore, very smart to charge moderate prices and hire help to handle the rush, rather than lose business or lower prices in a squeeze. If JC Penney's charged like Nieman Marcus, and Sears and Roebuck moved into town, we all know what would happen. But because Penney's is moderately priced and gives good service, it can handle competition.

Gourmet Photography

Here the public is dealing with the ego of a person who has a desire to photograph the world *his way*. He is often considered eccentric. His interest is in his work, rather than the albums and frames they are eventually placed in. When he has a customer, this kind of photographer usually has him for life.

If this is your style (as it is mine), then you must stop worrying about what the other photographers are doing and concentrate on what you do best, because you'll never be happy any other way. If you go under it will because you have not generated enough business, so you must have a low overhead operation and/or someone to help you, unless (and this can happen), you get lucky quickly.

What you must fight against (don't I know it), is some inner anger when a customer doesn't understand that you prefer to provide the photograph you are proud of, not necessarily the one he expects.

I recall raging privately because a political candidate asked me to take a "smiling bust shot" of him. I obliged him, but also took some pictures I thought were a lot more interesting, and felt no small pleasure when the "smiling bust shot" he insisted on ordering did nothing to win him the election. He lost.

As you are really competing with yourself, any efforts to try Fast, Franchise, or Beverly Hills photography may weaken you and ultimately prove fruitless.

Peter Ustinov describes himself in his autobiography, *Dear Me*, in words that any gourmet-photographer will identify with:

"I tried to widen the scope of what I had developed, and in doing so lost the esoteric audience I had acquired. A lesson learned, which I have had to learn over and over again."

Beverly Hills Photography

This is a smart businesslike man or woman who takes excellent pictures or hires a photographer who takes excellent pictures. He doesn't bother with a

business that doesn't bring in cash in *large* chunks. But he gives his customers a product that is so beautifully *produced* that they love it.

This is the prestige photographer. His customers compete to show they can afford his sky-high prices, his albums, and his gloss. When they see the beauty of his studio, the antique furniture and the wall-to-wall rugs, they are impressed and are willing to pay the prices of its upkeep. A Beverly Hills photographer can't succeed without taste.

You may think that this photographer can't survive outside a big city. Not so. Wherever there are social climbers, a country club, golf courses, and a competitive school system, the Beverly Hills photographer is safe—provided he can keep a distance in quality between him and the Family-Style photographer.

A Gourmet photographer can become Beverly Hills but not without a manager. I know one who did so and never stopped complaining that he was now a slave to his customers, not an artist!

I've had three offers from successful businessmen who wanted to finance a studio around me at triple my current prices. I refused because I remembered that self-styled "slave," and how miserable he was.

The Beverly Hills photographers usually like each other as they are fanatics and perfectionists—each in his own way. They are intensely competitive and understand how to compete without making enemies. Because their motivation is money, they feel sorry for the other types of photographers who do not openly boast of their incomes, which to them is just evidence of failure.

They must always have the best in all material things . . . that designer look. Such a photographer knows the top value of his work and dresses up his product so he can charge accordingly. He knows who will pay his price and how to find that person.

In work style he differs from the gourmet photographer in that his work looks definitely commercial. I recall listening to two old photographers of great talent discussing some of the masters of the time, Halsman, Penn, Feininger, and saying after each name, "Ah, but he has gone commercial!" What they meant, of course, as that these men had disappointed them. I argued that perhaps the high price on their work brought out their maximum talent.

"My dear," said one of these old men, "Don't talk like a fool. I know Philippe Halsman, a great talent, and he produces a shit *Jump Book.* Last time I met him in New York, he said to me, 'I would like *you* to be the person to take *my* portrait.'

"So I made him stand this way, and that way, and I pretended to decide which light was good. And all the time he was patient. And then I was ready and I took the camera into my hands and I said, 'All right, Philippe, *jump!*' and I walked away."

If you're wondering whether you're a Gourmet photographer or Beverly Hills, here's how you tell! If you could photograph a book of celebrities "jumping" without going out of your mind with boredom, you are Beverly Hills!

Looking—and Acting—the Part

The Beverly Hills photographer is gregarious, joins the right social groups and dresses well!

The Gourmet photographer often settles on an endless repetition of a single outfit or all manner of strange garb.

The Fast-Food photographer can and does dress as he pleases because no one notices it.

The Family photographer buys at the rack and looks clean and tidy, like his product.

The Beverly Hills photographer talks in thousands, "I made $70,000 the first year, $140,00 the second," and also lies by the tens of thousands. Lying about his income is second nature, especially to himself.

His Family brother is equally compulsive but talks about the Beverly Hills photographer's income, not his own. It's his dream to be *there*.

The Gourmet photographer keeps his money in a tool box and frequently fails to deposit it for several weeks. He may not know what his income is or was, and he falls asleep when he tries to attend a business course. When the IRS audits him they find they owe *him* money. The auditor then stays over for a sitting and they become friends for life.

The Fast photo operator is interested only in the profit margin. "I took 1,583 passport pictures this summer; that's 83¢ profit each, or $1,313.89 on passport photos alone." If you hang around, he'll tell you to the penny how much he made on old-time pictures at the Fair (withholding the cash receipts). If he gets audited, he borrows the auditor's pencil and keeps it.

Switching Your Style

You cannot choose to become one of these four kinds of photographer, the choice is already made. Wherever you start you'll eventually settle into your comfortable slot.

My fantasy studio would be in a building where a Beverly Hills, Family-style and Fast photographer are in three studios with me tucked away in the fourth. The kick would be that I would own them all!

The Hidden Market

There's a person who would never bother to hire a professional photographer unless he could get him for $10 or less, and I was one. I honestly could not believe that people would pay more. Yet when I saw a photograph done by Norman Brown, who later became my teacher, I wanted it—whatever the price. When he gave it to me, it became one of my treasures. It was a picture of an *egg*.

Yet this same man told me that there was no market for *my* work when I decided to start a studio! He insisted I would have to *lower* my level to interest the public.

He was wrong. My market was there. It was there among people who, like myself, did not like the usual studio work.

Trust your own instincts. There are people who *can* tell the difference between California and French champagne and I was looking for those people and found them; as soon as you have one customer, others will follow.

If your talent appeals to a hidden market, remember too that you don't have

to share your market with your competition; you'll be taking business they don't know exists. Even if they start imitating you, you were the "first," the person whose name is locked into your product like Kleenex or Jello or Scotch tape!

It's impossible for me, or anyone else, to find the hidden market for *your* product because if I had thought of it, I'd have gone after it myself.

Not only in style but in actual inventions is there money to be made by the businessman-photographer. Every time you solve a practical problem at the studio you may have stumbled on to a real money-maker. This seems as good a time as any to touch on the hidden market that could well bring you financial security beyond your dreams.

When Mr. Phillips invented his screwdriver he did it for his own use; someone else saw its marketing possibilities. There are times, however, when you get a good idea and the public is ready to buy that idea. You can be sure that if it appeals to you, it must appeal to someone else.

When such ideas fail it is because you're not reaching the people who are on the same wavelength. You need to develop the idea, not let it sit idle. If the idea is developed, then others will see it and spread the word. If there is nothing to see, how can they?

All over this country there are people saying, "The public will never buy that," and they are wrong; the public will and does.

If you are holding back because you think your idea could be stolen, patent it. This isn't a cheap process, but it's something you should at least consider if you feel your idea is really hot.

The place to write or call for information on how to obtain a patent is any department of the federal government. If the city you work or live in is large enough, there will be a local number for the U.S. Patent Office.

Your ideas will fall into one of four categories:

1. An idea that is entirely original. You have not seen anything like it before, but you think it would work (e.g., you think of a way of doubling the power of an existing flash unit; doubling the manufacturer's suggested maximum-power capability).

2. An item that can be marketed, even though it is an adaption of someone else's idea (e.g., a piece of equipment).

3. A way of doing something that is not quite what has been done before in your area (e.g., architectural photography in an area where it's considered merely, "pictures of houses").

4. Tapping a market that someone has given up on—which he failed at, but which you may not (e.g., providing a slide show plus color prints of an event, instead of one or the other).

The success of any of these depends on how much you believe in them, on whether you present them to the public in their optimum form. Later, they may buy a cheaper version from you or elsewhere, but, initially, it will be the idea plus the quality that will catch their attention, rather than one *or* the other.

TIPS

Business Sense and Artistic Ability

Are you:
1. A businessman who is using photography to make him money, or
2. A photographer who has to be in business to make a living?
If you are type one you can have no illusions. The making of money is the fun part for you—not the photography; that is merely the tool you use.

You take the pictures you know will sell and if that is something that doesn't particularly please you, you'll do it anyway. When you switch your style and try to do photography as an "art," you bore quickly.

Type two, on the other hand, must continue turning out pictures to please himself or he wilts. The making of money is not his real motive although he tries hard to make it to survive. Nevertheless, he forgets to meet the advertising schedule deadlines he has set for himself, and is better off leaving that to someone else.

Most of us fall somewhere in between the two types.

But let's understand our motives when we make studio decisions: *"This* I do because of my pride as a photographer, and *that* I do because it makes sense business-wise."

Old or Young

Photographers fall into one of two main categories:
Youth—energy and enthusiasm.
Age—experience and maturity.
Although many of us are in the middle somewhere, it does seem that we are hired either because of our "youth" or "experience." And these evaluations may change depending on who does the hiring. Forty is old to a twenty-year-old and young to a sixty-year-old and both buy pictures.

If you are young, you're going to find it easy to outwork your older competitor and you'll use new ideas, whereas he'll be more conservative.

If you are older, you'll often outsmart the new kid on the block by exercising caution and not making stupid mistakes.

In Sri Lanka I photographed a resort hotel for a brochure and asked my nephew Dominic to help me. As he ran around and did the carrying and organizing while I did the photographs, I remembered the days when I slung two Mamiya C33s around my neck and never felt the weight. I hadn't realized that I had aged, that I had come to expect exhaustion as part of the job; but with his help, I felt fresh after a day's hard work. There was a time when I did the legwork for older photographers and there I was, only sixteen years later, feeling like an old lady!

A friend's father is a doctor who was bald by the time he was twenty-five. He used to say, "That bald pate was worth $10,000 a year when I was young and discovered that youth is not an asset in a doctor. Now I don't need it. I'd like my hair back!"

The trick, of course, is to consider what we already have going for us and use it (which is easy), and not pretend to be something we are not (which is hard).

104

You're Best at What You Enjoy Most

If I have one fault to find with studio owners it is that their work often lacks any original touch. Where has *that* photographer's specific talent gone? Where is that reason that he took up *this* business?

Don't lose sight of your special love, that knack that you and only you have and which you went into photography to use. If that is taking baby-pictures, make your baby-pictures sing with your style; don't neglect those babies because someone tells you there's more money in weddings or commercial work. Even if your special photographic love is outside what you usually sell—landscapes, industrials, or even underwater photography— that's where your talent will shine brightest, so keep taking those pictures.

Ylla loved photographing animals and her sense of humor provided us with laughs in her photo-books. You too can have a photo-book published. I have had three published and if I can have a publisher accept my idea, anyone can.

I lost sight for a couple years of what initially got me hooked into this business, that is people intense in their moods, whether fun, sorrow, pathos, enthusiasm or whatever. I fell into the trap of providing the smiling faces that my customers asked for and saw in time that my pictures had begun to bore *me*. Evidently I had begun to bore my customers too, because when I went back to what I love to do, my business took a big jolt upward!

Don't Close Doors

If you are working in an established community you have to accept that there are certain types of photography that have always thrived here.

In one community it may be a tradition to hire a studio to photograph weddings, but all the *architects* are out there with their Nikons taking their own pictures. In another, commissioned wedding photography may be considered a luxury for only the rich, but everyone wants pictures of babies at birth.

If I had realized this I would have done much better in my early years. Instead I wanted to show that good portraiture had arrived and ignored many surefire money-makers!

One way you could find out the solid photographic work already expected by the public in your area, would be to join the local organization of photographers *for a while.* You can go to their studios and listen to their conversation. If they talk about weddings all the time, you can be sure it is something you want to take on.

My usual feeling is that you don't need to join organizations of other photographers because nobody needs the undercurrent of rivalry these innocent little meetings create. However, if you need this kind of *information*, it would be the place to get it. You can always resign later!

Other places to find out local habits are other businesses which have to know what is going on. Bridal shops know what percentage of brides hire professional photographers for their weddings; the stores with the largest ads know if commercial photographers are in demand, and so on.

Also look in the Yellow Pages of the phone book under "Photographers." You'll see what other photographers say in their ads, the markets they expect to bring in. If they say, "Senior Portraits; Passport pictures; Pets," you can believe that all three categories of photography are popular locally.

7

Portraiture—
The Studio
Photographer's Staple

The particular talents a photographer needs are mechanical ability, artistic ability, timing, and a feel for visual excitement.

These come together in portraiture, I feel, more than in any other field of photography. It's the most difficult field—not necessarily the best paying, but often the most enduring. It's the field, too, where you have the best chance of being remembered as a photographer. The great photographers are remembered for their photographs of people, not things.

To give an example, in my opinion, Ansel Adams's landscapes are beautiful, but not more beautiful than those of many other fine landscape photographers. Any one of these photographers could go where Adams's great landscapes were taken and come up with an as-good or better picture. I don't believe one can say for sure, "There is an Adams landscape."

"Is that an Adams landscape?" is more likely to be asked of any well-lit and well-composed b&w taken with overexposed, underdeveloped, fine-grained film!

However, Karsh's portrait of Winston Churchill can't be equaled. It was dependent not just on technique but on variables that couldn't even be repeated the next day—Churchill's mood and Karsh's rapport with the English prime minister. Churchill is dead; his place in history is assured; the portrait remains. There's no such thing as a portrait of Churchill, "much like the Karsh portrait."

My own specialty is portraiture. I am sure I did not deliberately choose it, it chose me. I used people to illustrate all my photographs and only left them out when I had no choice. I cannot even photograph a vase now without making a "portrait" of that vase.

The desire to take a good portrait is not enough. You must develop as high a technical skill as possible so you can take good portraits at will. Two abilities are of particular importance in portraiture.

1. You must be quick, able to hit that shutter at exactly the right moment. If your timing is off, take more pictures to compensate. Never assume that somehow you could be underestimating your lack of ability this particular day (though occasionally this will be the case).

2. You must know when something exciting is happening. It may be a mis-

chievous thought that flits across a face; it may be a sudden beautiful sadness that mirrors in the eye. If I see that moment, I must take the picture. I've seen photographers miss a wonderful expression because they were waiting for a smile. All the "say cheese" smiles won't make as memorable a picture, as one that captures an exciting spontaneous expression.

It takes time to learn to control a portrait, and arrange the light, yet take advantage of the variables in mood, rapport, etc., that occur. There isn't a better place to learn this than from a photographer/teacher whose technical ability is of a high level. Do what he says and watch what he does and do the same things but with your own ideas!

If you don't wish or don't have the opportunity to do this, then go to any camera store and buy as many of Eastman Kodak's books on photographing people as are currently available. Kodak has access to the finest technical developments . . . it creates many. I feel Eastman Kodak is one of our national treasures!

What is a Good Portrait?

What we strive for and what we achieve are not necessarily the same thing, but try for the finest possible portrait of each person, at that particular time. The portrait should be:

1. *Complimentary.* When someone produces an ugly picture of someone else and says "the camera doesn't lie," that's simply not true. The camera does lie; lenses, light, angle, color, all make a difference. Let the camera lie in favor of your subject. Choose the light, lens, angle, and color that favor him.

2. *Interesting.* Something must go on in a subject's face that catches the viewer's imagination. At the risk of sounding maudlin, it is like reaching for a person's soul through his body. A most difficult subject to photograph is the woman who was a beautiful child and shows up for her portrait and just sits there allowing you to photograph her prettiness. "Here I am. I haven't had an interesting thought in fifteen years!" Marilyn Monroe, one of the greatest photographic models of all times, never made that mistake; she seduced the camera and said, "Here I am, I'm waiting for you, come and get me!"

You must persuade the subject to relate to the camera as if it were a person.

3. *Technically good.* Your portrait should be admired by more than your subject's family. You should be able to show it to other photographers with pride. Good technique is merely control. If your camera is producing pictures like those in your imagination, your technique is just fine!

My Tips on Portraiture

Obviously, the better a photographer makes his subject look the more business he will get, for even if the customer doesn't like the final product, (some people dislike their looks), if it is actually a fine photograph, others will appreciate it.

Here are a few tips, mostly on the mechanical business of taking a portrait.

I've tried to give you those you may not always find included in books on portraiture.

GET THE PICTURE

Do whatever it takes to get that picture, make a clown of yourself to keep the customer relaxed, make him stand on his head, take more frames than you had originally intended.

When you doubt the film's ability to handle the situation, slightly overexpose, because you must come back with an image. This is the opposite of what you might do when taking black and white pictures for exhibition. Then you slightly underexpose some frames, because this kind of picture is easier to print (the grey-scale of the film fits the grey-scale of the paper). Professionally, in portraiture particularly, you can't always risk underexposing, you might lose important details in the shadows.

This advice applies only when you're not sure of the latitude of the film you're using. When you do know the film's capabilities you can underexpose or overexpose to get the effect you're after.

DON'T ALIBI YOUR WORK

Learn to work under stress. Nobody wants to hear of the picture that got away because of bad weather, the lens jammed, or you had a headache.

If you don't want to redo work or to find yourself in a lot of discussions about whether you could have done better, don't rush. It's better to know that you did the best you could, even if you have to spend a little more time on the job. If you have a sneaking suspicion that you speeded things up so you could get to your next appointment, you'll feel obligated (I hope), to redo the work if there are complaints. If you can't photograph several sittings thirty minutes apart, then give yourself an hour.

A customer wants a portrait, not an alibi. If you blow the job, do it over, apologize, if necessary, return the deposit or sitting fee, and don't blame anyone but yourself.

PLAY IT SAFE—FIRST!

When the situation demands that you have only one chance to get a picture, play it safe—take simple, strong, upbeat portraits. When you have those for sure, then move into more exciting techniques involving underexposure, extreme lighting, blur, double exposures, etc. Your customers will like the extraordinary if they have the ordinary to compare it with.

WHEN SOMETHING GOES WRONG

The man who taught me photography once photographed a very beautiful blonde. The pictures he printed of her were pretty nice, but I was disappointed in them. She seemed much more exciting in person than on paper. He kept a box in his studio into which he stuffed the 16x20 sheets that were flawed in printing, and one day I found in the box an absolutely stunning picture of this young woman . . . soft and dreamy. I asked him why he had discarded it.

"It isn't sharp," he said.

To me, that picture was worth all the others of her put together, but he

couldn't see it because technically, it didn't meet his standard of excellence.

When you make a mistake, let someone else judge that picture. He might see something in it that you can't, where the picture is improved because of the mistake. I frequently find an assistant at the studio will admire a picture that I planned to throw in the wastebasket and years later, I'm glad I kept that picture. I now see that in spite of its technical flaw, it's good.

For example, I have one camera lens that occasionally opens as I advance the film. I get it fixed, but sooner or later it breaks again. The result is a double exposure I hadn't intended. I tend to dismiss these pictures because they were accidents, but my assistant will show them to customers who will be crazy about them.

INCLUDE YOUR OWN PERSONALITY IN THE SITTING

I often wonder why photographers are so frightened to be themselves, and so conscientiously turn out work that looks excactly like every other very ordinary studio's. This is not just an aesthetic criticism. If your work is exactly like someone else's, why would your customer be loyal to you? If you're on vacation, he'll walk down the street and try another photographer, even if he likes you.

When I have discussed this with other studio photographers, they tell me that they have to play it safe because it pays. Yet I've found the opposite to be true. When my work has become imitative I've made less money.

And don't be afraid to try lighting techniques, cameras, and films, that you've heard don't work—maybe they'll work for you.

FULFILL SOME DREAMS

If a woman wants to look like Cheryl Tiegs, your picture should catch something of the Tiegs flyaway all-American girl look, even if your model looks more like Liza Minelli. If a guy wants to look like Bruce Jenner, give it a try whether or not he has muscles!

Talk to your customer and let him browse through your work until you have a very good idea of his taste.

A woman lawyer whose wedding I photographed insisted that she could care less how she looked, but when I suggested she lean over a balcony and let her veil blow in the wind, she admitted, "Secretly I've always wanted pictures like this, but I was too embarrassed to ask!"

Encourage such open statements, so you know what their dream is. Take additional shots if you feel she won't really like her dream picture—she wants to look pensive but you see her as a bubble of fun. Take pictures you know *you* will like; these may be the big sellers.

TO SMILE OR NOT TO SMILE

Possibly the longest waging battle I have with my customers is to get them to accept that it's not necessary to smile. My arguments are:

1. A smile obliterates the facial features. When someone smiles you can't see the shape of his mouth or jawline.

2. A "moody" picture has great lasting appeal; a big broad smile can be boring.

3. Some people are smilers, others aren't. A smile doesn't mean someone is

happy; just that he is smiling. Why force an uncomfortable smile on a non-smiler?

4. A smile is just one expression that the human face is capable of. There are others equally charming.

Always include a couple of smiling pictures in the sitting. There's going to be someone who won't accept a picture that doesn't have a big grin.

I've also found that someone who doesn't smile often laughs instead. If you can catch the moment just before he laughs, you have a very happy expression. If you can catch a laugh that doesn't show the tonsils that's another good one!

FEELINGS, OH OH OH FEELINGS

Let your picture show emotion. Don't be frightened of pathos, laughter, giggles, sulks. There's nothing wrong with the viewer being moved by a certain picture.

There is the moment when too much emotion can be embarrassing. Try not to milk it.

IMITATING ART

Try for timeless techniques. A good photograph, like a good painting, should be ageless. It may show its time in fashion, but not be absurd because of it. A good example is how well the work of such great photographers as Mathew Brady, Imogen Cunningham, and Edward Weston has held up. So have some of the photographs of the early film stars. The photographer tried to show the subject in the most flattering light and succeeded. Time had nothing to do with it.

An example of a technique that doesn't hold up well is any gimmick that loses the one quality that photographs must have: that ability to catch a moment and hold it forever.

This is easy to prove. Some of Cartier-Bresson's pictures of people are appalling as far as technique is concerned, but because he knew *when* to take the picture, *when* the exciting moment happened, these pictures have become immortal. It so happens that I've taken photographs of people that have become their favorites, but I offered these pictures apologetically—they were pictures where something went wrong. Yet because I hit the shutter at the right moment, my customer loved them.

Photography should not imitate art, it should *be* art. The photographic process is beautiful in itself. It needn't be covered with oil paint and people needn't be smoothed out with retouching so you can't see their skin.

Many painters abandoned realism at the advent of photography . . . photography did it better. Let's keep doing it better.

Disguising Flaws

The first rule of covering flaws is to emphasize instead any really stunning features that person possesses. Gorgeous eyes, a beautifully shaped face, pretty hair should dominate the picture so you won't notice the crooked nose, chipped tooth, or too large ears.

This emphasis can be created by light, by selective focus, and by covering up

with shadow or clothing the part of the face you want to hide. If you can't do this when taking the picture, you can work with the enlarger or retouch the final print.

Boris Dobro told me of photographing a woman he was very fond of but who had a long nose, very small eyes, a million wrinkles to her skin. Even her hair was thin and stringy. He took her shawl and first covered her hair, then brought it across the lower part of her face so only her eyes could be seen. Then he covered one eye!

"Ah, Boris, you are a genius!" she said with delight when she saw the picture.

Here are some facial flaws and how I deal with them.

THE DOUBLE CHIN

When faced with a camera the subject may lift his chin to tighten the folds below. This may work all right if he is looking off to the distance, but if he is facing you, the camera is now looking up his nostrils.

My sister designed a jacket for people with double chins, something she has been abnormally conscious of all her life. The collar is high at the back and comes down along the jawline, creating a slender face.

I sometimes pull a customer's collar up behind to create the same effect.

There are other ways to hide a double chin. If the customer is leaning on his

hand or hands, you can arrange the picture so that the hand obliterates the double chin. You can often pull a woman's long hair so that it cuts off the side of her face, and even her double chin, in a way that can look very pretty.

Dark makeup on a double chin will also minimize it, and shadow can be applied to the final print with retouching pencils and dyes for the same effect.

A jaw can also be made to look slimmer if the camera looks down on the subject. The eyes are enlarged, and the lower face seems slender, the double chin is hidden. The reverse also applies. A person with a slender jaw can lose it instantly if you angle the camera upward to him.

NO CHIN

Even Sophia Loren has this problem. She will not allow herself to be photographed in profile. If the chin is nonexistent, it won't be noticeable front-face. You can also have the subject lean on his hand or photograph him from a lowish angle where the shape of the jaw will not be clearly defined.

LAZY EYE

A binocular defect in the eyes (what we used to call "cross-eyes") can spoil a portrait. Have the subject look into the distance, or ask him if he can "unfocus" his eyes. The eyes straighten out if they aren't required to focus within a few feet.

If your photograph hasn't been able to cover this eye problem, merely alter the print with retouching dyes. Extend the colored part of one eye just a fraction, and with the other eye, do the same thing on the other side.

SMALL EYES AND EYES SET CLOSE TOGETHER

Turn the face to one side. People who have these eyes often look well in profile. If he has a "chinless" look you can still take that profile picture by having him lean onto his hands so you can't see the chin.

Makeup can widen the eyes, take the eyeliner beyond the edge of the eye, and use "whitener" from between the eyes to the bridge of the nose to make that space seem wider.

HOODED EYES

Some eyes are set in a way that, if you are not careful, will become shaded with a picture. Such eyes have an overhang of eyebrow that throws a shadow across the eye. They're often dark and so the problem is compounded. The solution is to have your lights set low enough.

THE FROWN

The person who looks as if he is frowning can pluck or shave his eyebrows so that there is a wider space between them.

If this subject lifts his eyebrows slightly as you take the picture, the frown may be gone and the expression is usually a good one.

ASYMMETRICAL FACES

A face that is much broader on one side than the other should be lit from the camera side, instead of the "off" side of the face (ordinarily, very beautiful lighting, particularly if the subject has fine features).

112

Let the subject look away from the camera. Now, by flattening the side closest to you (with the main light), you don't notice the difference in width. Such a subject always says his photographs don't resemble him. Just hold the picture in front of a mirror . . . and he'll see the face he recognizes. When someone looks in a mirror he sees a reversal of his face. The difference is minimal if his face is symmetrical. If it isn't he sees an entirely different person.

FACIAL BLEMISHES, SCARS, ACNE, BIRTHMARKS, MOLES, ETC.

Always ask the customer if specific blemishes should be removed, minimized, or left as they are.

One Christmas I carefully retouched every mole from a young couple who had a total of thirteen on their faces. But as they had initially been attracted to each other because of the moles—relieved to have found someone else with the same problem—I was ordered to put all the moles back!

That same year, I had to redo a picture of a young man whose dark beard showed up clearly under his skin—even though he was clean-shaven. His parents kept looking at the 16x20 portrait they had ordered, and suddenly realized what was wrong; his blue chin was missing!

I now ask, "Shall I take it out or leave it in?"

It's sometimes neccessary to talk a customer into having a blemish removed . . . an example was a girl who had a mole on the tip of her nose. She was a very pretty girl and couldn't have cared less. I talked her into letting me remove it, pointing out that you didn't notice it when you saw her in person, but in a photograph it would take too much attention off the rest of her face.

Scars can be softened (most people with scars have gotten used to them and don't want them removed), if broad flat lighting is used.

Most blemishes—particularly acne—are removed from the negative by my lab . . . for which they charge a retouching fee. The result might be a slightly lighter spot than the rest of the skin, but it can be made to match with retouching dyes.

I used to makeup the customer—male or female—to minimize acne, but in severe cases it would show up as a different shade from the actual skin and be a horrendous print retouching problem. I now leave the face of an acne sufferer pretty much alone, except to use a transparent powder to remove shine. The negative retoucher takes over from there.

If there are only small blemishes on the skin, I touch them out before the sitting with an erase stick. The secret is to put it onto the spot you want to disappear and not rub it in (or it will show through).

WRINKLES

Broad, flat lighting faced straight at the subject is the way to fill in those wrinkles. It is also possible to use a soft filter on such a subject, though many refuse to let me do it.

I've had great success with outdoor portraits of older people, backlighting the pictures and using a flash fill from the camera.

Each line consists, of course, of a dark line and a light line . . . the actual skin tone comes between these two shades. The reason is that light hits the line

lighting one edge of the ridge and throwing a shadow into it. This also happens, of course, with any spot that isn't level with the skin.

In taking the pictures, you are trying to fill those ridges with light so that this doesn't happen.

The negative retoucher works on the dark part of the line (which shows up as transparent on the negative). He fills it so it becomes the same density as the skin around it. Then the print retoucher does the same thing on the print, filling the light part of the line until the face is all the same color and no blemishes are visible.

If you obliterate the contrast with light, you usually need no retouching as older people don't want to look like children. They just don't want to look too wrinkly.

LIFTED FACES

A big problem is how to photograph the eyes that have had surgery to make them look young. A number of older people come to my studio with wide eyes that don't match their faces. The resulting portrait has wide, staring eyes.

My only solution is to have the subject look away and at something just above floor level, watching to get the eyes looking slumberous and soft.

GLASSES

If someone refuses to wear frames without lenses or to take off his glasses for the picture, run the shaft into the hair at an angle so that the shaft is not supported by the ear. This completely eliminates the glare problem if it is done correctly. You can also have the person tip his head downwards while looking up at you. Some people immediately look furtive like this, in which case forget it, but it was this angle of holding her head that gave Lauren Bacall "the Look."

THE VERY LONG NOSE

A most striking woman from Sri Lanka had an absolutely enormous aquiline nose. She pulled her hair back into a very severe style, and wore a jewel in her nose. Very few women with large noses, however, will allow me to photograph them in profile as she did.

To hide a prominent nose, use 135mm or longer lens and have the subject face the camera. The tip of the nose should point at the camera, and it will look like a very small nose. If there is a hook at the end of the nose, you can darken the end—on the print or with makeup—and make it seem smaller.

TEETH

Braces and broken teeth are not attractive, and we have no choice but to photograph that person with his mouth closed or just ignore the problem. Ask which way he prefers, and if he is uncertain, photograph it both ways.

Protruding teeth are less noticeable if the mouth is closed, but often the upper lip cannot close over to the lower one. (I personally find the resulting toothy expression rather sweet.) Put the hands in front of the mouth if you want to hide it completely.

If the subject wants to smile, then have him smile facing the camera. Sometimes you can raise the camera level and angle down at the subject and you won't notice the teeth.

114

OVERWEIGHT

If the subject is heavy, you can use a wider-angled lens than usual. If the face is broad too, it will look narrower. Overweight is a big problem in group portraiture because the people can't get close to each other. I've had to photograph as many as seven severely overweight people in one family portrait and it was quite a challenge, since only three of them could stand at the back where they would look less bulky.

In a single portrait I might place the subject behind something so that the lower part of the body is cut off. In the case of a man, it could be a wall (outdoor portrait); in the case of a woman, a small flowering bush. Dark colors help, but sometimes you just have to ignore the problem as best you can and go for a nice happy portrait, no gimmicks.

Generally speaking, standing makes the overweight body look better than sitting.

Overly large breasts, stomach, etc., can be de-emphasized by having the customer lean towards the camera and by using a narrow depth of field so the face only is in focus. If I do this I might cover the plump unsharp image with a dark shawl or other garment so it is practically invisible.

THE NONPHOTOGENIC FACE

It is no secret that we are not all as photogenic as we would like to be. Ideally, we should have large, wide-set eyes, a short, straight nose, high cheekbones, and a pretty mouth. Our faces should not be too plump. When someone is definitely nonphotogenic, have him face the camera and give a big smile. This is one time when the smile covers all the problems!

A photographer I told this to once, came back to my studio several years later and said it was the most valuable piece of photographic advice he had ever received.

Seize any chance to study faces—why one looks old and another young, even though they're the same age and style. Watch out for ugly expressions, people who unknowingly suck their teeth, grimace, twitch their noses! Gently explain that you've noticed this mannerism, and they should cut it out during the photo session. If you know the lines of age, and that they are not the lines of character, you can make a person look ten years younger with just one stroke of a retouching pencil. You don't have to work on the entire face.

SOFT FOCUS

I like soft focus in portraiture but I find it is tiring to look at. I never get tired of seeing a nongimmicky picture, but after awhile soft focus makes me feel there is something wrong with my eyes.

Many customers hate what they call that "fuzzy" look, but it will help their skin. If you take a picture soft focus, take it without the filter, too. If someone sees for himself that "fuzzy" focus has helped his picture, he'll accept it. Otherwise he won't be convinced!

TIPS

The Right Day

If a customer is looking less than his best and I notice it, I cancel the sitting. He'll never be happy with the pictures, so unless it's unavoidable he makes another appointment.

I have, however, taken pictures of people not knowing they didn't normally look like that . . . I had never seen them before. An example is a young woman who I thought had slanting oriental-type eyes. Actually her round eyes were puffed up from lack of sleep! The sitting had to be redone because the pictures didn't look like her.

Atmospheric changes can also drastically alter someone's looks. In San Luis Obispo, we're so used to good weather that everyone looks droopy when it rains; hair falls down, faces look dull. If it rains, all sittings are canceled if the customer wishes. Most are delighted to hear they can wait a few days.

I also ask adult subjects to make their appointments at the time of day when they feel most alert. I myself look best later in the day. I wake up in a fog! Many people look great the moment they wake and slowly deteriorate!

A Sales Trick

A person shouldn't have to pay for a photograph of himself that isn't complimentary. While you talk to your customer, look at his face, see how he moves, note when he's at his best. Then you can recreate that look in front of the camera. I've had very nice people arrive at the studio smarting with irritation because a photographer has told them, "It's a beautiful picture of you," when clearly it wasn't.

Ordinarily, I show only flattering pictures from a sitting. I put aside the others and only show them to the customer if he asks for a particular pose he remembers.

If I have a difficult customer though, I deliberately include any bad ones. This way the contrast between the bad ones and the good makes the good ones much more acceptable!

There are people who can't be pleased. I used to get acutely depressed when customers weren't happy with my best efforts. Now I can spot them as "complainers" in advance, and as I know they have to have something to gripe about I give it to them!

Full Length

Unless the customer asks that you only take close-ups, include a couple of full-body pictures in the sitting if he or she has a good figure. Someone is sure to say, "If only we could see her pretty figure," or something like that. If the subject is overweight, ask about it. Many parents as an example, would like to see their entire child, even if that child is himself self-conscious about his weight.

I often take pictures that only appear full-length. A very short-legged person can look taller if the picture is cut below the knee. This also helps if

a woman doesn't have slim legs. The English actress Jean Simmons is always photographed so her very heavy ankles are not shown.

A man or woman wearing pants can be photographed with one foot on a wall or box, and the picture cut just below the knee for an attractive full-body portrait.

Which Lens?

For a thin face use a long lens, for a fat or flat face use a wider one. Never use a very wide lens. It may make the subject look thinner but it will certainly make him look long nosed. I feel that the so-called "normal" lens is too wide for most portraiture (70mm-80mm on medium format cameras, 50mm on 35mm cameras).

One young actor couldn't understand why he was known as "the guy with the nose," until I showed him that his portfolio photographed in San Francisco had been taken with the equivalent of my 80mm. In the close-ups his nice medium-sized nose looked enormous.

Simplify

If you can get the same effect with one light, don't work with two. If you don't need a backdrop, don't use one. A good sitting should have some very simple portraits of the customer, no gimmicks, no props, nothing unusual. It may not be just the husband or the grandmother who will say "If only the wind weren't blowing her hair," or "If only that pot weren't there." You may find yourself wishing the same thing.

Imitating Other Photographers

When you see a picture you like in a magazine or elsewhere, look at it closely to see exactly how it is lit. The simple way to do this is to look for the shadows. Once you've found the shadows you know the light came from the opposite direction. If the shadows are nonexistent, you know that broad, even illumination was used. If you see that the shadows are very transparent, you know a fill was used, or perhaps umbrella lighting. Wherever you see a rim of light, there's a light behind it—perhaps from the sun—that's responsible.

When I have to do an advertising job—commercial photography—and am bereft of ideas, I usually thumb through magazines for twenty minutes or so, looking at all the recent ads from which I can steal technique. I let the great commercial photographers do my experimenting for me, and from them decide which style to use on the pictures.

This may seem to contradict what I've said about developing your own style, but I don't think so, any more than it is killing your own creative talent to take a class in photography. Just be sure your pictures have their own spirit and are not merely imitative.

For instance, some years ago I saw a very beautiful portrait of a small boy in a formal suit standing by a large chair. Many other photographers must have seen it, too, because later on there were several imitations of it in our photography studio windows. Not one of the imitators caught that first picture's quality, however. So their work merely looked contrived.

Available Light

Once a photographer starts depending on electric flash either as the sole lighting for a picture or as a fill, I've noticed he'll forget about natural lighting. It's so easy to take the picture. He knows it will be well exposed by the light he has brought with him. But when available light is not just adequate, but much superior to artificial, use it. A good rule of thumb is always to think of your flash as a supplementary light, even allow window light to play its part in your studio. I was a guest at a wedding and as the young couple was about to cut their cake, a high window threw a beam of sunlight onto them. Some of the guests actually gasped with pleasure at the sight, but the photographer took the picture with a powerful flash-on-camera! The beam of sunlight was completely invisible in the print.

Advance Warning

No matter how specifically the customer describes the picture *he* wants, in addition take some the way *you* feel he'll look best. You are the expert. I've found that I should never surprise a customer but tell him about the effects I am planning. For instance, "I want one picture with extreme lighting, you won't see more than part of your face, but it will be dramatic . . . now how about a totally different shot, very relaxed, as if you were at home on the couch . . ." and so on.

When he sees those pictures they'll probably exceed his expectations, but if I'd said nothing, he'd say, "This one doesn't show all my face, that one makes me look like I'm at home on the couch," as if these details detracted from the merits of the portrait.

This is my most successful portrait and the one that did most to cause me to be accepted as a portraitist. I was merely trying to make a perfect negative, one that needed no special printing, and was surprised at all the fuss about the picture.

Generally speaking, it is easier to sell pictures for stock when the people in them are doing things, but when you photograph people, be sure to get model releases. This picture shows part of the makeup routine of a circus clown, a series which has been borrowed more than once by amateur actors.

Soft-spot filter photography often leaves me feeling there is something wrong with my eyes. It seems a good idea at the time, but if you have two or three on the wall, you find yourself ignoring them and looking instead at the hard images. Soft-spot works best when there is a reason for the blur; here, for example, the flowers. The girl is in lavender in the color original, and everything else is in golds—gold hills, gold mustard flowers. I oil-colored the sky goldish, too, which is not as easy as it sounds. My first effort of yellow over the blue produced a brilliant green.

"No one looked at the clothes," grumbled the fashion expert. "They were too busy asking about the girl."

My idea for the layout was to use only black models and white Arabian horses. As usual, my subjects upstaged their clothes, confirming what I have long known, that fashion photography is not my thing. What I lost in fashion sales on that job I made up by selling this shot of a remarkable beauty, Diane McCrae.

One of the many exhibit portraits that started out as a pass-
port picture, this picture remains memorable to me because I
had run out of Plus-X, and bought a roll of Verichrome Pan at
a drugstore across the street. It was an eye-opener to discover
this excellent, inexpensive, fine-grained film, which I had dis-
missed untried because of the low price. I have used it ever
since for almost all black-and-white pictures.

Performers are easy to photograph and particularly easy to please. They know what they look like, and they follow the simplest instructions with style. Here is Richard Atchison, a singer, just looking to one side. The difference is that he is doing that very well.

In Sri Lanka, those without cars carry umbrellas. It doesn't rain as it does here; there the skies open suddenly and the water dumps on you. The umbrella man may be old, thin, poor, but he is clean. You can often sell your travel photographs to stock agencies.

8
Three Options in Portraiture

Whatever type of studio you are running, it is possible to take on some surefire, moneymaking winners.

The three that come to mind are the album plans, coupon books, and fund raisers, all presold to the public to the degree that they have become a staple of the photography industry. There seem to be two kinds of photographers in business—one knows all about these plans, and the other knows nothing. I started out knowing nothing, but gradually discovered that a large industry backs this kind of photography.

If you are starting out in your studio, you should know something about these plans. If you want to be part of them, then put out the necessary feelers, and get together with the organizers to see if you can be on their staff. Write to the Professional Photographers Association (PPA) or one of the pro magazines for the names you want, or Eastman Kodak, which knows everything!

The Album Plan

I was amazed to see the breakdown of the monthly income of a studio in a large industrial city and to find that it averaged only four portrait sittings a month. My own average was much higher.

Senior portraits, though seasonal, made the studio a lot of money, but the real surprise was the amount of money this studio made from album photographs.

As I have found them not exactly a loser—but no great money maker either—I was interested. For awhile I did represent an album plan and a few customers were sent to me (maybe twenty in all). Apparently, either my album promoter was not selling the plan well, or this area was already being milked by a rival plan.

But knowing that a city studio averaged $10,000 a month—more than $2,000 from album photographs alone—I could see I must have been doing something wrong.

The album plan works like this. The album promoter signs on photographers as official representatives each for a specific area. (For the names of major plans and their promoters, write to PPA, 1090 Executive Way, Des Plaines, IL

66618.) Anytime a customer asks that his album certificate be honored, the photographer must agree.

(That may be so, but I cheerfully honor *all* album plans if a customer calls. I have long since resigned from the plan I belonged to. So if a woman calls and asks if I am the Babylove Album photographer, I say no. But I tell her that she can come to my studio and I'll give her the same deal. I feel sorry for these people, often looking for photographers who are now out of business. They've paid their money and they want their picture, so I give it to them.)

The plan starts when a baby is born and his or her birth is registered at the county courthouse where anyone can get a look at the records. (Some plan organizers work through hospital records.) The promoter approaches the parents and sells them a "package" for several hundred dollars (it used to be $360 for my plan), which entitles the family to an album (provided by the promoter) for which any photographer on the plan must provide an 8x10 portrait of the child every six months. The promoter now has a "live one" and tries to sell the couple all kinds of merchandise, some of it very shoddy according to some of the plan buyers who grumbled to me.

The photographer does not pay to be on the plan, but he must provide the 8x10 portrait free. He is not paid at all for it. He makes his money by selling additional prints (and sometimes customers do not buy them). He also hopes to become the family photographer of the couple and is sitting right to pick up more business from them.

What I found a nuisance was informing the couple every few months that their next portrait was due. There were some customers who just came for their picture (no further sales), and there were some I was not crazy about! It was one thing to have *them* come looking for me, but I had no desire to keep soliciting their business.

I'm sure my attitude was all wrong. I provided the "reasonable" packages as advised by the album promoter, starting with two 5x7s plus eight wallets for $29.95, and usually the parents bought a few pictures. However, it seemed like a lot of work and though I showed a profit they never bought a whole lot.

What interested me about this city photographer whose balance sheet I saw was that he made so much money at it. Presumably it is well worthwhile to be an album photographer in a place with a large growing population.

Coupon Books

In 1969 I got involved in a very lucrative (for me) coupon book deal. A local radio station had me offer a free 8x10 in a book of coupons they were selling. I paid nothing to be in the book and the public paid $7.95 for each of them and received $400 worth of free merchandise.

I knew nothing about how this should be done, so I took a single photo of each person, had the whole roll printed up into 8x10s, and offered the customers additonal prints. Some of my better known exhibit portraits came from that promotion and it eventually generated a lot of business.

More recently, I've turned down several coupon book promotions because I was required to pay about $400 to be included in the book, which was to be dis-

tributed to households free. I felt that once the organization had my money, it would have no need to distribute the books. It could just print the 10,000 copies and throw them away. Interestingly enough, I've never seen one of the books I turned down, nor heard of anyone receiving one.

A more interesting coupon-book promotion was made through the school athletic orgnizations. Team members sold the coupon books for $10 each ($270 of free merchandise). However, the "free" merchandise was not entirely so. You had to buy something else at the same time, e.g., if you bought one dinner, a friend could have his free; if you had a brake job done, you got an oil change free. The athletes who sold ten books got their team shirt free, so there was a real incentive to sell. My son gave his receipts to a friend who wanted the free shirt very badly, so I had to buy two coupon books to show I was as kind as Dan was. This didn't just cost $20 either—the brake job I got with the coupon practically destroyed my car!

Be very careful not to offer something *too* tempting in a coupon book. A local hairdresser got caught in a lawsuit because he offered a "free haircut" in a coupon book and found he would have had to work full time for four-and-a-half months to honor all the people who called. An irate customer who got squeezed out sued the hairdresser, who sued the coupon-book promoter for not warning him, and eventually a judge made everyone back off.

The way to get the most out of the offer is to be sure that the free item is paid for by the customer! E.g., you may offer a free 8x10 with a $5 sitting fee. The cost of film, processing, and 8x10 machine print is just about $5 (if you don't use an entire roll on the sitting). Now the reprints are all profit.

Remember, too, that any "cheapie" promotion like this will not work on quality items. The customer is looking for a $7.95 bargain, not two 16x20 prints for $185.

Fund Raisers

Since starting this book I have taken on an aspect of "fast-food" photography, the fund raiser. I did it initially as a test to see whether it would work (i.e., make money), and to my amazement, it did! It turned out to be so lucrative that I should add some words about it here.

I received a form letter from a marketing organization asking whether I would be interested in a program that they were developing. It worked like this. Instead of hiring photographers to go to a town and take Sears & Roebuck-type pictures, certain established studios would be under contract to do that photography.

I was intrigued because I initially intended to be the McDonald's of photography, and what could it hurt to ask for further details?

An advantage, it seemed to me, was that it would open up a studio such as mine to a great many people who knew my name but presumed me to be out of their price range.

So I replied, "I already photograph the carriage trade, but am looking for a way to get other people into my studio." A couple of months later there was a phone call and I was invited to attend a one-day seminar at the marketing organization's expense.

At the seminar we were taught how to take pictures of entire families at speed—scheduling them eight to ten minutes apart, and how to sell them pre-printed packages when they come to pick up a "leader."

Here's how it works.

The marketing organization does a lot of legwork (actually phone work), with groups that are trying to raise money. The "leader" is a $7.95 10x13 color portrait *in a frame.* The club or organization gets all or part of this money (depending on how many tickets they sell). The studio pays for everything! We pay for the pictures, the frames; if a church directory is involved we pay for the directory! The cost runs somewhere between $21 and $26 per family photographed.

The $21 figure applies to the very large groups (over 100 families) because once you have set up, *hired* a receptionist, etc., the less *time* you spend on each family.

As the market people offer heavy "bonus" incentives for clubs to sell more than 100 tickets, the photographer with 100 + families to photograph may find himself facing $2,500 or more before he has seen any profit (a bill that he's not required to pay until the monthly statement is delivered). Some programs sell fewer tickets. The shortest one I've photographed has only nineteen families.

But I signed up, because we were assured we could get out at any time we wished. I figured *someone* had to buy an additional photo or two so the loss, if any, could be held down, and the advertising value was terrific.

And another thought kept coming up—could I afford to let these people go to another studio? It's one thing to let Sears & Roebuck get the big family market—but another studio?

One ominous factor at the seminar was that some of those attending had already photographed some "programs" and the man sitting next to me had a very negative experience; he had turned down a wedding because of a commitment to photograph a fund-raiser program, only to find he had not broken even. He was very resentful.

However, there was one young man who said that he had done well. He liked children—he and his wife had five—and he said he liked all that action. He seemed low-key, and like myself, the kind of person who looked first at the problems before going into anything new. He had taken on five fund raisers and made about $2,000 to $3,000 profit.

I signed up, returned home, and expected to be called on once or twice a year, and there was silence for several months.

Then I was given four programs in two months. Since then I've discovered that they come in bunches. Even so I have been able to keep up, grumbling often, but hanging in there because they make quite a bit of money.

The net profit from the five programs I photographed the first year was $3,500. Not all make the same amount, and it is difficult to predict the type of person who will purchase the pictures, since quality is often not the issue. The last of those five fund raisers accounted for $2,000 + profit. Added to the advertising value it works well.

The Bad News

1. The cost at the outset can be considerable. It's not pleasant to face a

$2,000 bill and know that you have to take in $2,000 in bits and pieces before the program will start paying! Say you have three programs "out" and no money in yet. Even though the lab gives you time to collect before paying them, $6,000 is a big chunk of money to owe.

2. Selling the packages is the opposite of photographing families (which I find fun). It is exhausting, whether or not the customers buy. I find that I can't do it and keep my sanity for more than three hours at a stretch. Many people are unappreciative. In my most *profitable* program, ten consecutive customers bought no pictures. That can take the wind out of anyone's sails (or sales)!

3. The members of some of the clubs are hard up (haven't we all been there?) yet you have to go ahead anyway. We're supposed to really pressure each person, oh so subtly, to buy but I haven't been able to do this. I feel very strongly that it would be a mistake to change my style of dealing with people to fit someone else's mold.

4. I would much rather photograph ten than 125 families, but the more there are, the more money I make.

5. It's not pleasant to have people turn down your pictures, particularly when they are very good!

6. There are people who, instead of saying, "I just don't have the money," feel they have to knock the pictures instead. Who needs that?

7. If something goes wrong, it goes wrong with a lot of portraiture. I had to recall the first fifteen families I photographed this way, because I took all my equipment apart and cleaned it the day before and put the sensor on the electronic flash on backwards. (This is the "eye" that measures how much light should be automatically dispensed, for the f-stop you're using. Usually, this is a built-in feature of the unit, but in the larger ones, the sensor can be moved around. This is necessary when umbrella lighting is used and the flash is pointing away from the subject, but the sensor must still point toward it.)

Another time the whole lighting system broke down resulting in twenty-five families having to be retaken about a month later. (I didn't know what had happened until the film came in.) Then there was a time when I had to use makeshift lights and ended up with shadows on the backdrop!

8. The time comes when your are really sick of dozens of families taking up your precious free hours. If a program comes in when you have other much more interesting jobs to work on, you don't want to deplete your energy on such tiring bits-and-pieces type of work.

The Good News

1. Suppose you just break even. You've still had a very large number of people come through your studio and see your work. This has to lead to business in the future.

2. The marketing group I deal with is not unreasonable and if there is a special case, they have done the sensible thing.

E.g., I came out $450 ahead with one group, but do not want to take any more programs from that area. I didn't like the many unsavory characters it brought into the studio. I will no longer be offered programs from that district, at my request.

3. Eventually, a numbness sets in and I find I'm not as touchy about my work being rejected! Once you're confident that enough of the pictures will sell eventually, and that the better ones can always be kept for display albums if they don't, it's easier to handle.

4. The selling of the preprinted portrait packages is the beginning. Customers will also buy frames, and reorder additional pictures from their favorites. I've received wedding and portrait sitting bookings from people who wouldn't have seen my work otherwise.

5. Some people who would never buy a cheap portrait ticket will do so when they hear *you* are the photographer. I have encouraged my regular customers who have never actually had a family photo taken by me to buy tickets (I might have photographed weddings in the family, and individual portraits). I don't go looking for people to buy these tickets myself; the group raising money does that. However, if my regular customers call to find out if they will be getting my usual work, I say, "As good as I can do it in eight-minute sittings."

6. At slow times, this action around the studio doesn't hurt; it always helps to look busy! The studio's regular clientele doesn't have to be told who these other people clutching packages of photos are. I schedule the actual photography for times when the studio is normally closed and unlikely to be booked for weddings, etc. These are certain Sundays (most weddings are on Saturdays), and evenings.

A question I've asked myself is what would I do if a wedding booked in at the last moment. I'd reschedule the families. The weddings are my living—the rest is a bonus (even if their dollar value is higher).

7. This kind of photography has opened up to me the possibility of doing similar programs for myself. I've just completed photographing seventy-seven fraternity members in exactly the same way but changing the number and size in the preprinted packages to suit the students. I never quite knew how to handle this kind of business before, and most of it went to other photographers. (And the president of the fraternity tells me he's going to send a newsletter to the other fraternities in this area, telling them what a terrific deal I'm providing.)

8. The marketing organization encourages the photographer to detach himself from the rules under which he now operates. It's great being able to say "They won't let me do that!"

TIPS

Tips on Photographing Fund Raisers

1. If you get involved with such a marketing organization, check it out. You must like the quality of printing as well as the company's style. Remember, too, you will be a sitting duck if something goes wrong and the customers get together and sue. A traveling photographer just disappears, or hides behind the organization that employs him; you can't do that.

One woman who was the coordinator of a particular fund raiser told me that a certain photographer had stopped in the middle of a photography

session where the children were rowdy and said to them, "I can't take any more of this," and walked out. This must have happened on what is called "location" photography. Sometimes a photographer uses a church building or community hall for the actual photography. An established studio photographer, working out of his own place, could hardly do the same!

2. Be a little understanding. The marketing group will be dealing with a great number of studios. It can't make too many exceptions, if any. Even so, don't be pushed around if you feel one of the employees is out of line. Let's say someone on the other end of the phone suggests you're being difficult because you want them to reprint some pictures that were received in damaged condition. If this isn't a pleasant experience for you, the head of the organization should know.

3. The better the people look, the bigger the sales. You may personally wish to murder a single difficult child, but don't "throw away" the sittings because of it. Somehow try to come up with a pleasant picture. Hold up everyone else until you've got the kid calmed down. When couples and single people come in, you can speed up the sittings to get back on schedule.

4. If there's a particular child who flatly refuses to smile, prepare the family by showing them pictures (perhaps on the studio wall), of other nonsmiling children who are adorable nonetheless.

5. In this kind of photography, you must have a system, a prearranged way of handling the people. One way is to work it out in advance. Have the poses arranged in your head. As you become more experienced, it will be easier. Fortunately, the marketing organization sends you samples of possible groupings so you can decide to use these if your ideas fail.

6. Play it *exactly* the way the marketing group tells you to . . . the first time. You have to try it their way because they have the experience. Once you're familiar with their system you can move from it. I'm talking about posing and dealing with people (soft sell vs. hard sell; particular posing ideas). I have, however, picked up lots of tips on salesmanship, and how to speed people up without their knowing it.

"Now let's have Mom and Dad here." (Click! Click! for shots of Mom and Dad.) "Now, kids, move in next to Mom and Dad. That's right, Junior, up on this block. Perfect." (Click! Click!) "Now the kids alone. Mom and Dad stand right here. Smile kids." (Click! Click!) "That's great. Be sure to keep your appointments to see your pictures." And out the door they go.

7. Don't let this kind of photography detract or distract from your usual work. Schedule it, including the "viewing" times, for your slowest hours.

8. Have back-up equipment on the spot.

9. If you hate the selling, have someone else do it and pay him a commission.

- Give your salesman a percentage of the gross, with a bonus if the whole package is sold.
- Don't presume, just because someone says he can sell, that he can. You could really be up a creek if this person blew a number of sales before you could monitor him.
- Find someone who is patient with and around children, someone who enjoys other people, someone who is naturally likeable.
- Your salesperson must be able to close a sale. This is a knack that is difficult to describe. It requires someone who instinctively knows the moment to back off and the moment to press a sale—someone who knows when to stop talking about the pictures and talk about the frames instead.

10. I have brought my sales up by switching to a portrait lens for the single people (that is, "families of one"), and taking as beautiful portraits as I can. (I use 80mm for groups, 105mm or 135mm for singles—Mamiya TLR.)

11. I've noticed that as long as the pictures are sharp, have sufficient depth of field, and everyone smiles, they'll sell. It doesn't matter what else goes wrong. One very lucrative program was carried out with a makeshift lighting setup (as I couldn't use my umbrella lighting), the time there were shadows all over the backdrop in some of the shots. Because *they* looked good, most customers shrugged it off.

12. Be very careful about hiring someone else to photograph your fund raisers. The investment is high, and if he doesn't have his own money on the line, he will probably be careless—getting the job done, rather than considering future sales.

13. These marketing programs have spread all over the country and I've found that people with young children often have their pictures taken once a month *somewhere.* This is a lot of photography I've been missing that has been going on under my nose, though not at any studio.

If you're enterprising enough, and well enough organized to think out the details in advance, why not approach the organizations and churches yourself?

You must have a competitive product, both price wise and in "gloss." Much of the "bonus" to the photographer working through a marketing organization is that the advertising material, bags, etc., are good quality and make him look good.

14. The organization I've been working for hopes to be able to charge photographers a franchise fee. I don't think I'd go for that. We're already charged for everything they cheerfully promise the customer (except some bonus packages that they print at their expense).

I much prefer this method of taking pictures to the various album plans because there's nothing more for a photographer to do once the program is over. (The photographer involved in an album plan is supposed to follow up on "his" families to keep them coming in.) It also seems to me that these family groups will be a natural for Christmas cards.

15. If you're working in a city and your work is a real quality product, then you may regret doing fund raisers. I'm told some photographers lose the respect, and even the business, of well-paying customers. Who wants to pay premium prices to a guy who is turning out quantity work on the side?

I honestly haven't noticed this happening in my business yet. If it did I'd quit. In fact I have started booking weddings and sittings from people who originally saw my work when coming in on a fund raiser.

The information above is based entirely on my photographing "programs" during a period of seven months. I honestly can't tell what the long-term effect on the studio will be. If you decide to take it on, you should understand the risk and keep plugging away at the rest of your business. You shouldn't depend on this kind of photography to earn your living. Treat it as a bonus.

You will, of course, wonder where to find the marketing organization. Approach any church, get a copy of the promotional paperwork involving their church directory (not all churches have these directories but the larger ones do), and write to the home office organization and offer your services—or at least ask if they hire local photographers.

And watch your mail! I'm on every sucker-list because I happen to love junk mail. Sometimes treasures come through that mailbox!

9
Extra Cash for Studio Photographers

In my early studio days I found I could make a little money on the side by selling my work, some of it done before I turned pro, through agencies who stock large libraries of photographs. These agencies are known as Photographic Stock Agents.

If you are starting out and have some time on your hands, I suggest you send your photographs (contact sheets and transparencies) to both agents and magazines direct. Some will sell I hope, but even those that don't will be returned if you send enough postage, and you'll get an objective view of the choice of subject and quality of your work from the people who buy pictures.

No one expects these side-sales to amount to enormous amounts, but little checks add up. It used to be an exciting day when I might see *two* stock agent envelopes in the mail and even if the first one showed I had five sales for a total of $45, and the second $125 for a single sale. I was most grateful for both. They are getting more money for those same pictures now, by the way!

But before I suggest the specific market lists and specific subjects of pictures you may sell both and in and out of your studio operation, let's break them down into general categories.

There are three basic categories of pictures.
1. Commercial—taken for money.
2. Personal—taken for family or fun.
3. Fine Art—taken as a timeless statement of beauty.

A single photo may fit all categories, but usually a photographer starts by trying to satisfy just one.

As it is the commercial side of photography that we're dealing with here, make a list from time to time of those areas of photography where there is money to be made, areas where you have the expertise and opportunity to grab a part of the local market for yourself.

My list is not definitive but it will serve as a guide. I've arranged the subjects alphabetically for easy reference. Add areas of your own as you think of them.

How to Find the Specific Market You Want

It would be great if I could give you a list of people to approach in each cate-

gory and say, "Go here; phone this number." It's not so easy. You have to ferret out the people who are waiting there to buy your photographs.

Here are some ways to make the job easy:

1. Each year Writer's Digest Books puts out a book called *Photographer's Market*. In it you'll find lists of magazines, record companies, stock photo agencies and others who buy photographs.

2. The phone company will let anyone look through the Yellow Pages of any city directory in the country. If you want to sell in a particular area, go over and ask if you can make copies of the pages you need. Then get on the phone or write letters to feel out the market.

3. If you need customers in a particular field, use your own local Yellow Pages listings to find them. Get in touch with the person responsible for hiring photographers and discuss the possibility of working for him. If you can, go over personally . . . but make an appointment. Follow this up after a month or so. The situation may have changed; someone new may have the job. After you've made the initial contact don't lose that advantage *if you still want the work.*

4. Talk to friends. Let's say you want to sell photographs of wildlife. Tell people about it. Ask friends for their advice. They may know people who know people who have the answer! Follow every lead. It's possible to get a job after waiting two years, but it's also possible to get it on the first call.

Occasionally, a photographer is wise to take the pictures and let the customer decide whether they are worth buying. It's difficult to turn down an offer from a photographer whose highest charge is, or should be, for his time.

Many photographers have forced their way into a market that was already crowded by taking speculation pictures.

Here are the major categories that photographs fall into:

Advertising

Sometimes the advertiser will hire a photographer direct; other times an ad agency is the place to go. Advertising is expensive. The customer is willing to pay a bit more for exceptional work. You have to be very good to get repeat business. You also must look attractive to the customer—clean, well dressed, not hurting for money, to justify a considerable investment in you. Once you have proved to be a responsible person, you'll have more leeway.

If you use people in your ads (not all photographers do—some specialize in pictures of food, for example), then you'll have to hire and work with models. The client must pay them, plus your assistants and all your expenses on the job.

Look under "advertising" in the Yellow Pages for your markets, and also contact local manufacturers and distributors. If you can find someone already hiring an out-of-town photographer, you're in luck. You'll probably be able to persuade him at least to try you on one job.

Animals, domestic

This is rarely a well-paid market but animal photography specialists make up for this by doing volume work.

Animals are usually photographed as livestock or as pets, for ads or editorial needs.

A really good animal photo has a better than average chance of a sale. Many photo buyers use them.

Photographers tend to specialize in certain animals, learning bit-by-bit what most owners are looking for in a particular breed. The usual breakdown of this field is:

- Livestock and poultry—cattle, swine, sheep, chickens—that is, animals bred for food.
- Horses—pleasure, racing, horse shows, rodeo and gymkhana (a special meet for competitive games played on horseback).
- Pets—dogs, cats, birds, and all manner of unusual creeping and leaping animal life.

Approach all breeders of animals directly and ask for a chance to show your work and take pictures initially on spec.

Animals, wild

There is a market for pictures of wild animals, even of those taken at zoos. Stock agencies (see below), editors, and gallery owners need such pictures. I find that customers who visit my studios love to see pictures of exotic animals. They get as much or more attention than people and sell well at exhibits. One picture of an eagle has sold particularly well.

Architecture

This is a highly specialized field for the photographer with an eye for design and one that is very well paid. The customer is usually the architect who designed the building, rather than the owner; magazines hire architectural photographers, too, but have staff photographers.

Architectural photographers must be perfectionists and be expert in black-and-white, as well as color.

Study some of the magazines for architects like *Architectural Record* and *Architectural Digest* to see if you can do as well as the photographers published there. When you can, collect a portfolio of your pictures of some better-looking local buildings and make appointments to show them to the local architects.

You may need a view camera, you will certainly need a method of getting top-quality processing done locally, and you will also need to work in color and black-and-white side-by-side. Many architects show their work in slide presentations.

Art

(See also *Copying Paintings.*)

Although we hear a lot about how well photography is selling as art, the reality is that it's a hard place to break in. It helps to know the right people.

Galleries that sell photographic art don't generally seem to be knowledgeable on the subject. I've visited much-touted galleries and been very disappointed with the photographs they were showing. The work seemed adventurous but not memorable and was without any technical control . . . there was a lack of contrast, fall-off of focus towards the edges of the pictures . . . I could go on!

This is a generalization, of course. The ones I visited were in Los Angeles. If you find a gallery whose style you like, then you can be sure it will like yours!

Exhibit your art prints and talk to art galleries about putting on a one-man

show. Price the pictures according to what the area is used to. You can't get top-dollar everywhere.

Books

My first act as a professional photographer was to try and get a photo book published. I wrote to two publishers. One accepted the idea and *Mother and Child* was the result.

I accepted an advance of $250 that barely covered the cost of printing the pictures (which I did myself—all black-and-white).

My second photographic book was for the same publisher, A.S. Barnes, and did a little better. Since then a small press, Cafe Solo, which publishes the work of poets, used some of my horse photographs to illustrate *San Diego Poets*. This was the best looking of my photographic books, but I was paid in copies of the book—no money!

The authors of photographic books whom I've met say they never made any money off theirs, either. We all agree, however, that there's a certain prestige in having one published and we're grateful for the chance.

Publishers go through phases. Most are unwilling to take a chance on an unknown author/photographer unless the topic of the book has aready proved successful. Right now the market for photo books is very depressed. As I got started by writing a couple of letters, however, I would think it is as good a way to begin as any. Find out the publishers of recent photo books and increase your chances of getting a live one.

Brochures, Cards, Postcards

This kind of photography is surprisingly easy. It is reasonably well paid, and once you have a sample or two to show, the people who need photographs of their businesses or products will use you if you're there when they want pictures. (Motels and hotels need postcards. For product photography find the manufacturers, craftspeople, and marketing organizations.)

Be sure to have your byline (studio name) on the cards.

The companies who do the printing for these jobs give the photographer a kickback for each customer. If the customer reorders from that transparency, you continue to be paid the kickback and you don't have to do a thing to earn it.

Catalogs

This form of advertising is hard work, moderately to very well paid, and lucrative because of the volume to be handled (usually by the day). When you get a catalog in the mail someone photographed it. It's city work, and I honestly do not know how you'd break in except by persistence, starting at the catalog house itself to find who does the hiring.

In all kinds of advertising photography be sure that your fee moves up with other photographers. No one is going to volunteer to pay you what you are worth. You're going to have to ask for it.

Study catalogs—Penney, Sears, Montgomery Wards—to see how well organized, simple, and effective the pictures are.

Competitions

There is little money to be earned in photographic competitions. I got my

share in the early days, entering any competition that paid a few dollars with a picture I already had on file. I once won seven awards in a single competition for total prize money of $27 plus a photo book on California parks! The pro competitions with better prize money seem less straightforward and the rewards are still inadequate, considering the competition level.

I've heard enough about national competitions to feel you generally shouldn't enter them unless you live in the area where one is being held and if possible know someone quite high in the organization putting on the competition and/or a couple of the judges!

If you want to enter any photographic competition and you're judged by a panel, your entries will do better if they're "formula stuff." If there is to be a single judge, you should try with your most exciting picture. When a panel is judging, you need a high cumulative score. Usually everyone's second or third choice is the overall winner—good subjects would be apples, strawberries, yachts whipping through the ocean—something most people like!

Crafts

Most photographers can pick up some money on the side with pictorial photographs, and at sidewalk art shows photography holds its own with semiprofessional paintings (seascape against seascape)! You'll do your best with moderate prices. My picture of Henry (page 000) sold instantly at a craft show where I rented a booth to try and get rid of photographs I happened to have on hand. Such pictures are sometimes called wall art.

Documentaries, historical

These are pictures that tell a story about the life and times in which we live. They make good illustrations for essays and articles and you must slant the pictures to the specific emphasis of the magazine you send them to. Caption them clearly and accurately, and be prepared to do the writing yourself. Make an inquiry first before sending material out.

Photographer's Market will provide you with some places to pitch your product.

All documentary photography is valuable if it's done with some imagination and insight. And even the most mundane pictures may someday be valuable, e.g., any street will eventually change and the new residents will be interested in the old photographs.

Invariably, documentary pictures only really pay off when their maker is dead. Take them in black-and-white so they won't have faded by then!

Every vacation trip (see also Travel), can be an opportunity to get that area down on film. File these pictures away or turn them into an essay on the area.

Documentaries, commercial

Another side to the documentary photograph is better paid. I've photographed surgery, livestock slaughtering, equipment in operation, a tour in progress, etc. An hourly fee is agreed upon and the customer picks up all expenses.

Your customer is the person who needs this record; a hospital, a writer, a manufacturer, a political organization, et al.

Editorial

Editors of periodicals and newspapers need photographs and have a staff to provide them. However, if you have the photograph and the price is right, an editor might buy it directly from you.

There's not much money to be made by selling one-time rights to pictures, but these little checks are for work that already exists and you have nothing to lose by approaching the publishers in your area. Prepare a list of the subjects you have already covered and update that list when necessary.

Events

For want of a better name, I call weddings, Bar Mitzvahs, anniversary parties, etc., "events." I cover this subject under weddings.

Exhibits

Exhibits may not bring direct rewards every time, but will establish you as a photographer in the public's mind. If your exhibit pays for itself, i.e., you sell a few pictures each time, you are doing very well because indirectly you will be advertising your studio for long-term profit.

The type of exhibit that pays best is one directly geared to selling, e.g., well-framed seascapes and landscapes or any type of photograph that can be bought as wall art.

Famous People

Don't turn down a chance to photograph a famous person, but don't expect to be paid for it by that person. Don't hide those pictures, exhibit them. A "famous" face will draw the eye to a picture and will interest the public in your work. Famous look-alikes also draw the eye. I took a picture of the heavyweight fighter Jerry Quarry (also his brother Mike) back in 1971. At that time Mike was #1 light heavyweight in the country, but Jerry (#3 heavyweight; Mohammed Ali was #1), was the more recognizable. Many viewers thought the picture was of country singer Glen Campbell and so it was an immediate eye-catcher in any exhibit!

Fund Raisers

In Chapter 8 I detailed making money from fund raisers.

There's quite a bit of money to be made here—the more tickets you sell, the more money you make. But the initial costs are high and you have to face the bills before you see the profits.

Gifts

If you can't sell a picture, you can give it away and at least display it in someone's home or on a gallery wall, advertising your business.

You can take full value (your cost) of a picture and frame as a deduction if you're donating it to a charity. Always check the latest tax laws before making a donation. On the other hand, if you give something to a political campaign you can take half your cost as a federal tax credit. (That means it comes off your tax.) A charitable *deduction* comes off your *income to be taxed* but you can take the *full* value.

Historical

This is a little different from the general documentary photograph in that you can also make a collection of old photographs with historical significance, make copy negatives and sell prints. Be sure that the pictures are old enough for the copyright, if any, to have expired.

Also be certain that you are not copying a famous photographer's work that may have an active copyright held by an heir.

Let historical societies and museums know you have these pictures and also write to magazines where you see similar prints published. I've occasionally seen old prints on the covers of magazines.

There's not much money in this unless you find a market that is in the habit of paying very well, but it is *something*. Some years ago an enterprising photographer was given some free prints from *Life* magazine's archives. He then sold the prints back to *Life*, always a terrific paying market. Surprisingly, the editorial staff at *Life* decided he had done nothing dishonest when the transaction was uncovered!

Insurance

There are two basic types of insurance photography:

1. A record of certain items to be insured. Sometimes you also get jobs where you photograph an item to be sold, because the owner needs a record of it.

2. A record of damage done to an object or person, because there is an insurance company involved. The lawyer representing the insurance company hires the photographer.

I like this kind of work as it pays fairly well and there is never any hassle.

Interiors

An architectural photographer must be able to photograph interiors as well as exteriors, but sometimes a designer will need photographs of just the interior of a building.

No chiseling here; designers charge for their time and expect to pay reasonably for ours. I have found them a pleasure to deal with. The pictures are usually in color and you must tie up in advance if the customer will pay for models; many provide office staff to give life to some rooms.

Invitations, Greeting Cards

Once a photograph has been taken if it could possibly be used on an invitation or other card, suggest it to the customer. E.g., engagement pictures can be included in wedding invitations; family photos make good Christmas cards.

This is another area where the profits are pure gravy. The pictures are taken; now you make a few extra sales which take no work.

Have a catalog of invitations and greeting cards available so the customer can choose what he wants.

Greeting card photography of a more general nature, the kind you purchase in the stores, can be sold through stock agents. If you have one or more likely pictures, write to a greeting card printer and offer it for sale. The price is negotiable so you might have to ask another photographer or an agent who has made such sales to suggest a reasonable figure to be sure you don't get stung. If some-

one won't help you, then call again and offer to buy a picture for use as a greeting card and you'll get your price.

Legal

Photographs can decide the outcome of a legal case and many of the smaller law firms take their own. Once a lawyer has grown accustomed to calling you to get the pictures, he will be the source of a lot of repeat business. I have not had luck contacting lawyers. I don't believe they read their letters! Those I work for heard of my work from other sources.

Such photographs are usually, but not always, taken away from the studio—wherever the accident happened or the item or person to be photographed happens to be.

I have a flat fee for legal photographs that includes a 5x5 or 8x10 (whichever the lawyer prefers) of each picture I take. Expenses are added, such as additional time (over one hour), travel if necessary, and duplicate sets of pictures.

There's no quibbling over money, but the lawyers expect a professional job.

One lawyer requests that the pictures show what he wants, but *look* as if they were taken by an amateur!

If the case goes to trial, the opposing lawyer will request a set of pictures too.

Model Portfolios

A photographer often works with a model agency and gives that organization a kickback. Approach the agencies. Work out a price range so you can offer this service. At first it may be necessary to work on "standby."

Occasionally, aspiring models will have their photographs taken by an outside studio, because he or she prefers its work. You can advertise that you photograph portfolios and/or let the people in touch with models know. Approach all the schools (theatrical, acting, modeling, dancing) or any place a "beautiful person" hangs out, (gyms, spas, health clubs).

When deciding on prices, remember that model portfolios require more poses than a simple portrait sitting. Also, allow time for several clothing changes, makeup, etc. In cities a photographer can charge several hundred dollars for a package consisting of various sized prints, black-and-white and color.

News

(See also *Semi-News.*)

News has to get to the public immediately, so you must have your contacts ready. If you want to cover a particular event, set up your market in advance. If you get an unusual, timely picture, you can readily find a market for it.

There's not too much money in such photography, unless it's a terrific scoop, e.g., you're on the spot during an assassination. For this reason, many photographers like to work for an agency and share commissions . . . a good agent will know what to charge. Look under "stock photos" in the phone book, or phone or write to Associated Press or United Press International, which have offices in the major cities.

News pictures do get printed over and over and you can make additional sales, sometimes to newspapers and magazines abroad.

Political

Many politicians want their own photographer with them on campaign trips and like to have one available if they need him. They naturally expect you to belong to the same political party as they do. (I blew one opportunity by blurting out that I was a Democrat.) Go to campaign headquarters and find out which candidates have budgets for a photographer. Just talking about such things will set their minds working. All expenses and arrangements are made by the campaign committee. If you have someone you trust to watch your studio, it's a good job, besides being fun. Charge by the day.

A different kind of political photograph is the official portrait or portraits used on campaign literature. There have been times when I have found myself photographing opposing candidates in a campaign.

Political candidates expect to pay your usual charges and buy lots of black-and-white glossies. I give a discount to Democratic candidates (but don't publicize it).

Portraiture

(See also Chapter 7.)

Many of the examples in this book have been taken from my own studio, and my specialty of portraiture. The following is a list of the chief categories in this field:

Individual—portraits usually taken as a gift for someone else.

Promotional—portraits to be used in portfolios, brochures, job applications, etc.

Executive—"boss"-type pictures, showing someone against the background of his or her business—often purchased to be displayed in a lobby.

Family—group pictures taken so that everyone can have them to show their grandchildren one day.

Passports and IDs—pictures taken as a method of identification.

Posters and Murals

Very large photographs can transform an ordinary room into a sensational one, so don't feel that your photographs have to be limited as to size.

When ordering these outsize pictures be sure that the customer understands that the inexpensive variety will not last and will yellow with time because it has not been properly fixed. Sometimes customers want outsize pictures to cost as little as the $7.95 2x3 posters they can buy elsewhere. I usually call a lab and get advice on what to charge (but would use the *Blue Book of Pricing* for an expensive decor print).

Proms, Dances, Banquets

A nice little money-maker is to be the official photographer at a dance. Never take these pictures on speculation; the couple you are photographing must pay for a certain package, e.g., two 5x7s and four wallets. You take one shot of each couple except when someone blinks; then you take two!

I take these jobs when they are offered to me, but most photographers approach schools and clubs to reel them in.

Real Estate

Realtors will buy the kind of pictures architects and interior decorators order, but they don't expect to pay as much. Most of them visit the homes they sell with an instant-process camera.

Even so, it's possible to talk them into letting you provide a portfolio of pictures of some of the more expensive homes and buildings, and I suggest these be put in an album to become either the new owner's property or something the old owner takes with him.

This appeals to the realtor, who can talk the owner into footing your bill. And you can do a more extensive job, besides getting a few extra dollars for the album!

School

School photography is the term used for the individual pictures taken of a class of school children; a composite of the entire class and the teacher is also provided. Parents can buy several additional pictures of the child as well.

The price has to be very competitive and most photographers work directly for the lab, or are given the job and all promotional materials by the lab.

As with any job where there are large numbers of people involved, the money can be considerable provided you do the job quickly, efficiently, and don't run up your outside costs. If you want to get in, find out who did last year's pictures and suggest they'd do better with a local (rather than a traveling) photographer.

Semi-News

News pictures depend on a *now* impact, even though the same pictures may have special significance at another time. A famous example is President Kennedy's assassination. Long after the event, news agencies were trying to find photographs however poor.

Semi-news is the type of photograph that can be used like a news item but doesn't need to meet a deadline. These pictures may be of celebrities (doing anything!), ordinary mortals, or animals doing unusual or amusing things.

Newspaper or magazine editors will buy these pictures direct and it pays to establish a relationship with them. However, most photographers prefer to use a stock agent (see *Stock* below), many of whom specialize in semi-news.

Senior Portraits

It has become tradition for high school seniors to forgo the usual school portraits provided for the other students, and hire a good professional photographer to take the seniors' portraits in their graduating year.

This market is very lucrative because parents are ready to spend considerable sums on their children. Last year, I was astonished to find that only *one* of the seniors I photographed bought the least expensive package.

Sports

(See also *Teams.*)

The athletes who participate in sports will buy pictures of themselves in action if these show their skills. But the pratfalls and near-misses that seem such

fun to us, aren't the pictures that bring in the money. Nor are pictures likely to sell if the athlete is not showing good "form."

Sports photography has to be done on speculation but you can increase your chances of making a sale by having an announcer at an athletic event tell the athletes who want photographs that they must inform you of the fact. Then you can take a small deposit, maybe $5 per person, which goes toward anything he or she buys later.

One sports photographer gave me some good advice, "The new and inexperienced will buy any picture. The ones who are used to being photographed only buy the exceptional ones." Sure enough, at the next horse show I concentrated on the novice classes and got some excellent sales.

When you send proofs to bring in orders, you'll get better sales if you send a size that can't be copied easily (a 35mm contact print)!

Sports photos make excellent stock photos, but you must have model releases for all recognizable athletes.

Stock

Photographer's Market provides the most complete list of stock agencies I know of . . . but does not include all of them. Possibly new agencies crop up while the book is being printed or the publisher's call to all stock people has been ignored by some. Look in the Yellow Pages for particular cities and you'll find others.

Stock photos are those that you have on hand and offer to sell for one-time use in a publication. The usual way to sell stock photos is to send your work to a stock agency. The advantage of having an agent is that he has access to many markets and what you lose in his commission you make up in multiple sales.

You don't make a whole lot from your cut of a stock photo sale, but the money can be welcome and arrives when you least expect it. Color brings in much more than black-and-white. When I started photography, those royalty checks often helped me through tough times.

Teams

There are two kinds of team photos.
1. A group picture of the team.
2. A picture of the individual athlete.

Usually the photographer takes both kinds on the same day. He's distributed envelopes to the coach a week in advance, informing each member when the photographs will be taken, what packages are available and the cost. The athlete (or parent) fills out his name and choice of packages on the envelope, encloses the money and hands it over when it's his team's time to be photographed. The photographer takes no pictures on speculation and everything is paid for in advance. Call the coaches, managers and sponsors of the teams. It isn't difficult to break in.

This is very lucrative because of the numbers involved, but if something goes wrong, you have a lot of people to apologize to and it may not be easy to reschedule.

Theatrical

There are two ways of taking theatrical photographs, too.

1. Photographs which appear to have been taken during performances, so that the company can use them for publicity, in the foyer, etc. Don't presume you can take photographs during a performance; actors' unions require extra money for such photos. If you are hired to take pictures during a show, be sure that you have the proper authorization.

2. Individual photographs of the performers which can be added to his or her portfolio. When you learn of any theater group call right away and make contact. Keep in touch. Although movie people have money, most stage actors don't and so the price has to be really competitive or they'll use a talented amateur. This could be different in New York and other very large cities; my own experiences are based on San Francisco and some small towns.

An offshoot of this kind of photograph is the amateur theatrical, fashion show, dance program, etc. Here doting moms and dads will pay for the pictures, and, if the price is reasonable, you can turn out a job with an excellent profit. The secret is to give some free pictures to the organizer in return for the title of *exclusive* photographer for the event.

Travel

Stock agencies need to update their files continually, and will always look at your travel pictures if they are unusually exciting, exceptionally well done, or so coldly documentary in style that they can be applied to a number of editorial uses. Take some of the simplest pictures that tourists miss, of anything unlike what you see back home. Be sure you know exactly what it is you're photographing. Don't guess. Write down the place, the date, the details of what you're photographing *at the time.*

Once an agent knows you have pictures on a certain subject, he can call you if he needs one, even though he has decided not to stock those pictures himself. For instance I had a call, "Do you have pictures of the Tiger Balm Gardens in Hong Kong?" I replied sadly, "No, only of the Tiger Balm Gardens in Singapore!"

There are articles to be written on your travels, and these should be about what you have *not* read, what seems interesting to you and not merely what you think someone else might like. My book *Mother and Child* was photographed because I became fascinated with the interaction between the beautiful dark-skinned women and children in Sri Lanka. My enthusiasm for the subject sold the book.

Wall Art

(See also *Crafts.*)

This comes in many forms and you hear people speak of Motel Art, Hotel Art, World Art, etc., and what they are referring to is the kind of picture you stick on the wall that isn't great art, but everyone kind of likes it. Photographers provide a sizable portion of these, all the way from calendar art (frankly sentimental), to wall murals (scenics that give the illusion of being outdoors).

To my chagrin, over and over again, I've had people bypass my better work to choose a pretty but "nothing" scenic, which I happened to take because it was there.

143

There are organizations that provide such photographs to decorators and other people who decide which pictures will grace the walls of which building. A little investigation on your part should turn up a couple of prospects. Work backwards, that is, find out who provides a particular hotel with its pictures and ask that person where he gets them.

Selling photographs as wall art is an excellent money-maker for a photographer with a file of the right kind of pictures, that is, striking shots of neutral subjects, landscapes, children, animals, sports, etc. Anything that wouldn't scare the baby or upset the P.T.A. would be suitable.

Weddings

Weddings, Bar Mitzvahs, anniversary parties, christenings—these are some of the "events" that make the big profits for the portrait photographer because we're hired for several hours at a time and paid well; the reprint orders can be considerable; the pictures are seen by a lot of people; and the customer is usually working with a budget that allows plenty of money for photographs. Even those brides who are shopping around for a bargain are not looking for a $25 bargain but a $200 bargain.

Writers

Not all writers are photographers and if a writer needs photographs, the editor he's dealing with will insist that they look professional. Then he's stuck with hiring a photographer to do the job, unless he will split commission with him. I am reluctant to do this unless a writer has a contract with a publisher.

As writers are not often paid too much, you should work out a package that is affordable and insist on a good portion of that in advance. Many whose photographs I've taken have tried to make me wait for my money. I always refuse.

I always suggest that I take a few pictures of the author, himself, for his publicity photos and book jacket, while I'm doing the other pictures.

I have to be very careful not to be negative about some of the ideas that writers bring to me, but I flatly refuse to do the photography for a cut of the profits on an unsold book! If a book is obviously going to be published then I have every reason to take the royalty split and throw my heart into the project, dealing with the publisher direct, if possible, to be sure the pictures are what they need.

As you think of additional markets for your photographs, you'll see that a single photograph can be sold to several markets. *Never* sell "all rights" to a picture. If business is slow, start these file photos on their way to making a few extra dollars—eventually, they'll pay off.

I've earned my real profits when I've been working on one job and see an opportunity to take photographs for something else. Suppose I'm hired to take some aerial pictures of Morro Bay next Monday. I will, of course, get aerial pictures of Morro Bay and of San Luis Obispo as we fly over it. I'll pay for any additional time spent on *these* pictures from my own pocket. It so happens that in the last couple of years I've had calls for aerial pictures of this area—from customers who wanted to pay for a photograph already taken, not for a photographer's time in taking it.

144

Sidelines

In addition to actual photographs you can also make money selling photographic sidelines, equipment of various kinds, albums, folders, frames, and all manner of gimmicks—one of which may suddenly bring in solid money.

Don't be frightened of getting into a sideline to take care of excessive rent, but look for one that doesn't take too much effort because you must keep your energies for the studio. Obviously, something related to photography is ideal:

Frames

A line of frames that *no one else has* which will prove irresistible to even a small number of people might make up the rent on a very few sales. Do you have the space? You need only one frame of each kind and can take deposits on orders if you are short of cash. Get a supplier who responds quickly to your orders.

Restoration

I've always backed away from doing this for a living, saying, "I'm not a retoucher, I'm a photographer." The fact is, if you advertise with a stunning display, you'll find that people who ignore today's portraiture still want their ancestors to be cleaned up, copied, and restored! The great advantage is that you can farm this work out (if, like me, you don't enjoy it), and merely act as a middleman.

Copying Paintings

Artists need transparencies of their work. If they make a sale and don't have a good photo of the painting or sculpture, it can be lost forever. Very often artists don't have much money, but the sheer volume of their work will make it worth your while to do it inexpensively, e.g., a minimum of ten items to be photographed.

Teach

Check with the colleges in your area and see if you could teach an evening class in photography or any other subject you have expertise in. City recreation departments usually welcome such instructors or you could advertise such a class yourself.

Rent Space

If there is space you can do without—an attic perhaps, or a basement that could be rented to someone in need of storage—you might get enough for it to make the difference between an unwieldy studio rent and one you could afford. Try and find something that needs no new expenditure from you.

A CPA told me his family took in a "lodger" to get them past the first two years of his practice. An extra room at home is worth whatever the traffic will bear—in our area, one room rents for $200 per month minimum. (According to the San Luis Obispo *Telegram Tribune*, our *average* two-bedroom home rents for $450.) Find out the figures for your own area.

Office Work

If you can type, take in typing—advertise in college newspapers, or simply

tell everyone you know that you want the work. Bookkeeping and data processing are other marketable office skills.

Transportation

Do you have a van? A pickup? Moving a household pays well and nonunion labor is sought after. Advertise for local work only; people do move from one house to another in the same city. Think what you would do if you broke something you were moving, and either have an agreement with the owner that you're not liable or insure against it.

Darkroom Work

This has to be a natural, yet not many photographers want to take on someone else's darkroom work. Consider it.

Field Trips

Organize a photographic field trip, a bird watching trip, any kind of trip. Rent a bus or a plane. Remember, the carrier owner will have insurance to cover accidents that might occur. You should carry liability insurance anyway; it's not particularly expensive.

To give you an idea of how lucrative it can be, here are some current figures on this kind of trip. I'm going to a computer fair in San Francisco, 200 miles away. A bus and its driver will cost $800 for the day, leaving at 5 A.M., arriving there at 9 A.M., and leaving San Francisco at 6 P.M. the same day, to be back home by about 10 P.M.

To break even, the seats (forty of them) must sell at $20 each. The current Greyhound individual fare for the same trip is $37, but it would take longer and we'd have to leave and return at very inconvenient hours.

A couple of ads in our local and college newspaper will more than fill the bus, because word of mouth is selling the idea already.

However, let's consider running the same trip to make the organizer a profit. The only cost (exclusive of time) would be the ads, let's say a maximum of $60. If I sell the tickets at $30 each, I make a profit of $310 (and I wouldn't be paying for my own ticket). If I charged $35 each, my profit would be $505.

This reversal print was made from positive color. The picture was taken to encourage brides to be freer in their portraits. Some decided to forgo wearing a veil just because of Laurie's wreath.

A striking bride in a 1968 portrait practically became my studio logo. I used the picture over and over again, in ads, brochures, and displays. It is not a picture, however, that brides-to-be identify with. I learned the hard way that an exhibit must generate orders, not just oohs and aahs.

Here's a portrait of a real beauty, whose expression is disquieting. It is a very strong picture and most brides are not looking for that strong a style. It is a picture to exhibit where I have other bridal portraits, but I would not display it without thought.

A formal bridal portrait that can be used in display is not that easy to come by, because not many brides are great models, and those who are may not want a special sitting.

This was a portrait that just happened. Tara needed a model portfolio (she was 10), and among her own "dress up" clothes was a wedding gown bought at a thrift store. She is standing on a stool under the dress. (Pearls on her head made more sense than a veil.) I believe that the display picture, which is 30x40, has been directly instrumental in bringing in wedding business.

149

This is a picture people remember and like. Over and over again, I am reminded that it is not necessarily the exceptional photograph that is good for business, but the subject—here, this particular girl.

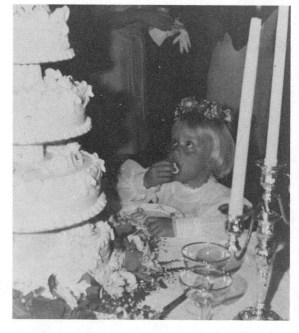

Although the picture is from a wedding in 1969, this little girl eyeing her sister's wedding cake still gets stares. Watch the public's reactions to the pictures: one you have dismissed as merely cute, may be a winner to someone else.

This couple were photographed in 1977, which marked the beginning-of-the-end of the flower-child look. I loved the wreaths of flowers and the brides who wore no makeup (and so didn't have to look in the mirror every two minutes).

PART TWO
Taking Care of Business

To succeed in business, there are three points you must never forget.

1. More important than the efficient running of a business, you must concentrate on bringing the business in. E.g., should you write that ad or do the filing? Write the ad.

To generate business, you must have something to sell, even something as intangible as a talent. Let people know that this product is available and make them want to put their money down on it.

2. Order is absolutely necessary, so a system for the handling of every phase of business must be worked out. Order itself, however, is not *enough* (which is why a salesman is paid more than a clerk).

Before I was a photographer I worked in San Francisco in an office where the incompetence in office procedures was absurd enough to film as a sit-com.

To give you an example, when I complained that a door off a hinge was leaking light onto a sensitive copier and ruining the copies, the office manager bought a new machine instead of a screwdriver. This new copier could produce good copies even if light leaked onto it!

He once threw away six boxes (500 sheets each) of paper that cost five cents a sheet, because someone found a place to buy paper at two cents a sheet!

Yet the volume of orders that came through this office was such that the company made colossal profits.

This company put all its considerable energies and resources into turning out very fine machinery and in training and driving a high-powered sales team to sell it. Inside the office, the time wasted was insane.

Keep that in mind! Say to yourself, "What can I do to generate more business?" If it's a choice between taking care of existing orders or getting new ones, get the new ones—unless there's a deadline.

10
Advertising—
Spreading the Word

Have you ever walked down a familiar street and suddenly noticed a house which was there all along but somehow you had missed? Maybe a neighbor's cherry tree took your attention from it, or the house was hidden behind hedges and trees. The purpose of advertising is to make an invisible business visible.

Advertising has to be learned the hard way. We have certain ideas that we've grown to believe will work and nothing is going to change our minds until we've tried them. Do this as inexpensively as possible.

Even the ad agencies don't always know what's right for us; they're often full of theories and muddling along just like everyone else. But they're in business, so they have to try to sound knowledgeable. I always listen carefully, but never put money on any idea without a lot of thought.

I wish my advice on advertising could be as simple as on bookkeeping, but this is a tricky field full of gopher holes. One of our local companies made millions with a brilliant advertising campaign and a few years later was bordering on bankruptcy. While things looked rosy, the owners gave interviews on how you can't miss if you know the public's mind. They had to sell out, got a new product, and again made millions. I hear they plunged dangerously downwards again and once more sales improved.

The public does not necessarily jump in a predictable way. If it did, a peanut farmer from Georgia or a movie star would never have become a U.S. President. Are you old enough to recall how we all hooted when we first heard that Carter and Reagan were running?

The president of a photo album manufacturer phoned me one evening from the other end of the country to ask why I was buying so few of his albums. I told him frankly that I give my customers a choice and they were choosing other lines. He then gave me a lecture: I wasn't running my studio right and I should be creating a demand for his merchandise. "You don't have to believe me," he said sternly, "this is how *General Motors* operates."

"General Motors," I told him, "is in a lot worse financial condition than I am." (At the time they were operating in the red.)

Consider your own reaction to an ad before proceeding. Which ad do you cut out and keep? Which do you ignore? Which business do you see as you drive

down Market Street? Which store do you want to visit when a neighbor talks about it?

Now ask what those businesses are doing right. What are their competitors doing wrong?

A very large studio, for instance, well situated in a large metropolis and staffed by three or more excellent photographers might have a considerable advertising budget and believe that its success depended on it. That may be true but there could be other reasons for its success and the studio may also fare as well without that money spent on advertising. I, for instance, have never bought a car because of an ad; I never look at automobile ads or listen to them on TV. I buy a car because someone who owns one tells me it's a good one.

Does Advertising Bring Direct Rewards?

The photographers I've talked to swear that a lone newspaper or radio ad—even a TV spot—rarely covers the cost. I've talked to businesspeople who use radio advertising and their experiences have been similar. If you can afford *several* spots a day, every day of the week, it makes an impact. The owner of a large automobile dealership said, "If you can afford to put on several radio ads every day, then put that same money into one TV ad a day. The returns are much better."

The reason I don't use TV advertising isn't because I don't believe in it. For one-time ads it is *the* media. However, the local photographers' TV ads have quickly disappeared. I figure they just weren't worth the money.

A good way to gauge the success of local media advertising is by watching for the advertisements of other photographers. If one advertises consistently, you can presume it's paying him to do so. If he puts a few ads in and then after a month or two pulls them, it isn't.

I met one photographer who had a single order from a newspaper ad and decided that he would be able to snowball this into a self-perpetuating advertising campaign. The single order paid for two more ads. Whatever those ads brought in would pay for further ads. I watched for his ads in the papers, but after a month or two he dropped them, from which I surmised he'd been disappointed in his expectations.

When Leonard Mayta owned the Picture Shop in San Luis Obispo, he was the first photographer who openly admitted to me that newspaper advertising had never done a thing for him! He felt that in a small time operation the best advertising must be by word of mouth.

His most successful ad was a matchbook his customers received with their photograph on it . . . it became his only ad.

He bought the matchbooks at the grocery store, removed the cover, and stapled on the customer's black-and-white picture.

Remember, your ad must not merely remind the viewer of photography, or it will benefit a competitor as much as you. Leonard's matchbooks were not generally available; you have to be his customer to get one.

Before plunging into advertising, consider that there are three ways to advertise: one shot, residual, and free.

A one-shot ad appears and then is gone, except in the memory of the person

who read, viewed, or heard it. Every time the same ad is repeated, however, it more than doubles its impact, because it's now recognized like an old friend. If the same ad is used too often, the old friend is merely boring, but a new twist can revive its charm.

One-Shot Ads

The least complicated and *most* expensive form of advertising is the one shot. It brings your studio name and product in front of the public, perhaps in a newspaper, radio show, or on TV.

If you need to advertise and don't have the money, it's a huge predicament. Is a small classified ad better than none? Will borrowing money to advertise "right" be worth it? Can you trust the sales person's advice?

One-shot advertising isn't very satisfactory unless it's part of a regular program of one shots—and that costs! But often the rewards from an ad that appeared to have had *no* response will turn up later, even years later. That one order might more than pay for it—this has frequently happened to me. So I no longer expect direct returns on ads. I just throw them into a local newspaper when I get a good idea. Sometimes the response is immediate, sometimes not.

One good idea dawned on me when I noticed that the picture of Superman is a real eye-catcher. I placed three tiny ads in our college newspaper (a three-for-the-price-of-two special), at the beginning of the new school year. There was a drawing of a guy who looked a lot like Superman and the copy read, "San Luis Obispo's Superman of Photography Is a Woman." This ad was also a coupon.

So I hoped to:

1. Catch the eye with a Superman look-alike (Superman is copyrighted).
2. Tie the art into the studio with the copy (written portion of the ad).
3. Bring the customer in with a coupon.

One student from the entire university brought in the coupon; two others phoned. Others may have seen it; my student business is up this year. I figure it must have paid for itself, but I have put it out of my mind.

One-shot advertising is not a precise science. If it were, the mammoth companies that advertise heavily on TV and in magazines—airlines, automobile manufacturers, restaurant chains—would never get into financial difficulties.

Important factors are:

1. The timing of the ad.
2. The mood of the public.
3. The pocketbook of the public.
4. The attractiveness of the product if it is already well known.
5. The experience the public has had with the product.

Even a heavily advertised business can fold without notice. For instance, a restaurant in San Luis Obispo that had a large regular ad in the newspaper and seemed to be a terrific success was actually losing $1,000 a day. The owner told me so after he sold it. It was just one of his many enterprises but this time he had guessed wrong for the area.

"How?" I asked.

"Because this community doesn't dress up to go out in the evening. I

157

thought they would if they had the chance. What they wanted was what they had, restaurants with a casual atmosphere."

You might say that its ads worked against the restaurant by emphasizing "exclusive" and "luxury."

But a new restaurant here specializing in soup, ribs, and salads had people standing outside all evening waiting for a chance at a table. A single ad did that.

Residual Advertising

If you pay to have a print made of a favorite picture and display that picture with your name, then that is residual advertising. The initial cost of printing has resulted in a piece of advertising that will last many many years. I have pictures that are still on display but were initially printed twenty years ago when I was an amateur and some of these you will see in this book.

The writing paper you use for business letters is a form of residual advertising. Your letters will be filed; they don't always go into the wastebasket. Some of your self-stick labels will surface years later, as will your business cards and price lists.

One-shot advertising, therefore, is much more effective if it can be made into *residual*. A coupon is kept for awhile even if it is not brought in. Before being thrown out, it will be looked at at least once again. Last year someone phoned me that she had found a "free picture" offer of mine in her deceased mother's papers. She wanted to cash in now! That offer was made twelve years ago! Another person found the same type of coupon at the Greyhound bus depot and called to ask if he could use it. (I said "no" as it was four years old.)

When possible, turn over each piece of advertising in your mind and see if it can't be made into "residual."

If you're advertising in a newspaper, a weekly supplement is often a good spot to choose. I have a small ad running now in our TV supplement, as a lot of people use this instead of *TV Guide.*

Very recently our newspaper has started publishing the TV programs each day as well. I now have a dilemma—whether to leave the ad where it is, or move it? The advertising staff at the newspaper suggests I leave it where it is.

The Yellow Pages

The Yellow Pages advertising section of the phone book is far and away the most important printed ad for the photographer. The Yellow Pages are available to the public all year long; everyone uses them, so this is a powerful residual ad. Many customers come to me just because they have seen my ad there.

You will be listed in the Yellow Pages when you put in a business telephone whether or not you also decide to take out a display ad. The display ad merely reinforces your image as someone who owns a substantial business, which can afford to advertise, and it gives the public a definite idea of your style.

The ads are expensive and will cost in proportion to the population figures for your area. Your ad is also more likely to become lost among those of many oth-

er photographers; therefore, in a big city, you might have to take out a very large ad so it can be seen effectively.

In my early days I did not have a display ad in the Yellow Pages because I felt I couldn't afford one. When I eventually did, however, to my amazement it covered its costs in the first week of every month. I have a fairly small ad, but I think it is striking enough to carry at any size and as I keep pretty busy there seems no reason to change at this point. I have considered advertising with a second identically sized ad, however, to attract more commercial work, which is less seasonal than portraiture.

Because a new edition of the phone book comes out only once a year, give considerable thought to your ad's visual impact before you place it. Also ask that it be placed as close to the beginning of the "Photographers" listing as possible. I discovered some years ago that a first-come, first-served priority is applied to the favored spots. When you take out, let us say, a two-column by two-inch ad, all the existing two by two ads will be positioned before yours and photographers signing up later will be displayed afterwards.

"Oh?" I asked the salesman who told me this. "Then why is Mr. X's studio ad placed before mine?"

"Because he was first!"

"He wasn't in business when I placed that ad," I told him. He called later to apologize and I was moved up. However, I had to question why I couldn't have a better position before I was told of the rules.

The Play's Not Necessarily the Thing

A less effective form of residual advertising has been on playbills and programs. I am approached by various theater and sports organizations from time to time and did buy the ads when I first opened. If you decide to try this form of advertising, consider whether the audience will contain enough potential customers. I didn't get one order as a direct result of such ads. I now prefer to donate photographs or a gift certificate for photography which can be auctioned, raffled, or given as a door prize.

Don't Waste Your Time

For awhile my son and I had a sideline, "Computer Lists," and I learned the uselessness of placing an ad that you can't really afford. We advertised in national magazines, such as *Popular Photography*. We were paying $350 an ad—sometimes more—and that was a lot of money to us. But it gave us a very small ad, only fifty words ($6.50 a word).

Computer Lists provided photo markets by subject. The cost of the ads was too high for our $5.95 list, though obviously the demand was there because we did get a fair response. But it was never enough to cover the cost of the time we put in . . . just our expenses. We tried upping the price and had no better luck. Even so, orders still come in—more from abroad than the U.S. I think people abroad don't throw away their magazines the way we do.

159

The Best Ad of All

The greatest residual ad is a conspicuous and good-looking sign outside your place of business. It will sit out there twenty-four hours a day and advertise your studio. Be sure to get the benefit of those full twenty-four hours, and put a light on it in the evening.

The floodlight that shines onto my studio, and particularly my sign, goes on automatically at night. The lamp was stolen after a few days, but that, too, has a simple remedy. A metal cage is sold just for the purpose of protecting the lamp, and you can put a lock on it.

"I passed your new studio the other evening," said a woman after I'd been in the building about a year. "Does anyone come to you out there?"

I told her, "It's easier to park than downtown, and a lot of people like you pass it at night, see the sign, and know where it is."

Architectural firms have found that their sign brings in as much business as client-referral. There's no business that we photographers are closer to than the architect's, and anything that works for them will work for us.

Eight Tips Before You Hang Your Shingle

1. Check with city hall (your planning department) before putting up the sign because there may be local ordinances that control its size and distance from the street. You may also be required to apply for a sign permit.

2. Be sure the sign is visible—it should be seen by motorists as well as by pedestrians. If customers complain that they drove twice around the block before they found your address, your sign is not visible enough.

3. Your sign should be simply lettered and painted in a way to make it easily visible. Avoid using your favorite lettering if it's elaborate. Old English, Moderne, and other unusual faces are suitable for a letterhead perhaps, but are usually difficult to read.

4. Make the sign large. If your sign permit allows a six-foot sign, make it six-feet long, not three feet.

5. Let the sign reflect your style. For instance, if you don't want to give the impression of a nice, friendly country person, then a rustic sign is not for you.

6. The sign should look professionally made. This is no time for something that looks as if your teenage son made it (even if he did).

7. If you have a corner lot or a business visible from two streets, make sure that you have a couple of signs (if the city allows it) one visible from each street.

8. Let your sign make a point. Here are some signs with varying emphasis in what they say:

Harry Smith
PHOTOGRAPHER

HARRY SMITH
photographer

PHOTOGRAPHY
by Harry Smith

Smith's
COMMERCIAL
PHOTOGRAPHY

PORTRAIT
photography by
Harry Smith

More Residual Ads

Advertising with a Christmas card can be a residual ad, particularly if the card is so beautiful that no one wants to throw it away. My Christmas card this year will be a *foldout* calendar with all the state flowers pictured on it. I chose it because I myself would never throw away that calendar.

When businesses send me Christmas cards I get a feeling (true or not), about their operation. If someone sends me a photo of every person in their company, I rather like them (although until that time I could have cared less what those people looked like). If someone sends me a photographed "holly and candles," I think he has no imagination. If the card looks cheap (rather than merely "inexpensive!") I think the place isn't doing too well.

This is all a matter of taste, of course, but the quality studio would be wise to consider the reaction to its cards, especially if it wants to give a good impression.

At Christmastime I also send out "Christmas" postcards to customers who need reminding that their photos are in, instead of my usual studio postcards.

I do, however, remind my customers in September that they should order Christmas cards, and usually several of them do, using pictures I've taken of them and their families. Another photographer said it was a mistake. Why sell a Christmas card for $1.25 if you can sell a print for $30? Why not? Are you sure you'd get that $30 one-print order?

Some residual advertising just happens, even though at the time you are merely acting like a good citizen. You'll be astounded at how much business such incidents generate.

One customer brought me quite a bit of business because I found her hanging onto a railing and thought she was having a heart attack (she was). I helped her into the studio, made her sit down, and flapped around asking if I could call the doctor or get her something. She just sat there and, after about an hour, said she was all right, thanked me, and left.

She has however, come back over and over again, and sent others, and never stops talking about my kindness.

A small dog was struck by a car and injured badly. I stayed with it until the owner turned up and he later returned and thanked me. I told him I'd take the dog if it was too injured for breeding (it was a Manchester terrier) because I had become quite attached to it.

He returned later to thank me and tell me the dog didn't survive. The woman whose car had hit the dog was with him, and these two seem to have become a couple. Now if that leads to the altar, they're certainly going to know a wedding photographer!

"Almost-free" but really residual advertising is to reward someone who recommends your studio. I do this with free pictures. My free pictures come in different sizes, depending on the job done and how much I get for it. E.g., each bride receives a free 11x14 when a friend books me for *her* wedding. It is the mother of the bride who usually claims these free pictures and one young woman asked me to stop giving her mother free 11x14s as they were running out of wall space! But since the mother was aggressively recommending my studio just

for those pictures, I ignored her daughter's plea!

I hold back on the free pictures until the new bride has paid her bill in full. And I give gifts of additional free pictures when I feel like it, but always after the initial ordering momentum is over. I do this if the customer has been unusually sweet, patient, or fun. The new picture is one the family didn't order extra copies of, just didn't see its merits. However, when someone owns a copy at a larger size, it sometimes starts a new flurry of orders.

I also lend pictures to anyone who will display them, maybe an indefinite loan for wall decoration, or for a special party or exhibit of a different kind of art. I might suggest I lend someone pictures for an exhibit. For example, a potter is putting on a show, but the walls are bare and could well be covered by photographs.

When I lend photographs, I have the borrower sign for them. It's easier to say, "There's one missing," if we *both* know that, although these pictures are not really the borrower's responsibility, but mine.

Exhibits

A great form of residual advertising is the exhibit. The investment is quite high thanks to the cost of printing and framing—I probably spend more on my exhibits than any photographer anywhere! I rarely order less than a dozen very large prints at one time. My exhibits do pay for themselves, however, because as soon as a picture has been used for a while, I offer it to the subject substantially discounted (often below 50 percent).

If you're doing your own exhibit printing, be sure to make a second perfect copy of every picture. Later on you'll be glad you did. If you sell the exhibit print, you have a replacement—and sometimes pictures do get damaged. It is a nuisance, at the very least, to have to dig up the negative if you want another copy. Of course, many photographers don't replace exhibit prints and only show their current work.

I exhibit pictures that I am a bit in love with, those that are timeless in style and have nothing to do with "old" or "new" work. If they sell I feel I'm lucky, but that isn't the prime reason they're exhibited. *That* is to share my enjoyment of them with the public.

A small girl said to her father as he threw away the possessions she had accumulated, "Dad, you are throwing away my *life.*" I feel my exhibit prints are my *life.* When they sell, I'm even a little sad!

I mention these details so you won't feel a failure if you, too, are a bit possessive about your work! Many successful photographers print for exhibit only those pictures they think will sell. Financially, there are obvious advantages to doing business this way.

Occasionally, when I want to raise a little money I send out cards that say, "The picture we've used in exhibit that would normally cost $... is now available for $.... If you would like to purchase it, please let us know before"

These little cards create a flurry of business, not just in the sale of the display pictures, but in sittings.

Tips if You Are Putting on an Exhibit

1. Divide your work into different categories. When you have enough excellent pictures on one theme, put on an exhibit of that subject only.

My *Men of the County* exhibit showed off my simple way of photographing men. I chose this subject not just because I happen to enjoy men's faces, but because almost every other category of portraiture was covered locally. It seemed no one was photographing men.

Other exhibits I have given on one subject are *Men and Women of the Country, Weddings, The Father of the Bride* (featuring in each picture a bride and her father); Horses; Rodeo; and Cal Poly Architects. I also have many displays of photographs covering a number of subjects, some of each category above, and animals, birds, sports, fashion, commercial, landscapes, etc.

2. In each new exhibit be sure to include a few old favorites, pictures that identify the exhibit as yours. You'll know which pictures these are when people say to you, "Remember that picture of . . .?" Also include your own special favorites.

3. In an exhibit, if the subject is *People,* do not include unknown people who are neither interesting nor good-looking. This may sound cruel, but the purpose of an exhibit is to interest the viewer. So if you have a picture that someone left town without paying for, don't just dump the picture in an exhibit because you have it on hand.

4. If you're lucky you may find a lab that will print your exhibit work for half-price. Suggest it to the lab you use when ordering prints for an exhibit. Some labs expect to be paid the other half of your price if the print sells. They are giving you the discount to increase your business not to subsidize you.

5. If you can't afford expensive frames, keep the framing very simple to almost invisible. Exhibiting pictures without frames (mounted) is better than not exhibiting them, but they can get damaged.

6. Be certain that everyone connected with the exhibit understands that these are valuable photographs. They may not be able to cover them under existing insurance policies, but if you're careful with your work, others will be too. (You can't take this for granted, however. I lent several dry-mounted photographs to a gallery at the owners' request and they were returned with staple holes along the edge. They had been *stapled* to the wall.)

7. Color photographs can look like cutouts from magazines if they are displayed together. Somehow the better the pictures, the more likely this is to happen.

In portraiture you're pretty safe unless the pictures have the look of an ad . . . a young woman stands at the crest of a hill with her hair blowing in the wind, a man wearing a handsome sweater stares at the camera aggressively. People like these pictures of themselves, but often you're dealing with a parent who's going to foot the bill. You want that parent to stop and think, "Here is an unusual photographer, my son/daughter would look great in such a picture," not, "I saw a picture like that in *Seventeen.*"

It is possible that most people are accustomed to seeing pictures in magazines and so identify all color pictures as looking like them. It is a compliment to

your work, in a way, because the national glossies have the finest photographers in the world doing the editorial and ad pictures.

Again, this is less likely to happen if the photographer's work would obviously not make it into a magazine!

You can avoid this feeling of a magazine cutout with the lavish use of matte spray and by including black-and-white prints in the exhibit. Some people won't notice they're black-and-white, and some will think all the photos are black-and-white, but the overall impression will be an increase in quality.

8. Sometimes you'll be one of many exhibitors, and if there's a choice, try and get the most visible location for your exhibit. I've found that by making an issue of the location of my exhibit very early—when the organizers will agree to almost anything—I've been able to get excellent spots. I often have the choice of an entire hall because no one else has asked for a particular location yet. Ideally, I want a well-lit location which can be seen as you enter the room, and which all foot traffic is bound to pass.

9. Be sure that every person in your exhibit has signed a model release or his or her parent has. Be sure that every purebred registered animal has similarly been "released." Even though this is a precaution that should be automatic, if someone makes an issue of a certain photograph being used you have to prove that you did not damage that person or invade his privacy if he brings a case against you.

Here's an example. I took a photograph of a small baby at a wedding. A shaft of light fell on the sleeping child and I took the picture for fun. It was so striking, however, I decided to use it in an exhibit, but was unable to find out whose child it was. A guest had brought a friend, who brought her baby!

I exhibited the picture and a young woman called to ask where I had taken it. I told her and, sure enough, it was the mother of the baby; she had recognized it by the little dress that was barely showing. Her husband insisted it wasn't their child.

She now wanted me to give her the 16x20 print, because I was "making money off it." I told her, "But I take beautiful pictures hoping people will buy them. I make my living that way." I was prepared to let her have the picture half price, and I said if she'd prefer me not to exhibit the picture again, I wouldn't. But I reminded her, "We both know it's your baby, so I'll *give* you a small print of the picture. But as your own husband wasn't sure it was the same baby, how can I have hurt you or invaded your privacy?"

My withdrawing the picture from the exhibit was the last thing she wanted because she was sending all her friends to see it, but she wanted that picture and she didn't want to pay for it. Eventually, her sister bought her the picture (at half price), but before that she phoned me regularly saying, "That picture is *mine.*"

If the child were at all recognizable, however, I should not and would not have exhibited the picture without a model release.

10. It took me a long time to realize how important the frames were that I used to exhibit my work. Initially I displayed pictures as I had been taught as an amateur; dry-mounted and of a uniform size (16x20). When a mount became damaged, I trimmed the picture and remounted it (with the old mount still at-

tached) onto a new 16x20 mount! The pictures themselves would shrink in size and the mount would now be at least a couple of layers thick.

My first effort at framing exhibit photography was to put borderless dry-mounted prints into ¾" inexpensive wood frames painted black, giving a nice uniform look to the exhibit. A local carpenter turned these out at only $2.50 a frame. But then I realized how impressed I was when I saw beautiful artwork of any kind displayed in ½" metal frames. Bit by bit, as I could afford it, I replaced the old wood frames with the metal. This not only actually improved the uniform "look" of the pictures, it also made them look *much* more expensive. Customers expect to pay a bit more for such a good-looking product. It also allowed me to exhibit much larger prints with the 16x20s and not lose that "uniform" look. The thin wood frames were useless for larger prints because the wood warps. Even quality wood frames, by the way, if they are thin, will warp at the larger sizes.

A clue I should have picked up was that no customer ever wanted to buy my cheap wood exhibit frames, but even if someone is not buying my photography now, he might ask if I sell the frames themselves because he has something at home he wants framed. (I do.)

Free Advertising

Every time you say, "I don't think so," or "I'm not interested," are you sure you aren't turning down free advertising?

Go for any offer to speak to groups or camera clubs, or to expose what you do to *any* section of the public. But don't do for free what people can well afford to pay you for. You need to draw the line between being the neighborhood sucker and someone who can be relied on to help a good cause.

My line is drawn at being asked to photograph or "give" photographs. If I use a camera for nothing, it has to be at *my* suggestion.

Don't hesitate to suggest you'd put on a program for any club. Women's clubs, camera clubs, hobby groups, and other social organizations often expect to pay speakers. If someone puts me on the spot and asks if I charge, I usually say "Yes, if it's the policy of the club to pay."

If the club has paid other speakers but doesn't pay me, and I find out about it, I could legitimately send a bill.

All necessary expenses should be picked up by the group that's asked you to speak: meals, accommodations, and travel. I require that accommodations, meals, etc., are also provided for the person I bring on the trip, as I dislike traveling alone. It used to be one of my children who accompanied me; now it's a woman friend. I'd never ask a club to pick up the expenses of a friend of the opposite sex. I don't expect anyone to finance my love life and I think they'd feel they were doing just that.

It's customary for a speaker to bring his spouse at his own expense. It would, of course, depend on what he was being paid and the agreement between the parties. I frequently attend professional meetings now where men are there in the spouse category; very successful men in other fields too!

Just because a group is respectable and organized doesn't mean that you can always expect fair treatment, as I once found. I was invited to talk to a group

150 miles away and we had agreed on a modest sum for the lecture plus overnight accommodations for my daughter and me.

At the end of the evening, someone handed me an envelope and, fortunately, I looked inside and found half my fee, in cash. I asked why the amount was short and there was some embarrassment and denial of responsibility. Then I became irritated and said firmly, "Someone can write me a personal check. Figure it out later amongst yourselves."

I must point out that normally I would never have opened the envelope in front of anyone. I did this on a hunch, a feeling I got from the woman who had handed it to me, and the fact that it was obviously cash (there was more than one sheet of paper inside). A check would have been "usual."

$$$ in "Joining"

I'm not a joiner. There are, however, some organizations it pays to join so you can meet customers on a social level.

If you're choosing a club or other group to belong to for professional rather than personal reasons, keep these things in mind.

1. Join an organization that has a definite purpose, not just one where you will meet a lot of people. You'll feel more useful and it will never work against you to be involved in something genuinely worthwhile.

2. Avoid the "circular" organization, where the activities are devoted just to keeping the organization going. E.g., fund raisers are put on to raise money to send members to conventions that teach them how to put on fund raisers.

Such organizations will cut your productivity, because they aren't productive themselves. They will expect you to give freely of *your* time, because the other members have time on *their* hands.

3. Consider the many service organizations available—Rotary, Lions, Elks, etc.—and if you are a woman, one of the women's service groups, Zonta, Quota, Junior Matrons.

4. Consider joining a church. A prominent Episcopalian told me he joined his church entirely for that reason . . . it brought business. I have no moral judgment on this, but it's obvious that Catholics (I was one), Mormons, and Jews are loyal to and like to patronize their own. For whatever reason you join a church, there are some advantages in socializing with people of like religious faiths. Many people also get a great deal of inner peace from the encounters.

5. Avoid organizations which *have* to make you enemies, that is, ones with extreme views of any kind. Unless your convictions about what they're doing are very strong indeed, there's no point in alienating half the population while making friends with some of the other half.

6. Avoid organizations that consist entirely of other professional photographers. There's nothing you can learn from them that you can't learn elsewhere. And you may learn some very bad habits in photography, because there are, sadly, not that many photographers anywhere who haven't been dulled by commercialism; you must sharpen the quality of your work, not flatten it. Also, most photographic clubs and societies critique each other's work, and give each other awards. From what I've seen displayed (in several cities) of these "winners," tal-

ented amateurs would be embarrassed to enter such pictures in a competition, let alone win with them. The life has been critiqued right out of them. If you want a critique of your work, take it privately to some photographer you admire and trust. You'll also dissipate time that could be spent as easily developing other business friendships which may be more emotionally rewarding (less stress).

In an effort to provide continuing programs to entertain and educate their members, professional photographers' clubs sometimes bring in "experts" who have created a photographic technique that should have remained uncreated. E.g., those blotched, handpainted backdrops, song-sheet negatives for sandwiching with bridal portraits, etc. Suddenly, just to be "one of the group," you'll be talking yourself into accepting these ugly gimmicks. Artists, advertising people, designers, and all other professionals in the visual arts will tell you that good photography doesn't have to be dressed up with junk like this. Yet, photographers who hang out together accept hokey ideas if they're told by a visiting lecturer "It sells!"

The general rules of thumb when joining an organization for business reasons are:

- Do you agree with the aspirations of the organization?
- Will you meet people who are potential customers?
- Will you be spending your time productively with this group, even if social events are a major part of their activities?
- Will this group lift your energy, rather than deflate it?
- Will this group take time from your business?

A Walking Billboard

The walking billboard for your studio is, of course, you. Encourage your family to be open about the fact that you are a photographer because their friends will tell their friends.

Every time you meet someone and say, "I'm a photographer," it may turn into money.

Here are two examples to show you how this works.

Twice a week I go to an exercise class. One day I realized that I only spoke to the women I already knew and decided to change my ways. Every time I could, I'd introduce myself to the person next to me.

The first time I did this the young woman on my right sent me a friend who was shopping for wedding photography.

Later that *same day* I spoke to a woman in the changing room and she asked if I did commercial photography. She needed photographs of her motel. This would be a job in the distant future as it had just been photographed (for postcards), but she was sure she would not use that photographer again. She thought the pictures were "dull."

The second example was a follow-up to the first! To see if my exercise class idea was a fluke, I decided I wouldn't return home until I'd walked downtown and introduced myself as a photographer to three different people or businesses. I actually did it only once—the results were so immediate, I forgot to continue.

The first place I stopped was at a clothing store. Some months before, I had met the owners at a restaurant. I went in now and, seeing no customers, I reminded the couple working there that we had met.

At that moment their assistant came into the store with an armful of clothes on hangers and seeing me, said, "Oh, I've been meaning to call you. I'm getting married." And she booked an engagement sitting right away. I later photographed her wedding.

Meanwhile the store owners agreed to hang a large display photograph of mine in the store, and promised me that the next time the family is all together, I'll be doing a portrait of them.

You may not feel like going out and meeting people just to publicize your business. But try it and you'll see it bring in dividends beyond what you imagine.

Bartering for Ads

When I came to San Luis Obispo, one of the photographers had a small ad listing his place of business, and I was told he had arranged a trade with the local newspaper. He did their photography and they advertised his business. (Remember, as far as the government is concerned, the dollar value of such an exchange is taxable income.)

For awhile I worked out a similar deal with a radio station and it ran my ads *nine* times a day. These thirty-second spots made no effort to sell photography, but my business is still feeling the impact of them ten years later.

I always noticed that the advertisements I remember are the ones with an amusing gimmick. So I tried that approach myself.

"Ou est Jeanne Thwaites?" asked a French voice and this was followed by five other foreign voices, each asking the same question in their own language. "Jeanne Thwaites?" asked an American voice at last. "She's the photographer-owner of Jeanne Thwaites Photography," and he gave my address.

Best of all, I didn't have to pay for the voices. The salesman went to our local college and found a number of foreign students who wanted to volunteer just to say, "That's *my* voice."

My favorite of those radio ads was one in which my son, Michael, then sixteen, played his guitar while an announcer tried to question him about the "photography of Jeanne Thwaites."

"Why did you come here, Michael, if you aren't going to answer my questions?" he asked at last with irritation.

"Because my mother is Jeanne Thwaites," replied Michael, "and she told me that if I came, I could play my guitar on the radio." Then he launched into a musical number.

Years later, people chuckled, "Isn't that just like Michael," and many thought the ads were still playing.

As it is *your* name the public must remember—yours and yours only—if you have something special to offer, mention it in your ad.

From the very beginning, I felt I had to push the fact that my work was "different"—not because I wanted it to be, necessarily; it just *was*.

169

Therefore, in my radio ads I hoped to give the impression that I was so sure of my skills I could laugh at myself on *paid* time. I wasn't paying for the time, of course, but nobody knew that!

I should point out that I've tried similar radio ads since, and have never been able to afford enough of them to have real impact. Also, the young man who put the original ads together was very good at it. Since then I've been unable to get a local radio ad with the same sense of fun.

Eye-Catchers

My hair stylist Pete has a notice in his salon that prices his services. The word "permanent" is written "permnent."

"You've spelled it wrong," I told him.

"I know," he replied. "People remember something that's spelled wrong."

So very soon after I put a notice outside the studio advertising PASSPOrT PICTURES. Sure enough, people came in just to tell me about it and they stayed to look around!

Not all eye-catchers need be so blatant. Anything that shakes someone up will do. How about:

1. A pot of flowers *outside* your door?
2. A new *red* doormat?
3. A light inside shining on a photograph visible at night?
4. A big *sale* notice?
5. A big *free* notice?

TIPS

The Four Ws

Be certain all your ads contain the four Ws: Who?, What?, Why?, Where?

WHO: That means *you.*

WHAT: What are you selling?

WHY: Why should someone buy photography from you and not someone else?

WHERE: Where would someone find you?

When you have prepared an ad, go over it carefully to be certain that the person who reads it is not left there hanging. Over and over I see an ad and am attracted to the product only to find the business address or phone number is not included—in one case the business name was omitted. Never be frightened of including a price—haven't you wondered, "But what does that cost?"

Clip-Art, Press-Ons, and Other Goodies

I'm impressed by professional-looking artwork so I expect it to impress others. But my costs in getting attractive artwork, logos, etc., were greater

when I couldn't afford them than they are now. I'd try to talk artist friends into making the drawings for me in return for the advertising value they'd get if I gave them a credit, but I often resorted to paying for the drawings.

When I discovered "clip-art," I no longer needed an artist. There are, available to anyone who has a few dollars, books of drawings that are not copyrighted. With a pair of scissors and a bottle of rubber cement, you can have a great time pasting up a variety of decorative formats for each price list. When I want to make up a new price list, for example, I make copies of the sheets I might need so I can leave the book intact.

I made a handout very quickly from clip-art when I found I should have had 500 brochures printed for the local high school seniors. As often happens with me, I forgot all about it until the deadline was two days away!

In this paste-up I used my letterhead for my name and address and typed the rest. The border was from one clip-art design, the center a menu design from another. Then the sheet was copied onto off-white parchment paper, which seemed appropriate as the ad looked rather old-fashioned.

It isn't easy to find clip-art in small-town bookstores. I've had the best luck in college bookstores and large-city stores. The sales people usually deny that these books are on their shelves, but you'll find what you need in the art section of the store (also look under architecture). Dover and Van Nostrand Reinhold are the publishers with the big selections. Art stores surprisingly don't often carry clip-art, and although they will order clip-art books for you, I prefer to look through the entire book before purchasing it.

Now that you have the drawings and borders you need, you can also produce professional-looking lettering with press-on letters from any art store. They come in plastic sheets and by placing each letter where you want it and rubbing heavily with a pencil (or any hard pointed stylus) on the plastic, the print comes off onto your paper. This is easier to demonstrate than explain, but takes no talent at all.

While at the art store also look at the sheets of self-stick letters, which work better when you need large letters for signs. In a recent job, I used them to mark some jogger's weights that were to be advertised. The manufacturer's numbers were almost invisible and I just placed white self-stick numbers over them.

There are also stencil letters and numbers at art stores but they are a bit crude for our needs.

When making an ad or price list don't switch letter styles too much, and pay attention to how well certain styles "read" rather than just how attractive they are.

The rule of thirds that we use to compose a difficult picture, can also be used when building ads. Divide the sheet into thirds and start the major lettering on those lines. If you need more words, you can break those thirds down into further thirds.

Five Advertising Tips

1. Choose the spot for your ad intelligently. As photographers are not interested in *you*, don't advertise your studio at a photographers' convention. Similarly, don't advertise your commercial photography in a school newspaper, or sports photography in a senior citizens'. Learn to say

no to ad salesmen who might try to make you abandon your own common sense.

It is also absurd to think that a person who will spend a thousand dollars on a single garment will clip a coupon or rush to get in under the wire on your $17.95 special. That person may be enticed with something that is *only* $250 so that he or she can buy four.

Of all photographers, the gourmet-type has the hardest time reaching his market in a single ad. The people who accept him instantly are those who are photographers, artists, architects, and other high-level do-it-yourselfers. Beverly Hills, Family, and Fast-Food, all have well-defined markets. People cross lines, of course, to buy out of their normal price ranges, but it is not difficult to guess who is most likely to read the quality magazines, the local newspaper, or a free booklet of classified ads.

2. Don't expect others to read an ad you wouldn't. If a salesman tells you that he is giving a plastic phone book cover to every homeowner in the city, and for a mere $600 you can have a small ad on it, the point to concern you is not how many homeowners there are but whether any actually read those covers. Would you?

Perhaps you already have such a cover and cannot remember a single ad on it. But maybe you are a person who doesn't read *anything* unless you have to; in that case, you must call up a few friends and ask their advice. Do they read their phone book covers? I read almost every word written on every package that comes into my home, but I don't read the ads on the phone book! When I reach for the phone book, I want to call someone right now, and I have no time to browse.

Therefore, when any ad salesman approaches you, refuse to take out that ad until you have given the matter some thought. Such salesmen invariably tell you that they have just one more space left, so if you don't make up your mind now you will be left out. Don't allow yourself to be hoodwinked.

3. When you sign up too fast, try to get out of the contract. Did you also know that you can sometimes cancel a contract you have already signed? If you feel that it was misrepresented in any way, even because you were not aware of all the facts when you signed, you can't be held to that contract. If you feel you were pressured into a too-quick decision and that you cannot afford what you agreed to pay, the company selling the ads will probably be as glad to cancel the agreement as you will. It would prefer to sell that space to someone else rather than advertise a business it might have difficulty collecting from, and will want to avoid any legal hassles. The salesman working on commission is an employee of that organization and is only interested in closing the sale, so if he balks when you want out, go to the person he works for and if necessary to the very top.

4. Don't be talked into an ad you don't really want. I'll buy advertising to any dollar value," I say now to persistent sales people, "if you'll invest the same amount in my photography." After years of no takers, a radio station phoned and took me up on it. We'll exchange $400 worth of advertising for photography.

One young woman selling ad space didn't let go easily, "But you *need* us! We want you to succeed."

"No," I insisted. "You need me to earn your commission. If you cared about me, where were you when my house burned?"

5. When trying for a trade in advertising, don't talk to salesmen—go to the top. "I'd like to talk to you about the possibility of trading photography

for advertising. How about lunch or coffee? How's your week scheduled?" is the direct way to kick off the discussion. Realize that even if you are turned down, you have now successfully advertised your studio. The man or woman who turned you down now knows you are *there.*

An Advertising Trick

Any ad that does not appear to have been paid for by you is powerful. Such an ad might include a small picture of you and underneath as many nice things as you can think of about yourself (go overboard).

Recently, our newspaper ran two full pages of Women in Business ads. We each paid $36 for our one-column x five-inch spot. A small photograph of each of us was at top of the ad with anything we cared to say about our work below. I asked that my ad be as far to the top and to the left as was possible because this is where we are accustomed to start reading a page, and I got that corner spot.

Suddenly, people I met began to congratulate me. They thought I had been chosen to be on that page. One woman told another (right in front of me), "Jeanne was given an award for her contribution to the community!"

I also found that many readers started looking at those ads and quickly tired of them. There were four pages to wade through. As I was the first one, they noticed me . . . but a friend who was on page three said she got little feedback.

A Few Examples of Smart Advertising

Read your ads over and over, and never send one in till you've let it sit overnight (unless you have no choice). Let others read or listen to the ad and then *ask them what it says.* Be sure that whatever you *intend* to say comes across quite clearly.

When playing bridge we learn to ask, "If I say three-spades, partner, what would it mean to you?"

Keep a recognizable image. Use a logo, distinct lettering, a certain picture that identifies you to the public.

A local chiropractor came into this city when several others were already in practice. His ad appeared to be a column and gave advice to people with aches and pains. A small picture showing his face was in the corner of the ad. I presumed he was a paid member of the newspaper staff, but learned latter it cost $50 each time it was displayed.

I asked him if it did him much good.

"When people think 'chiropractic,' " he said, "they now think of me."

It was true. I did. (He was treating me at the time for a neck injury.)

It wasn't long before a prominent realtor started placing a similar "column" ad, this one giving advice to people buying property. Obviously, it's a terrific gimmick.

(Some newspapers—not ours—require ads that look as if they're editorials to state, "paid for by . . ." or "advertisement" and that does take away some of the ad's impact.)

Eight Thoughts on Self-Promotion

1. Stand behind your work for great customer relations. The lab's error is *your* fault, so is your assistant's, and so is the weather. The stronger your

shoulders, the more they will be leaned on, but those who lean will depend on you to give them a fair deal. It's great to find a person who stops passing the buck.

2. Give more than you promise. If you're taking twelve poses per sitting, say you'll take eight. A happy customer is one who thinks he got more than he paid for.

3. Which sounds like more to you?

- $4 plus 50 percent.
- $6.
- $9 with ⅓ off.
- $9 with 33 percent off.

All are, of course, the same amount. If you want the price-conscious customer, then bring him in with the most effective visual bait. To me $4 plus 50 percent looks the least when compared to the others; $9 with 33 percent off, the most.

4. One photo is worth a hundred words, maybe more! Every time someone sees a photograph and likes it, it's an advertisement that has paid off the for photographer. So use photos in ads, have some of your work with you as often as possible, and lose no chance to display a photo.

5. When you have an exhibit, let the people whose portraits are in it know. They'll bring their friends and act as your agent.

6. The impact of a booth at a fair shows in your studio receipts. Even if you decide not to have a booth, one year, people will think you were there, but they didn't see you! Be sure the viewers know it was *your* booth they saw (not John Smith's or Mary Jones').

There are two ways of manning a fair booth. You can keep your distance so people can wander in and out and look closely at the pictures, or you can be there to answer questions.

Sometimes I've sat at my booth reading or writing and it has filled up. If I look up and say, "Please let me know if you need help," they'll trip over each other trying to get out of there! On the other hand I've had customers complain that I wasn't there. And for every person who complains, there are dozens of others who were equally irritated but said nothing.

A large booth solves the problem—you can sit in the corner—but at present prices of fair booths, we pay $300 to $360 for just one 10x10 space. You might wonder if you get enough advantages for double the cost. I have had double-sized booths and do as well with the single.

7. We are advertisements for our studios and we can't expect the public to notice us only when we want to be noticed. I've made decisions about business people just because of the way they behaved at a party.

8. Be proud of what you do and don't let someone else put it down.

A photographer once said to me, "Do you want to know what I think of your work?" It wasn't difficult to figure he was going to knock it, so I replied, "No!"

"You don't like criticism?" he asked nastily.

"Nobody does," I told him.

Now I have a reply for people like him. I say, "If you can do better, let's see it."

If you don't like your work, you should be doing something else. You don't have to defend it and you don't have to listen to some armchair critic. Many people make a negative comment about everything they see. It took me years to realize I didn't have to stand there and suffer.

Ten More Ways to Advertise Yourself

1. To say "I'm a photographer" isn't enough. People must know what you do for a living and that you need their business. Let them know that you own a studio and what kind of photography you do. Invite them over.

2. Don't hard sell once someone knows who you are. Don't appear hungry. All business is a kind of barter system. If the other person knows you are in the market for a lawn sprinkler and he sells them, he will automatically be very interested in you!

3. If you invite someone over to the studio who has shown an interest in having some photographs taken (whether of a product, a person, or anything else), and he doesn't show, telephone and remind him. Ask if you can send the price sheets over if he seems less enthusiastic now. Then forget about the whole matter. You've done your part.

4. Follow up. In other words, do what you said you would do. One of my most devoted customers told me that she came to the studio—even though there are a dozen good photographers in her own area—because when she stopped at my booth at the fair, I had offered to send her prices and did so. Apparently, I was the only exhibitor who followed up.

5. Write thank-you notes. I dislike receiving any form letter, however freshly typed it may look, and I don't want to hear "Thank you for your business." But I write thanking everyone for any unusual favor or kindness and these people are grateful years later.

(I know someone who won't enter a business owned by a woman who ran for public office. He sent a donation to her campaign but received no thanks, though his check was cashed.)

6. Your business card is your cheapest gift to someone else. We remember anyone who gives us something. It's better to give a blank piece of paper than not to give anything at all! Carry your business cards with you at all times, and pin them to any bulletin board you see.

7. Your business cards should either be very simple and easy to read or distinctive. So should your writing paper and all other studio-printed matter. If you have no ideas about what you'd like these to look like, stay with something simple until the ideas come. Never mind what the printer suggests; what impresses you will probably impress the customers you want. Listen to all suggestions and then go with your own taste.

Some photographers have their photos on their cards and I don't like the idea, for several reasons. Realtors do it and a "realtor" image is not my favorite. Photographers are more service- than sales-oriented. And if your picture is on your card, then it's not "your" photography. Your photography should be what you're advertising.

If you're a man and you've put a man's photograph on a card, people will think he's you. If it's a woman, some will give it a connotation you never intended. Expect sniggers.

If you're a woman, all the same applies in reverse. People thought I was a man because there was a male portrait on my *Men of the Country* exhibit notice. A business card with a portrait of a glamorous girl, prompted several people to ask if it was me. Then they looked up and saw I had neither her blonde hair, her glamour, nor her youth, and asked, "Your daughter?" Sometimes I was asked if "that girl" was me on the phone. I must have been a terrible disappointment to others when they met me.

You can, of course, have a photo card showing your work, but of

necessity it can only show a very small part of it. If you put a landscape or other neutral subject on it, then it may not give the right feeling about the commercial side of the studio.

For awhile I had my favorite work made into wallet pictures. I put self-stick labels on the other side and gave them out as business cards, but they didn't look very professional.

You might find a way to make this work. The advantage is that you can order sheets of wallets, a minimum of only eight at a time, and have a number of different cards for different needs.

8. Something that worked better for me than photo business cards was using up the end of a roll of film by photographing my dogs or flowers or some neutral but attractive subject. I'd do this with unexposed film on the last roll when I had photographed a prom and the film was to be printed uncut into packages of two 5x7s plus four wallets.

The 5x7s could then be used as postcards and the wallet pictures rubber cemented onto greeting cards, or for notes to people who love them. I've even framed some of those pictures and donated them for various charity auctions.

9. Every bag or piece of paper that leaves your studio should show where it comes from. It's cheap advertising and keeps your name visible. If you have to pay for something, let that something work for you.
- Use self-stick and gummed labels lavishly.
- Rubber stamps cost more than they should, but they do hold up for years and work well on paper bags.
- An embosser can be very effective if you buy gold seals and use a circular embosser for a beautiful label on special boxes and packages.
- Your name should be on the reverse side of all photographs and the 5x7 or larger, at least, should have some kind of signature. A "hot" pen will write your name in gold, but I also use a Pilot Scuff pen that writes on anything.

I used to stamp my name and address on the back of photographs using special quick-drying ink on the stamp pad, or a stamp pad made for fingerprinting. Recently I've found that many of my smaller photographs were being copied cheaply through the drugstore. Now every print that leaves the studio, even the wallets, has a stamped notation that the copyright is held by "Jeanne Thwaites" and that it is illegal to make copies of the picture.

10. Place an ad on a page that is *always* read by *some* of the subscribers. Sooner or later they'll notice it. For example, the sports section is always read by sports lovers; the classified section by its addicts; moviegoers check the movie listings, whether or not they can go to a movie; others read letters to the editor; popular columnists, and the community page. Where will the most readers find you?

My feeling is that the best places for newspaper ads are:
- Any supplement that is *less* likely to be thrown away after one reading—a weekly special edition, the TV section, etc.
- The community page (for portrait photographers) because brides, parents, and socialites read these pages.
- The first page of any section, the one that will be seen when the paper is folded.
- The food section—there are people who read every recipe and others

who clip every coupon. They will search your ad along with everything else.

- The issue with the biggest circulation (call the circulation manager and ask for this information). In our town these issues are Wednesday (the supermarket ad day and also the food supplement day), and Saturday (when two weekly supplements are enclosed—also the day the garage sale addicts buy the paper).

- Once you've decided where to place your ad, keep it there for at least six months, if not forever. That's where someone will look for your ad if he has seen it there before.

If you don't get the spot you want and think you're getting a runaround tell the newspaper advertising department you'll pull it. Remember that newspapers make their money selling ad space, not selling the papers. Of course, you may have to back down if they decide to stick to their guns, but they may not!

And although it's necessary to keep an ad in for some time to get its full impact, there's no reason to waste money with needless advertising. If you think you've made a mistake and don't need that ad, stop it at once.

Nine Tips on Soft Sell

1. Never push a sale. Let people think it's their idea to hire you. However, when you have made a sale, don't talk your customer out of it.

2. Show enthusiasm for *their* ideas.

E.g., "We've been thinking of getting pictures of the family."

Reply: "I'd love to take them," or "Let's do it," or "Sounds like fun," but *never* "I do a lot of family photography."

3. Never "count" on business. Just do your stuff and *forget about it,* unless you've promised the customer to follow up. In that case, do so right away by doing what you said you would do. If you lose a job, there's nothing wrong in asking a customer why you did.

4. If you don't enjoy talking to near-strangers, then work only in short bursts! It's like medicine, quickly over and soon forgotten. One hour a week telling people you are there is better than none.

5. Never try to "sell" someone who is preoccupied, (e.g., the staff or owner of a store when there are customers to be served). Wait for a time when it seems natural to bring up the subject.

6. Introduce yourself and remind people where you met. Don't leave someone floundering, "Who is it?"

7. First, talk about *them* and *their place,* not about you and your place.

8. Never take rejections personally. When someone starts praising a competitor's work, listen politely (don't necessarily agree!) but make sure that at the end of that conversation they think *you're* a very nice person.

9. Be positive. Learn to say yes first and then qualify it.

"Yes, I'd like to, but let me think about it," is so much more inviting than, "Let me think about it," or "I don't know." If you're saying, "I've got to ask my husband," or "I've got to ask my wife," score zero!

11

Pricing—What's It Worth to You?

This complicated subject, like advertising, has no definitive answer. One stock agent told me honestly, "Charge what the traffic will bear."

Pricing creates a special dilemma for me, bringing out that schizoid attitude toward money I talked of before. The photographers I truly respect grumble, too, that they *hate* charging people they care about. It would be great if someone would subsidize us and we could work gratis only for those we enjoy, but this doesn't usually happen. So how do you put a price on your work that's fair to everyone? The usual methods of charging for your initial work (the photography itself) are:

Time plus

The photographer decides on a time charge and the customer pays that. To this charge you add the costs of the job, film, processing, transportation, etc. The advantage is that the customer knows exactly where he stands and the photographer knows his time is covered no matter what.

Narrow end of the wedge

The photographer sets a minimum charge for taking the photographs. The customer is then faced with ever-increasing charges. This works best when the photographer avoids mentioning any further costs initially, answering only direct questions, and then mentioning the cheapest quality available but not qualifying it as such. Eventually, the customer has paid much more than he intended and often resents that he wasn't warned in advance.

Packages

A photographer might put together several packages and offer them for a flat fee. Model portfolios are most often photographed this way, e.g., for six 11x14s and twelve 8x10s in color and six 8x10s in black and white.

The costing has been done within this price frame and the photographer knows his exact profit from the job.

Maximum

Some photographers are able to quickly gauge what a customer will pay and can come up with a round figure and charge that. E.g., "I'll do the job for $185."

178

If the customer replies, "Can you do it on a Sunday?" the photographer might say, "For a Sunday it will be $235; Saturday, $215."

However, the next customer asking for the exact same service may get, "I'll do the job for $650 and throw in my assistant's time."

This is *extremely* effective because it makes the photographer seem like an expert (he appears to have his prices filed in his head) and of course he gets more when a "live one" walks in.

Price Lists

If you don't want to discuss the prices, just load your price lists onto the customer and let him figure it out!

Trade

All businesses welcome a chance to trade services.

I've used variations of all these types of pricing. It's difficult to know, at first, which works best; I find myself repeating those methods which have brought in the jobs and avoiding those that haven't!

High prices *will not* keep customers from coming to you, but they might not bring in enough customers to keep you in business, particularly in the beginning. The fewer customers you have, the more of a loss you experience when one decides to go elsewhere. If you have many, you won't notice the loss.

The Mortuary Approach and Other Guerrilla Tactics

A studio salesman might work on a customer's guilt. I call this the "mortuary" approach and think that the work from such studios often looks as if it came out of a mortuary. My feeling is that the body looks embalmed—"almost lifelike"—and is displayed in a velvet-lined frame that's like a coffin. But don't let me put you off. Mortuaries make a lot of money!

The mortuary approach used by studio sales staffs is to embarrass the customer into buying pictures for the family, obliquely suggesting that you love your family less if you're not willing to do so. At a sales meeting I attended recently, photographers were encouraged to call the customer's family, "your loved ones." I could hardly keep a straight face, remembering Evelyn Waugh's famous book *The Loved Ones* which was about a pet mortuary.

Although using these tactics on the public is a little disgusting, there's no doubt that they work enough of the time for successful photographers to swallow their pride and squeeze a few more dollars from each sale.

My own system of charging has worked very well for me and I've *never* regretted it. Each year I evaluate what I'm worth as a photographer, by the hour. I decide on this partly by what I've been charging, what the customer seems willing to pay, and by what others are charging. If I hear a particular photographer is charging $100 an hour and I feel that's absurd, I expect others to feel it, too.

I pay no attention to what others tell me I'm worth, or should be charging, but make this decision myself. It's easy to say, "You should. . . ," when it's not your money. Recently, a former studio owner told me that I was charging too little, absurdly underestimating what the public would pay for my work. I pointed out that I was still in business and he wasn't.

This photographer had left the business, he said, in spite of great financial success, because of the stress. He had ulcers and his heartbeat was irregular. I feel that if you're comfortable with people and treat them with respect (specifically, resisting any temptation to overcharge them), there is very little stress.

Currently, I'm charging $60 to $90 an hour and at weddings $50 to $60. A four-hour wedding makes me at *least* $200 profit . . . parent's albums, reorders, etc., are gravy. My price goes UP with more than four hours because that takes more out of me. So, if a customer signs up for a wedding coverage of $520, I'm not expecting the cost of album, film, prints, my time talking to the family in advance, gas for my car, and time putting the album together to exceed $320. My two-hour wedding coverage starts at $239. The big profit is in reprints.

Pricing Gauge

One way you might begin to gauge your price levels would be to phone a particular studio for its prices. Let's say a photographer, Lewis, is charging $65 an hour.

1. *Is your area comparable to his?* E.g., I would charge two to three times what I do in San Luis Obispo if I were in one of the more affluent areas in Los Angeles because my expenses would be greater. Also, my customers would expect to pay more; indeed, they would not respect me if I charged less.

2. *Would you benefit by undercutting Lewis?* If you would, then try to make the public aware that your prices are lower . . . for equal quality.

3. *Is he successful?* He may be overcharging, and in that case, he may not be doing much business.

4. *Do you feel, instinctively, that he could get more for his time?* If so, then go ahead and charge more.

The advantage of being up-front with my prices is that I can tell my customers that if they take my hourly charge out of the total price, then they'll see exactly what the material and overhead costs for the job are. I explain that it's immaterial to me if I do the job by the hour or by the project because I'll come out about the same.

The Choice

Have three different prices for everything you do—not three prices for the *same* thing. Appeal to the:

1. Person who has to have the top-of-the-line.
2. Person who always compromises.
3. Person who buys the cheapest, whatever it is.

When customers start ignoring the cheapest prices *or* start ordering mostly from the most expensive, then you are priced too low.

Some photographers offer three qualities of print: a machine print, custom printing, or canvas.

Others specialize in portrait packages giving progressively larger quantities of pictures with the more costly packages. There are photographers who have different sitting fees for a studio sitting, an outdoor sitting, and a studio and

outdoor sitting. Other photographers price their sittings by how many pictures they take.

If you wonder what to charge when conventional mark-ups don't seem to fit your needs, break your prices into the three ranges.

There's a theory that if you give a person a choice of three, he'll usually choose the item in the middle price range. I've found this doesn't apply to my wedding prices; customers either choose the cheapest line or the most expensive. These prices are based on the style of album. More than $100 separates the cost of the least and most expensive albums with the identical number of pictures in them.

There's one line of albums that sells very rarely, but until my stock of them runs out, I'm stuck. This is the mid-sized album.

You can change your prices up or down, but if you give only one price, and the customer walks away to "think about it"—which usually means he has thought about it and decided "no"—you may never know why.

On the other hand, if you have a price *range* you can gauge his reaction pricewise by the discussion. Using the album example, I've noticed the bride who can afford what she wants will ignore prices and say, "I like *that* one," even if her mother pretends to read the price sheet to show you they're on a budget. But if a bride *first* studies the prices and points to the cheapest listing and says, "What does *that* one look like?" she'll, of course, be more limited financially.

By the way, when you know you have lost a customer it's the time to try anything to get him back. Don't just sit there. Now is the time to try out all those selling techniques you've wondered about. You have nothing whatever to lose. The fact that he entered your studio with the intention of having photographs taken makes him a much more valuable target for your selling techniques than a dozen people chosen at random for a marketing letter.

Reprints

One way to charge for reprints is to have several grades of printing and several prices. A sensible markup is five to nine times what we would pay to have the picture printed (less for very large prints and for orders where we can afford to take less because of the volume). Another way is to decide the profit you want per picture and add that to the cost of printing.

Let's say you have an 8x10 printed for $3. You could charge $21 ($3 x 7), or $21 ($18 profit). But if you paid $10 for a custom 8x10 print you're now talking $70 ($10 x7), or $38 ($18 profit).

Very soon you get a feel for what you should charge. Sometimes a price seems too low, sometimes too high. If you wouldn't pay that yourself for this particular job, adjust it. An example would be a continual run of orders from a specific family or company. You might be wise to discount one order sharply, because intuitively you feel they are getting tired of forking out all that money to you. On the other hand you might sense a wealthy person is going to be a pill to deal with and take much more of your time than you would ordinarily spend on this particular order. Estimate the job higher than usual to allow for that waste of your time.

When I discount a job, I do not discount my time charge, but the cost of the reprints. I want my pictures out there advertising my studio.

With restoration work I now charge no markup at all. I send it all out and charge my customers $60 an hour for my time and $30 an hour for my assistant's time, with a minimum one-hour of my time charged per order. These time charges are *just* for handling the order, and knowing who is the best person to do it! In addition to this time charge the customer picks up the entire tab for phone bills, mailing, and the actual print job which I will send to one of many specialists (Venetian Arts perhaps), who will do a superlative job. I get an estimate for the job first, and if the customer turns it down, I might charge for my time anyway, though sometimes I don't.

On a really complicated restoration job, I might still make only $60 (it more usually runs $90), but the customer is grateful for saving several hundred dollars which is what the other labs have quoted her above my price. For me, it's like picking up $60 off the sidewalk, my work has been so minimum.

You might be thinking, "But the more expensive studio would have made *much more.*" Of course, but it didn't get the job at all so it made nothing!

My pricing is geared to people like myself who want to know in advance what a product will cost. I have no sitting fee but my initial charges are higher than most studios. For instance, a customer who books a 16x20 sitting pays $215 for a framed (usually a silver aluminum frame) 16x20 portrait plus one 5x5 of every pose. I discuss this in detail in Chapter 12.

My reprints cost much less than the same quality elsewhere ($24 for an 8x10). I want my customers to order *lots* of pictures. I'd as soon make a $50 profit from selling six prints as from one. Although my customers are usually able to afford what they want, I'm also dealing with rural working class incomes where price is a major factor. My customers have often decided in advance what their limit is. I'd rather that they'd come in under their budgets than feel they couldn't afford my prices.

More Pricing Options

Because I don't want to turn *anyone* away, I have a mini-sitting that I use occasionally. Affluent people used to take advantage of it and so I discontinued it except for particular needy cases. In a mini-sitting I might take only two or three pictures, and the choice of the final portrait is mine. All the customer decides is the size. It's like going to an artist and saying, "Paint my portrait. I want to be painted in an outdoor location," or "I'd like the painting to be a close-up."

Meanwhile, I get a creative kick out of the sitting because within some very broad limits, I can take the picture any way I want and it has been paid for in advance. I price the mini-sittings: $65 for an 8x10 (additional fee for more than two people on 8x10s only); $75 for an 11x14; $145 for a 16x20; $210 for a 20x24; and $400 for a 30x40 (so far no takers for the 30x40 on this price list).

These prices include no extras such as retouching, framing, or sprays, and customers pay a higher price for reprints than off my other sittings. The reason is that "mini" customers can usually afford a special gift for someone who isn't on as tight a budget. E.g., the most recent mini was booked by a family of seven

children (aged thirteen to twenty-four), who wanted to give their parents an anniversary present. The 20x24 mini gave them what they wanted. If the parents had ordered the picture they would have paid full price.

Psychologically, this has worked to my advantage. If such parents reorder, they then see only my normal prices and the gift seems like an even greater sacrifice from their kids. If their children have been so generous, how can they refuse to be?

I might show a customer the proofs from which I have made my selection and if one says, "But I prefer one you didn't choose" I then say, "You may order that *too,* or we can treat the sitting as my usual portrait sittings, which start at $145."

When a job comes in that is outside my normal pricing, I insist on preparing an estimate and calling the customer back. Usually, how much time will be spent is the most important factor to be worked out, but I might phone other studios or consult the *Blue Book of Pricing* as a guideline. I occasionally take the *Blue Book's* suggested low and high price and go right down the center for mine.

I think the *Blue Book* prices are a bit steep. But the $64 book paid for itself within a week of purchase when someone wanted a photograph for a public building. Before that, I'd been charging less than half what I got for the same print.

Going by the Book

I consult the *Blue Book* when:

1. There's no need for me to be concerned about someone's pocketbook and the job is outside my normal price sheets. E.g., I'm hired to go to a particular event, take a single picture, and return. The customer wants me to put aside all other business to do this job.

2. The customer expects to pay well. He may be from an area where good photographers charge premium prices. I'm therefore not going to undervalue my work to him.

3. The job is difficult and may have several presently invisible potholes. I must get top-dollar for it or I might end up doing the job at a loss.

4. The customer patronizes me. I give no "bargains" for bad manners. If someone starts pushing me around, he invariably pays more than my regular customers!

When someone complains to me that another studio is absurdly high on photography he needs, I often undercut that studio. If I'm not already under the price, I work it around so that I now am. If I like the studio owner, however, I never do that!

It's very easy to pare down your prices.

● Drop special charges (location charge, extra people in picture, transporation fee).

● Think of some gimmick to charge less; it's June, you're on vacation, the customer reminds you of your Dad.

● Discount to special customers. If the customer is a computer programmer, give him a discount for being one (a professional discount).

When pricing a job, I may also call someone who knows what that customer is expecting to pay. If it's a company that's hiring me, I might ask, "Will I have to cut corners?" "Are they putting out bids on this?" "Do they really want *me* for this job?"

In one case I asked a businessman if a picture for his boss should be behind glass or not, as he knew where it was to be placed.

"Don't put glass on it," he replied. "It will certainly be damaged and he'll have to order another and you can put glass on the second one."

I put it behind glass!

When talking prices, I watch my customers and suit my manner to their pocketbooks. If a customer is intensely price-conscious, we might talk a *lot* about money, discussing how everything can be done cheapest.

It's agonizing to hear, as I have done, a desperate, "We have to pay *tax*? But we've been saving for this and no one told us to save *tax!*" Or from an elderly woman, "I can't pay now, but I can bring you $25 every payday."

It's also touching to know these people can get much cheaper portraits elsewhere—at Sears & Roebuck, K-Mart, and other chains—but they've seen a picture I took and they want *that* photographer.

I've spoken to other studio owners and one of the surprises of this business is that so many people with very little money still want quality photographs. Tom Smith of Santa Maria told me of one poor family to whom he discounted a slightly damaged frame. They would have none of it. They went away, saved the money, and returned and bought the best frame in the studio.

It might take longer to tie up a cheap job than a costly one and meanwhile you make a lot of friends in many walks of life!

If I had to give a photographer starting a business three pieces of advice about pricing they would be:

1. You're talking about someone else's money and should be grateful that they have chosen to give it to you. Respect someone else's pocketbook as you would like him to respect yours.

2. Respect your work and make a fair profit on each order. You're not a wholesaler or a drugstore. Don't charge as if you were.

3. You can always raise your prices. But if you start too high, you're giving the established photographer the advantage.

Coping with Inflation

To multiply the base price by seven or nine, or whatever factor you decide on is sometimes dangerous. If your cost goes up 50¢, should the customer then have to pay $4.50 more? If that's for a very small print it seem excessive—a raise from say, $7 to $11.50. Yet $21 to $25.50 seems fair.

One way I cope with the rising costs is to raise my prices beyond what I need to, and then the next raise or two in film costs and lab fees have already been taken care of. If you do this on a couple of price sheets or even one at a time, then it's easy to absorb price increases. As an example, raise the base price only and leave the reprint prices where they are, or vice versa. If too many prices are raised simultaneously the public pulls back.

I've also found that it's to my advantage to raise my prices out-of-step with my competition. I leave my prices where they are when other photographers hike them so that I appear to be the best deal. When I raise them, I do that alone.

Raise your prices *enough* if you raise them at all.

TIPS

Prices Over the Telephone

Should you give prices over the phone? Why not?

There's no reason to be secretive about your prices. If the caller isn't sure what he wants, give a top figure and a bottom figure and invite him over to the studio to look at the pictures.

It is, however, important to deflect customers from prices. You're not selling mayonnaise, you're selling talent, so keep the conversation going. As soon as you find out something about that person (name, interests, what he needs the pictures for), the situation has changed. You're now talking about photography, not just the cost of it.

How to Deal With Customers Who Expect Dime Store Prices

"May we borrow the negatives, then?"

I had given a woman some pictures of her sparrow feeding her cat as a gift. Following up on an ad in the newspaper, we had gone to get my son a kitten and saw this unusual sight—a crazy little sparrow who was determined to share his worms with the cats. I had the camera in the car and asked if I might photograph them.

Later, she phoned to ask if she could buy extra copies for her friends, expecting to pay drugstore prices. I mailed her my cheapest price list. Even so, she came to the studio to try and get the negatives.

What would you have done?

I didn't handle it very well. I explained to her that a photographer couldn't allow inexpensive printing of her work. I got on the defensive, showed her custom price sheets of prices I had to pay, etc., etc. Nor could I afford to give her the number of prints she wanted.

Had it happened today, I would simply explain that I cannot allow inexpensive prints of my work. Then I would turn her over to my assistant, who would have been instructed to explain how much this generous gift would have cost if I'd been paid to take the pictures. The assistant could also suggest that she have photo cards made at the studio, the cheapest way of buying smaller prints (cheaper, in fact than wallet-sized prints).

There are times when it's better not to handle a sensitive problem yourself. Someone else's explanation will sound more reasonable.

My way of dealing with this—explaining what I did for a living—left her annoyed, not grateful.

However, I did stop short of saying, "I wish to God I hadn't given you the stupid pictures," even though I felt it. I've heard of photographers turning on ungrateful clients in a rage, and I'm sure they've lived to regret it.

8x10s and Other Yardsticks

Currently, photographers are judged by what they charge per 8x10. I feel uncomfortable when another photographer asks me what I charge per 8x10. What does it matter?

Here are some questions that interest me more than the actual selling price per picture.

1. How many prints does the photographer sell per year?

2. How much does he spend to bring in those orders (on ads, etc.) and pay the lab costs?

3. What is his net profit per print?

If no. 1 and no. 3 are high figures and no. 2 is low, then I become very interested in what he charges for *all* the sizes of prints.

Photography by the Inch

Eastman Kodak's publication *Studio Light* is, in my opinion, the finest photographic magazine for the studio today. Ask for it; it's free if you're in business.

A Kodak sales representative once said to me:

"Why does someone like you sell your work by the inch? Charge for a portrait the way an artist does and decide yourself the appropriate size for the picture."

If you're already in the studio business, you'll know why I ignored him. Customers expect to pay by the inch. They think by the inch and don't see why they should pay as much for a small picture as a large one.

I have only one customer who doesn't care what size my portraits of her family are. She asks me to choose the size I think the picture will look best at. In her home she has one 30x40, several 16x20s and one 11x14 of my work. She's an artist, which is probably why she doesn't think in inches.

However, the point I want to make here is that just because someone represents the largest photographic lab in the world, he can have his own opinions and these may not be appropriate for *you*. Perhaps this is what I like best about the Kodak people. They think independently yet can give you all the advice of their great organization's experience. But it's necessary to know when a representative is talking as himself and when as a Kodak man.

Taking the Hidden Profit

As a photographer, you're not an ordinary retail merchant, but you do sell some retail items.

You can, therefore, approach your sale of retail items in a way that's different from a department store and make a little more money.

Let's say you're selling photo albums, not as a part of a wedding, but in the way you might sell a frame. If you were to buy a case of albums, you needn't pass on that "case" price to the customer.

When you buy at the "case" price, and get a better price per album, you take the profit.

In addition, when your business buys in case-lots, you're inconvenienced in that you don't have a warehouse. You can, therefore, charge a stocking charge—rent for the space that holds the frames. That

stocking charge is passed on to the customer, too. In this stocking charge is an additional "hidden charge," which is the amount you'd normally be earning on your money, if you hadn't decided to buy that case of albums.

So let's say you buy a case of albums at $25 each (individually priced at $30 each).

It's usual to *double* the cost of the album to find the retail price, but in this case you'd still use the $30 figure (single-album cost) . . . $30 x 2 = $60 (instead of $25 x 2 = $50), and reward yourself for $3 for stocking the item. The retail price is now $63.

If the cost of that album goes up, and you still have eight unsold, reward yourself again; this time for being smart enough to buy at the lower price. E.g., the album would now cost you $35; so your customer pays $70, plus the $3 stocking charge equals $73.

You paid $25 for the album, and now your profit is $48—instead of $25. You've been more than adequately rewarded for making such a good buy.

What if you only charge $50 now for the album (double the actual cost)? That means any photographer who buys this item now for the first time is making more money on it than you. Yet you thought you were being smart by buying by the case lot. He's making twice *his* cost, which is $70, of which $35 is profit. You're making only $25 profit and haven't had the use of your money since you made the purchase. It therefore becomes important to keep up with the new prices of items you stock and bring their prices up-to-date.

Three Tips on Pricing

1. If you're selling a diamond don't charge as if it were a rhinestone and vice versa!

This stuck with me after a visit from a photographer, Jack Wilson, whose newspaper pictures had attracted my eye for some time. He dropped by the studio one afternoon, introduced himself, and we talked for a couple of hours.

At the end of that talk he said, "I'm going to give you some advice. You're trying to sell a diamond at rhinestone prices, and people don't respect you for it."

Never one to slough off advice that comes from a knowledgeable source, I doubled my prices that day. Two months later I raised them again, to what was now three times what I had been charging. I did this on Jack's word that a price increase meant not just more money, but more business. He was right.

Put yourself in the customer's shoes for this one. You phone a photographer and ask what he charges for a 16x20 portrait. You know what you're prepared to pay. If the cost is a *bit* higher than you expected, you'll go over and look at his work. If it's too high, you probably won't. But it it's too low you might think "Well, this isn't what I wanted. I wanted quality work, not something *that* cheap." You'll make another phone call.

That's what had been happening to me. I wasn't getting the customer who hadn't seen my work, the one who was making phone calls from names in the Yellow Page listings.

2. At my old studio I nailed a small handwritten note on cardboard at the downstairs entrance. "Upstairs," it informed passersby, "Passport

Pictures," and an arrow pointed to the stairs. Right away people rushed up those stairs! I was charging more at that time for passport pictures than any photographer in town, but I suppose because the notice looked cheap, the public presumed I was cheaper and for passport pictures that's what they wanted.

3. One year I had the idea that a photographer like me shouldn't charge for passport pictures. When someone came in for portraits, I'd provide them with passport pictures if they needed them, *FREE*. Stupid idea! Most of my customers can afford to pay for *any* pictures and if I wanted to give them a gift I should have given them something they would really appreciate like a loaf of good bread, always one of my favorite gifts to receive.

People Don't Respect What is Free

When I was involved with a radio program that offered a free 8x10 to the holder of a coupon, I learned a valuable lesson . . . not everyone respects what is free.

Some people did, but others would stand rolling their picture through their hands as if it were a gum wrapper. Some didn't even bother to come and pick theirs up.

This program produced some of the best work I'd ever done and it brought me a lot of attention and repeat business, but it was horrible to have to sit there watching someone twist my photograph of him. It left me simmering! I'd never again be part of a promotion where the customer paid nothing at all.

I now offer a two-fer with such promotions, "two 8x10s for the price of one."

Others use, "Buy one and the second is one cent" (or half-price). You can, of course, offer a free frame with the photograph or eight free wallets.

Underbidding

There will be a time when you'll be asked to bid on a job.

You must, of course, ask what the work entails, but also question whether the lowest bidder will be chosen or if quality will be taken into account.

If it's a low bid they're looking for—let's say it's school pictures, or team pictures—then you might wonder where to start.

First, if you have any doubts about how to do this job, call a reputable lab, one with experience in all lines of photography, and talk to someone there about it.

A lab won't tell you what to charge, but will advise you of what the "usual" charges are. E.g., "Most photographers mark the job up by three to five times cost."

Remember, if a job is being given to the lowest bid, the low bid need only be a few cents lower than the next to lowest. By charging say, $7.65 per person photographed instead of $7.95, you might get it.

But don't charge too little. Better miss the job than take it and run into disasters. Any bid should give you enough money so that if you ruined the entire job, you could redo it and still not lose money. That may not be your option—you might have to return the money—but don't bid so low that you can't afford to retake the job.

Any goofs on such jobs are usually minimum—a synch cord slipped, the x-setting slipped to the m-setting (tape that down before going on a job), a flash failed. You'd probably catch the problem and can redo it on the spot.

However, I've been told by lab representatives that photographers have been ruined by taking on an enormous job at too low a cost. By "ruined" I mean one had to file for bankruptcy and leave town.

Team and dance photos—where there are a large number of separate portraits—can bring you a higher profit if you find one of the many labs that specializes in the field. Their prices might run sixty cents per package lower than labs specializing in "custom" prints. If you have 200 to 500 people to photograph that's $120 to $300 more for you.

These labs do an excellent job (Bremsons and Associated Photographers come to mind), and they do it fast.

The choice of one lab over the other for this kind of lowbidding doesn't just rest on price. You might not want to entrust to the mails film that can't easily be retaken. You should, therefore, find out exactly what your local labs will do for you before sending the film across-country and if you do send it off, secure it well, and mail it in a box—I use First Class or UPS—never by parcel post.

12
Operation: Studio

The boring part of a business is running it. Creating the pictures is the fun part. So we must set up a system that cuts out all unnecessary work.

The basic operation of a studio should be simple, consistent, and clearly laid out by its owner. Everything should be done the same way every time. If you want a paperclip you should know *exactly* where to find it, and everyone should learn to put things back in place after they've used them.

Because of my office training I was able to start with a system that has never needed changing. Also because of my experience as a temporary secretary in so many offices, I noticed that a number of them were doing paperwork that was unnecessary. Someone had set up an office in a particular way—often an extremely inefficient way—and years later, his successors were still filling books with needless information.

If you're running a factory, it may be imperative to run a "costing," which will juggle the figures of your business and give you various averages, estimated future earnings, etc. If you're running a one-man photography studio, you could use the same costing. But do you really need to know the comparative ratios of the different kinds of work you did over the last five years, or which month comes closest to your average income-per-month?

If you're already running a studio, it might be worthwhile to analyze the way you keep your records. If you've been doing unnecessary paperwork, the remedy is immediate. Stop.

Office Procedures

1. Each job must be done *once.* It should be done correctly the first time. A great timewaster in an office is having to do a job over. Whoever does it should be responsible for its accuracy.

2. One glance and anyone should know what any piece of paper says. No creative handwriting, either. I don't let up on this. I detest trying to read something that should be taken in at a glance.

3. Each worker must exactly continue the system of the previous one. Columns of figures must be written precisely, one under the other. There should be only one creative aspect in the studio—the photography. For this reason an as-

sistant who isn't methodical is a waste of time and money.

4. Forestall an error before it happens. E.g., if each glassine has both the customer name and the file number, then surely *both* will not have been entered incorrectly.

I tell my workers to expect to make mistakes sometimes and my system protects us against human error. If we pick up a glassine marked "Smith," the file number protects us from putting this in J. Smith's instead of H. Smith's file. (I once had three unrelated Walkers come in for photographs in one week. Last Christmas we had six different Smiths.) If we find two glassines marked 83066 (with negatives obviously taken from different orders), then the name will clarify which one should be 83066 and which is the mistake. The master index has all the file numbers numerically listed with the customer's name as well. Thus, the error can be corrected without pulling any files.

5. Anyone can make a mistake but when he makes it more than once, it's time to be on the lookout for sloppy behavior and take that person aside. Too often I've avoided a confrontation and regretted it later. Tell the employee you care. "Please be more careful" is all it takes.

Portrait of a Portrait Sitting

Here's how a sitting is treated, "businesswise" at my studio.

Someone wants a picture taken. It's a woman, Mrs. Murgatroid, and she wants a portrait of her three-year-old son, Felix.

She has phoned for an appointment and decides to come over and look around first, at which point we give her our price lists. If she wants them sent to her home, we do that, too or I quote her prices on the phone.

Mrs. M. might have just walked in and done all this on the spot, but however she makes her first contact, she is welcomed warmly, put at ease, and allowed to take her time making decisions.

She asks questions. "What colors do you recommend for Felix's clothes?" I tell her what I think. "Keep it simple; not too many clothes. The colors aren't that important. Bring a few outfits so I can decide on the spot."

I might also ask questions; does she want a simple portrait of Felix or a little action scene of him playing? Should the sitting be outdoors?

I let her look at albums of pictures and at the framed work on the studio walls. I note which pictures she likes and which techniques don't interest her. If there's any doubt in my mind, I ask her to tell me what photographic techniques she doesn't like.

Let's say Mrs. M. decides to go ahead (either right away or at another time). My studio policy is to take the pictures on the spot if I feel like it and the customer is looking his best and wants to go ahead. More often an appointment is arranged.

The Appointment—Be Flexible, But Firm

I encourage customers *not* to be photographed unless they look and feel great. I hate to spend time on a sitting only to hear, "I had a headache that day."

"Call and rebook," I tell Mrs. M. "I want to photograph Felix when he's rested and in a happy mood." Most young people, of course, look pretty good all the time!

If Mrs. M. forgets the appointment, and we haven't remembered to call and remind her the previous day, then I shrug it off. If this happens more than once, however, I refuse to take the third booking without a deposit being paid. If the customer doesn't show without phoning first, the deposit ($25) becomes mine.

These protective policies are always explained with good humor. "I put aside the time for the sitting, so when someone doesn't phone, it costs me money. The deposit costs you nothing and comes off your bill even if you're detained, provided you phone to say you can't make it."

I've never had to keep *one* such deposit! If the sitting is on Saturday a nonrefundable deposit of $50 is paid on every sitting.

If Mrs. M. calls and drops the sitting for any reason, I say, "Well, let us know if we can help another time."

Payment—Now or Later?

When the pictures are taken, Mrs. M. signs a purchase order and pays a deposit of about half of what she has signed up for. Of course, if she wants to pay all of it, I don't argue. At other studios she'll pay a sitting fee. This is, of course, at the photographer's discretion. I occasionally use a sitting fee when a customer's needs don't fit my portrait sittings, e.g., political candidate's portraits. Then I charge $45.

The sitting fee works like this:

1. The customer pays a nonrefundable sitting fee (let's say, $35, though these fees vary considerably), which should cover the cost of film and processing.

2. The photographer provides "proofs" or "previews" so the customer can choose which, if any, poses he'd like made into portraits.

3. The proofs are then offered for sale, either as a package or individually (or both). E.g., $35 the package (eight to twelve), or $9 each.

4. The customer then orders whatever he wants, pressure being put on him to bring in the biggest order possible right away. It's much more profitable for a photographer to insist on speedy ordering than to say, "Well, take your time. There's no hurry." Give a discount for an order in, say, fourteen or thirty days.

5. Future orders have a higher "first print price" and when this is made clear to the customer, he starts thinking about what pictures he'll need in the future and should order now to save a few dollars.

Back to Mrs. Murgatroid. She receives a 5x5 copy of every pose from the sitting, but I don't give her pictures of Felix if his eyes are shut, his tongue is out, etc., unless they're cute. Nobody wants to see uncomplimentary pictures of themselves or their children. These 5x5s are custom proofs, but we don't call them "proofs," although I tell Mrs. M. frankly that the film is printed uncut, yet each picture has been individually analyzed. When each negative has to be loaded individually into the holder the cost of the print is higher than if the film is run through uncut and printed full frame.

Mrs. M. has signed Felix up for one of the many different portrait sittings, the difference being the size of a single final portrait that she gets framed (minimum size 11x14).

Mrs. M. must decide which of the poses she'd like for that portrait and gets a price break on other pictures ordered at the same time.

Lab Work Records

Each order is entered in a book as it goes to the lab. The orders are entered by date and state how many prints are needed and our customer's name. When an order returns, the date is recorded. If a customer phones about his order, we can then tell him where it is and whether it's being printed, retouched, or framed. We phone the lab and check if the delay is unusual. A certain lab may usually have a "turn around" time of two weeks; if the order is not in three weeks later, obviously *something* is amiss. Perhaps retouching the negative has taken longer than usual, but it could be more serious (the lab has sent the order to the wrong photographer).

Any time we send out for something—whether print orders, estimates, or merchandise—we enter the item in this book. Thus, if we send a negative to be printed, then don't like the color and return it to the lab with a request that it be reprinted, and later receive an additional print order off that negative, there will be three separate listings of that same negative—a record of where it is at all times.

The sheet in the notebook we use looks like this:

Date	Going To	Lab #	Order	Customer	Returned
2/7	Photic	43887	30x40	Jones	
			$11x14^8$	Phillips	3/1
				Display	
2/8	Arrow	37667 RUSH	$rolls^4$	Miller	2/11
2/8	Photic	43888	$8x10^4$	Cathay	
			5x7	Jones	
			$5x5^6$	Somerset	
2/8	Duffy	retouch	neg^3	Mark	
				Wiser	2/16
				Smith	

You'll see that the record is easy to read and that the order of 2/8 to Photic has not been returned, though the others have.

Which Lab is Best?

I do no color printing myself. If you're doing your own printing, remember:

1. A photographer costs more than a printer. In other words, hire a printer, not a photographer, if you can't handle all the work.

2. A good lab will have better darkroom equipment than a photographer.

This makes no difference to black-and-white printing, but makes it very difficult for a photographer/printer to keep his quality high. I'm told by lab owners that to get optimum service from lab equipment chemicals should be run through the tanks every day.

3. It's usually cheaper to use a lab than purchase top equipment for low-volume processing and printing.

4. If you're looking for low-cost lab service, what you particularly need is consistent excellence. Thus, if you decide to use a newly established lab, insist on the same quality after a few months that you did initially.

Most labs offer "machine prints" where the negative is not cropped to your exact specifications and a machine (operated by a person, of course), makes the decisions about print quality. They also offer "custom prints" of many qualities. The *ultimate* service is a print that costs more than most of us charge our customers. The lab may offer to redo this as often as the photographer wishes, matching color to his exact needs.

All this comes down to the fact that there are actually two kinds of labs:

1. One is extremely proud of its work and no matter what the customer pays, the print quality will be excellent.

2. The other doesn't know the difference between good and poor printing. The lab that sometimes prints well, sometimes not, belongs in this category. Whoever okays those prints before they're returned either doesn't know or doesn't care about print quality. If he did there would be consistent printing. If you feel you're "lucky" to get an order without flaws, then you have this kind of lab. If I were you, I'd look for another one.

If a lab you've been using starts turning out poor work and doesn't correct it when you complain, you might as well find someone else who will. Some years ago I discontinued using what I thought was the finest printer anywhere because the prints he used to return clean became dirtier and dirtier, and eventually took hours of spotting. I later found out from a Kodak representative that this man had set up a darkroom in his garage; I suppose it's not easy to have a dust-free garage. At first he was careful, but as business picked up he'd gotten careless and it was costing me money. It's a very competitive field and the owners of labs know there are dozens of others for us to choose from. Use the lab that wants your business the most and works to keep it.

Stand Behind Your Work

I guarantee my sittings; the customer and I both have to be delighted. I don't wait for complaints but tell a customer immediately if I'm not happy with the pictures and offer to retake a few more. Often the pictures will be fine technically and I'll still retake if they're not spontaneous enough or if they have no emotional quality.

I have to do this, as I'm continually making cracks about photographs that look embalmed. If I've missed on four frames, then I know my timing was off, and I'll retake a few pictures automatically because even if those eight pictures are acceptable, it was an off day for me. I can do better.

I've promised the customer eight 5x5s (unless she's decided on a double sitting when she will get sixteen 5x5s), and I now give her several more. I always give more than I say I will.

Each roll of film has twelve or twenty-four exposures and I expect to get a good picture on each frame.

So Mrs. M. expects eight 5x5s but will probably find twelve 5x5s instead. What I'm sure of is that she won't get just eight.

(Sometimes as I photograph a sitting, I think things are going wrong and take additional shots to cover myself. When the prints come in, I might find I was doing just fine and now I may have sixteen prints for Mrs. M. In that case, I give her a choice of twelve and I keep four; or she may buy those four at a discount.

Packaging: Advertising in the Bag

We deliver photographs in transparent heavy-duty plastic pockets with tissues separating the prints. We buy the pockets from Twentieth Century Plastics. (There are several other plastic-product suppliers, many with their own catalogs.) Because it's unlikely that these pockets will be thrown away, they have a gold label with my name and address, so they can advertise my studio while they're in Mrs. Murgatroid's home!

These pockets have replaced folders at the studio, although I have those, too, but charge for them. All folders have my name on them, too.

I also have much lighter-weight plastic bags for albums and frames. These have the advantage of being waterproof, plus they're reusable and very inexpensive. I get them from a local wholesaler who sells paper products.

Paperwork

All correspondence and other paperwork regarding an order is kept *with* the order until it's complete. This package, just a bundle of papers either stapled, paper-clipped, or rubber-banded together, is then held until there are no questions about the order. Only then is it discarded.

I prefer to keep such "packages" until the customers' checks have cleared the bank. The proof of that is sometimes a month or more after they've been written.

When an order has been mailed to a customer, we note on our duplicate order form which day it was sent and keep all paperwork related to that order till there is no question that the customer has received it. I never even discard an order form that had to be rewritten because the customer changed his mind. Most customers are entirely straightforward, but there are those very few who set you up so they can say, "I've paid for this," when they haven't.

Occasionally, I meet photographers who tell me that they have never had a bad experience with a customer. All I can think is, "Then you haven't done much business."

If there has been a complaint on an order I keep the paperwork for a whole

year. I don't file it. I just keep throwing the package back into my filing bin. Fortunately, this doesn't happen much.

The Snowball

I'm always aware that Mrs. M. and her son Felix are the beginning of a snowball of advertising. What they say may not make or break me, but it doesn't hurt if the snowball is good news.

What I do know is that they won't hide those portraits under the sofa. If they speak well of my work and show it where someone else might admire it, that person will start a snowball of good will. If not, it's a grim thought.

If Mrs. M. is a difficult person, even with her friends, then she can bad-mouth me all she wants and no one will pay attention because I'm just one in a long line of her gripes. However, if I've genuinely failed her by treating her ungraciously, producing substandard work, or chiseling over money, then those complaints will ring true to her friends. A snowball of negative remarks has started rolling, my business will suffer, and I'm to blame.

And let's not underestimate Felix. He won't be three forever. Some of my greatest advertisers are small children who come proudly to the studio and tell their friends, "She took my pictures when I was little."

Negative Files

Felix's order is given a file number and each negative is numbered to match the print. Let's say there are twelve negatives in that particular order. On the reverse side of each print there will be a number from one to twelve. This will match the negative numbers on that roll. If several rolls are used for a sitting, the negatives must also be renumbered consecutively by hand, or there will be two or more negatives of each number. We use a Pilot Scuff pen for all negatives and prints, as it is waterproof and writes well on slick surfaces.

All prints have my name and a copyright protection notice stamped on the reverse side to prevent pirating of the picture.

Every order at the studio is numbered consecutively as it comes in, regardless of the category of photography it falls into. Thus I have a quick check of how many jobs I'm doing in comparison with last, or any, year.

In the index file, the first two digits of the file number show the year the picture was taken. The last three show how many orders have come in that year.

Felix was the 102nd order in 1982. I know this because his file number is 82102. If his were the third order in 1984, his number would be 84003. If I had more than 1,000 orders in the year, I'd extend the number to six digits (841002, 841003).

Mrs. M. points out that I photographed Felix's sister in 1978. I look her up; her number is 78362 (the 362nd order in 1978).

The index of these numbers is kept in a ledger I started the year I went into business, that is, 1965. The list looks like this:

File No.	Subject		Ordered By	Phone
82101	Bobo (poodle)	C	Steve Garry 101 6th St.	555-2222
82102	Felix Murgatroid (3 yrs.)	C	Mrs M. (mom) 143 Del Mar Ave.	555-7682
82103	Harrison, Joan	B&W	202 Grosvenor	555-9740
82104	Law, Harold	pp	43 Golden Ave.	555-2472

You'll see each number is written in full. This is followed by the subject of the picture. The next column gives a brief description of the type of sitting; "C" for color; pp for passport. Then follows the address of the subject, or the name and address of the person who is responsible for the order. Finally we have the phone number.

At the beginning of each month we make a note so I can see how we're doing compared with the same month in previous years.

I insist on tidiness and that the record be kept the same way every time. When an assistant messes up with too many erasures, alterations, or creative handwriting, I cancel the page and make her redo it.

It's cheaper to spend an hour making the file legible than to go several years wondering what happened on that page.

Our negative files are recycled 4x9 envelopes, the type used in most offices, so our junk mail helps pay my overhead! I recycle *everything*. If corrugated cardboard mailers come in looking clean and in good shape, they're used for our mailing and also for my customers who pick them up at no charge for sending their pictures at Christmas. When they do, I give them a supply of *my* labels—advertising!

When large print mailing boxes start mounting up, I send those to the nearest lab for *them* to recycle.

Back to Felix. If his mother has ordered more than once, his file will look like this:

Sally Tootone
18 Corvette Drive
Sunroof, CA 93006

3-8×10^2 11x14 -Display 16x20
8-5×5^3
6-5×7^2

Thwaites, Jeanne
1957 Santa Barbara
San Luis Obispo, CA 93401

FELIX MURGATROID

3

The first line shows me that negative three (which is also my favorite picture, as you'll see from the number on the bottom right of the envelope), has had two 8x10s, one 11x14, and one 16x20 (a studio display print) ordered from it. Negative eight has had three 5x5s; negative six has had two 5x7s.

To save time we do not enter each print order on the outside of the envelope, only those when we are ordering once again from a particular negative. *Inside* the envelope there will be glassines, each with the print order noted on it. If we have a new order from a negative, we note on the envelope how many prints were previously ordered, put the negative in a new glassine and discard the old one. Otherwise an envelope would contain a bundle of glassines, some empty, and the file would be thick with unnecessary paper.

You'll see that the file number is at the top right of the envelope so that we can flip through the file cabinets and easily find the file we need.

Each file envelope has up to twelve negatives in it. Double sittings are counted as two orders, that is, they get two numbers. Thus, a wedding of 108 negatives numbered consecutively would be listed as nine orders (nine separate envelopes). In the master file they're listed this way:

82105	Jones, Mary/	wed.	143 Houser St.	555-7392
82106	Jennings,			
	David		(Mary's parents	
82107			H.T. Jones,	
82108			466 Atas Ave).	555-8122
82109				
82110				
82111				
82112				

On each of those envelopes will also be noted the negatives inside:

 Jones/Jennings

 1-12

and the package is held together with a rubber band and filed in a special cabinet for Weddings, Bar Mitzvahs, Receptions, etc. I call such photography "Events."

Glassines—The Envelopes We Can't Do Without

When you put a negative away it should be protected in a "sleeve" or smooth envelope of some kind. Most labs return the film "sleeved" in transparent plastic. This works well in the file envelope, but isn't enough when the negative is returned to the lab for reprinting. Then, something a little easier to handle is in order . . . the glassine.

The glassine is a semitransparent waxed envelope, and has been used by photographers since way back when. Most labs send photographers glassines at no cost, and request that each negative to be printed to be placed in a separate one. All the appropriate information is noted on the outside in the spaces provided. Glassines are very inexpensive and you should have a box of your own for

emergencies. (McGrew Color Lab, in Iowa, has a good price on them.)

When the glassine with Felix's negative inside is returned from the lab, there will be notations on it of the exposure used. The negative in this glassine goes into Felix's file envelope. Then if Mrs. M. decides to order another copy of that picture at a later date, we know what decisions were made in printing that picture by looking at the old glassine.

The lab will test the negative again before printing and all ask that you don't send the negative back in the old glassine. However, you need to know if that picture was ordered "vertical," if special cropping was needed, and so on.

Before throwing away the old glassine and putting the negative into a new one, a note is made of the previous order on the left of the envelope so we always know exactly what was ordered of a particular picture.

You can see this saves a great deal of confusion. Recently, an order was placed for an 11x14 print of a particular portrait, as the picture had been damaged at the customer's home. We could reorder the print over the phone, knowing that the copy would be color balanced to the original and identically cropped. We merely copied the original instructions to the printer onto the new glassine:

<div align="center">

Acme Photography
1984 Main St.
Anytown, U.S.A. 00001
800-555-1313

</div>

Lab Customer	Murgatroid			
Your Customer	82102-3			File No.

Neg. No.		Batch or Invoice No.	
Mask No. _____	Vert. ☒	Horiz. ☐	

	Wal.		8x8		11x14	
	3½x5	2	8x10		16x20	
	4x6		8½x11		20x24	
	5x9		10x10		24x30	
	5x7		11x11		30x40	

Other

Special Information: crop in from left

Density	Cyan	Magenta	Yellow

I once had a young employee who drove me crazy trying to help, always doing things too fast and without consulting me. One afternoon she decided to go through the file envelopes and take all the negatives out of the glassines (which she discarded), and replace them with the negatives that had not been ordered. This way the files looked "tidier." Fortunately, I got rid of her before she had another free afternoon, and it was only a couple of months later that I discovered what she had done. Today I still get orders from those files and the customer has to bring in the original picture so we can be sure we've made the instructions to the lab correctly.

Hidden Assets

Many photographers destroy their files after some years. Others keep only pictures that have been printed at a larger size than the first proofing. If a commercial order is taken on positive film, they keep just one slide from the order. I hang onto everything and occasionally get the reward that someone wants a print from a *very* old file.

There's a gold mine in negative files—to get rid of them is like throwing money away. You can't be sure which picture will be ordered. A man comes in for a passport picture and, years later, you find someone wants a 16x20 of it; a camera has been stolen, and you got a picture of it in the hands of a bride's uncle; or a home's up for sale and there's no point in having someone take pictures since you did that three years ago.

As I write, I've received two similar orders this week. One is for pictures of the mother of a bridegroom, five years after the wedding. She has died and the family wants three 8x10s of the picture with her son. The other is for a portrait of a rancher that I took for his wife. He has a new wife now, and she wants the picture. His mother brings in the order and adds two more 8x10s and two 5x7s for herself.

Some photographers ask a stiff price for printing from an old order, and the customer has no choice but to pay. I ask my current prices, whatever they are, and often the customer is shocked because they're higher than what they were when the picture was taken.

Do what seems comfortable about pricing, but *keep those negatives.*

If it ever gets to the point where you feel you can't keep all old negatives, go through them and keep only one from each sitting. This is a job you don't have to do yourself, unless you'd like to go through the files for fun.

Start a new file of glassines containing only these special pictures. Don't make a judgment about whose passport pictures are unlikely to be needed, because all famous individuals started somewhere. Even some unknown college student may become a Nobel Prize winner, and what fun to have his first resume picture on file.

In Chapter 17 I mention that some stock agents want pictures of well-known people. If one is interested in your pictures, he'll stock them in his files and send you a royalty if they sell. He can't do this unless he knows they exist. If you keep a list of people you've photographed, you'll find some make it to the top and others halfway. Add those to the already famous and you have valuable files.

(Over and over again I see people I have photographed before they were actors, playing roles on TV.)

In Case of Fire

As orders filter in continually over the years, your files gradually build to an independent reprint business of their own. You must protect them from fire and other dangers. One photographer/artist lost his entire collection of negative files in a garage fire and killed himself. I know how he must have felt.

Protecting negatives is a major problem. Fireproof cabinets, would be my ideal choice. But these are hideously expensive, so I do the best I can by being careful.

When my children were young, I would preach, "Accidents don't happen on purpose. If you don't want an accident, be careful."

I've been in several major fires yet, fortunately, haven't lost my negatives. But they were always in the safest place in the building, and *that* was no accident.

Recently, I bought brand-new cases (18x18x12)—originally made for discontinued electronic equipment—to store old negatives. I found them at a garage sale and bought twenty five at $4 each. I later met the person who sold them to me and he had regretted it the very next day when he needed some quality boxes with locks.

Presently, my files are in a wooden cabinet, in a building detached from the house. They're placed in the safest end of the room, and I frequently open all drawers to see if they're all right.

Computers—Are They for You?

An important addition to my studio this year has been a small computer. I, like many others of my generation who left school without ever hearing the term "absolute number" or "integer," or even "negative number," was convinced I could get along very nicely without a computer. But there came a time when I saw myself as a commander of a Polish regiment attacking German tanks on horseback, and I decided to go with progress.

My son Michael made his first computer when he was nine.

The computer was in a cigar box and performed three additions (Michael also stashed his glasses, a piece of string, and his other smaller treasures in the same box).

"Why only three sums?" I asked him.

"Because, I've spent all my pocket money. The flashlight bulbs cost fifteen cents each!" was the reply.

With this child in my life and some ability in math, you'd think nineteen years later, I would understand computers. I thought so, too. But when I took a BASIC programming course at Cuesta College this year, I found I knew almost nothing. If, like me, you think you understand computers but have had little direct contact with them (glorified calculators, right?) read on!

I'm not going to ask whether you can afford to own a computer. Anyone who

can figure out the f-stops on a camera (or would want to), is eventually going to become intrigued with this national obsession and tool for changing the future. Once you are hooked you will somehow find the money to buy your own; it will not be *whether* you need one but *which* one will be your first.

1. IS IT ECONOMICAL?

Probably not. Owning a computer is like owning a washing machine in that it's actually quite a bit cheaper to wash your clothes at the laundromat, and costs almost nothing but time to do the job by hand. There's the cost of the actual machine, all kinds of extras you suddenly "must have," and the upkeep.

Most tasks that a photography/businessman would need a computer for (an address file, billing information, equipment information) can be done as easily on index cards.

Michael is now one of a team that has just completed work on a computer program that took four years. He has access to four computers—one is his own—but he has never used a computer to balance his checkbook. The one-time adding and subtracting of figures needed for checkbook balancing is a function easily handled by a calcualtor if your own ability with simple calculations isn't reliable (as mine isn't).

His advice to someone considering the purchase of a computer is to make a list of the jobs he thinks it will do (or help him do), then talk to someone who already owns and uses a computer, and see if his expectations are realistic.

2. WHAT IT DOES

As an office aid, a computer can help with record keeping and resulting calculations. Although the computer can store any simple record that you now keep in your ledgers or on index cards, it really saves tim in performing the same task over and over again *but* with slight variables.

For instance, I've written a program to collect my monthly income into exactly the same tables I used to do each year by hand. The amounts are always different but the *calculations* are the same.

In addition, it sorts each year's figures and rearranges them in a table showing the month with the highest income first, something I'd have liked all along, but it was too time-consuming to do by hand.

Each year, from now on, all I'll have to do is to type in the new figures and all the other calculations will be done automatically. I can also go back and do the same for previous years.

Any time you need to manipulate a very large amount of data in some way, a computer can do the task rapidly and efficiently—something that you may find impossible to do by hand.

In a simple example let's say you have stored all your customers' names and the number and amount of orders received from each on a disk. A computer can list and print out only those you want, e.g.: 1) those who have placed three or more orders; 2) those whose names fall between the letters J and M; or 3) those who have spent more than $100 at the studio. It can also arrange the entire list alphabetically.

It will do this to thousands of names with complete accuracy in seconds.

The basic customer information remains on file. You can add to it or obliterate any part of it any time you wish

A computer can also give you precise and sometimes difficult to calculate information (information you might not bother to obtain otherwise), and bring it up-to-date if you merely change the variables, e.g., put in new prices. This kind of information might save you thousands of dollars, if just by telling you what *not to do.*

Let's suppose you're printing photographs in your garage and make $1 profit per print. You've calculated this by adding your costs (paper, chemicals, and time), dividing that by the number of prints you make, and, finally, taking that amount from the average sale price per print.

However, you can only print 1,000 prints a month in the garage; your equipment is getting old; you'd like to hire an assistant to do the printing; and you need to enlarge the garage.

Therefore, you may have to raise your prices to take care of the additional costs, but you don't know by how much.

A computer can take the figures for:

Chemicals
Paper
Average sale price per print
Cost of addition to garage:
 Permits
 Cement
 Wood
 Roofing
 Paint
 Labor
Equipment
Help

and compute whether it will be worth your while to expand. It can compute in seconds any calculations you need using these figures, e.g.: at what date you'll break even with new equipment if your charges are unchanged and you print, let's say, 1,500 photographs a month. Or it can tell you when you'd break even if you raise your price by 75¢ a print.

You can always change the "variables"—the costs, the number of prints, the hours worked. It would take hours to obtain these calculations without a computer, though.

You might learn now that it would be well worth your while to expand the garage, or that you should junk your present equipment and send the printing out (if it will take you ten years to break even after the expansion).

Once the original program is written, your own work will be minimal.

E.g., the computer prints on the screen:

"Do you want to hire a printer? Type yes or no."
You: "Yes."
"At what cost per hour?"

You: "6.50."
"How many hours per day?"
You: "Six."

And so on.

A computer can serve as a word processor—a superbly efficient typewriter that only types the final text when you've made the alterations you need electroncially, on a screen. Gone is the need for correction fluid, erasers, and correcting tape.

To use it as a word processor you'll need a special printer for your computer. The margins, the tab keys, and the distance from top and bottom are preset by the user.

You can also store specific text on a disk or tape, which I'll explain further along.

The computer is also useful for personalizing master letters that can be saved on a disk or tape and then printed when needed . . . varying only the names, addresses, and other specific information. An example is a letter to customers reminding them of overdue bills.

The customer gets a letter that appears to have been written for him alone. There's no change of type when his name is printed—unlike some personalized form letters.

When you use a computer to keep track of office records or inventory, you no longer need permanent ledger records. A floppy disk can hold a great deal of information in a very small space, and bring any part of it onto the screen instantly when required.

3. HOW PRACTICAL IS A COMPUTER FOR THE SMALL STUDIO PHOTOGRAPHER?

The question is, of course, do we really need the jobs mentioned above?

Do we need to have a computer type a perfect letter? There's no reason why we can't type letters with errors, correct them by hand, and mail them. I've been doing that for years!

Do we need to keep computer records of our files? Isn't it actually easier to grab a pencil and write in a book information that will only have to be written once?

Does a small business like a studio need elaborate cost calculations? Isn't a simple guess almost as efficient?

Is the computer cost-effective (a term used to weigh the savings in time and material against equipment cost and maintenance)? Will it recover us the outlay in a reasonable length of time?

The answers to these questions are probably all "no." No, the computer is not a necessity in a one-photographer studio. Photographers have managed without them for generations. However, I'd say get one, anyway, as soon as you can afford to (used computers are often a great buy). The fun of having your own will be worth it!

4. PROGRAMS

A computer does nothing by itself. It must be programmed to write a letter,

prepare yearly records, or store a customer list.

Programming is a learned skill and the choices are:

● Buy the program (and they are not cheap—$25f. Some cost $100f). It's illegal to "pirate" copyrighted programs, i.e., copy them without permission of the publisher. Photographers should be particularly sensitive to this.

● Have a friend or member of your family write the programs. As programming takes time, it's unkind to say, "I need six programs for my business. Would you write them for me?" If someone volunteers, however, go for it!

● Hire a programmer—expensive.

● Learn to do the programming yourself. Study on your own or learn in a classroom (much the easier). Either way, it will take time. This was the route I chose.

5. COMPUTER LANGUAGE

Each computer has its limits. You can alter the capacity of a particular computer and the more you know about how it works, the more you can make it do.

But first you must learn a computer "language" for the computer you own. A language is a body of commands that has its own syntax; its own grammar. The commands may sound like English, and you can often interpret them in English. However, turn that around and the same thing may not apply. Give the computer the command in English and it probably won't understand!

"Print" in the computer language BASIC means "print the next item I type." I may then type in quotation marks, "Good morning, Jeanne."

When I run the program and it comes to the command, "Print," the computer will print, "Good morning, Jeanne."

But in BASIC the computer won't take the command in *any other form.*

If you were to type "Please print" it would reply, "Syntax error" as "please" isn't in the BASIC vocabulary. If I were to type Good Morning (without the quotation marks), it would again tell me I had made an error.

Machines can't follow vague commands as we can.

Here's another example:

"Take those papers upstairs" is perfectly understandable in English, but a computer must first know *how* to take, *what* papers, and *where* upstairs before it can handle the command.

You learn very quickly to break down a task into precise consecutive steps and to command the computer in the limited vocabulary it understands.

There are many computer languages, but the most commonly used are:

● BASIC (Beginner's All-purpose Symbolic Instruction Code). BASIC, therefore, does not mean "fundamental." As it's used by more microcomputers than any other, it's the first language most people learn.

In the early computer days, various computer manufacturers used BASIC for their microcomputers and various "dialects" developed, with different machines taking different variations.

● COBOL (Common Business Oriented Language). We photographers don't need COBOL, but if someone wanted to go out right now and get a job as a programmer, COBOL would give him the best chance. It's an archaic language that industry locked into before the more innovative languages were created. Be-

cause it would cost too much to change at this point, many large companies still use COBOL.

• FORTRAN (FORmula TRANslation). We don't need FORTRAN, either! FORTRAN is older than COBOL and is a language used by the scientific community. It's not considered a language for business.

• PASCAL (Blaise Pascal, the first computer programmer). The unique quality of Pascal is that everyone uses exactly the same form. It's more restrictive, discourages bad habits, gives better commands, and is more "powerful" than BASIC. This merely means it's more efficient and does more. This is the language I'll learn next.

The "bad habits" I refer to include writing a convoluted program that may provide the correct result but is difficult to "read." Pascal allows a complicated command within a single statement so the programmer is forced to write a tighter program. The program is also more "powerful" because it needs fewer steps. A convoluted program is difficult to read even when you write it yourself and takes longer for the computer to execute.

Pascal is also "powerful" in that it allows programs to be segmented so that one segment can be isolated and changed without altering the others.

When you are writing a program you assign letters to numbers when it will make everything very simple by doing so. You might command the computer to work out a calculation and assign "B" to the number which is the result of that calculation. However often you change the figures in that calculation, if you type "B," the computer will interpret it as the answer to that calculation—until you give "B" a new value. In the languages other than Pascal if you were to use, let's say, the letter "B" in *various* segments of the program, all the "Bs" would have identical value. You couldn't change a "B" in one segment without affecting all the "Bs."

Here Pascal is more like English where a "B" can stand for Barbara or for Ben and we can accept that "B" is sometimes a woman and sometimes a man depending on the context.

• In-House Languages. When there are large-scale operations with very specific requirements, in-house languages are developed. We photographers are too small for in-house languages to be applied to our businesses, however, it is quite possible that our big daddy, Eastman Kodak Company, has one for its operation!

6. INPUT/PROCESS/OUTPUT

Each computer program has three parts:
• Input: Facts must be fed into the computer.
• Process: The computer must be instructed what to do with those facts.
• Output: The result. This can be displayed on the monitor (the TV-like screen that is a necessary adjunct to the computer), and also printed.

7. HARDWARE AND SOFTWARE

Any part of the computer and its components that can be touched (handled physically), is called hardware. This includes the computer itself, the monitor, the disk drives, the printer.

The part that can't be touched is called software . . . that is the "programs."

Hardware experts are electronics experts and mechanics.

Software experts are programmers.

In large companies the cost of the hardware is always less than the cost of the software. In other words, the machinery costs, but the people who operate it cost more.

8. STORAGE

There are two ways of storing computer programs: on magnetic tapes and on floppy disks.

Magnetic tapes are cassettes of the type used to record music mostly commonly used by hobbyists and Apple is one computer that can be hooked up to an audio recorder like the ones we have in our homes. Other computers require special cassette recorders, in which audiotapes can't be used, i.e., you can't play music from them.

The very large computers are hooked up to reel-to-reel tapes.

The disadvantage of storing computer information on tapes is that a tape must be searched through its entire length before a program can be found, while a disk can *instantly* summon up the program you want.

• Floppy disks come in two sizes. The smaller computers use 5¼ disks, which look like 45 rpm records that have been sealed into a thin cardboard jacket. One small piece of the disk is visible and this section should never be touched with the hands. A paper protector is provided with each disk so that the exposed section is covered in storage.

The disadvantage of using disks is that the device that allows you to use disks (the "disk drive") is generally more expensive than devices that access tapes.

Both disks and tapes "save" or hold the information that has been put through the computer; the computer itself doesn't store information permanently. Thus, it's imperative to protect the disks, both from human error (liquids poured on them, magnets, etc.) and acts of God (fire and flood).

We learn to make backup disks duplicating all information stored, and the backup is usually kept as far from the original as possible (another location is ideal).

Michael's office triplicates all computer information for the day, and before the office closes two tapes are taken to two separate locations where they're stored in underground vaults! The third tape is kept at the office. The information stored isn't secret, but it's the result of so many man-hours that the cost to replace it would be immense. This isn't too cautious for important programs. Quite recently, a San Francisco school lost its entire computer records in a fire, as all copies were stored in the same building.

In addition to losing valuable information this way, you can also lose programs while working at the computer. The system can "crash" for no reason that you're aware of. It suddenly refuses to take commands. You have no choice but to turn the machine off and back on again, losing everything in its memory. This has only happened to me once, but it taught me to put my work onto the disks in shorter segments.

A power blackout can also lose what's on the computer memory; even a flick-

207

er in the power will do it. If this happens while the program is being transferred to the disk, the entire disk's contents are lost. A solution is to make your backup copy immediately after the original, so that if the master is lost the program can be copied onto the computer and back onto the master disk.

There are all manner of surge protectors, devices to help avoid losing programs this way they start at about $60 (for a device which will protect against noises and minor power changes). For about $400 you can buy a solar electrical storage unit. If there is a complete blackout, you can now "buy time" to save your program. The smaller units are protective rather than preventative and most "single users" as we are called, don't bother with them. The more sophisticated computers will allow more than one user to program simultaneously and need more protection.

The amount of important information stored is what one must consider when buying these protective devices.

9. MEMORY
Another computer term is memory, and there are two kinds:

• *Computer memory.* Each computer can handle a certain length of information. The larger the computer, the more it can handle. This is not a matter of what the computer can do, but how much space a particular program takes up. In the case of a computer being used as a word processor, the computer can handle only so many words.

This memory is enormous and in even microcomputers is adequate for photographers.

• *Disk or tape memory.* Disks and tapes also have "memory" and a warning is given to the user when they're full.

10. WHICH COMPUTER FOR YOU?
There are three sizes of computer.

• If you can carry yours in your hands it's a microcomputer.

• If you need a wheelbarrow to move it, it's a minicomputer.

• If you need a truck to haul it away, you have a maxi, or as it is more usually called, a main frame computer.

Obviously, the more expensive the computer, the larger it is and the more it can do. A microcomputer can work on only one program at a time. Mini and main frame computers can handle several programs simultaneously.

As microcomputers have been developed for small businesspeople and hobbyists, one of them will probably be your choice. Some of the names you'll hear are Apple, IBM, Atari, Commodore, Radio Shack. It's necessary to get a computer that does more than play games and if you can afford it, get one that stores information on disks, not tapes.

Consumer Reports has published a description of microcomputers, and it's worth a trip to your library to read that issue and any updates of it. I found it explained the differences in the small computers in a way I could understand. Discuss these differences with computer owners; there are user groups in every city and many small towns. Just as Nikon, Polaroid, Hasselblad, Yashica each conjures up a different image to the photographer, so each computer name does to the computer buff. It pays to take their advice.

11. MY COMPUTER

I set out to buy an Apple-IIE computer at a computer fair and came back with a hodgepodge of electronic equipment that quickly snapped together and gave me exactly what I wanted—for $1,400 less than I had expected to pay. What I ended up with was an Apple II, and several hardware items that extended its memory, etc. I shopped around and was fortunate to have good advice. A close friend at the same fair paid $300 more than he could have if he'd bought his computer at home.

I chose this particular machine because:

1. It has a good reputation.

2. There's an Apple Users Club in San Luis Obispo where I can meet other owners of the same computer.

3. My older son has one and I could ask his advice.

4. The college where I took a class has a number of Apples so I was already using them.

The Okidata 82 printer works best for me because:

1. I like the look of the Okidata's dot-matrix printing. The cheaper letter-quality printers (typewriter-style print), looked just that to me, "cheap" (even though they were $400 to $600 more than my printer). To get excellent letter-quality I would have had to pay $1,000 + more.

2. I already have an IBM Selectric typewriter with seven type styles if I want a better-looking print for price lists, etc.

3. The Okidata has a reputation for being an unusually rugged printer.

4. The price was reasonable.

There are a variety of good printers. Ask a retailer to demonstrate each before you make a choice.

12. COMPUTER USES FOR THE PHOTOGRAPHER

I expect the computer to do the following jobs at the studio, though I must admit I bought it initially for fun.

1. Write and store form letters.

2. Write and store forms.

3. Store the text of the books I write.

4. Store file information:

> Addresses.
> List of delinquent accounts.
> Exhibit-print file numbers and where the pictures are *now*.
> Equipment information.

5. Sort names alphabetically.

6. Make financial statements, calculating all the details.

7. Make comparative figures for business records.

8. List and store contents of all files.

9. List contents of various boxes and cabinets.

The Paper Copier—Spend Money to Save Time

A most surprising timesaver in the studio has been a quality paper copier.

For a small studio such as mine, it's indeed a luxury.

It hasn't been cheap to buy or run, but is very convenient and saves considerable time.

The major problem in having copies of printed matter made has never been the price. Copy-shop copies are inexpensive. But the time spent going to the shop and standing in line adds considerably to that cost. It takes us forty minutes to walk or drive to get a copy made at the nearest copy shop. It takes us under a minute to turn the machine on and make the same copy at the studio.

There's also more time saved if we notice an error in the master after making a copy. If it's a price sheet we're copying, we can make the change on the spot.

My copier is made by Savin, cost $3,000 new in 1980, and needs an additional $240 per year for the nine-year service contract. This is necessary as it is a liquid processor. The more we use the machine, the more efficiently it runs because then the ink is used instead of evaporating and leaving a thick, gooey sediment in the tray. The machine has to be cleaned out periodically; not using it doesn't solve the problem.

In addition to the cost of keeping the machine going, there's the cost of the chemicals it uses. The major expense is the ink, or "toner." A second chemical, the solvent, is inexpensive. The chemicals are very simply and cleanly added to the machine, which lets you know by light indicators when you need to add more of them.

You have to be careful to get the correct chemicals for the machine, not just something sold as such. The Savin sales office takes care of all these needs, including paper—a slick surface paper that doesn't absorb too much ink for optimum performance.

Savin advertises the cost per copy (including paper), as 1 ½¢. The less you use it, we found, the more it costs per copy (for reasons explained above).

This machine gives wonderful performance. It's fast and makes beautiful copies on white or colored papers.

Copiers can cost considerably less than we paid, and also more. They, like electronic equipment, are getting cheaper all the time. The cost varies according to how fast the machine operates, how many copies can be made of a single sheet without resetting the machine (we can make ninety-nine), and whether you need to hand-feed the items to be copied into the machine. If you want one copy of 500 pages, some machines will do the job with the press of a button.

Shop around, and as with any piece of equipment, don't buy until you've met someone who has already owned the machine you like. If you don't know such a person, ask the salesperson for local customers who wouldn't mind being used as references. A local church is currently trying out every copier on the market. Someone like that would be an ideal consultant before you buy.

Reasons to Buy a Copier

1. To prepare advertising. It takes more effort to *make* an ad than to dream up a *design* for it, so if you have the means of making a copy of a paste-up, it's much easier to build the ad gradually, adding and taking away from it until it seems perfect. Unnecessary lines can be removed with correction fluid so you

can keep making changes until you've got it right.

Here's where a quality copier is essential: The final "master" copy should be indistinguishable in contrast from the first.

2. Overlays. By copying onto transparent plastic you can make an overlay. Suppose you think a tree might look nice in the corner of that sheet. Copy the tree onto the plastic, print the paper sheet with the plastic overlay, and test your idea. Meanwhile, you have that original sheet without any permanent change.

The plastic is available at art stores, but you can also use plastic protectors for album pages and plastic protectors made for three-ring binders (available at dime and drug stores).

3. Short runs. To take advantage of the price breaks for quantity at most print shops, you'll find yourself ordering 200 or more copies of a single price sheet. If you have your own copier, you can make twenty-five or less at a time. If you need to change prices, you have very few sheets to throw out.

4. Colored paper. Instead of hoping the print shop has the color paper you need, you can now stock your favorite colors and be sure they're available.

I have my different price sheets printed on colored paper, which helps us to find the right one easily and also makes a colorful package to hand to the customer.

If I have to print several hundred copies of a single price list or brochure to be handed out at an event, I usually print them in very bright colors, just because they look striking and will attract more attention than white.

5. Photocopies. Make copies of photographs when you don't need quality prints. These can go to:
- The lab (for special cropping).
- The customer to ask "Do we have the right picture?"
- The customer, if you think he'll make off with a picture.
- Actors and models can't always afford to order all the pictures they want. I give them paper copies of the pictures so later when they have the money, they can decide what to order at home and phone the order in.
- Editors. Publishing houses nowadays will often view photocopies with certain initial presentations and save the photographer having photographs made on speculation.

6. Money-maker. If you're located where members of the public need photocopies, put up a notice that you have a copy machine. Occasionally friends, too, would just as soon give you the business as go elsewhere.

7. Permanent record. Newspaper clippings yellow quickly, making a copy of them ideal for protecting the information you want saved. Some copiers make excellent copies of newspaper photographs, too. If you want to make a quick copy of information, you can without clipping it from a magazine or book.

Always remember that though you can make these copies for your personal use, you can't sell them without violating a copyright on that material.

8. Checks. Before owning the copier, I had occasional bad debts that occurred because I didn't know the bank of the person in question. I eventually started copying out all information off certain customer's checks, which was a laborious task.

It's not enough to get a small claims judgment from someone. You have to

tell the sheriff's department where to collect the bill if the customer doesn't pay within thirty days. The logical place to attach the sum owed you is to the bank of that person.

If you have a photocopy of the deposit check on out-of-town customers you need look no further.

There are times (a wedding that doesn't make it through the honeymoon or friends who quarrel after the photographs have been taken), when a customer who incurred the debt in good faith has now lost interest in the pictures. As this person isn't *really* dishonest in his own eyes, he keeps the same bank account, while his debts slide. With local people you can quickly trace the bank, but it's not so easy with out-of-towners.

9. Carbon paper. Gone is the need for carbon paper. A copy machine enables you to make a single copy of every letter and then run off perfect copies for your files.

In evaluating any piece of machinery, consider first whether you've *already* felt a need for it. What will it save you in money, time, and energy?

Don't let someone talk you into a need you don't feel you have. I don't buy anything expensive, unless I have longed for it for several months!

TIPS

Labs—Cost versus Quality

A large studio that had built its reputation on fine photography always paid premium prices for its printing. Then the owner decided to test the public and the lab. For one year he ordered only the *cheapest* print job available. He discovered that his customers—and usually he himself—couldn't tell the difference, and it didn't change the volume of business.

I was told this by one of the photographers he hired. It made good sense and I do it myself, moving only to the more costly processing on tricky negatives. I will, however, have a negative reprinted at my expense if I've misjudged this.

I once sent Meisel a negative to be printed eight different ways. This excellent lab returned the negative with a test print and said that there would be very little difference in the various print qualities because the "negative is well exposed and the girl's complexion is already flawless."

The answer is, therefore, to use a really good lab and work to improve your negative quality until you can use its cheapest processing. Scrutinize the prints and/or the negatives, and next time correct any problem—if possible, in the taking.

I sent a single negative to Rinell, another lab I like. This time I didn't tell them what I was doing, just put the picture through three different times. I paid $2, $3, and $8 for the 8x10s (prices were cheaper then), and as an experiment gave the customer the choice without telling her which was which. When I told her she had chosen the cheapest, she still wanted it. It wasn't that it was better than the more expensive print; it was a little pinker than the others. My own favorite cost $3. It was almost identical

colorwise with the $8, but cropped a fraction differently.

However, someone decided to have a 30x40 print made of a very ordinary little picture I'd taken and I sent it to Photic of San Diego, currently my favorite lab (their customer service and print quality are nothing short of remarkable). They made nine corrections to the color in different parts of the picture. It needed negative retouching, print retouching, and airbrushing. The final result was worth the cost, which, typically of Photic, they called to warn me about before going ahead. I recently received 11x14s from Photic that I had merely instructed them to print "cheapest." The pictures were returned flawless. (Another lab which is very small and which I have nothing but praise for is Arrow Photo. For drugstore prices they turn out fine printing.)

So, as I've said, my method is to use the least expensive printing from a good lab, unless the negative needs corrections, special cropping, and/or a special surface. If you have any doubts, let the lab make the decision for you. Send the negative through "cheapest" and note on the glassine, "If custom printing is needed, please send this negative to the right department."

None of the labs I've mentioned know what really poor printing is, and that's the kind of place you're looking for.

My prices allow for a possible tricky negative and I suggest you think about this. You charge as if you'll have to go with the more costly processing, and then reward yourself with those extra dollars if you do a very good job. It's like picking dollar bills off the sidewalk.

Most labs give a discount for prepaying, and I take advantage of it—if possible, paying with a credit card. If there is no discount for prepayment and the lab doesn't allow credit card payments, I apply for credit and pay against a monthly statement.

Photic has installed an optional credit balance account that I use and like a lot. The customer overpays, leaving a credit in his account, and receives an additional discount.

If you accept poor work from your lab then it's *your* fault, not just theirs. They are not a supreme body, but several workers and some of those may be lazy, sloppy, or just not know what they are doing. A good lab has a person who cares at the top. Contact that person.

I never use a lab for the first time on a customer order. And it's a good thing, too. Three or four times I've tested a lab with a roll taken for my own amusement and received appalling prints.

Two Labs are Better than One

The wise photographer always has more than one lab (I like to have at least three), he uses regularly. My choice of lab is determined by quality, service, fair prices, reliability, and speed.

All studio work goes to my current favorite lab, except:

1. What it can't handle.

The job requires a 4x5 transparency of a 3'x6' map and I don't want to take the picture in the studio. I may have to go to someone who is set up to handle large copy work.

2. What it can't do at a competitive price.

The job requires 200 8x10s from the same negative. If I can find a lab

that will do the job at $1 per print less on quantity work, I make a quick $200 additional profit.

3. What it can't do in the time needed.

The job requires prints in four days, yet the customer may not be willing to pay for air freight both ways. If I can find a local lab that can bring the job in on time, I use it.

4. When I'm committed to another job.

The job is initiated by a lab on the condition that I use it for the printing.

5. When I want to develop a relationship with a lab (to use later, perhaps as a backup).

I might use a lab once or twice a year, just to keep my account open there.

6. When it's more convenient.

The job requires an unusual service, e.g., a mural. I might send ALL the prints needed to a lab specializing in murals if the one I normally use is unable to make one. Usually, however, I don't do this; I split the order.

If you see a competitor's work and it seems better printed than your own, ask who did it. And pass the good word if you're asked about *your* processor by another professional. You want your lab to get lots of work and stay in business.

I don't give the names of my processors to the public when they ask, however, because if their negatives don't print as well as mine, they'll complain to me. (And they have.)

Mailing Film and Print Orders

To be certain that you don't lose film in the mail, try and find a local processor or one that picks up and delivers in your area. But we all have to use the mails on occasion. As I keep repeating, accidents never happen "deliberately" (a careless person has more "accidents" than a careful one), but try to forestall accidents by packaging all film very carefully, seeing that the address is correct (most labs provide prepaid printed envelopes), and the package is sealed. If I'm sending undeveloped film in the mail it's placed in a plastic bag inside the lab's own envelope. My name and address is on every roll of film (self-stick label) and on every glassine.

I never put valuable film packages into a local mailbox. I take them to the post office drops. It's a good habit to get into if it's something you'd really be up a creek without. A frequent teenage prank is to toss raw eggs into a mailbox. In fact, I'm so paranoid about mailing film, that I've been known to take it to the post office and then return with it unmailed because I've become suddenly uneasy about it. I then send it UPS.

Remember, if a negative is lost *after* proofing there's a quick solution. Have the proof copied. This happened to us. The lab copied the proof and the senior whose portrait it was never noticed the difference.

For weddings and other one-time events, I have most customers sign a waiver protecting me to the extent of having to return their deposit if "unforeseen misfortunes" should occur. It reads:

"The studio takes utmost care with respect to the exposure, development, and delivery of photographs. However, in the event that the studio fails to comply with the terms of this contract, the studio's liability is limited to refund of deposits."

Film and Photographic Papers

A major problem when I started professional photography was that, without knowing it, I was paying too much for everything. If a supplier gave me ANY discount I was delighted, but I came to realize I could often have purchased the same item cheaper without a discount, and THAT supplier might also give me a professional discount on top of his already lower price.

On any item you are going to need a lot, such as film (and photographic paper if you do your own darkroom work), try to find a supplier who will not only give you a rock-bottom price but, and this is particularly important, also give you fast and efficient service. Sometimes you will need a lot of film of a particular type and the difference in cost between having to buy it at a camera store and a wholesale supplier can be enormous.

In addition, if you have a rush job and need special film for it, you must have a supplier who will appreciate that this time he must pull out the stops and get your order to you quickly. You don't want to order such film and have it delivered in three weeks without a call to explain there will be a delay. Nor do you want to find that you ordered VCS and received VPS or Type L.

Anyone can make a mistake but it should not be a regular occurrence.

City photographers have best chance of getting heavily discounted supplies and often need only to take a bus or drive to where it is sold and can check on the spot whether they are taking home the right product. If like me, you have to buy out-of-town for the best deals, you may have to try out a lot of suppliers before you settle with one. Besides cheap prices and speedy delivery try to find someone who orders from Kodak in sufficient quantities so that it is usual for him to be able to fill your order from stock on hand. I buy all film and paper from Bill Olson unless I have an immediate need for a particular film and must buy locally. (One reason may be that I have the film for the job but it is in the freezer and I need it in an hour—insufficient time for it to thaw.)

Here are a few actual examples to show you how a film order can be handled. Bill Olson provides such service as a matter of course.

1. I ordered eighty rolls of VPS and specified *one* emulsion. The exposed film was to be taped into a continuous very long roll and portrait packages printed from each exposure. The printer would therefore need to make only one analysis (from the first frame) to expect the color balance of every other frame to be identical.

Kodak was behind in all its orders so the Olsons were out of VPS 220 and phoned to tell me so. They were expecting a delivery in time for my job though and if that came in too late for the film to be shipped UPS to me they promised to phone. The film arrived but, worried that UPS might not get it to me overnight, it was sent Greyhound (although I was charged only the UPS cost).

Note I did not *ask* for this special treatment, they just provided it.

2. On another order when they were again out of what I needed, Bill phoned to say he had several rolls in the freezer but they were a few months out of date. Would I take them at an additional discount until supplies arrived? I was delighted to get the bargain. Some of the film in my freezer is over four years old, (it doesn't deteriorate there), and I would use it without hesitation!

215

3. As a photographer, printer and supplier of film, Bill also helps when I need advice. I have phoned him to ask which color film should be used for a job (films vary not just as to speed but also grain, and color balance), or about the new emulsions and what ASA speeds to use for them. (On some of the pro-films we take them at an ASA other than their official rating.) It was he who alerted me to the extra contrast of VCS which makes it better for some commercial jobs; when I explained that I didn't like it because of the garish color prints I had received from that film, he insisted the problem was the lab's fault not the film's or mine (in the taking). And he was right! I have no trouble now.

4. I usually get my film order the *same week* I send the Olsons an order. It is in the mail the very same day they receive it. The price, by the way, both on film and darkroom supplies is lower than I have seen elsewhere.

It is not possible to expect special service from a supplier, but when you have established a relationship with yours and find you are not getting it, start looking around for someone who can serve you better.

Pens and Pencils

For any kind of writing at the studio, figure on the best pen or pencil to use and then make no exceptions. I'm sure you'll have a few calamities just because you carelessly picked up the closest writing tool instead of the *correct* one. When that happens, remember, it has happened to us all!

One calamity occurs when a print has been numbered on the reverse side with enough pressure for the lettering to come through, giving an embossed reversal of the file number. Either a pencil or ballpoint is the culprit.

The Pilot Scuff which I use for writing on any surface—resin-coated prints, glassines, negatives, and even to mark tripods and other metal—is a great pen.

It dries almost—but not quite—instantly, as every one of my employees has found out to her sorrow. When she puts one print on top of another while numbering them, the ink will mark the surface of the picture below unless she has given it a couple of seconds to dry.

Nor is it easy to get off. Alcohol will do it but if it's left on too long, it will change the color of a picture. More recently we've used turpentine and acetone with better luck. If the color has changed, you can still save the photograph. Spray it matte and bring the color back to the original with Prisma Color pencils; or use retouching dyes on an unsprayed print (Veronica Cass sells a wonderful set of them, but there are many other kinds available). Don't try pencils or dyes on a picture you're going to sell till you've worked with them on several test prints.

On our file envelopes, it doesn't matter what we write with as long as the negatives in the envelopes aren't directly under the pen. Ballpoint pens work well if you have the kind that don't smudge, but I prefer pencil for all records.

It's true, by the way, that documents last much longer if they're written in pencil rather than ink, which fades. I'm not sure how all the new inks hold up, but many years ago a chemist told me, "If you want it to last, write it in pencil."

Catalogs

I love junk mail; it has saved me a lot of money. Competitive companies send out catalogs and it's simple to sit at home and compare prices for the same merchandise, then make a couple of phone calls to local suppliers to see if they can come close to the cheapest catalog price.

When buying from a catalog remember:

1. Add the cost of transporting the material to you.

2. If you're in a state where sales tax applies and you can save the sales tax by buying through a catalog, it may more than make up for the cost of transportation. Look at the order form carefully. Sometimes you'll be charged your local tax anyway (even if the item is being sent from out of state). This is because that state and your state have an agreement to collect sales tax for each other!

Filing catalogs poses a problem because there are so many of them and also because you do need the information—if not this month or even the next, *eventually.*

I used to keep catalogs in three-ring binders. First, I removed the three rings, then held each catalog in place with a heavy rubber band. I slipped the rubber band over the binder's spine, and inserted each catalog through the rubber band so it is held to the spine.

This worked temporarily but not very well; the rubber bands kept breaking.

Now I have a system that works better. It consists of a simple rather long, very strong, cardboard box with dividers.

The box is separated into two parts. Part One consists of all the companies I already deal with. The dividers are arranged alphabetically. Part Two consists of all the other catalogs I *might* need divided by subject, e.g., office supplies, labs, and frames. And those headings are also arranged alphabetically.

When a new catalog comes in we replace the old one in Part One. We just dump it into the appropriate slot in Part Two. Later, if a particular section of Part Two gets too full, I go through it and throw out duplicates as well as anything I am no longer interested in.

Forms

An expensive need of the studio is its office forms.

In the first years I had only one "form"—I sank a little more money into the expensive looking stationery that was my letterhead. It was the best white bond with very simple raised lettering in black. This became my order form—and every other form—and I just used carbon paper to make copies on the cheapest "second sheet" paper I could find.

After a while, I added a shorter version of the same form, a half-sheet letterhead.

The next purchase was hardcover receipt/order books from the local stationery store, which I bought one at a time when I needed them. There was a space for my name to be rubber-stamped onto each sheet, and a duplicate could be made with the carbon paper provided. There were four forms per page, perforated so they could be torn out. Today I still have one of these books on hand to give someone a quick receipt (e.g., someone buys four folders).

I then moved to purchase-order forms, which are superior to simple order forms, as the customer signs for the order (in the boxed space provided), agreeing to pay for it. I bought these, too, at the stationery store, and eventually made my own on the typewriter so I'd have columns for the exact information I needed. The local quick-print store runs these off with an n.c.r. (non-carbon-record), which costs a bit more than carbon paper but is cleaner.

In addition I now have contract forms, for both weddings and commercial orders. (Recently, I noticed in a New England Business Supplies catalog that they have excellent forms available for photographers. I bought mine from Curtis 1000.)

Tips on Business Forms

1. Buy the least number possible on your first order. When you've tried out the form and like it, you can put in a bigger order for the best price breaks. It's not cheaper to buy in quantity when you have to put up with 500 forms you wish you didn't have.

2. There's no point in buying a form that is "almost" right for you. You don't want to spend time "x"-ing out the parts you don't want; it will look tacky.

3. Price the same thing at your local printer before buying from out-of-town.

4. When buying from out-of-town (by catalog), it's worth a phone call to see what kind of operation they're running. Many catalog houses have 800 numbers (toll free), or you can call at a cheaper rate if you're phoning a different time zone (either early in the morning or after your hours in the evening), and get their company during office hours. The person who deals with your questions on the phone will give you an idea of the type of organization. Quality companies don't put up with incompetent or even disinterested help.

5. If you belong to the Professional Photographers Association (P.P.A.), write and ask what forms are available. P.P.A. sells forms to its members and will send you samples. I find most preprinted forms for photographers emphasize "proofs" or "previews," which don't fit my business.

6. Ask other photographers what forms they use and where they buy them.

7. If you don't feel ready to draw up your own forms, college students taking graphic arts or architecture can do it easily for you. Some colleges are so eager to find jobs for the students that someone will take your notice over the phone. You can, of course, offer to do a trade—photos for drawing.

The Cheapest Deals I've Found

1. I buy many self-stick labels through Labels Unlimited, Walter Drake, or other mail-order places, but I never order from a mail-order house unless I've seen their ads for at least six months.

I start by putting in a very small order, to test them. Once I've had a couple of good experiences, I buy in bulk—1,000 or more labels at a time.

At these mail-order catalog houses you can pay one-third to one-half what a discount office supply house charges.

Self-stick labels have multiple uses:

You aren't restricted to your name and address. As long as you stay within the letter and line limits, you can have anything you want printed.

I have some labels printed with a copyright notice that goes on every bag the customer uses to take his pictures out. The same notice is rubber-stamped on the reverse of every print, but I notice the customer often reads the notice on the bag before he/she leaves the studio. If a customer has been hoping to have cheap copies of my pictures made elsewhere, he soon finds out that it's illegal.

Self-stick labels with your name and address are great timesavers. Carry some with you. Some people don't want to clutter their pockets with business cards, and instead carry an address book. If someone wants to write your name and address down, just hand him a label.

Self-stick labels make great gifts for friends, but even greater gifts for people in other countries where they are not available. Have their name and address printed on them.

Many of these office suppliers provide bonus gifts for orders of a certain dollar value. Labels Unlimited sends us scads of free gold seals (self-stick) with any order for labels. We use them to send out form letters (like those reminding customers to order Christmas cards in September for a discount). Instead of putting the letter in an envelope, we fold it and secure it with a gold seal. Sending these letters on brightly colored paper overcomes the cheap look.

Mail-order catalogs also provide my mailing labels at one-sixth the cost I used to pay for them. I also buy their double-size folded business cards to write notes to customers, since my usual business cards look too formal.

2. Office supply catalogs provide further savings. You can find any number advertised in business periodicals, but the cheapest I've found is Quill. You can buy typewriter ribbons of all kinds, inks, paper clips, adding machine tapes—all at about half what they cost elsewhere. Even so, I usually phone the local stationery store to see if I'm actually saving money.

I recently bought copy paper from Quill to save money, only to find the $22 transportation charge brought the price back to what I would have paid locally!

3. Have you discovered corrugated cardboard cartons? I've used them for years, and now doctors and lawyers use them for storage of important, but little used, files and other material.

I even *buy* them now. All stationery stores and office supply houses sell them with detachable lids, but some of my best came from a CPA whose tax books arrived in six identical boxes that are a strong as wood. These have been used every day for four years and show no sign of wear.

With the rapid growth of my studio, I have a large number of orders partially completed. To keep these organized, I use the matching heavy-duty cartons that transport assorted frames (covered with contact paper and labeled for convenience). Weddings, as an example, would contain anything about incomplete wedding orders. Since we started this we've stopped hunting around for the order that might have been buried under another order (because a customer came in while we were working on it). Now we stop, put everything to do with the one we're working on into a plastic container, and dump it into the appropriate box.

Do you see how this works? Orders don't all fall into one category. If you can keep each category separate, then you have at least cut out part of the search!

(I don't pay full price for contact paper, either. A store where it's sold by the yard usually has a box of roll ends for half price.)

4. Heavy-duty cardboard trays are given away at paint stores and are perfect for storing small jars full of thumbtacks, nails of different sizes, and erasers, etc. These too, can eventually be separated into categories. These trays are like cartons, but the sides are two or three inches high and they're stronger than cartons that are cut down to the same dimensions. It is more convenient to grab a tray of jars rather than several jars off a shelf.

I also use widemouthed jars and coffee cans for storage. My friends are instructed never to throw them out.

5. Someone else's discard can be your treasure. Outside a store, I recently saw some good-looking pine crates, 18x18x24, priced at $3 each. They had been used for displaying yarn. As all my 16x20 exhibit pictures are in sectional metal frames (almost borderless), they can now be carried twenty to a crate without fear of damaging them.

6. Plastic stacking bins are also a great way to keep papers and photographs. The ones I use cost $1 at Sears & Roebuck during their dollar-day sales. They cost $6 in a stationery store. Brookstone, Quill, and other catalogs sell them, too. The CPA who prepares my tax returns uses an identically shaped tray of more solid quality for each of his clients' tax information. Cat litter trays work even better because their sides are vertical, but they cost a bit more.

Use the Local Stores

Do your buying in town because:

1. It's to your advantage to keep money in your own backyard—that's where it will trickle back to you.

2. These merchants are your potential customers, so let them know what you do when you visit their stores. Let the checkers and salespeople know, too.

3. These merchants will also be your best credit references. If someone is checking up on you, the local references will have the most weight.

4. One of the advantages of paying by check or having local accounts is that every time someone sees your name, it's a form of advertising. Thus, be sure to use your business name on checks and accounts.

Don't Lose Those Calls

The first contact someone makes with the studio will be on the telephone. Be sure that you sound welcoming.

It's also a disappointment to the caller if there's no answer. If you list both your home and business number in your Yellow Pages ad and on your business cards, risking the lack of privacy it will bring, you'll definitely get jobs you might have missed otherwise. The very fact that you list your home phone makes you sound more approachable.

Here are four other ways not to lose business phone calls:

1. If you're alone at the studio, and will be absent for just a few minutes (we all have to go to the bathroom sooner or later), take the phone off the hook. Everyone understands a busy signal, but if the phone rings for forty-five seconds and no one answers, the place sounds empty.

2. Have an extension of your business phone put through to your home

(inexpensive only if you live close by). The phone rings at both places simultaneously.

3. Hire an answering service. This is a hard one for me because I haven't always had luck with them. If the service gets too many businesses signed up and is inadequately staffed, it can become careless, muddle the calls, delay answering, and often do more harm than good.

4. Buy a telephone answering machine (my present solution). The main disadvantage is that some people hang up instead of leaving messages. A secondary problem is your existing message rarely fits exactly what you'd like to say. E.g., "If that's Mrs. Wright, your pictures will be ready on Monday."

Other customers don't wait and start speaking before they hear the tone. *They* think they've left a message, but all *you* hear is ". . . so if you can call me right away, I'll be at home."

My first answering machine had all the extra gadgets. I prefer the present one (a Phonemate), which has given less trouble—in fact, no trouble. It just takes calls on a reel tape and plays them back, there is no "conference" line, recording of a conversation in progress, or other extras. I got this one because the other one was lost by the company that was repairing it.

Listen To Your Customer

If a customer is not happy with an order and he's not a chronic complainer, then you must take the time to iron out the complaint in a way that makes *him* happy.

E.g., if someone thinks the picture doesn't make him look good and you think it does, ask him why. It's cheaper to retake a few shots his way than to have him knocking your work. It's again a case of a snowballing of ill will, when it could be a case of good will.

A marvelous looking rancher came to complain because I'd cut the top of his cowboy-type hat. I explained that the picture was of him and not his hat, but I had left it entirely in *some* of the pictures.

"But not the one I like best," he replied.

"Because it's cut!" I showed him other portraits both with and without hats and that a dominant shape like the top of a hat distracts from the face beneath it. (But if you are selling the hat it is better to include it!)

"You've convinced me," he said at last. "When I see my friends' pictures, I'll tell them all I can see is the hat!"

Should you return someone's money if he's not happy?

Not if you can make the job right. By all means discuss the situation and perhaps a price adjustment can be made, but *never* return the money if you feel you're right.

I had an interesting situation where the lab had streaked the film (or it was a bad roll), but either way there was a dark line running through all the transparencies. It was a commercial order.

I told the customer I'd do the pictures over and he said he didn't need me now because he had a friend who had offered to take the pictures free. He asked for a complete rebate.

I agreed, provided my time was covered, and he balked at that.

Now, the customer had sent his wife to pay my bill, so I had his check. He asked for its return and I instead wrote him one of mine for the full amount, withholding my time charge, which I felt was reasonable because I

221

had put a lot of work into the pictures, which could very quickly be retaken now that the basic work was done. I had tested the lighting needed, particularly as there was glare involved, and decided against a particular lens, mentioning why. He had seen me take the pictures and would be using *my* knowledge to have the new ones done.

"You're an architect," I said to him. "Aren't you paid for *your* time?"

"Oh, I'd do the same thing if I were you," he announced. "But I'm still going to stop payment of that check and you can stop payment of yours."

The moment he left the studio, I left, too. I went to his bank and cashed his check at the drive-up window.

Thirteen Customer Gripes

I asked a customer what annoys her most about small businesses. She's the kind of customer I value; generous, appreciative, and quick to spread the work if she likes something.

She came up with a great list:

"Anything that wastes my time," she said.

"But would you go to another place or not return, if someone wasted your time?" I asked.

"I would and have."

Here is her list of specific gripes.

1. *The person who doesn't keep to his business hours.*

"I saw some beautiful dishes at a craft show and decided to order a set of twenty-four, which was about $400. I lived eight miles from the potter's address and made a special trip there to order the dishes. The potter wasn't there, though the hours on his door said he should have been. There was no note of when he would return. I waited fifteen minutes and left.

"Then I got to thinking he could have been called away on an emergency and returned the next week. Again he wasn't there. And again there was no notice of when he would return. So I decided I shouldn't have to put myself out any more, and he lost my order."

2. *A promise that isn't kept.*

"I get mad when I'm told something will be ready and when I go to pick it up, it isn't. My time is as valuable as theirs. Why don't they call?"

3. *The salesperson on the phone.*

"If I go into any place of business, I don't want to wait while someone talks on the phone as if I weren't there. If the person on the phone even acknowledges my presence and tries to cut the call short, I understand. Years go by before I return to a store where that has happened."

4. *The price-evader.*

"When I ask the price I want the *price*. I ask how much something is and the person describes how great it is. I know it's great; what I want is the price."

5. *The "cash only" business.*

"I don't like shops that don't take checks. I expect all stores and restaurants to notice the kind of person I am and gamble on me! I'm loyal to the businesses I deal with and I don't mind showing IDs. But if I don't want to pay with cash and see something I want, I expect to be able to buy it."

6. *Unpunctuality.*

"I don't like to be kept waiting if I have an appointment. I phone if I'm running late. Why can't professional people and businesses do that? But if a

delay can't be avoided, then I expect to find a comfortable place to wait and to be offered a cup of coffee!"

7. *Errors.*

"I don't want to take a purchase home and find there's an error in the order. If there's something wrong with it, why didn't the merchant catch it? He knows his merchandise better than I do.

"Now I'll have to go back, often more than once if the store can't give me the correct order right away.

"Even worse than this is having someone act as if it's *my* fault. There's the kind of clerk who says to you, 'Aren't you the lady who had trouble with another order?' "

8. *Packaging.*

"I love pretty packaging. If I buy something that costs $100, I don't expect it to be dumped in a brown paper bag. I don't expect to have a $5 item put in a gift box, but a store that thinks well of itself should consider how the merchandise will look in its bags and packages."

9. *Selective salespeople.*

"Another gripe I have is the sort of salesperson who looks you over. My husband sometimes goes shopping with me and if he's been working outdoors all day, he might have shabby clothes on. We bought our Porsche from a dealer in another town because the salesperson didn't bother with us. He was taken with a more flashy-looking couple. And we couldn't resist going back with the new car and asking him a stupid question, just so he'd see from the temporary registration plates where we had shopped."

10. *The salesperson who is a pest.*

"I don't like to be overwhelmed. I like to relax and look over what I want, not to have someone trying to hurry me." She made an example of, "the sort of saleswoman who's always looking in on you in the dressing room when you're trying on clothes: 'Are you ready? Do you have any dresses I can put away? Well, call me when you need help.' "

She called me later to say she had thought of three more gripes!

11. *Loud music.*

"There's *nothing* I hate more than to go to a place where the music is too loud for me to think. I only like listening to *my* kind of music anyway, so I suppose that when a store plays music it limits itself to customers who have the same taste."

12. *Inconsistency.*

"I like consistency in quality. It's such a disappointment when you go somewhere with very fond memories, and find the service or merchandise is no longer of the same quality.

"There was an experience my family had with a photographer. The first pictures of my son were great, but a year later the color was really washed out. When we complained, he said that was how they should be!"

13. *Stores that won't recommend other stores.*

"It's annoying when you're a customer and the store doesn't have what you're looking for, but refuses to help you find it elsewhere. I've been told that such merchandise is not made—even when I know it is—and at other times that it's not available locally, and then I find it is.

"Yet, when I've asked a store clerk where I could get a particular item they don't stock, and he has told me, I find myself going back because it makes him seem more expert, more on the ball. That clerk now seems like a friend."

Trouble-Shooting Your Business Operation

A way to update your studio's main trouble spots is to make a list of your thoughts on the major disaster areas: e.g., promotion, filing, bookkeeping, decor, price lists, and storage.

Always start on the easiest task or the one that sounds the most fun, and don't rush it. After an hour, get up and make a cup of coffee if you get restless.

Attack one drawer of one filing cabinet, throw out the "deadwood" papers, tidy the rest, make new labels. Suddenly you'll be whizzing along thinking, "That was easy. What will I do tomorrow?

Why not paint a wall tomorrow? One wall. If you finish early and feel like it, paint two walls.

Rainy Days

My grandmother had a rainy-day cupboard. We rushed to her room when it rained, she unlocked it, and took out the toys we could play with at no other time.

I, too, had rainy-day toys for my children. They came in yelling, "It's raining! It's raining!" and I'd give them the windup train that went around on tracks and other "special" toys. The moment the sun came out they packed them away, already tired of them anyway.

I keep rainy-day projects to do at the studio. If there's something I'm not getting around to, I promise myself, "On the next rainy day!" Somehow it makes that job a lot more fun to know that the moment the rain stops, I'll have to put it away.

Here are some of my rainy day projects.

1. I tidy a particular drawer, or file, or shelf.

2. I catch up on one of my backup files. I have an "almost alphabetical" file of my customers (all "a"s together). This is often a rainy-day project—I turn on the TV in the studio, and bring it up-to-date.

3. I compose form letters to customers. I wish I'd get around to making more of these because when I send them out, they do bring rewards. I might, for instance, write to all people whose pictures are on display and offer to sell them half-price.

4. I update the price lists.

5. A frequent rainy-day project is "deadwood disposal." I go through files and catalogs and throw out anything I thought I might need but have changed my mind about.

6. I thoroughly clean one corner of the studio . . . what the English call "spring cleaning." It's washed, repainted if necessary, repaired . . . made new again.

7. I also have projects that I'd never do unless I made time for them; tiling is one. I love tile and might buy the tile and put it aside until a suitable rainy day. My next tile project will be the studio table, a coffee table that I want to cover with decorative tile. My last was the window seat in our waiting room. It's now covered with bright blue ceramic tile.

8. My own famliy photographic albums are a much neglected project waiting for a suitable rainy day. I have the albums and the photos, now all I have to do is put it all together.

9. If I've been wanting to experiment with lighting, or some technique of

photography (try a new filter, try out some home product for retouching), I might make it a rainy-day project. My poor dogs are so resigned to my using them in experimental photographs, that I have only to say, "Let's take pictures," and they get onto the modeling boxes.

Make your own list of rainy-day projects—on paper or in your mind—and when it does rain, remember to do what it was you planned.

Make a List

If you never look at a list again, make it anyway.

Make a list of things that you should have done and would like to.

Make a list of ways you could be making money and aren't.

Make a list of pleaures you've wanted to have and can't afford.

Make a list of things you'd like to buy.

Making a list focuses your attention on *specifics* and your mind begins to work on those specifics.

A lot of the *Make a Million Dollars in Three Weeks* books just tell us this, "make a list and read it every day."

Whether you'll read your list or not, sit down and make it. It's a wonderful pick-me-up.

Year-Round Schedule

In lean times:

Plan promotions.

Get on the telephone and contact possible customers.

Give talks to any group who will have you as their guest speaker.

Clean up everything.

In good times:

Invest part of the profits you're making.

Pay bills early, so when you can't pay you'll be known to be a prompt payer.

Keep smiling, and treat every customer as if he were the only one.

Don't boast.

Take time off between jobs, so that you're not working *all the time.*

In busy times:

Be methodical. Don't depend on your memory; write things down.

Put everything that can wait into a box or a file where you can put your finger on it if you need to.

Decide how you're going to handle your bills, either by paying each as it comes in or paying when they're due. Don't leave them until you "have time." That time may not come in time!

Try to keep an orderly look about the studio. It's better to keep someone waiting five minutes than invite him into a place that looks like a war zone.

Never become impatient with customers.

Be good to yourself. Get help; give yourself a leisure treat; go to the beach, the mountains, a movie; take pressure off by spoiling yourself with your favorite meals, etc.

Don't panic your employees by panicking yourself, or be impatient with them.

Expect that confusion will lead to mistakes and try to be extra careful with all orders.

Don't let your customers know that you can no longer tell them apart, that there are too many of them!

Neither be impatient with your friends nor allow them to take your time from your customers for leisurely socializing that you ordinarily fit in.

Don't ease up on the caution you normally use—check items on bills to be paid, as an example. Just because you're busy, other companies won't make fewer mistakes.

Don't slow down the impetus all the business is creating. Find a way to deal with it, not stop it.

Once a week, do something to promote your studio or to make it look better.

Once a month, decide some way that you'll make the studio more efficient. Look back on the previous month. Have you been putting in too many hours? Do you need a break?

Once a year, learn something new about photography; something beyond the experience you're getting. Learn a new technique.

How to Cope with Misfortune

If something goes wrong—be it financial disaster, a ruined order, or any setback—put it out of your mind and imagine that you are starting all over again.

Out of these disasters will come something good because you're not, *in fact*, starting over. You're now beginning with a studio that is already established and you can use all that to your advantage.

Once you've seen how well this works, you'll realize you needn't wait for disasters to happen! You can tell yourself that you're starting with "this studio," as if you just moved in. It's surprising how quickly fresh ideas will flood your mind and what business will come through the door as a result.

It's the philosophy of Krishnamurti, and he calls it "instant awareness." In an instant you see with fresh eyes, things you haven't seen before; you hear sounds you haven't been listening to; smells you haven't consciously smelled. And it all adds up to a wonderland, neither good nor bad, but just there. Somehow all the problems of your life will cease to exist from that *instant*.

I have used "instant awareness" for years to bring me out at the other end of a crisis. Rather than beat it around in my mind, I look at the world with fresh eyes, and instantly my problem becomes very minor, next to the wonders that I suddenly begin to see.

13
Other People's Debts

The first time someone walks in, has his photograph taken, and pays for it, it's excitement indeed! Everything seems so simple; nothing to it!

The first time someone walks in, has his picture taken, and avoids paying, you'll want to climb the wall. "Why did he waste my time?" I used to rant inwardly. I would then brood over every detail of my encounter with this particular individual: the questions about price, the decision to go ahead, and finally the sitting itself. So much energy was spent, surely not just to rip me off?

With my present system it is almost impossible for a customer to get away with the pictures without paying for them. If I am stuck with the expense of ordering them, at least he doesn't have the satisfaction of getting more than the time I spent on his order.

Customers who specialize in rip-offs have different methods. The sitting may have been satisfactory; the customer comes by, looks at the pictures and likes them (if he has a good reason for not being satisfied I will offer to retake the sitting, so he has no gripe there). However, he says he is short right now; he'll be able to pay "next week," only next week never comes.

Another type of nonpayer never shows up at all to see the pictures. One of these called to ask for the return of his deposit because he didn't like them. "How do you know you don't like them if you haven't seen them?" I asked. There was silence. I phoned another local photographer and found we had both photographed this same man. Apparently he liked posing and had done so all around town! He then looked at the previews or proofs and said he didn't like them and asked for his sitting fee or deposit back (maybe he did get it in certain cases). When he phoned me he had confused his photographers and forgot he hadn't seen my shots of him. Later, when I confronted him with his style of operation, he didn't confirm or deny it; he just hung up on me!

There is also the individual who likes the pictures I have taken enough to make a generous reorder—perhaps some months after a job which he paid for in full. I put the order through and never hear from him again.

The customer who specializes in writing bad checks is another person I can do without. How infuriating it is when your bank returns a check stamped "account closed," or "insufficient funds" (particularly a sizable check that you've gleefully deposited and perhaps used to pay some of your own bills).

Often when we're victimized *we* feel guilty. "What did I do wrong?" you may find yourself wondering.

The answer is usually, "Nothing!"

Every victim—the raped, the mugged, the relatives of a murdered person—thinks, "I should have done something to avoid it."

Not so. Some people are always looking for a victim for their crime; all you have to do is be there.

The more difficult you make it for someone to get away without paying, however, the less you'll be bothered by trying to collect on a bill.

Bad debts come from:

1. *Honest people.* The bounced check can be a genuine accident and the unpaid account a matter of sudden and unexpected hardship. Just hold on. The bill will be paid sooner or later.

Four times I photographed weddings and the bridegroom returned from his honeymoon to find he had been laid off. Two of these happened in the same month, and, of course, the bosses thought they were being kind by delaying the news till after the happy day. The couple felt otherwise. They wouldn't have spent so much if they had known hard times were ahead.

I believe many sad stories without asking for proof. This has brought me more business than it has lost. I have been in their shoes and know how grateful I've been when someone believed me without skepticism. I am, however, much less trusting than I was and frequently check stories if any detail seems unlikely.

2. *The impulse buyer.* Someone who carelessly purchases anything, regardless of the amount of his resources, gets into trouble sooner or later. The threat of small claims court sends most first offenders scurrying to the studio, checkbook in hand. More hardened cases wait for a summons! Usually, the day before the case is due in court, or even at the courthouse, there he is with the full amount! If he gets heavily into debt, he might leave town, close his bank account, and soon become an expert in nonpayment.

Not all people who can't pay their bills are intentionally irresponsible. They really think they can keep up with their debts, but . . . I phoned one recently over a bounced check for $84 and she promised to have the funds to meet it in two days. So, two days later I drove to her bank (which was also my bank), and asked if the money was there. The teller looked at her check and called the bookkeeper to okay it. I was amused when she said, "If I were you, I'd cash the check now while she has the money. If you deposit it, you may have to wait another month, as there will be others in soon and they'll be ahead of you."

"She must run up a fortune in charges," I said.

"She does," replied the teller. "But eventually everyone gets paid."

3. *The con artist.* This is someone who doesn't *expect* to pay and is an expert at setting others up for a fall. More on these guys later.

Four Ways to Avoid Bad Debts

1. Have a policy that makes it virtually impossible for someone to avoid paying. E.g., no order leaves the studio unless paid in full.

2. Impose a penalty on bad checks and accounts unpaid within thirty days.

Remember that the law limits the amount of interest you can charge on an outstanding bill, but you can charge a "service charge" instead of "interest." The customer must agree to this charge in advance. If it's printed on the order form and that form was signed at the time of the order, then he's agreed!

3. Spot a potential con artist and prevent him from pulling his usual tricks. By some simple changes in studio routine I came up with no bad debts last year. I noticed the four I had the year before were all Christmas orders, so I refused to take checks in December from new customers and anyone who looked under thirty! "Cash your own check," we told them. "It's easier for us."

When you accept a credit card, call the WATS (800 prefix, toll-free), number you've been given by your bank for authorization on even the smallest sums. This voucher is now like a money order, that is, it is *cash*. The authorization number you'll be given guarantees that sum from the customer's account.

We're told to call for authorization for amounts over $50 only, but I do it for all credit card payments since I noticed it was the small sums not the large ones that had trouble going through.

4. Insist on rush orders from new customers being paid by cash, money order, traveler's check, or credit card, as there is no time for the check to pass through your bank and theirs. Traveler's checks are signed when purchased and so are prime targets for theft—the signature can easily be imitated by a forger. Thus, never accept a traveler's check that has already been endorsed, or one from a customer you do not know—unless he can produce further identification. If the owner of a traveler's check that you've accepted has reported that check as stolen, you'll get stuck.

Get a Deposit

A deposit on each order shows a commitment on the part of the customer. A signature for the balance of the order is a further commitment.

The mother of a high school senior came to my studio and complained that her son had left the country instead of continuing his education. So she had no need for the portraits he had ordered and she wanted to reduce the balance due!

I explained that he had ordered the *minimum* package, which was already reduced from my normal prices. Whether or not she wanted the pictures, the balance was due. She then said that he had ordered the pictures without her authorization. I pointed out that it was true he signed for them, but that he had paid a deposit with *her* check, so she must have given her consent.

I didn't agree to her request that I keep the pictures and let her pay a reduced amount because this was not a hardship case. She was trying to make me the scapegoat for her trouble with her son.

Some years ago I told one of my customers, an attorney, about someone who had whittled me down on a bill.

"Well," he replied, "the next time I need photographs, I'll just make so much fuss that you'll do the same for me. And I'll tell my friends!"

I no longer "reward" people who are difficult. They have to pay just like the nice people.

A deposit against an order will also break up the bill so it seems less.

Try to Collect Amicably

When a bill hasn't been paid for *whatever* reason, the first step is to phone or write and bring it to the attention of the customer, who may have forgotten all about it.

> Dear Mrs. Doe:
> The balance due on your account is $43.50. Please let us know if there is a reason for the delay in payment.

Short, friendly letters say it best.

If we don't hear from the customer, or get a promise of payment but no money, we try again! And after two or three attempts to collect, it is:

"We will have no alternative but to put the matter into the hands of the courts."

Between these letters we leave enough time for someone to have returned from a vacation or recovered from an illness. In a letter threatening collection I break as much bad news as possible:

". . . In a case like this, in which I expect to get a judgment, you will also be liable for the $9 filing fee. Of course, we'll also have to add the service charge, which has been waived until now."

If all this has been done by telephone, put it in writing also and mail a copy to the customer: "As we discussed on the phone today . . ." You can't file at small claims unless you've given a customer adequate opportunity to pay.

Simple Ways to Collect Out of Court

I have various ways of coping with the bad checks that come through the studio. I also distinguish between the people who are temporarily out of funds—and admit it—and the *deliberate* nonpayers.

● When a check bounces, telephone the customer or write if you can't reach him quickly. Most bad checks will quickly be made good with an apology.

● A check marked "insufficient funds" can be redeposited without contacting the customer; just make a phone call to the bank and put it through when there are funds to meet it. If it's a student (or obviously someone in the habit of overdrawing his account), I go to the bank and cash the check the moment I hear the good news.

Banks are obviously reluctant to give out information about their customers, but if you say you have a check for $15 made out by Jane Doe on her account number . . ., you'll be told if there are sufficient funds in that account.

My first bad check came from a woman I felt uneasy about, but I took her check anyway. She never saw the pictures and, when I called to tell her they were ready, I found she'd left town. Afterwards, her check was returned to me.

But when I phoned her bank, her account was still open. So I wondered if she was expecting money to be deposited into it. Sure enough, a few days later the money was there, and I went over and cashed the check.

I noticed it was April 3, and guessed that the money put into the account

must have been wages or an allowance due at the end of the month. Since then I've waited until the second or third of the month to call the bank, and then redeposited the bad checks. Almost every time I've been rewarded by the check going through. The customer hasn't had time to overdraw the account again!

• We used to have luck collecting from customers who were in financial straits by asking them to postdate their checks. Then I discovered that this is illegal. The date on the check must be the date of the signature. If a customer will trust me, and most do, I now ask him to write me the check, and I hold it until a specific date.

These customers aren't seasoned bill dodgers, but people who don't have the money on hand who might ask if they may pay "next month" due to some sudden financial problem—maybe the loss of a job.

I've had a customer ask me to hold a check as long as two months, and I've done it, but usually I hold checks just a couple of weeks. That time, I have to admit, I wondered if I was being a bit too trusting. But when I eventually put the check through, there was no trouble. In these cases get a Social Security number and another form of identification to be safe.

• The person who *is* a seasoned bill dodger usually tells a sad story to postpone writing a check. Eventually, you begin to recognize these stories as inventions, e.g., an effort to involve someone else: "My girlfriend crashed my car," "My boyfriend left and took my money," as if this person thinks you'll believe a story where *he* is the victim. Sometimes, of course, the customer has been victimized, but the way the story is told isn't so slick. Be alert rather than suspicious.

• When the bill is in doubt, we stop work on the order. Most customers accept my, "Well, I'll hold up the order till you get in touch with me again."

This situation may arise when someone orders a picture, perhaps for Mother's Day, and says, "I don't have the money for the deposit now, but I'll have it in a week." If I don't put the order through now, it may be too late for Mother's Day. If I insist on the deposit *now*, I may lose the order.

But if I say something like, "Don't worry. Bring in the deposit next week and we can air-express or air-freight the order to speed it up" (charges which the customer pays), the deposit money may appear the next day. In fact, more than once when I have said this, the customer has replied, "Let's do it that way then," and is appreciative that I'm willing to go the trouble!

If there's any doubt of getting paid, find out the customer's address, place of work, and the driver's license and/or Social Security number, and be sure he signs your purchase order or contract. Also, phone the bank to see if the check is good *before* putting it through.

Of course, if a regular local customer or someone I know I can trust is temporarily unable to pay, I put the order through without the deposit. These people, though, are more likely to have left their checkbooks at home, or be out of checks.

• If someone who owes you money can't be reached for a week or two, sometimes all you need to do is track him down and he'll pay. Family and friends often cooperate if they *don't* know why you're looking for that person. If they think you're a bill collector they'll clam up.

If someone asks why I'm looking for his relative, I merely say, "I have photo-

graphs of him taken at my studio, but there is no answer at the phone number he gave me."

Unsigned and Wrongly Written Checks

One of my customers failed to sign a check and when I phoned him, he said, "Write my name on it in your handwriting and when the bank calls me to question the signature, I'll okay it."

Did you know you could do this—sign *his* name if he gives you permission to do so? It saves the customer a trip to the studio to make that signature good.

If you fail to sign a check, you can do the same. Just let the person you made it out to write your name in *his* handwriting at the bottom. When the bank calls you, okay it.

A check for the wrong amount can be changed by the person who deposits it. If the amount is too large, just change it to the lower figure. Draw a line through the amount "$40," and replace it with "$30," the correct figure. Also, draw a line through the amount written out, "Forty," and write instead "Thirty," above or below the line.

If you want to change the figure to a larger amount, you can also do so with the permission of the customer. Change the amount as before and write his initials under the alteration in your handwriting.

If you do this without someone's permission, you can go to jail!

Out of Town Checks

A shopkeeper who had seventy-two bad checks last year told me he no longer asks for IDs from tourist customers because those checks don't bounce. He figures that when people travel, they arrange to have enough money.

My experience has been the opposite. Although bounced checks are not common at the studio, I find that more of them come from out of town (*way* out of town). Of course, our business doesn't cater to tourists, but usually parents of bridal couples—or the the couples themselves, who have moved out of town—have been the culprits. So far I've never had trouble, however, with out-of-town customers who hire me for commercial photography.

I've become so cautious about out-of-town wedding orders that I photocopy any check, and try to get as many addresses as possible with, "You'd better give me your parents' address, too, in case I can't contact you," or "Is there someone I could call with a message, in case your daughter isn't back from her honeymoon?" This information is easy to get when the wedding contract is being signed.

The reason for copying the checks is that, in the event of problems and getting a judgment against that person, the most frustrating part of all is not knowing where he banks, so the sheriff can enforce collection, if necessary. A seasoned bill dodger does not appear in court to answer the summons and so while you may get the judgment against him, you may still have to pay a law enforcement officer to serve the defendant's bank or place of business to collect. (This fee will also be owed to you by the defendant.) The law does no detective work; it is up to

you to provide these addresses. If you already have the bank address and the account number, your work is done!

Last Resort—Small Claims Court

There is a limit to how much can be collected in small claims. In California the limit is $1,500? which is more than adequate for most of my bills. Neither you nor the defendant may retain a lawyer. There is no jury. A judge listens to both sides and gives his judgment. Be sure to have all the information proving you are owed the money.

First, you must go to the courthouse where you'll be required to fill out a form stating who owes you the money and for what. You'll need the name and address of the debtor. Decide whether you want him served by mail or in person. You pay more to have the constable serve the summons in person.

If, for example, someone works full-time, have him served at work, or have the summons mailed there. Just indicate on the form the hours you expect the person to be at the address you've given.

As "cause" you'll write, "Photos orderd and not paid for," or "Photos ordered and paid for with bad check."

A date will be set for your case.

Then, if it's your first time, go to the small claims court in session and listen to a few of the cases and see how others make their presentations. You'll notice the judge cuts off those who give long descriptions, "And then he said . . . and then I said . . . "

There's really nothing to it.

One time my case went like this:

I arrived on time, we were all sworn in, and there were three cases scheduled ahead of mine.

The clerk called, "Thwaites versus Doe"; and I stood up but Mrs. Doe was not there.

The judge asked me to present my case and I said "Your Honor, Mrs. Doe ordered portraits at my studio and paid with a check that bounced. Then she gave me another check and that, too, bounced. Since then I've tried to collect from her and she often promises to pay, but it's now eight months since the order was completed and I'd like the money."

"Did Mrs. Doe have complaints about the pictures?" asked the judge.

"No, she liked them. This order refers to an additional print she ordered. She hasn't even seen it."

"Have you any documentation of this transaction?"

"Yes, Your Honor," and I gave the bailiff all the paperwork, with a list of dates when we had contacted Mrs. Doe and what her response was on each occasion. The two returned checks were included.

He looked them over, "Judgment for the Plaintiff."

That meant that Mrs. Doe (the defendant), owed me (the plaintiff).

This particular case went further.

After thirty days I hadn't received Mrs. Doe's check, so I returned to the courthouse. In the sheriff's department, I was assured that Mrs. Doe had been

233

served with a court order to pay me. They asked if I knew where she banked or worked.

She worked at a bank and so I paid a further charge so that her wages could be attached. I now found that she had someone else who had filed ahead of me, and as only a certain percentage of her wage check could be attached, I would have to wait in line. Eventually, I received two payments and she left the area, at which point I dropped it.

I have more than recovered the cost of my filing charges and am only about $30 short. I put this into "collection," but don't expect miracles.

You could, of course, put the bill into collection right away. For about 50 percent of all money collected (the rates vary with the company), an agency does all the work.

One last word about the small claims court. A defendant (that is, Mrs. Doe), has the right of appeal. She doesn't have to accept the judge's decision, but can take it to a higher court. A plaintiff can't. Thus, I have to accept the judge's decision.

It's also up to the plaintiff to prove the case. The best proof is a signature. But if you don't have that signature, take a witness. Perhaps your assistant or one of your family is aware of some or all of the details.

Most defendants will pay, once the judge has told them they owe the money. If someone doesn't, it's because he's expert at avoiding payment.

Small Claims or Collection Agencies?

When I first started my business I used the small claims courts to collect my bad debts. It took time to go to the courthouse and file and make an appearance on the day of the trial. However, I had plenty of time on my hands and could not pass up a chance to get a sure settlement in the hope that a customer with an order (that could not wait) would walk into my studio. Our small claims court opens at 9 a.m., my studio at 10 a.m., and as mornings are usually slower than the afternoons I felt pretty safe. So I just closed the studio and left a note on the door saying that I hoped to return much richer—and usually did.

Nowadays I never seem to have enough time for myself, and since I can afford to share a bill with someone who will collect it for me, I usually find it wiser to use a collection agency for bad debts.

There are still times, however, when I would not use one:

1. When I am chasing a local person or business from whom, if I get the judgment, I will have no trouble collecting the entire sum. This could be because the person I am after (perhaps a woman whose child ran up a bill, without, she says, her approval) is obviously willing to pay me *if* the judge decides in my favor; or because I can easily find or already know the bank and/or place of business of that person.

2. The sum is such that I will suffer quite a loss if I hand over half to someone else. Let us say my property is damaged by someone and I am collecting $720, the sum needed to repair it. I don't want to collect half the sum, as I will have to spend the entire amount, and since I have someone working for me in the studio most mornings, I won't lose any business.

3. The amount I am asking includes a charge for "loss of time." A collection agency is not allowed to collect that part of the bill.

I must also mention here that I *never* go to small claims court or bring in a collection agency unless I have *no doubt whatever* that I am owed the money—and have sufficient evidence to prove it.

More Pros and Cons of Filing a Small Claim Rather than Hiring a Collection Agency

The pros are:

1. You'll probably win the judgment. Ours is a cut-and-dried business. But if the customer has complained about the quality of the work, then you should have a witness with you.

2. Usually, the customer arrives before the case is due and pays you. Often he arrives the day before. Take the money, of course, but be sure you take it in cash or the equivalent (credit card or money order), and that you add the filing fee. You must now cancel the case.

The cons are:

1. When you know a customer has flown, a collection agency is in a strong position to find him. You aren't.

2. A collection agency will chase someone across the country, splitting commission with other agencies if necessary.

3. Collection agencies do make a tremendous effort on the bigger bills (on the smaller ones, I don't think so).

4. If a customer is in the habit of *not* paying bills, the agency knows it at once because there are other people in line in front of you. So if this person comes back to order pictures you, too, know his reputation and can demand cash.

5. If you've made it a practice to take a deposit to cover your material costs, then why not split the balance with someone who will do the leg work?

6. A collection agency may hire a lawyer eventually—more hassle than you probably want.

Finding a Collection Agency

Recently, P.P.A. sent me literature on a collection agency which, for a yearly fee, will turn back to the studio the entire sum collected. As I have very few hard-to-collect accounts—none at all in some years—I'm better off paying a percentage of the bill, but for large city studios, it sounds like a very good deal.

I learned quite early that all agencies aren't the same because I once worked next door to one. They spoke in whispers and used a crowbar to make a point. The partners even turned on each other and I would hear crashes from behind their locked door!

These kind of people have made it necessary for rigid laws to be passed. There are now enforced guidelines on how far a collection agency can go to get payment on an account.

If there's more than one collection agency to choose from, find out which

one a local hospital uses. Every time I've been in court trying to collect, someone representing one of our three hospitals has been there with a long list of nonpayers! Surely a hospital administrator doesn't want to get these people back in the hospital, and would use someone with gentle tactics.

A collection agency can trace anyone through his Social Security or driver's license number. Copy the number down yourself. One customer wrote hers onto her check and I had to point out she had written it wrong!

The Professional Thief

Besides the people who don't pay but are actually, at least in their own minds, honest (the amateurs), there are the pros.

Not all professional thieves steal indiscriminately. One explained, "We specialize so as not to spoil each other's game," when I was taking pictures in a prison. He asked if he might look at my camera. I said, "Forget it! You just told me you were a thief."

"I don't steal cameras; I steal automobiles!" He didn't mention if he was a liar, though.

Con men never pay if they can steal, whether it be a professional service, a TV set, or another man's business. They habitually lean on people to get something for nothing.

The most common con works on the premise that it's impossible to con an honest person. His victim can't turn him in, as he has become a party to the crime.

If a stranger suddenly takes a liking to you and tempts you by telling you of people who have made a lot of money with him in certain ventures, wonder why. He may not ask you to invest, but he'll let you in, if you wish. Don't go for it.

Here's such a case. Albert tells you he knows a jockey who will tell him just before a race if it's going to be fixed. There's no time for you to put your bets on, but if you give Albert your money, he'll get the information and place the bet for you before the Tote closes.

If you decide to test Albert with, say, $20, you'll probably do all right because he wants only the bigger stuff. Perhaps you'll get $60 (out of his pocket). What he wants is for you to think it's such a sure thing that you'll try to make a quick killing with one large bet. Then he'll take off and you won't see him again.

Fixing a race is illegal. Don't go for it.

A con man ordinarily doesn't allow himself to be photographed, or if he gets trapped into it, manages to destroy all pictures and the negatives—something to remember!

Another con is to make you feel that you'll make a lot of money in the long run if you do some free work now. "When I'm famous, *you* will be my photographer," has been said to me more times than I care to remember. I always thank the gladhander and reply, "I'd like to take you up on that, but right now I need the money."

Intimidation is another kind of rip-off. "If you don't do this, it might turn out to be very unpleasant for you."

I was once threatened by a politician who was powerful enough to make it

stick. He ordered a lot of pictures, and then when I gave him the bill that we had agreed upon, he said he would pay half!

I decided not to cross him, but campaigned against him. I privately told his opponents what he had done and was delighted when he lost the next election!

Then there's the person who thinks that the prospect of sex with him or her should be well worth some free photography.

Another type of con is manipulation. One photographer, Phil, asked a friend of mine, John, for some friendly help with photographs at a night club. John was the more experienced photographer and good-naturedly agreed. Phil dropped off the film of "our job" at John's studio to be developed and printed the following day. "No, it wasn't *our* job," John explained, returning the undeveloped film. "It's only *our* job when *I* get paid."

There's also the charge account thief. Mary looked classy and this was her greatest asset because she used it to open charge accounts.

"If someone wants references, I go somewhere else. But, eventually, a store will trust me just because of the way I look. When you have one account, then you can open others."

Mary paid her first bills and then very little on each of her accounts, until the stores closed them and turned them over to lawyers for collection. She then went to another city, somehow got a new Social Security number and started over.

I worked with Mary years ago in San Francisco, and she told me it was her third move and she could keep going in one place for about two years. I have also met her equivalent at my studio. This kind of thief pays the first bill, then orders more and more, paying *something* each month. Then you realize the bill is very large and you've been conned. When the bills have to be put into collection no one can find him.

A variation of Mary is the person who drops $100 bills as if they were cigarette stubs. In 1971 I got caught by one who left me with a lab account of $1,800.

The first three $100 bills were dropped on the counter, "Can you take my picture for that?" I could and did. When the bill went higher, he dropped a few more big bills and said it was all he had on him. Altogether he paid $800. Besides the lab bill, I also had to find $300 to pay for his frames and albums.

"I'll be back next week and settle your bill in full," he said when he picked up his final order, "to show some friends."

I never saw him again and, too late, realized I had no identification (because he had paid cash). And I hadn't noted the registration plate of his car. In the resulting inquiry, I never collected, nor did the other local businesses that got stung.

That happened a long time ago, but I have since discovered it's common practice. This kind of person *has* money. He just doesn't pay all his bills!

It Can Happen to You

I'm a cautious person. I never really thought people could steal from me, but they have.

I told this to a prominent businessman. He told me that he, too, had been

ripped-off more than once.

"I didn't think it could happen to you," I said.

"We're all human. If we like someone, we want to trust him."

More recently I heard another sad story. This one was about the loss of $400,000 and the culprit was someone everyone liked. He simply siphoned the money from the payroll account.

When the company finally caught on to what he was doing, the police came into the act and found him hiding in another state. It turned out his company was now *second* in line. He had ripped other people off and one of them had brought charges first.

If this happens to you, don't take it personally. Just use the utmost caution when you feel you're at last doing well. Other people will notice it, too, and will think of ways to take your money.

TIPS

The Bride's Father

This is an attempted rip-off story, but I wish I had been forewarned.

At a wedding the bride's mother, who lived 200 miles away, asked me to make her a duplicate album and I asked for a deposit on it. She replied that her checkbook was in the car and so I wrote out the order and she signed it. These seemed charming people and they'd been to the studio twice to look at my work and decide what coverage they'd like.

When I informed the bride that her album was ready, I got a phone call from her father saying he didn't authorize the second album.

"But your wife did!"

"She had no right to," he replied. "It's my money!"

"Mr. D!" "You're saying that to a woman in business? It's not just your money. It's your wife's, too."

This started a series of calls from this man. He accused me of browbeating his wife into ordering something she hadn't wanted; threatened to pass the word on my money-grabbing studio; and, finally, threatened me with courtaction . . . because I wouldn't part with his daughter's album unless *both* hers and her mother's were paid for in full.

Then he offered to pay half for the second album, "to help you out. Let's deal!"

"No deal, Mr. D!" I replied. "You owe me."

A good source of quick advice about what to do next in a legal matter is the D.A.'s office. I called and was put on to an attorney in charge of consumer affairs.

'Why don't you come over and sign a complaint against this man for harrassment?" he said. "I went to school with a guy like him. He was always figuring ways to rip-off merchants."

Mr. D. phoned the following morning.

"I heard that this is not an isolated case," I said coldly. "The D.A.'s office informs me that people like you do things like this all the time. So I'm signing a complaint against you."

"Calm down," he said at once. "I was calling to say I'm prepared to pay for the albums . . . "

We mailed them to him, but he still couldn't let go. He phoned to say they had arrived, "cash only," and "I don't keep that kind of cash in the house."

"It's up to you," I replied. "If you don't honor your wife's signature, why would you honor your own?"

And eventually I received a money order from UPS.

I didn't know before this that there's a law to protect you from your customers! If you feel you're being taken to the cleaners, call the D.A.'s office!

If your D.A.'s office has no consumer protection department, it will give you the name of another agency to call.

Collect at Home

One way to collect money due is to go to the person's home and wait for the check. Over and over again, I've found that it was worth having someone pick up a check, rather than wait for a slow-paying customer to drop it off or put it in the mail. I learned this from an auto repair shop.

I owed them money. The owner said, "I'll send someone around for it," and I was delighted.

Later I thought, that should work for me. It did!

A word of caution:

Visit business offices or customers you know fairly well, or know of (well-known local people), but don't venture to try and collect at some stranger's home unless someone goes with you *and* you've told a friend where you're going (even if you have a black-belt in judo).

Women photographers should be particularly careful that they don't even go out on a job without letting someone know the address they're going to and the phone number there.

Another caution. Don't send out an employee somewhere you would not send your own sixteen-year-old daughter. A male photographer may well have a very good personal relationship with another man, but to send a young woman assistant to collect a bill from him would be foolhardy—again, unless it's either the kind of business or a family residence where you have no qualms at all.

There's Gold in Those Files!

A studio photographer made no effort to collect on bad debts. Year-after-year, he threw them into a box and there they stayed. He hired a new employee who went through the old order, started sending out some letters, and managed to collect $1,700 before putting any orders into collection. So, eventually, more money trickled in.

The photographer told me he actually thought he was owed about $400 to $500; he had no idea it was so much. We're so used to "eating" our bad debts that we forget that we may be throwing away a *lot* of money.

14
Insurance Basics

There are so many different kinds of personal insurance available. Let me mention just four of them: life, health, equipment, and liability.

Because they're not directly related to business, I'm not going to discuss either life or health insurance, except to say that I think both are for the birds!

It's not that they're actually useless. It's just that what's available is hopelessly inadequate and overpriced, except when a large company pays the premiums for policies that have been gone over with a fine-toothed comb.

Before taking out *any* insurance, remember:

1. The carrier of the policy is in the business of making money for himself, not you.

2. Insurance should protect you from losing what you have, not what you don't have. E.g., if your dog has no teeth, you don't have to insure it against biting anyone.

3. You can't be sued except to the extent of your bank account (and other material assets). If you have 1,000, you don't have to fear losing $100,000 in a lawsuit.

4. Money sunk into insurance is tax-deductible, but don't buy more just to save tax! If you want more expenditures to bring your tax down, look at the studio and figure what it needs: painting, better equipment, a new floor?

Or spend it on yourself. Take a trip and shoot photographs in Bermuda; visit the labs you use; or talk to a publisher.

I'm sure you can think of other ways to spend tax-deductible dollars.

Do You Even Need It?

If a company insures your personal belongings, say, your hat, it's betting that the amount of your premiums will far exceed the possibility of you losing that hat by fire, theft, or whatever the policy covers.

But the insurance you *need* is where your risk is highest, and these premiums are correspondingly highest.

If you insure your $20 hat against snow damage and you live in Florida, the premium may be $1 a year. If you lived in Tibet, it might be $15 a year. If you had two hats, the insurance might rise to $1.25 in Florida, and $25 in Tibet. And if

240

you claimed on those policies, the premiums will rise because you're not a good risk any more.

If you claimed *twice*, the carrier may refuse to insure your hats again. I say *may* because it might be to its advantage to let the policy stand. Every time you collect on insurance and tell your friends, they'll rush in and insure their hats and many of them won't be as careless as you.

The insurance company makes the money by knowing the odds and charging accordingly.

The expert who sells the policy makes a great deal of money in commissions and unless you're *very* sure of that individual, it's difficult to know if what you're being told is the exact truth.

Like a realtor—unless you're very lucky—he can be your *enemy!* But he's an enemy you need. Thus, it's *very* important to find a well-established local insurance agent whose reputation has helped him survive in a particular community for some years.

Ask, listen, and then act with common sense.

It didn't take me long to figure that when my equipment insurance was raised to $650 a year, I couldn't afford it. The previous figure had been $250 a year, three years paid in advance. But then a friend pointed out that if I kept my cameras where they couldn't all be stolen at once, and if I could be almost certain of not losing $650 of camera equipment in one year, I would be ahead. I lost no *major* piece of equipment in the six years I've been uninsured and have ended up $3,900 the better for it.

Photographers have told me of cheaper policies, but none locally. I feel I need a local agent; someone I can get to easily.

Essential Equipment Insurance

If the loss of an item you own would be a *colossal* loss, then you have no choice but to insure it. If my home burned down (and one of them did), I would have lost my total investment in it, had there been no insurance. Property owners have to consider this a possibility and if you carry a mortgage on another property, you must *insist* that the owner insure that home adequately.

If your car is wrecked, that too would be a colossal loss, so *that* insurance is also imperative. A good way to value your insurance is to consider how put out you really would be without it.

One Friday in my early married days, my husband bought a small Ford and we drove it across London that Saturday. I had taken my first driver's test earlier that month and insisted on proving my skills, so just outside London I took the wheel and eventually proceeded cautiously around Kensington Square. A double-decker bus started squeezing me against the curb and I forgot I had brakes and drove the car into a lamp post!

My husband had taken out insurance on that car by telephone immediately after our purchase, although it was a half-hour before most offices were closing for the weekend. So it cost us nothing to replace the car, yet we hadn't even paid the premium. But by phoning a reputable agent and insuring the car right away, he had protected us. It's a lesson I haven't forgotten.

Last year I was driving from Morro Bay to San Luis Obispo and saw a motorcyclist driving erratically on the highway. I pulled up ahead of him and asked if he was all right. He said that he had just bought a Nikon with two lenses and other accessories and had strapped it on the back of his cycle. He had arrived at his destination to find the package had fallen off. He was going up and down the nine-mile stretch he had taken, hoping it had merely been thrown off the road, but apparently someone had already picked it up.

He had not had time to insure the equipment yet.

If you have camera insurance, then you should let your insurance agent know when you are about to purchase a piece of equipment. It can be insured from the moment the salesman puts it in your hands.

If you have only one camera, insure it. If you have six and don't keep them together (like me, keep equipment at several different addresses), you may not need this protection.

Insure all your automobiles, though. Most state laws require that they be insured, though many young motorists disobey the law. If you're in a collision with one of them, you'll be glad of your insurance. One American Automobile Association official told me that he'd been struck by uninsured cars three times within one year.

If you have to rent a car, check with your insurance agent and see if that car is also covered while you drive it. The rental agency will try and sell you additional insurance, only a few dollars a day. If you can't get in touch with your insurance company and have left your policy back home, take out that insurance. In 1971, I totaled my car in a highway skid, and rented a car that was also rear-ended the same day. I had paid $6 ($2 per day) insurance on that car, and was most relieved to be able to go right over and trade it for another.

There's also an insurance which, in the case of your death or permanent incapacity, will pay any balance owed on your home, automobile, equipment, etc. The advantage of this kind of policy is that it can be tagged onto your existing home insurance. If you don't have dependents you may not need it unless your "permanent incapacity" will be lived out in the same house and/or there is a new large sum owed on your home. E.g. if you have a very large house with a few thousand owed on it, you will be able to sell and move to someplace smaller. "Permanent incapacity" is very rare.

When you wonder about insurance don't let someone else tell you what you need. Sit down with your family (or a good friend) and figure what kind of a disaster would hit you *hardest*.

Liability

An insurance that we photographers have to consider is protection against the possibility that we may injure someone else. This is called "liability."

If someone trips over my camera, I may be liable for his injury. If my automobile runs into a wall, the owner of that wall will blame me (whether or not I was in the car).

When you're insuring against liability you don't have the same cut-and-dried decision to make as with your possessions. In the case of liability insurance, are you insuring a $500 knee or a $500,000 heart? As you're not sure

what you're insuring, you have to guess. However, if you have a $1,000 bank account, you don't have to insure against causing someone a $500,000 injury.

Have you heard of a court requiring a criminal to pay for the medical bills of a person maliciously hurt or killed? The only reason the man doesn't pay is because he can't afford to. If he had taken out insurance, however, he could then be sued!

Thus, the wealthier you are, the more you need liability insurance. If you're poor, you won't. Certain bankruptcy laws prevent a person from losing his home, business, or car, a fact that lawyers are aware of. Most will rarely take a case against the insured who doesn't have considerable financial holdings. Many liability cases are handled on a "contingency" basis, that is, the lawyer gets a percentage of the amount the client wins in court.

I'm not suggesting that you gun down your customers and default on the responsibility, but when starting out you just don't have to worry about the astronomical lawsuits you hear about, provided you haven't been criminal in your actions (in which case it's no longer a matter of money but jail)!

Specific Liability

There are times a photographer does need liability insurance and you can buy it for the specific need, or possibly for the day.

An occasion calling for this coverage would be photographing dangerous sports. I've needed it for rodeo and auto racing. When asking for permission to photograph any event (except from the stands), see if the organization sponsoring the event carries insurance to cover you.

When this coverage is required, you can't just sign a waiver that you won't hold the officials responsible because they're more concerned with a person suing you and you suing them. Let's say that a horse steps on your camera and the owner sues you. If you carry no insurance, the owner will go after the owner of the arena where the incident happened.

Such insurance may already be in existing policies but if not, it can be quickly added to certain homeowners policies. It's very important that the insurance agent knows that you will be on a job while you need this insurance, that you will not just be hanging around as a spectator.

I carry liability insurance but for years I didn't, except for special events. I feel I have more assets to protect now.

Whatever insurance you carry, try for a company that will update your policy as costs rise. If yours doesn't, question it every year. Intensive care wards currently cost $1,000 a day plus. Once you're paying on a policy, the premiums to increase it are very small.

TIPS

Secure Your Equipment—Ten Tips

1. If you haven't already taken out adequate insurance on your equipment, do so when you travel. If an item is stolen, report it to the

nearest authority and get a copy of the report for your insurance company.

2. Carry equipment in cases that don't look like camera cases. I carry mine in baskets.

3. Never mark your car in a way that invites thieves to break in. "John Doe, Photographer" would certainly do this.

4. If you drive a station wagon, cover your cameras with an old rug or something that seems unlikely to be covering expensive equipment.

5. If you open your car when there are people around, don't make it obvious that you have a trunkload of costly equipment. I won't unload my cameras if there are people around. I might even drive somewhere else to take a particular camera from a case.

6. If you have to put a camera case down in a busy area (a street or an amusement park), put your leg *through* the strap or in some way make certain that if someone picks it up, they can't take it away without taking you, too.

7. If you stay at a motel, never leave your camera in the room. Leave it at the front desk (get a package check receipt), or take it with you.

8. Never leave a camera in a car in a hotel parking lot. There are parking-lot specialty thieves, a hotel detective told me. They watch you as you come and go and notice if you have something worth stealing; then they notice if you leave your car without it!

9. If you're staying at a hotel or motel but know people in the town, leave your equipment there. This happens to me a lot when I photograph weddings in other cities. I just leave all my camera bags with my host.

10. Be sure your insurance covers you in the way you think it does. Discuss your policy with your agent.

15

No-Tears
Bookkeeping

A business needs *only* two basic accountings: to itself and to the government.

The first accounting includes: money owed to the studio; income; comparative figures—this year against any other year (optional); and money spent on the studio and its operation.

The second accounting includes: income; money spent on the studio and its operation; depreciation; and sales tax that has been collected (does not apply to all states).

We can't make up *any* of these figures; they are *fact*. They don't include our goals, hopes, or emotions of any kind, but in these figures is the truth of how the studio is doing financially.

We might prefer not to know what is hidden in these figures, but we can't make them go away. Any businessman has felt the pain of *knowing* it was a fantastic week, till he looked at the figures and discovered otherwise. It works in the reverse too. A lousy week can bring all kinds of money in. One thousand telephone calls from prospective customers, a beautiful ad campaign or compliments won't change your current financial situation.

To keep my feet on the ground, I never "count" a job until the money is already in. Nor do I think about how much money I'll have made by the end of the year! I consider my financial position as it is today. How much money do I need for my expenses today and how much do I have? And this is a question I don't even think about till I feel the squeeze!

The only exception to this is money I have no choice but to pay in the future: property taxes, income tax, business licenses, insurance. Thus, I put aside a small part (at *least* 10 percent) of my income, *no matter what*, to take care of those contingencies.

Don't Duplicate Information

The eight records listed above can actually be reduced to four and one of those needs no energy to keep. It is the SPIKE.

A spike is just that. It is a weighted base with a metal spike sticking out of it upwards. Purchase yours at a stationery store or, as I did, at a garage sale for 10 cents.

The spike and three ledgers are all you need to keep the studio money in order and, initially, it can all be kept in one book, as I used to do. But the time will come when you'll need three, so you might as well get them right away. To save time later on, get the books of a uniform size, but in different colors so you'll automatically reach for the right one.

Government records and your own are kept in the same ledgers, so you now have: Ledger 1 to record money paid to you—your income; Ledger 2 to record what customers and others owe you—your debtors; Ledger 3 to record money that goes out—your expenditure; and the spike to hold receipts and other information to put in Ledgers 1, 2, and 3.

I have mentioned that I was married to a CPA for thirteen years. This man was a whiz at finance, particularly at tax accounting, and I learned from him a lot of things *not* to do. He heartily disliked bookkeeping, so he taught his clients the simplest system they could do themselves, saving them what he'd have to charge for the service.

Not one of my husband's clients, some of whom were without more than elementary education, had trouble with the system he taught them. When I started my own business, I used the same system, thinking that I would expand it later.

Not so. My records today are in exactly the same form that they always were. The spike fills up quicker than it used to and so do the ledger pages. Otherwise, there's no change.

Get Rid of the Bookkeeper

I hear photographers who are proud that they now have a bookkeeping service to handle their accounting.

"Whew! We don't have to do *that* any more."

Except for the single day it takes me, once a year, to total my figures for tax purposes, it takes two hours at the most for me to keep up my records every month or two (and I do it while watching TV). Remember, a bookkeeper has to have figures to work with, so there's always day to day work to be done by the owner, in any case.

Find an Accountant

I hope I've made it clear that an accountant and a bookkeeper do two different jobs, even if they are the same person! You'll need an accountant to prepare your income tax returns. A businessperson who prepares his own tax returns invites an IRS audit, and tax laws change so rapidly that you may cheat yourself by missing deductions. Also, your accountant then becomes your financial advisor—I know of none who charge extra for giving quick advice over the phone—and this could save you lots of money.

The time to consult an accountant is often before you need one—before you hang out your shingle and before making major purchases or any important business decision.

If you're about to receive a very large sum of money—maybe from a sale of property, an inheritance, or even a sweepstakes—talk to a tax expert *before* you

deposit the check! You may not want to bank the lump sum now, but accept payment over a few years, thus deferring income in a way that would benefit you taxwise.

When looking for a tax consultant, avoid:

● Tax services staffed by quickly trained bookkeepers. If something complicated comes up in your business, you don't want your tax adviser to give an educated guess—you want someone who *knows* the answer.

● An accountant who talks only in generalities and either refuses to, or is reluctant to, give you specific advice.

● Someone who is vague about his background or has *only* out-of-town references. Occasionally, people lie about their qualifications. An insurance agent once told me that he got the job originally by pretending he had a degree in maritime law. *He* was able to handle the job, but he emphasized that no one checked his credentials and that the world is full of charlatans.

● Someone recommended only by a friend who is neither in business nor particularly interested in it. Would you expect someone who's not interested in music to know whether a symphony was being played well or merely adequately?

Unnecessary Accounts

A prime reason people think bookkeeping is difficult is that they keep unnecessary accounts. They copy out scads of information they'll never need and endlessly review papers that should have been looked at once. They duplicate information.

Fortunately, help is now at hand and we can buy a computer and let it do the work for us, but someone still has to put the information in. (See *Computers*, p. 201.) But computers are expensive and even those who own them find it simpler initially just to do their bookkeeping the old-fashioned way.

Some of the most absurd bookkeeping systems I've seen require you to record every transaction on a voucher and these vouchers are filed numerically. It takes hours to copy onto the vouchers the information already on customer's and your own purchase orders. When you want a specific figure, you have to go through all the vouchers to find it. If anyone recommends you try it, just say, "No!"

Practical Bookkeeping

The system I use is based on the double entry that in any transaction one person gains and another loses.

If I buy film from Bill O: He loses film and gains money; I gain film and lose money.

Thus, I can keep a ledger page for film either under Film, or under Bill O., or under Darkroom Supplies and still have the same transactions recorded.

If I decided to keep my purchases from Bill O. on one page, that page might look like this:

	BILL O.	Due	Paid
3/8	40 Rolls VPS 120	$181.55	
3/15	Check #4380		$(181.55)

I have made three notations above that have specific meanings in book-keeping:

1. $181.55 A double line under a figure *always* means that the transaction is now closed.

2. $181.55 A single line under a figure *always* means that all the figures directly above that line up to the last single or double line should be, or have been, totaled. If there's a figure under the single line, *that* is the total; otherwise, the total must be brought forward before more transactions are added.

Often, as in the listing above, the total may not be directly under the line but is "carried" to one side.

3. ($181.55) Parentheses around figures means that this is a negative number. In my accounts, as the first $181.55 is obviously a figure owed, a figure in parentheses will, therefore, refer to money paid. You might, however, not use the parentheses when the figures appear in two different columns because it is obvious that one listing shows amounts owed, and one paid.

So, looking at the one item entered on that ledger sheet, we now know there were two amounts owed and together they totaled $181.55, and my check #4380 dated 3/15/83 paid that bill in full.

Any new transactions now won't include any figure above the === line. (If I wanted to add $181.55 to my future purchases, I would have to carry the amount to a further column on the right and not underline it.)

If a ledger sheet reads:

	BILL O.		
3/8	40 Rolls VPS	$181.55	
3/15	Check #4380		($100.00)
		$81.55	

The listing shows that my check did not pay the amount in full, $81.55 is still outstanding, which will be added to anything else I buy from Bill O. This could also be written: $181.55 - $100.00 = $81.55.

It may be more convenient not to keep a separate page for Bill O. I could list all my film purchases together, like this:

	FILM	
3/15	Bill O. Ck #4380	181.55
4/8	Picture Shop Ck #4481	14.65
5/14	Picture Shop Ck #4501	34.82

At a glance you'll see I have another supplier of film now, Picture Shop. This kind of listing might lead to confusion if I didn't pay each bill as it came in, so it's only efficient if I enter the item when I pay the bill.

If I want all my film purchases on a single sheet, I could move to a ledger sheet with more columns and list them perhaps like this.

		Olson	Pic. Shop	Smith Inc.	Jones	David	Misc.
3/8	40 Rolls VPS	181.55					
	Ck #4380	(181.55)					
4/8	6 Kdme 64		35.40				
	Ck #4388		(35.40)				
5/14	6 PX 135.36		17.70				
	Ck #4402		(17.70)				

When there are a large number of items of one kind—e.g., film processing, where there may be several bills incurred on a single day—I could simplify the system even further by using a ledger sheet with more columns like this:

PROCESSING & PRINTING

Rinell	Pic. Shop	Photic
1/2-$16	1/2-$6	2/8-$104
1/3-$32	1/3-$8	2/9-$35
1/4-$45	1/3-$32	3/11-$200
1/6-$12	1/4-$11	4/7-$320
	1/9-$71	

You'll notice that in the first diagram you could simplify further by writing the figure only once, making it much easier to bring down totals at the end of the year (and I do so, only entering the item when I pay the bill).

In the second diagram, I've rounded off each figure to the nearest dollar. The reason is I'm actually only keeping a record of the bills from individual invoices, not my payment of them (perhaps with a monthly check).

The only time I keep a record of cents is when I may need the exact figure later, for example:

● For a customer's check. If we haven't marked a certain bill "paid," but recall that it *was* paid, it will be easier to look for the check by the exact amount. So figures in my income ledger are rounded off only *when* I total them.

● I might want to know exactly what an item costs. If I'm doing a job time plus, it helps to have the actual cost available to charge the customer. But, again, when I add the year's totals, I round the figures to the nearest dollar.

● It's much easier to look up one of my checks if I have the exact sum I wrote it for, so I always list the amount of my check exactly.

In my income ledger the record kept also tells me how much money but this time *from whom* instead of *to whom*.

The precise method you use is not important, provided you: keep a written record of all financial transactions; don't duplicate information or if you feel you have to, do it as little as possible; are well organized from the start; simplify your system when it needs it; and don't lose necessary information you may need.

Let's now return to the accountings we decided we needed for our own information *and* that of the government. Next to each item write the ledger into which it will go:

Information for the Studio
1. Money owed to the studio	Ledger 2 (debtors)
2. Income	Ledger 1 (income)
3. Comparative figures	Ledger 1 (income)
4. Money spent on the studio and its operation	Ledger 3 (expenditure)

Information for the Government
5. Income	Ledger 1 (income)
6. Money spent on the studio and its operation and its operation	Ledger 3 (expenditure)
7. Depreciation	Ledger 3 (expenditure)
8. Sales tax that may have been collected	Ledger 1 (income)

I have not listed the spike because it isn't a permanent record.

You'll see that instead of keeping eight separate accountings, we actually need only three:

Ledger 1. Income. A record of all money coming in.
Ledger 2. Debtors. A record of money owed us.
Ledger 3. Expenditure. A record of what the studio pays to others.

The spike is merely the holding tank for the information for the ledgers.

Ledger 1—Income

Income is automatically recorded when it is paid into the bank. *Do not* withhold cash sales when you do this. Your deposit slips are also, therefore, a record of your total income.

It took my husband a lot of tough talk to persuade his clients to declare all their income! Cash sales, as one woman told him, "Are between me and God!"

Later, he proved to her it's cheaper to declare the cash and take the full deductions besides the obvious fact that you no longer have to worry about anyone finding out anything!

It's hard for the small businessman to have to share money that it can't be proved he has! He's as involved in all the same government red tape as the large operation, but he doesn't have the volume to bring in the extra profits to take care of it.

However, in the case of my husband's client, she was so frightened that someone would find out that she was withholding cash income that she wasn't taking the full and legitimate business deductions she was entitled to. The profit from one action actually offset the loss on the other. He showed her that she could now go even further and spend much more on her business in a way that was tax deductible and pay *less*, not *more*, tax without fear of findings in an audit.

"It's the first time I've slept peacefully in years," she told him when she returned to pick up the completed tax return.

The four obvious benefits of declaring *all* income are:

1. Peace of mind. You don't need to fear discovery if you're hiding nothing.

2. Self-confidence. If you feel you're being entirely open with the IRS and later want to stick to your position on a particular deduction that the IRS contests, you're now in a much stronger position to argue the point. I saw this work over and over again in my husband's practice. The IRS representative would try to bully him over someone's tax return and he'd refuse to budge if he felt the return had been prepared correctly and that the deduction was legitimate. The client's records could be searched and invariably the IRS backed down. It also happened quite often, I must admit to my delight, that this search unearthed deductions that the client had overlooked and the government ended up owing him money, rather than the reverse.

On the other hand, if the client suddenly started backing off, it became obvious that this person was scared of an audit and then a bargain would be made (part of the deduction allowed or it would be dropped altogether), so it often cost the client more, in the long run.

3. Simplicity. It's much easier to run a business when the rules you apply to it are aboveboard. It leads to confusion when you sometimes do one thing and sometimes another.

4. Honesty. There's also the moral issue, that it is unfair for those who are honest to have to carry the burden for those who are not.

I don't even lock up my records. They're in the front office where anyone can look through them. Later in the book, when discussing employees, I mention one who, years ago, stole my credit cards and did some other unfriendly things! When I took him to court he accused me of underpaying him (at that time my income was pretty low and he was paid one-half of whatever I took for my personal expenses and overhead at home).

His attorney suggested I kept hidden records.

"Where are your record books kept?" my attorney asked me.

"Under a table in the studio," I replied. "I don't lock things away because I always mislay keys."

It's a great comfort to me that I can say to anyone, "Take a look for yourself!"

It's entirely possible that you may pay no tax at all in the early years. This is when your cost of doing business—the total of all your business bills—eats so heavily into your gross income that what is left over, the amount which you have to live on, will be *less* than the accumulative totals for that year of:

Depreciation (those items that will be listed on your tax return as depreciating in value).

Dependents (the amount each year that you are allowed tax free for each dependent you claim—one of whom is you).

Charitable donations. You can give to charity items that you already have of a solid dollar value. Be sure to have them listed when you get a receipt from the charity you donate to.

Uninsured losses. Burglary, fire, etc.

Take *all* your deductions and declare *all* your income and when your net in-

come rises to where you'll have to pay tax, find some way to invest that surplus where it isn't taxable. You don't have to justify that expenditure. If you decide to run your business with three automobiles, that is your decision to make.

Cash for Spending

Why deposit cash in the bank when you need it for spending, you might wonder. To take care of that, enter the amount *as if you had deposited it,* then enter it again, as if you had cashed a check:

RECORD ALL CHARGES OR CREDITS THAT AFFECT YOUR ACCOUNT

Number	Date	Description of Transaction		Payment/ Debit (-)	√ T	Fee (if any) (-)	Deposit/ Credit (+)	Balance $
						$	$	682.11
4111	2/11/82	Smith & Co.	(ledger)	$ 14.43				
	2/11	Cash		C.100.00			C.100.00	
4112	2/12	Howser	lab	42.22				
4113		P.O.	stamps	30.00				
4114	2/13	Williams	groc.	26.66				
	2/13	Deposit					635.00	1,203.80

Notice the $100 items above. They're recorded on the same line (simultaneously a deposit and a withdrawal). I have written a "c" beside each (contra) to alert me to this. When bringing down totals I ignore all items which show a "c."

However, I now have a record that I've taken $100 from the studio cash box and put it in my pocket.

You'll notice, too, that I don't figure my balance every time I write a check or make a deposit, just once in a while. It saves time, and causes fewer chances of error.

I've also included personal expenses in this list of checks paid. If you feel it would be easier to have a separate account for business only, or perhaps a savings/checking account for personal expenses (paying yourself a definite salary from the business account), do so. As a sole proprietor I see no need to do this, though. It's just one less checkbook to mislay!

A checkbook is a sufficient record of your income if you are salaried. However, as your income comes from various sources, you need a breakdown and that's where Ledger 1 comes in. Here, too, you use columns to tell you what came from where.

First, make a list of possible income: sales of photography and related products; gifts of money; rental money on property owned by you; fees for teaching photography; sale of stock photos; child support; alimony; and repayment of loans.

Here's what *my* ledger page looks like; you'll see it is very simple:

DATE	NAME	Out-of-State	Photog-raphy	Teach-ing	Stock Photos	Misc. Taxable	Misc. Non-Tax	Writing	TOTAL EARNED
4/6	Thorpe		86.92						86.92
	City of S.L.O.			40.00					40.00
	James		40.28						40.28
	Am. Stock				18.00				18.00
	Smith		132.50						132.50

Date: Date of deposit.

Name: Source of income.

Out of State: Income I might have earned in another state or country which is not subject to sales tax.

Photography: Includes frames etc., all California income which includes sales tax paid to me.

Teaching: Income from classes, lectures, seminars.

Stock Photos: Sales of photos by stock agencies only. My own sales of stock photos are under "Photography" as I have collected sales tax on them. My stock agency sales are actually royalties. If sales tax was due on the transaction the agency has collected it.

Misc. Taxable: Income from sales such as personal belongings, equipment.

Nontaxable: Income such as gifts and child support, where the amount will, all the same, show up as a deposit in my bank account.

Writing: Payment from publishers.

Total: The total of all income except "nontaxable."

Every time you enter an item in any column, you carry it into the "total" column, *with the exception* of income that is not taxed. Thus, each month's totals of all taxable columns should equal the "total" column, when all those figures are added together.

Before buying a ledger, make a list of the headings under which you might receive income and add three. Two are for unexpected income; one for the total.

Some photographers like to break down their studio income further: portrait sittings (both color and black and white); weddings; commercial; print orders; album plans; senior portraits; passport pictures; etc.

Income from frames, folders, etc., are also listed separately. I don't do it—it's too much work.

The Grand Reckoning

Once a year, in early January, I make a summary of my income by months. All the totals of the columns of earned income from a particular month should equal the "total" figure in the last column. If it doesn't, there's an error and I look for it.

Then I take the monthly figures and make a chart, one month to a line, under the same headings.

I total all the columns once again and end up with grand totals for the year and in the final column is my gross earned income for that year. The chart looks like this:

1983	1 Out-of- State	2 Photog- raphy	3 Teaching	4 Stock Photos	5 Misc.	6 Tax Writing	7 Total
January	$						
February	$						
March	$						
April	$						
May	$						
June	$						
July	$						
August	$						
September	$						
October	$						
November	$						
December	$						
A. Total	$						

Total of all figures on Line A should equal totals of Column 7.

The two totals (columns 2 and 5), which include sales tax (6 percent in California), are then added together and I work backwards to find out how much California sales tax I have collected. This total is 106 percent of my actual income in those columns, not 100 percent, and I now work out what the true figure (100 percent) should be. (If the 106 percent equals 424, 100 percent would equal $424x100 ÷ 106 equals $400.) I also know how much sales tax should be paid the State Board of Equalization.

This is all the information I now need for myself or the government about my year's income.

As a homework project in my computer class, I wrote a program that will do this for me. All I have to do now is type in the figures each year and the computer prepares and prints the table.

I have: a breakdown of my income; comparisons to make with other years; an income figure for the IRS and state of California; and the amount of sales tax I owe the State Board of Equalization. I can also gauge how certain events during the year have affected my income. If I've been on vacation for two months I find that it hurts me—not just during that time, but in future bookings. On the other hand, the move to my new location, which I expected to be a setback, turned out to be no loss at all.

Ledger 2—Receivables

Because I have a cash-on-delivery business, people rarely owe me money. There are, however, some accounts that have to be carried, unless I want to limit my business.

It's against the law to levy a service or interest charge on accounts without the customer's agreement. My purchase orders, which are signed at the time of the sitting or when pictures are ordered, state that there will be a service charge of 1½ percent or $3 (the larger) if the account isn't paid in thirty days.

I actually never charge this fee unless the customer has shown obvious irresponsibility or I have to take their bill to collection.

Here's a partial listing of accounts I have to carry:

1. The very rich who never pay their bills personally. A secretary does it for them.

2. Certain large companies where a head office pays. If I haven't heard of the company, I ask for a personal check from the customer and tell *him* to collect from his head office. But this would be absurd when I am asked to bill such organizations as the government or phone company.

3. Friends with whom I never talk money if possible. I can always nag them later if they're slow with payments, but I don't even ask for a signature if I write up the order.

4. Bounced checks (the order is now "unpaid").

5. C.O.D. delivery orders, where the customer refuses to pay for the order (probably doesn't have the money or is out so often that the package cannot be delivered). We write to the customer a few days in advance of mailing the package to warn him that it's coming.

These few orders are entered in Ledger 2, as well as a note of stores that carry a credit on their books (we have overpaid or returned something).

They're entered like this:

Date	Name	Address	Phone	Owe	Date mailed or called
6/25/80	Rose	121 Oswald	555-5432	$119	8/3/80 wrote after 4 calls. 12/1/80 letter. 2/2/81 collection.
12/21/81	Smith	Rte. 8, Box 1.	555-2291	$43.80	1/21 phoned (check bounced).
1/11/82	Sully	Higuera	555-1198	$20	credit

We use a yellow hi-lite pen to note when an order has been paid, running it through the entire transaction (you can see through the strip). Above, Rose has no strip so that the account is still due me. "Letter" refers to the date we last wrote. "Collection" means I've placed the account with a collection agency. Smith, on the other hand, has made his bounced check good and has been marked in yellow.

When it's obvious that an order will never be paid—even the collection agency has given up on it—the pictures and all information are stored and after a few years they're thrown away. The law is specific on how such accounts can be handled. The last time I checked into it, if an account had no action for four years (and "action" includes action on *our* part), then it couldn't be collected through the courts.

Remember, you can't claim a tax loss on such a bill because you have already charged the cost of film, processing, etc., against the business. You get no tax deduction on time spent on the job or your profit margin.

Always check the most recent tax laws when you have a situation outside your experience.

Ledger 3—Payables

The bookkeeping system that I keep on one page of Ledger 3 has already been explained.

I use a loose-leaf binder for this ledger, for which I buy the special ledger pages that suit my needs. I keep a note of all the money I spend and where it goes. Remember, we *want* to spend money to bring our gross income down—we don't want to make taxable profit! As an English businesswoman said to me, "In our company, profit is a dirty word!"

You may wonder what the point of being in business is, if you're to make as little profit as possible. The way business usually works is that the early stages consist of hard work and little profit, and then quite suddenly—if you're going to make it at all—you'll start making a great deal of money consistently. *At that point,* you'll do all the same things (to keep taxes down), but will have a sufficient profit margin to be able to spend money on luxuries unrelated to business and also pay resulting higher taxes without ending up in the poorhouse!

I arrange the ledger pages alphabetically and list products of a single type together: frames and glass, albums, folders, and folios. If I ever look under the wrong letter for an item, e.g., "glass" under "g," I put a page there right away to tell me where to find it the next time . . . "Glass, look under Frames."

The advantage of the loose-leaf ledger is that after taking the figures off it for last year's tax return you can remove pages you no longer need. I put them at the back of the book and when sufficient old pages have accumulated, I bundle them together, put them in a large envelope clearly marked with the dates the pages cover, and I store that.

On my ledger pages, I note when I paid by check and when by cash, unless I always pay certain amounts by check. Utility companies are an example. If I need figures for any financial statement, I use a hi-lite pen (transparent ink) to mark the figures as I take them from the book.

The Spike—A Hold-All

The spike acts as a temporary file for all papers that may have to be entered in the ledgers. When you come into the studio with a pocketful of bills, receipts, addresses, etc., and don't feel like taking care of them permanently, put them on the spike.

I don't feel like keeping up Ledger 3 at all! So I put all papers for it on the spike and my children are well trained too. If they purchase something for me, they know the spike is the place to skewer the receipt.

It's a great file; it's papers do not fall on the floor, get lost or forgotten. Once in a while, always on a free evening, I turn on the TV to a program I can listen to without watching and go through the spike, noting the information from each piece of paper. I discard the deadwood (duplicates, nondeductible receipts, etc.), and then put all the others into a large envelope, note on it the period it covers: "Receipts Jan. 82-July 82" and put it in my storeroom.

Checkbooks, Credit Cards and Charge Accounts

I should take a moment here to cover another business practice which must now become routine: the use of the checkbook and charge accounts to record your business activities for you.

Many people, and I was one of them, pay what they can by cash and resort to the checkbook or credit card or charge an item only when they have no cash on hand.

When you own your own business, change this around. Instead of paying with cash, pay for any item related to the studio with a check if possible, so you automatically have a record of the transaction. If you lose your receipt *(which the IRS does demand as proof of purchase)*, you can return to the person who took your check and clear the matter up at once.

I've turned a lot of people on to the use of the checkbook that produces an automatic duplicate, so you don't even have to keep up the register till it's convenient. These cost more, but *much* less than the time it takes to wonder what you wrote that check for if you forgot to write it down. Or if someone questions a check, you can look it up without going to your bundle of returned checks.

On one occasion, without even knowing I was doing it, I printed my name on several checks instead of signing them. The bank telephoned to ask if it was my writing. I was able to tell them that it was, because the counterfoil showed the printing.

You can see how a checkbook works exactly like a charge account. Instead of a store keeping a record of your exact purchases, you do. You note in the checkbook whether the item is related to business and keep the receipt that itemizes the purchases.

Let's say you're buying a dozen pencils from Hill's Stationery and automatically pay by check. Remember to note "pencils" or "studio" in a column in your checkbook listing, and when you get to the studio the receipt goes onto the spike, without a further glance, with all your other receipts.

When you eventually go through your checkbook register, list that item under "studio expenses, miscellaneous," or "office expenses" or whatever you care to call it in your ledger.

When you go through the items on the spike, you look at the receipt and say to yourself, "I pay *all* Hill's Stationery bills by check," and put that receipt away to be saved, without entering it in the ledger again.

If you were paying most of your bills by cash, you would have to go through your checkbook to find out if *this* one was paid by check or not—unless of course you wrote on the receipt that it was paid by cash or check. And if you're like me, you'd forget to do that half the time, so you'd spend quite a bit of time searching!

Naturally, if Hill's Stationery *did not* itemize the receipt you would have to note what you spent it for right there in the store, before you forgot. It seems much easier to me to catch something that hasn't been done by someone else than to remember to do something myself. It's so easy to say to the clerk, "Please write 'pencils' on the receipt."

I can hear you say, "But many stores note on their receipts whether a bill is paid by cash or check." True, but you have to scrutinize the bill to see if it has

been done. And only in the big stores is the process automatic. It's easy to see that a register tape has itemized your bill, but not so easy to hunt and see if a little "ck" is written somewhere!

Credit cards are another boon. Instead of writing eight checks, write only one and it's like letting someone else do the bookkeeping for you. Both your copy of the charged item and the statement from the charge company will list where the money went. Your receipt will tell you what it went for.

When you charge an item, you're borrowing money to purchase it and you might have to do this sometimes, *just* because you can't afford the item right away. Doctors, lawyers, hospitals, many local stores, and photographers like me will not make a service charge if they receive some money on their bills.

If you have Master Charge or Visa you can also lend yourself money, even if the interest is high. Just accept your own credit card and advance yourself $200 or whatever you need, and remember not to record this as "earned income."

The perils are obvious. You catch bank interest charges in every direction unless you pay the amount in full when your credit card payment is due. You have to pay for taking the charge anyway, but you can pay yourself back over several months.

When you consider the red tape you must cut through to take out a loan, though, you can see it's a terrific option in an emergency.

It's also an option if you have a friend you want to lend money to. I've never done it, but someone suggested lending money to me if I ever needed it in an emergency. I didn't take him up on it, but could see that *he* would be quite safe. He could call up for verification; meanwhile, I'd have a few hundred dollars to tide me over.

Whether charging an item or paying for it on the spot, be sure to have a record of the item you spend it on. You can do this by clipping the tag on the item to the receipt or just noting on it (or having the cashier do so) what you bought. This way you can separate what you buy for home use from what you buy from the studio.

There will be items you can't buy except by cash and others where you can't get a receipt—a newspaper, garage sale items, a cup of coffee in a strange town while waiting to photograph a wedding, a charitable donation into the church collection plate.

I usually ignore the smaller items, except when I'm traveling; then I check to find out the current figure that the IRS allows for expenses when traveling on business. I keep all the receipts anyway and the travel ticket stubs and other proofs that the trip was on business, but I'm always aware that I could just take the allowed daily expense figure.

If you have any question at all about these expenses, don't work in the dark. A simple phone call can clear up the matter in minutes. Your accountant, the IRS, and anyone who has to travel on business knows the answers.

And that's all there is to bookkeeping!

TIPS

Debts

Odd as this may seem, it isn't smart to overdraw a "small" check. If you're going to write a bad check (which your bank should honor, though they will charge you a fee for the same), then let it be a big one. Even if the bank doesn't honor the check, you've bought "time," and the person who tried to cash that check will be a lot less worried if it's for, say, $200.00 rather than $4.50!

Lucy (a student) had overdrawn her account and received a notice that she would be charged for the five checks she had written. At $6 a check, her bank fees were now $30 and as she had taken out a small loan ($50) to get her temporarily out of the red until her allowance arrived, much of the loan was eaten up by the bank charges.

She sat weeping on my couch so I went with her to the bank, asked for the manager, and told *her* exactly what had happened. I explained that Lucy realized she had done a stupid thing and would not do so again, and asked that the fees be reduced. To Lucy's amazement the manager agreed to reduce the bank fees by half ($15).

Lucy had made three mistakes.

1. She had made five different people aware that she had money troubles.

2. She had paid more than double for a particular item. It had cost $5.80. The charge for overdrawing that check was $6.

3. She had borrowed $50 at 16 percent interest. She narrowly escaped paying an additional $30 (which was reduced to $15).

It's nice to feel you'll never overdraw your account, but once you're secure financially, insist that your bank put your checks through if you do. Even if you must pay bank charges, your customers should not know about your empty coffer.

Many banks will put overdrawn checks through if you keep a balance in a savings account at the same bank. See if you can have this arrangement.

Bill Paying

I hope the time never comes when you can't pay all your bills. But it does happen, and I know that because it happens to me. I was more careful when I had no resources at all to draw on. Now I expect to catch up eventually and often get a bit "carried away" on my spending!

There is an order to pay bills and this is:

1. The local businesses, starting with the *small* local businesses (who need the money). This is also where your first credit will be checked and you need all the local friends you can get.

2. If you can't pay your larger local bills pay something on them.

3. Pay all small bills around $20 or less. This way you cut the bills you own to the *least* number.

4. Pay your mortgage and rent in full each month because it's a sizable dollop and you can't afford to let it back up. It's often possible to delay a

week or two on these bills without paying penalty charges.

5. If you have a couple of mortgages and one is due to a private individual but collected by a bank, delay on that one if you have to. The bank is not a collection agency in this instance. It is a depository for the payment. If your payment is late, the holder of the mortgage may never be aware of it, unless he inquires each month.

6. Utility bills also occur each month and unless these are huge—when you'd better get them out of the way in time—you can make a token payment toward them or even miss a month without having the lights and gas go out. Check this locally!

7. If you have a home phone and a business phone, the home phone will be cut first! Pay that! The phone company is more lenient towards businesses, so cut down on your long distance calls and pay *something* toward your business phone bill.

8. Pay part on all other bills, or ignore them for a single month and then pay them. Gas and credit cards require just a token payment in hard times.

9. If you have a small regular payment to make, pay several months at one time and get it out of the way.

My own way of paying for bills when I don't have enough money in my checking account is to write all checks in full and then pay them as the money comes in. This way my checkbook shows a nice loss, which puts me off spending money in my usual freehanded way.

Say I have a $400 balance. I may write $700 of checks, only mailing those (in the order 1 to 9 above) that won't overdraw my account. I also leave some money for emergencies.

It does foul up my bank statement—all those outstanding checks, but I'm always surprised how quickly the whole thing adjusts.

Don't do this if you are in genuinely hard circumstances. In that case, make a small payment on each bill.

If you asked my son Daniel to hide, this is how he did it. Technically, this photo disproved my teacher's theory that, "Every black-and-white print must have a dense black, a clear white, and a series of smoothly graded gray-tones." There is no black or white here, only gray tones. (Underexpose and over-develop, if you want to try it.)

In the first of the Daniel Series, he was 3 weeks old, asleep in his sister's arms. It contradicts the general notion that a successful portrait must show the subject with eyes open.

The Daniel picture that sells best from exhibits is this one, showing Mike and Daniel, and captioned The Brothers. Men *buy it—men whose closest childhood friend was their brother.*

Baby shampoo works well for all bubble pictures; it is easy on the eyes.

This is one of a series within the Daniel Series. The pictures show Daniel playing with a glass of milk.

Mike was on the roof with a hose, and Daniel was being happily drenched when he abruptly decided "No more." I took the picture, then turned the water off.

Victor's portrait has sold more times than any other in my collection—26 times as a stock photo. It's also been used on a poster showing that all children are not born equal (Victor is deaf), and has been bought from my exhibits. He was 4 when this was taken, and his mouth was full of cake.

A successful portrait causes more than one emotion. Here, the beauty of the child's face is not the whole story; one also senses the cry from within, even if one does not know that it's a child who cannot speak trying to communicate.

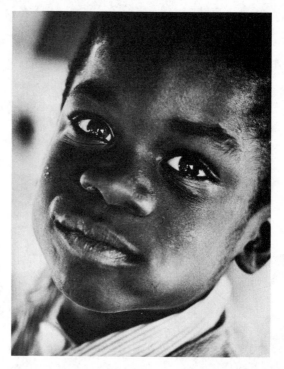

This particular little face has
worked hard for me in exhibits.
Nobody cares if someone else's
child is not smiling.

I've learned to get the camera ready in anticipation of something happening. It was the first time the child and kitten saw each other. I asked someone to hold the kitten till I was ready.

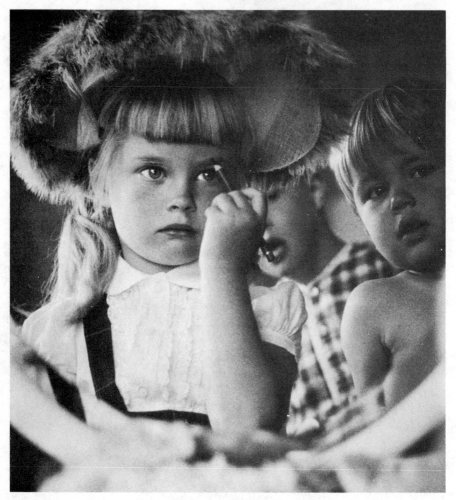

This kind of picture has to have complete subject-involvement to work. Often one child of a group will be staring at the camera and ruin the shot.

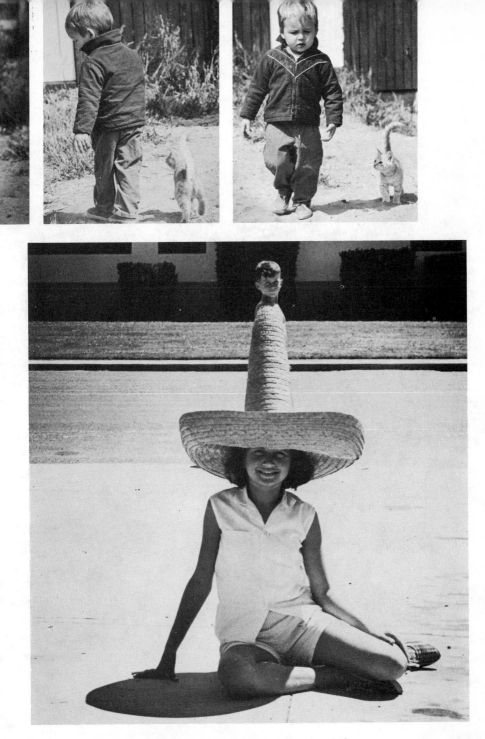

My husband, Seamus, bet me I couldn't get a picture into Life
magazine. Life *took the first picture I sent to them, this one,
and I had my first sale five weeks after I accepted the chal-
lenge.*

The child is in a scarlet dress with a white collar; the hibiscus are pink. After the sitting, the little girl whispered to her mother that we hadn't used the flowers she had brought with her. I suggested she look down at them, but she shook her head and said she wanted to look like a lady. "Show me!" I said, and she did.

I was photographing the frog-jumping at Calaveras County for the London Daily Express *but forgot to send the film away on time. I forgot these were news, not "semi-news," pictures and mailed them a week later.*

This chance shot at the beach has been used over and over as an illustration.

Daniel's preschool education was paid for by pictures of the children at the Oceano Day Care Center (this shows one youngster with finger paints), where I was lucky enough to place him. I took roll after roll of the children at work and play, and provided contact sheets. A lot of these pictures ended up with stock agencies and even today, when Daniel is in his third year of college, I see them in magazines.

16
Government and Some Other Business Associates

You have a good product and are serving it up in a clean, simple, intelligent way. You've persuaded people to come to *you*, rather than another studio. The purpose behind all this is to make a profit, enough of one to make it worthwhile to remain open.

Government

The government (which includes a large number of organizations right down to your own city hall), has now become your partner and will expect a percentage of that profit. The more profit you make, the greater the percentage the government will take.

Thus, it becomes imperative to make as little net profit as possible so you can get the use of as much of your own money as possible.

Let's say I make *no* profit.

I start out underfinanced and all I make gets swallowed by the business. I am in the lowest tax bracket of them all, the one where I pay no taxes. "Making a loss," has therefore produced a silver lining.

I begin to make more and I realize that instead of working for myself, my profit seems to be siphoned off into federal and state taxes. How is it, I wonder, that I owe the government $1,000 when I don't have it in the bank? I haven't squandered my income; I've been working like a donkey just to keep going. And if I don't pay the government out of money I don't have, I can be charged interest on the sum and could even go to jail.

So I decide to visit an accountant.

He tells me that every time I paid $1.40 on nails for the studio, $2.50 on file folders, or even 49 cents on a roll of toilet paper for the studio bathroom, I should have kept a receipt because all that is "deductible." Taken off my earnings, it would bring my profit down to where the government would find my net income in a bracket that pays no taxes.

"But now I have *nothing* left," I tell my accountant with mounting terror. "I've got a loss again!"

"Yes," he smiles and pats me on the head, taking all the credit for my failure. "That's what business is all about. Arrange your affairs so you lose your money,

and you get the benefit from your hard work. When you make a profit on "paper" the government will take part of it, so make a *loss.*

So, your aim must be to always bring your net profit down as far as you can, giving the government only the smallest part of it.

"Oh *thank you!*" I reply gratefully to the accountant.

"That will be $100," he replies. "Now that you're making a profit everyone will want to take it, even myself. But my fees are deductible, so keep a receipt."

A net loss now becomes a good thing and until you can find a way to make so much money that you'll gladly share it with the government or any other needy cause, you work at making *no* profit. And your net worth alone will rise becuase the studio and you are the same thing. The more you invest in the studio, the richer you're becoming.

Taxes and More Taxes

Every level of government is run by money collected by taxes, licenses, etc. It seems everyone wants part of your pie. Each state has a different method of raising these funds. Only the federal government applies taxes to each individual or business alike . . . Federal Income Tax.

Depending on where you live, here are some of the ways the government may lean on you for regular payments: the state government—income tax and sales tax; the county—assessment tax and property tax; and the city—income tax, sales tax and a license to do business.

In addition, every time you ask one of these government agencies for something specific, you're levied with additional licenses, fees, or filing charges. It's a bit depressing for someone who is working his tail off trying to make ends meet, but there is good news in sight!

People like us, who live a more perilous life than salaried people, find the tax laws generally lean in our favor.

The salaried worker who has no tax-deductible overhead actually bears the heaviest burden of government costs, and only by finding investments that give him a tax break (the most usual is buying rental housing), does he manage to bring his income into a lower bracket. Many such workers don't bother with tax shelters. They just pay the tax.

Owning rental housing is financially very rewarding. The rent should more than cover the mortgage payments plus property taxes and the housing is depreciated each year by an amount that comes off your taxable income. Meanwhile, your equity in the housing increases.

Salaried people may also take on a small business on the side, letting it show a tax loss for a few years to bring down their salary taxes. Sometimes one member of the family works and the other runs the business. Other times this business is of a type that can be run alongside a salaried career.

A teacher who was ready to retire started an import art business. He paid a student to be there a few hours most days and for the first two years he showed no particular interest in the sales end, only in gradually stocking the shop with merchandise bought on vacation-business trips; both trips and purchases were tax deductible while he was salaried. Then he retired after the business had

been open four years, closed the store, reopened out of his own home, and took his merchandise to fairs, flea markets, art shows—again with a nice, tax-deductible excuse to travel, only this time by trailer, and doing enough business to make it worthwhile.

The government currently allows a business seven years to begin showing a profit. After that an unsuccessful business is classified as a hobby. You don't want this to happen as you will now be accused of having a hobby all along—not a business—and will be billed for back taxes because many of your deductions will now be disallowed.

If you do make a loss for six years, and can't see much hope for the seventh, you would be wise to close shop and get another career!

If you have had several years' profit, and then show a loss, though, it won't affect your status as a "business."

When a business like ours begins to show a sizable taxable profit, the proprietor can act exactly like a salaried worker and find a second business to eat up that profit. Both businesses will increase in net value during this time, and either can be sold like any asset and the money reinvested whenever the owner wishes. When his business booms, an owner can also incorporate instead of diversifying, with considerable taxable advantages.

Incorporation costs money. There are salaries now to be paid and more red tape to be dealt with. It's not the freewheeling arrangement of a partnership or sole proprietorship. Don't do it too soon, that is, until you need it. The magic figure is $50,000 a year net profit. When you reach that, incorporate!

When I took that one-day seminar on tax shelters for the small business (which I described at the beginning of this book), that was about all I learned—that when you're making $50,000 net, you should incorporate. Once I realized it didn't apply to me, I had trouble concentrating on all the details, but at least I stayed awake, which was more than the person beside me did!

Ronald Reagan, Howard Hughes, and some other very wealthy people whose records have become known to us, pay or paid absurdly little tax. Howard Hughes, with an income of several million dollars a week (that's right), paid $20,000 in income tax a year. His right-hand man, Noah Dietrich, who wrote a book, *The Amazing Mr. Hughes*, was just one of Hughes' employees who paid more tax than his boss. Dietrich's income tax on his annual income of $240,000 was $80,000.

Reagan is a millionaire with many business interests, which is why he can pay so little tax. His write-offs create business deficits that give him this advantage.

If you're an owner-operator and are paying a lot of tax, you're just not taking advantage of all the tax-saving situations left open to you. That's why successful businessmen have CPAs on their staff; they want to make a lot of money disappear to bring their taxes down. When my husband worked for W.R. Grace in Bogota, Colombia, he was one of *eleven* CPAs on Grace's Bogota staff alone.

Imagine the tax write-off that Hughes must have had with his income! Imagine having to come up with $2 million or more of deductions every week! But it can be done. We know because he did it. And he was never accused of being unpatriotic.

It is the right of every taxpayer to arrange his affairs so he can pay the least tax. That's a Supreme Court decision.

Federal and State Income Tax

We in California are required to prepare two sets of income tax returns each year. There is a deadline to get them in, although you can get an extension. The tax to be paid on each return is not the same.

Salaried people often make out their own tax returns. One of my friends who insists he can do it as well as anyone else has been audited three times in seven years!

A government audit is often much-feared by the taxpayer and it *is* a nuisance. We have to get all our financial records together and an auditor goes through them to see if we've been declaring all our income and not making deductions we were not entitled to. If we've declared everything, there is nothing to fear. These are black-and-white matters, though the IRS makes a big deal of the "gray areas." A gray area could be the *percentage* of your vacation you spent on business; whether the people you entertained were really customers; whether the porch swing you also like to loll in was really purchased as a studio prop.

In fact, I don't think there are gray areas. My own feeling is that if it was purchased as a studio prop, it was. I don't think it's a matter of what "sounds" right but what *is* right. I have never, for example, deducted one of the hundreds of hand-carved elephants that walk in procession around the studio on all the window ledges (most of which were purchased by me). These are my son's personal collection. The camel-saddle-chair was however, bought just because it seemed perfect for children to sit on for their portraits. So I deducted it.

I also deducted the white bathing suit I bought my daughter Jo because she hadn't one and I wanted an example of white-on-white glamour photography. She had other bathing suits I had bought her—I didn't deduct those.

Here's another example I refuse to consider a gray area. I have two children in the Bay Area. If I'm hired to photograph a wedding there, I might stay with them. I expect neither the customer nor the government to pick up the tab for something I am getting free, but it *is* a business trip and not a personal one, so I keep the receipts except when I take my children out to dinner.

Your income tax must be filed before the date due or there are penalties. If for some reason you're unable to come up with the figures in the required time (you have from January to mid-April to file), it's possible to ask for an extension.

At the time you file you'll pay the tax you owe (unless you owe nothing). If you have had money withheld from a paycheck, you may get some tax back—tax which you overpaid.

When a business has filed a federal tax return, the owner must estimate the federal tax for the following year. Let's say you paid $100 tax last year. Then it's safe to say that you'll be owing about the same this year, so you send the federal government a check for $25 every quarter. Your accountant will set this up, and it is exactly like withholding tax. If you've paid too much, you'll get it back, If you haven't paid enough, you'll make it up when you file again after January.

To find a good accountant don't ask friends, but business people who can

afford to have the best and are obvious successes. Accountants are like motels. It costs little or no more to have the best—till they're famous and become exhorbitant. However, accountants are also like lawyers and doctors, apt to charge what the traffic will bear. So this is a visit to be made in a respectably shabby outfit!

Ask a lot about the cost of preparing your return, and get an hourly fee and how many hours it will take. You'll probably only get an estimate, but, if possible, get it in the accountant's handwriting and then scream loudly if he goes too much over it.

Professional people sometimes deny that the wealth of their clients makes a difference to their fees, but when my husband and his CPA friends got together, it was openly admitted that many charged what the clients could afford. Seamus would get a bit carried away with what he called his "widows and orphans," who, he often pointed out, particularly needed his services because they could not afford to pay. One elderly woman paid him for preparing her tax return with a candy bar and another tipped him 10 cents for a job well done!

My grandfather was a very wealthy man and he was more than aware that professional people vary their charges. So that a doctor, lawyer, or other consultant didn't know who he was, he dressed shabbily and had the chauffeur drop him off a few blocks from where he was going! My mother also told me she was advised to do the same thing when she visited a doctor who happened to be the king of England's doctor. She wore an old dress and scuffed shoes and, sure enough, her bill was modest. It's hard for a professional person to bring his fees down after billing, so make it easy for him to have them down already!

Every tax return is not audited by the IRS. Most go through without question. A certain percentage are audited when the computer that records the information smells a rat. (Another small percentage are audited at random.)

Many accountants suggest that you ignore certain deductions (a good example is the purchase of a boat, plane, or cabin, *only* for entertaining your business associates), which will earmark you as an almost certain audit case. As I've said before, I am dead set against this kind of thinking. Take all the deductions you're entitled to and if you're subjected to an audit, so what?

But do not take deductions you are not entitled to. One of my husband's clients bought 140 pairs of boots and wanted them charged as a necessary business expense. Another wanted a *maximum* deduction on every item on the sheet. He even listed several churches and other nonprofit organizations and wrote "Max." after each.

"Forget your friend, Max," advised Seamus. "Just give me the actual amounts you spent!"

On the other hand, an artist who was having a hard time making ends meet got a job as a nurse's aide and was delighted to find she could still charge her expenses as an artist. She thought she could not because she had been unable to sell a painting for a year. She came into the office weeping and left with stars in her eyes because she got a big rebate from the tax withheld by her employer.

The IRS protects us all, of course, by making a serious effort to catch tax evaders. However, the agents it hires often get carried away and it's not unheard of for them to overstep the boundary between investigation and persecution. It is important for the honest taxpayer to know his rights and be protected by a

professional who is used to dealing with the IRS (his accountant).

Recently, I read an article in *New Woman* in which an IRS auditor spoke very frankly of the methods used. He made these points:

1. The purpose of the audit is to get as much tax money from the taxpayer as possible. (I took this to show that this is not an impersonal inspection of someone's records, but a determined effort to extract more money if the taxpayer will stand for it.)

2. Taxpayers who use an accountant who has a reputation for turning in honest tax returns are less likely to get audited than others. The reason is no. 1 above.

3. If someone has kept almost all of his receipts, the auditor won't usually make a fuss if a couple are missing.

4. The burden of proof is on the taxpayer. You can't just say something is so, you must be able to prove it is so (the reason to keep all records).

Preparing Tax Returns

Now, as we move on to the specifics of preparing a tax return, you'll need the following information for your accountant:

Income

1. From Ledger 1. The amount of your gross income.

2. From lending institutions. In January in the mail you'll receive a note for the interest you've earned on each of your savings accounts for the previous year.

3. W-2 forms. If you have a wage or salary from which tax was withheld, you'll receive a W-2 form from your employer. It will show what tax was withheld from your paychecks.

4. Stocks. If you've been playing the stock market, collect everything that has been sent to you.

5. Interest. If you hold any mortgages or interest-paying loans, be sure you have a copy of any sheets or passbooks covering the transactions for the past year.

6. Rentals. If you have income from rentals, find those records.

7. Miscellaneous. Put together all information about income you have received from any other source.

Expenditures

1. From Ledger 2, starting at the first page, make a list of the totals for the year.

At the end of this list mention which of the items also involve your personal expenditure. For instance, do you make business calls on your home telephone?

Your list should start something like this (alphabetically):

Advertising	$ _____
Auto. . .Gas & Oil	$ _____
Repairs	$ _____
Insurance	$ _____

Attorney fees . . .List names against total
 for each$ _____
Camera Repairs. $ _____
Charity. . .List name of charity
 and amount $ _____
Doctors. . .List name of doctor
 and amount. $ _____

You don't have to list each supplier, just the total figure you have spent on frames, stationery, etc. But do list separately all charities and professional fees you've paid.

Major Purchases That Will Be Depreciated

On a separate sheet list any major purchases you have made of equipment, furniture, etc. I only take items over $50 for depreciation. If you haven't made such purchases, write "none" on this page. These items should *not* also be listed in the previous list under "Expenditures."

Each item must be clearly identified and include the date of purchase and whether the item was new or not:

3/7/82	Mamiya camera (used, twin lens reflex)	$100
3/7/82	105mm lens for above (used)	$120

Property

List any purchases of property, the total price you have agreed to pay, and all details as to mortgages, etc. List the balance due at the beginning of the year; the principal paid during the year; and the interest paid during the year and the remaining balance.

You can, of course, just make photocopies of pages from your mortgage payment book.

If you have been paying on any loans, add that information.

Home

List no expenses that are entirely personal, but include those that are not in your Ledger 2. If you keep your home expenses in your business ledger, you won't have to list them twice.

Sale of Items on Depreciation List

From year to year your depreciation list will change as you delete certain items and buy others.

List *all* items that you no longer have and state what happened to them and on what date. You could have sold them, given them away to a friend, thrown them away, or given them to a charity auction, etc.

Your Spouse

If yours is a joint return, your spouse should have a similar accounting. If he or she is salaried, just send in the W-2 form.

When a business finds it's making too much money, that is, it's paying a large amount in tax, often the owner decides to start a sideline or create a sec-

ond business. All this must be accounted for—how much was made, how much spent, as above.

Additional Information

List anything that you feel an accountant should also know. Some examples are loss by theft; tax free investments (bonds, IRA accounts, etc.); gifts to children (tax free or otherwise); any calamities and bad debts; and winnings and gifts to you. You will then have given him, very simply stated, a picture of your entire financial life for the previous year.

The first time you get this information together, it will take a little discipline not to forget something. The way I avoid this is by putting into a file marked "Information for Tax Return" any relevant papers that come up during the year. When I go through them I have everything I should list.

You now present this to your accountant and he will telephone if he has any questions. Answer simply and truthfully.

Remember, your accountant is not responsible for the accuracy of the figures—you are.

If your accountant asks for a figure you haven't provided, make a note that next year you should also provide this figure and put that sheet in your new tax folder.

When your accountant calls to tell you the returns are ready, look over the figures, sign where he tells you to, make out a check if necessary and that is that. You're set till next year.

The State Board of Equalization

The states of California, New York, and others require retail businesses to collect taxes for them. Unless you agree to do so, you won't be allowed to carry out your business in these states!

To collect sales tax, we must add it to our customers' bills. We then pay the government when it asks for an accounting.

Not only does the state require that this tax be collected and handed over, it requires that we post a bond which could be confiscated if we don't live up to the agreement. After some years it will sometimes give us back our bond, which has been in a savings account gaining passbook interest. I've got mine back and I'm now trusted by the state to give them their sales tax each year because I've always been prompt and honest in the past!

Collecting sales tax would be simple if it weren't for our very human nature. If I deposit $318 of which $18 belongs to the government—added to my bill in the form of sales tax—I might still feel reluctant to hand it over.

The way to handle this is to consider the $18 a loan from the state . . . a loan that the state allows you to invest until it is due. The easiest way is to have a sales tax account into which you put $18 when you deposit the $300 in your checking account.

This money becomes useful:

1. It can be placed in a savings account and earn interest.

2. It can be used to bring your own savings to an amount to qualify for a higher interest loan.

3. You know when you'll need the money, so it can be placed in a savings account for a fixed length of time (ninety days or more), qualifying it for higher interest at a fixed rate.

4. You can borrow from this sales tax fund if you need a short-term loan.

5. You can lend it to someone else at even higher interest.

Occasionally, I lend my children money from my sales tax account, if they can return it to me in a short time. I like to help my children on government money!

It's also possible to juggle the fines for being late with your payments so that they work to your advantage. If you have money invested, or need the money, it's sometimes smart to give the government the sales tax collected, just before it takes proceedings against you to withdraw your license.

However, if you don't have a stomach for minor wheeling and dealing, forget it. Pay the tax when due.

The County

Our county also levies taxes in the following ways:

1. *Yearly Assessment.* Once a year you may be asked to assess the value of all your inventory—any items you have bought from wholesalers and will sell to your customers—and also the value of your equipment. These latter items are listed on your income tax return where you're depreciating them.

Before the assessment date (which is noted on a form sent out by the county), sell as much inventory as possible. When you see "inventory sale" advertised, a retailer is dumping his inventory, rather than pay tax on it. Once the date has passed, the retailer then stocks up again. Similarly, you can buy equipment after—not before—the deadline and avoid paying tax for the previous year and if you were going to get rid of equipment, you should do it before it gets taxed again.

If you want to avoid having an "inventory" only take orders for albums, frames, etc. from display samples. Don't keep a stock on hand.

I'm not certain every county in the country has an assessment tax; if yours doesn't, now you know how lucky you are.

2. *Property tax.* The immovable property we own is also taxed by the county each year. We are required to pay it a percentage of the value on our property.

By all means question the property tax you're billed for, if you feel it's unreasonable. If there has been a mistake made on your property, others will be in the same boat. Usually when that happens, everyone affected gets together and marches down to city hall and protests, and it's not unheard of for the city to back down and reassess the properties.

No tax collector is on your side. His business is to collect as much as he can.

In some areas—ours is one—anything you do to improve your property must be done with a permit that you must buy. (This is called upgrading the property.) Any applications for the permit inform the assessor's office that it can raise your taxes when the job is done. It also follows that if something happens to downgrade your property, your taxes should be lowered.

Remember this if you suffer land or building damage of any kind from a fire,

earthquake, or storm. Go to city hall and ask that your property taxes be lowered.

Once the property has been restored, it will be upgraded, of course, probably putting your property value higher, unless you plan to put back the original ancient barn that fell down, or decide you don't need a barn.

Thus, every small businessman who owns property should be extremely careful to consider the implications taxwise of any change he may make on it. This is a time to consult with a realtor who is aware of the specific local regulations involved.

Also, don't hesitate to talk these matters over with friends and business associates. One advantage photographers have is that we meet such a variety of people, we have experts in every field to lean on.

The City

You'd think there's nothing left to tax us on. Not so. Our city requires its own pint of blood in the form of a business license. There are three ways of administering business licenses that I know of:

1. A "no fee" license. All the owner must do is register the business.
2. A license that is paid for by a flat fee, applicable to everyone.
3. A sliding-scale license fee, like ours. The fee rises with your income (another form to fill out, alas), and downtown the fee is twice that of the outlying areas.

Notification to pay taxes comes by mail. In most areas there are penalties for not filing. It is the taxpayer's duty to stand up and be counted. It would be wise to ask another businessman in the same district what you should do on the local level.

TIPS

Exchanging Gifts

The government doesn't like business people to trade services. We must declare as income the value of such services, that is, pay taxes on them.

We can't trade photography for dentistry, photography for roofing, photography for typewriter repairs. We must instead make a spontaneous gift of photographs to our friend, the dentist, the roofer, or the typewriter repairman!

It so happens that if these friends may indeed decide to fix our teeth, replace our roof, or fix our typewriter as a kindness, then we are lucky indeed.

Crazy, isn't it?

Deflecting Income

Your mother wants to give you a trip to see her. If you can turn this into a business trip, don't let her give you the ticket. Pay for it from your studio

account; it's tax deductible. Her gift could instead be the same sum of money to help you with your day-to-day expenses at home.

On my last trip to Sri Lanka, where I was born, I was able to tie up two contracts to photograph hotel brochures and do other commercial jobs on the island. It was, coincidentally, a trip to visit my parents. I had no hotel bills to deduct because I stayed with my family; the money they offered to spend on the tickets was my personal spending money during the vacation (not deductible).

This is the principle behind the photographic convention. It is a fully deductible expense, a few lectures are made available, and the partying is considerable. That the conventions may be held on a luxury liner, in Hawaii, or in Las Vegas doesn't make them ordinary holidays. They are business-trips!

You don't have to join someone else's business trip. Organize your own.

Work similar switches on other things you do.

1. If you need a coffeepot at home, retire your studio coffeepot to your home, and buy the studio a new coffeepot.

2. Let's say you take a salaried customer out to lunch and it costs $30 for the meal and he gives you a gift of a shirt, which also costs $30. You get a $30 deduction and a shirt. If he pays for the lunch and you buy your own sweater, you have lost your deduction and he doesn't get one for the meal, because you aren't his customer.

Very soon it will become second nature to think a moment before spending money. It's like giving yourself a discount on the item.

Don't Deduct Yourself into the Poorhouse

The purpose of turning purchases into tax deductions is to lessen your income tax. If your income is at a point where you'll be paying little or no tax anyway, you'll need that money for living essentials, not deductions.

If you don't have much cash flow yet; if your income is barely keeping up with your overhead and day-to-day studio bills—don't be tempted to spend unnecessarily, *period.*

One of the common delusions of salaried people is that we, in business, should always pick up the tabs because we need the deductions! They seem to think that we're going to get all that money back. Whereas, we're actually just not going to pay tax on that amount of money (which otherwise we would be doing).

Turn a purchase into a tax deduction when you: need that item (a vacation); can afford it (don't go to India if you can only afford Mexico); and can legitimately charge the item to your business—there *must* be a business tie-in.

Garage Sales and Gambling Income

Do you know that if you give a garage sale or take items to the flea market and sell them, the government feels you should pay tax on the proceeds? This is one of the reasons that it's a smart move to give these items to a charity instead (and take the deduction). It's sometimes worth more in the long run.

If you do give garage sales, you should, of course, remember to keep a tab on all the expense you go to to put them on.

Gambling profits are also taxable. So, you must keep a tab on gambling losses, which is not as easy to do as it sounds. If you lost $1,000 in a game of poker, do you think the person who won it is going to give you a receipt? However, if you gamble in Nevada or Atlantic City, be sure to keep a tab on all your expenses (hotel bills, etc.), which is money spent in making that money.

At the racetrack you may have seen people picking up losers' tickets, which are usually discarded angrily when the numbers go up. Now you know why they do it. Every large winner is reported by the track to the IRS, and casinos are required to do the same.

You might think a trip to Las Vegas would be entirely deductible. If you make money it's *income* therefore, if you lose it's a *deduction*. Not so! The IRS has turned this in its favor. You may only declare your losses to the extent of your gains!

Charities

As photographers, we find ourselves from time to time solicited for donations to charities. If we're hurting for money, starting a business, or looking forward to expanding, the last thing we need is someone telling us about a needy organization. In fact, *we* are a needy organization.

There is a way, though, that we can help genuinely worthwhile causes, and that is when we're asked to donate items. An item can be a service or a "free sitting." Best of all, it's a great way to get rid of the white elephants we accumulate:

1. The frames that don't sell.
2. The pictorial photographs we have several copies of. If you have a sample to "show," you can always order another.
3. All kinds of tools and other marvels that you haven't even taken out of their boxes. I have, as an example, a glue gun with the plasting wrapping intact. I bought it to make my own frames. That was nine years ago!

These items can be treated as donations for their fair market value (usually what you paid for them). "Works of art" can be valued at current value (what the sale price would be). There are varying opinions on whether a photograph can be considered a work of art if it is sold by the artist, that is, *above* what he paid to have it processed. Discuss this with an accountant, or call the IRS for a clarification, so you are aware of the latest ruling on this. I've been advised two ways on it: 1) if it is a work of art, then it is; and 2) a photographer can only take the cost of printing any photograph.

Be sure to get a receipt from the organization you make a donation to and be sure that it is a registered nonprofit-making organization, a legitimate charity.

A side benefit to the business that gives to charity is the mention of its name at a sale or auction, on the radio, or in a list with other donors. It becomes a form of advertising.

Professional Fees and Other Losses

Legal and other professional fees, even on personal matters, are tax deductible.

Any uninsured robbery loss is also tax deductible. Of course, such a

crime must have been reported to the police. If the loss is more than you need in a particular year, it can be spread over other years. So when you list your studio expenses for tax purposes, don't forget to add any disasters that may have occurred, with dates, prices, and other details. So that you won't forget this, have a special ledger page marked losses or disasters.

Stock market losses are also deductible and the loss can be spread over several years.

IRS Tax Changes

Ask the person who prepares your taxes if the laws have changed in any way that you should be aware. It's worth finding out the changes. For example, I found out this year that if your college-age child lives somewhere else, you may still be able to take him or her as a dependent (even if the student has a job). And if someone comes to live with you, inquire into the status of that person, too. The general feeling you should have is that the tax laws may not be based on *your* idea of common sense. And sometimes there will be nice surprises, not just disappointments.

17
The Hiring and Firing Line

No matter how competent and energetic you are, a successful studio often becomes more than one person can handle.

There's a decision to make now. Should you stay small or expand? If you decide to stay small: give up the least profitable of your lines; raise the prices on your cheaper lines, so you'll earn more from orders; and give up a line of photography you dislike.

Only you can decide where to cut or where to raise. A lot of this will have to do with your competition.

The advantages of growing big enough to need employees are obvious.

1. Now you can leave for a few weeks and come back to an appointment book that is full.

2. Your customers will blame the employee if something goes wrong, never *you*, the owner.

3. You can decrease your own involvement in the areas of work you dislike.

4. You can go into other interests that you haven't had time for.

Here's a Laugh (or Governmental Requirements of the Employer)

If you've waded through the chapter on taxes, you'll have found that the government is merciless in trying to get its hands into our pockets.

It doesn't stop there. It ties you up in knots if you want to hire someone to help you.

Like to hire an office worker? Here are a few government requirements of the employer.

Federal Government
The employer must:

1. Apply for an employer's ID number.

2. Pay the employee a minimum wage decided by the federal government.

3. Carry workman's compensation insurance. Your own insurance company can provide this, or you can buy it from the State Compensation Fund (at least you can here in California).

4. Pay to the Social Security Fund a matching amount to that withheld from the employee's wage.

5. Withhold a certain percentage of the employee's earnings for Federal Income Tax.

6. Send the IRS and Social Security office the amounts withheld and otherwise owed them.

7. Send the employee a W-2 form once a year telling how much he earned and what was withheld.

State (California). Your own state laws might differ slightly.

8. Apply to the state for an employer's ID number.

9. Contribute to the state's unemployment fund.

10. Withhold from the employee a sum for the state's disability fund.

11. Withhold a percentage of the employee's wage for state income tax.

12. Send the state the money withheld for its unemployment, disability, and income tax funds.

Well maybe it's no laughing matter, we should merely cry.

Years ago, I heard the President of the Midstate Bank say angrily in a speech that the government regulations and taxes seemed specifically designed to create dishonesty in small businesses.

I would add that they're also designed to create unemployment.

When I first needed help around the studio I knew nothing about all these regulations. I came from another country and so had no frame of reference about hiring American-style. In Sri Lanka you hired someone, told him what you would pay him, and that was that.

Getting Caught in the Employee Trap

The first people I hired in my business were part-time workers. They were young people who came around looking for work, and I'd say, "All right, do this," and then pay them. Some worked quite regularly. I always paid minimum wage or higher. I had absolutely no idea that I should register as an employer or any of that.

When I found out the complications of hiring help, I decided I would do without. I was making so little money that to pay someone else to take some of the chores off me was quite a sacrifice. I didn't want to make more work for myself by having to fill out documents, withhold tax, etc., and I frankly didn't feel I could handle more responsibilities than I had.

Next I tried a partnership. A man I knew started hanging around the studio helping me with the heavy work. He had another job and worked the night shift. He explained that he slept very little and would just as soon keep busy. One day he announced he had quit his job and decided to help me full time for a while. I should have left it at that! Instead, I was embarrassed to be having all this free help and, as I couldn't pay him enough, suggested a partnership, splitting the profits. I go into this unfortunate arrangement in greater detail later.

I don't make decisions lightly, and I thought I had developed a way I could expand and take on more business. I really thought it would work out! Instead, I

ended up with considerable financial loss at a time when I could least afford it and eventually had to pay off *his* bills.

After that I again tried to work on my own but became exhausted in my busier times (always from May to January). Besides, I now had a second career: writing. It's only when work is no longer fun that I begin to look around for solutions . . . to ask myself what I'm doing wrong.

Hire Another Small Businessperson

It was then that I seriously studied the "hiring business" and discovered there was one kind of person I could hire without red tape. I discovered the independent contractor.

An independent contractor is a freelancer, but not every freelance worker is an independent contractor and the distinction is an important one. Many freelancers must be put on the payroll (all those forms to fill out and money to be withheld, etc.) whereas independent contractors are not employees at all. They are the owners of independent and often one-man businesses.

The studio photographer is actually an independent contractor. We don't work for wages, but arrange a fee with our customers. We set our own hours.

Say I need windows washed. A "window washer" in business for himself washes my windows, yet is not my employee. He has the buckets and squeegeies he needs, and I don't pay him a wage or salary. I pay him a fee. His fee may be a time charge or a flat charge for the job, and he takes care of his insurance, his income tax payments, etc. All I have to do is to write a check when he tells me what I owe him.

An additional big plus is that I don't have to hire him next month if I'm a bit short of cash. He has other customers. A wage earner may be dependent on my check.

I began to see why people use service businesses.

Since then, I've hired only independent contractors for every kind of studio help. If someone applies for a job and is not already working for himself, I tell him to set himself up in business, buy the tools of his trade, or I can't use him (or her). Many women prefer to work this way. They're not always aware of the option!

This worker then lets me know what he'll charge to do a certain job and if I think that's reasonable, I hire him—at $x for retouching; at $y for secretarial work; or $z for cleaning. He lets me know which days he'll do my jobs, the days he'll be on vacation, etc. It works very well!

Yet another reward is to see someone develop his or her business—something that was suggested basically for my convenience—and watch that business become a real asset to the other person as well. He'll get hooked on keeping the profits of his hard work for himself, and welcome the tax benefits of taking business deductions, depreciations, etc.

Freedom Through Independent Contractors

When I called the State Office of Employment to ask for the rules governing

independent contractors, the man on the other end of the line nearly had apoplexy. Apparently, he had no desire to give me the information!

Part of our conversation went like this:

ME: "Say I were to hire a gardener. Would he be considered an independent contractor?"

HIM: "You don't need a gardener in a studio. You need clerical help."

However, I finally got him to admit that what I already thought I knew about independent contractors was correct! And just in case anyone else had to suffer the same runaround, I wrote to our assemblywoman and complained about this lack of cooperation.

In the discussion on hiring of ICs before, I've perhaps glossed over an important point. You don't have to pay them a specific wage, or even the minimum wage. The amount paid is anything agreed upon between you.

There's also a problem that comes up. Many employers list their employees as independent contractors. Then the worker is laid off, tries to collect unemployment benefits, and is told, of course, that he does not qualify. If he insists that he *does* qualify, then the employer had better have a strong case for his position.

Ordinarily an IC is *not* paid less than the usual employee; he is paid more. That's because he's usually a specialist in a particular job; he has higher Social Security payments to make; and he doesn't have the usual employee benefits.

Even so, a person can come down on his fees, accept what you offer to pay, or make a special price to you if you can give him enough work.

Advantages

1. You pay for the job done and have no more paperwork beyond letting the government know how much you've paid, after the IC has earned $600. You will, of course, list these amounts in your ledger.

2. Although an independent contractor is required to *own* the tools of his job, you can hire someone to do the work at a lower price if yours are used. I know someone who had his house renovated and the workmen agreed to do the job for less per hour if *his* tools were used, saving the wear and tear on their tools. Because a variety of workmen were used, he eventually more than covered the total cost of the tools on what he saved.

Disadvantages

1. You may not make demands as to *when* some jobs are done, though you could, of course, refuse to hire someone whose hours are not convenient to you.

2. A priority requirement of any employee is loyalty. If someone is working for you and another studio—a possibility—will you find out about it if he isn't loyal?

Find a Jack-of-all-Trades

Right now I use Michele's Multi-Services, run by a young woman of great intelligence and energy, who provides me with almost all the help I need. When I need assistance, she works at the studio or at her home, taking on more and more jobs as she expands her skills: secretarial work; retouching; facial make-

up; cleaning (even my car); delivery of packages; repairs; yard work; and photography. If she can't do the job when I want her, I wait!

She also makes cakes, caters parties, etc., and thus, we can bring each other extra business. At some weddings, I'm the photographer and she's the baker. I initially discovered her as a baker and ordered some cakes. Very soon, she took on other jobs for me.

Very occasionally, I might have a student come in for a few hours if I need additional help and Michele is not available on that particular day. The student usually does light work or may act as a receptionist, and I rarely have the same one twice. These kids are looking for permanent employment and will have found it by the time I call again.

I also might employ at various times a window washer, a gardener, an electrician, a carpenter, a plumber, a house painter, and so on. They are all independent businesspeople.

Throughout this book, however, I speak of "my employee" or "my assistant"—so much easier on the ear than "my independent contractor." We do the same thing at the studio. I might say, "Call my assistant," and give a customer Michele's number. I also, of course, talk of employees I had in the past, before I found the advantages of not carrying a payroll.

When to Start Hiring

If you're not generating enough business to hire someone yet—but the work is still a bit beyond you—think about why you need an employee. Office help may not be your main need.

You may actually need someone to help with the heavy work, do the cleaning, or help out with the photography. If you find you're particularly tired at *home*, and have no spouse to help, perhaps that's where you need help, not at the studio at all. Home help is not deductible, but it still may be what you need so you can relax in the evenings.

Also hire for the job you enjoy the least or are slowest at. I'm astonished at how easily other people can clean a room, a job that destroys me both physically and emotionally!

At the studio, I've found it's better to hire someone for a few hours every day than all day, twice a week. My workers who have tried that complained that they lost the continuity because, unlike a retail store, each order has a life of a couple of weeks, at the least.

As You Grow

Make a list of the tasks that can be done by someone else, such as mounting, retouching, restoration, photo spraying, framing.

Now, give up those someone can do as well or better than you, and the jobs you don't like.

Before hiring someone at the studio, find a place you can have many of these jobs done. If possible, have the lab that does your printing take care of them.

When you have an employee, always work out if his or her time is better spent on a job that can be done elsewhere. In slow times, you may want to take on the jobs again that you ordinarily farm out.

Above all, don't turn down work because you're "too busy" to handle it.

In costing a job, consider points in this way. For instance, for photo spraying, the cost at a lab is $1.25 per print minimum. Someone you hire can spray a lot of prints in a short time, and the spray per print costs very little.

However, in damp weather, spraying has to be done under controlled conditions because some of the matte sprays glob up or become granulated instead of covering a print evenly. Thus, it's cheaper to let a lab hassle with the problem than to pay someone to rework prints to get it right.

Or, maybe dry mounting prints yourself saves about $1 each and you may find it an easy job. But if you continually botch the mounting and it becomes a matter of risking a ruined print versus paying to have it done, then the $1 is well spent.

Keep your eye on these costs because when you grow you must have an efficient money-saving system in existence to take advantage of your increased income.

The Bottom Line on Hiring and Firing

A business is run around the convenience of the key employee and that means *you*, the photographer/owner. Without you, there would be no business.

An employee should be made aware of this the first day of work.

When interviewing an employee check his or her references. We forget to do that. If there are no references, wonder why. Sometimes a previous employer won't tell you the truth about an employee. If you know someone else in the same firm, ask him.

If, as an example, Emma says she has worked for Bob's Donut Shop, Bob's wife or the waitress there might be franker than Bob himself.

You will need to tell an applicant of the skills you need and he should tell you the skills he has. Sometimes you can use those skills to good advantage.

I once hired a young architectural student who was a whiz at lettering. Some of my price lists today were originally lettered by her; we've just changed the figures. She could also retouch prints quickly and very well. Both those jobs were once mine. I gave them to her, and did the jobs I had intended for her.

Try to get a feel for whether you'll get along with this person. If you think and act quickly, someone who is slow will drive you out of your mind. And the reverse is true.

If you have any kind of instinctive dislike of someone, don't hire him—even if it just a matter of not being comfortable around him. It's amazing how some little thing can become really irritable if you have to work side-by-side with it. A sniff begins to sound like a roar; a giggle, like a hyena's laugh.

Look for your employees everywhere. You can get a good one through the least likely source. Michele, who works for me now, was a bride whose wedding I photographed. I offered the job to her friend and Michele turned up and said, "What about me? I need work."

For photographers, put out the word at newspapers (their own photographers often moonlight) and camera stores. For studio office help tell every friend and customer you're "hiring;" watch the ads in the newspaper; place an ad in a newspaper; consult employment agencies.

It takes a little time for the word to get out and working for a photographic studio is something most youngsters like the sound of. I know that my employees have been startled to find how quickly and easily they've been replaced. I'm always sad to hear that a good worker is leaving, but by the time he has come back to say he can still spare me a few hours, there's someone new, firmly entrenched.

I'm always surprised, too, that the ones who leave for more money are the first ones back asking to be re-employed.

Getting an Employee Started on the Right Foot

All employees should be taken on two weeks' probation. Thus, if someone wants to give up a job and work for you, he or she takes a risk. Make this quite clear; specifically, that you will not merely be considering her talent or capability but also whether this will be an all-around good arrangement for both of you.

Twice, young women have refused probation, only to return and tell me how much they regretted not "trying it out." There they were, still without the right job, and the person who tried out with me was now permanent.

If you want to try out someone at a lower wage, do so. You make the rules. I pay temporary employees the minimum wage and raise it after the two weeks are up. I never pay a regular employee "minimum" because I feel the job he's required to do is not "minimum."

Be Tough Initially

On the first day, we sit down and discuss exactly what I expect and I make it sound tougher than it is. I tell them the things that really bother me about employees and explain that it is up to *them* to get along with me. That way, when they find I'm actually very easygoing, they're relieved, and when I get tough, they don't sulk.

Each employee is given a list of employee virtues:

1. Punctuality—I expect it to the minute.
2. Loyalty—to me and my work.
3. Efficiency—I don't want to have to check over every job to see if it's done correctly.
4. Courtesy—to me and my customers.
5. Telephone manners—it usually takes several weeks before I can train an employee to be instinctively charming on the telephone. Few have arrived with this vital talent. When they leave, they all have it!
6. Truthfulness—if someone makes a mistake I want to know it. I don't need excuses, just the facts.
7. Care—I expect mistakes to be made, but not the same ones over and over.
8. Consideration—I don't want the phone tied up with calls to and from

friends. In an emergency it's all right, but otherwise, friends can just leave a quick message and the employee can call back during the lunch hour or after work. As I have two telephones, one for outgoing calls, I let them use that for returning calls. I also don't want friends coming in just to visit.

9. Attentiveness—customers are to be waited on, never hurried, and should be treated as we would like to be treated. A customer who comes into the studio takes precedence over one who phones, so we take the name and number of the one on the phone if it sounds as if that customer needs time.

10. Conservative clothes—no beach clothes on hot days; no almost bare breasts or short-shorts.

11. Responsibility in work habits—I want someone who is self-motivated and who, when a job is over, won't wait for me to find the next job. My employee should tidy, paint, file, clean and during busy times make a list of chores for slow times.

12. Honesty—I not only expect someone to be honest in handling my money, but to save me money in any way he can think of!

13. Health—I don't want a sick employee. He must call and stay home if he's ill. Nor do I want an employee to get a hernia doing a job that is too strenuous.

14. Thoughtfulness—if something comes up, the employee should let me know. "Don't wait till Monday to tell me you can't come in on Monday. Call me Sunday or tell me on Friday."

15. Security consciousness—we discuss what an employee should do if someone comes into the studio and threatens him in any way. If the person will not leave (e.g., the employee says, "I have to close the studio now," in an effort to get someone out, and that person still won't go), then the employee must leave himself and call the police. All employees are also told what to do if there is a fire or other emergency.

16. Thoroughness—all records are to kept exactly as they have been in the past, numbers should be written one under the other, margins should be kept straight.

17. Handwriting—each new employee is asked to write out the alphabet and all numbers, so I can see for myself that there will be no confusion in how the letters and numerals are formed and how important this is.

18. Confidentiality—customers' confidences must be kept. I want no gossip about them, or about me. I shouldn't have to watch my tongue about every little thing in my own place.

Breaking Someone In

The first weeks at the studio, I only show a new employee how to deal with specific jobs that come in. I handle each customer and tell him to watch what I do and come up with something as close to the same thing as possible!

If there is a problem—my expectations and his performance don't jibe—we sit down and talk about it.

Say someone has a poor telephone manner, abrupt and not very helpful. I might suggest the employee break the habit by trying to find out all he can about the customer during the phone call and to extend it to five minutes. "Imagine

that this is your studio," I have said. "Now, say you have had no business all week but then there is this *one* phone call on which your survival depended . . ."

Don't be afraid to hire an employee who sounds uncertain of his or her skills. These are often the ones with the imagination to see there could be problems. If someone acts as if it's going to be a snap, I get nervous.

Employee Discounts

It should not cost your employee as much to order photographs as someone else. Nor should a studio owner expect an employee to pay for his time. I have even told women who work for me, "If you'll marry on a Sunday or any day of the week *except* Saturday, I'll give you the wedding photography as a gift," and they've taken me up on it. Saturdays are, of course, the most popular days for weddings.

Any supplies they need, cameras, film, etc., they buy at my cost. I also give them items I no longer need or wish to sell (old display albums as an example).

Pilfering and Temptation

When you have only one employee, you can quickly discover if you have one of those incorruptible people who would never take a dime. I find it hard to work with any other kind of person.

If you have additional employees, you may not be able to be as sure. Someone who would not ordinarily steal, might if he felt someone else would be blamed.

In addition, if one person gets away with systematic pilferage, other weaker workers may be tempted. I've seen this in offices where I worked . . . one thief will corrupt almost every member of a department. The management has to discover this on its own because even the honest employees won't inform on the others.

One way to prevent petty pilfering is to place a single person in charge of the cash box, your keys, etc. Another is to keep a check on those things yourself. Don't let all employees go to the storage room to bring out supplies. Don't let an employee take in cash from customers without writing down the exact amount and the change given to that customer.

Hiring is Not Easy

A business executive of one of the largest life insurance companies listened to my hiring woes when I was in New York.

"What am I doing wrong?" I asked him.

"Nothing," he assured me. "We have the most elaborate screening process we can devise to pick personnel and our success level is only thirteen out of 1,000!"

That's right; only thirteen of a hand-picked 1,000 work out for them, stay with the company, find a career, and really give the job a chance.

Was I relieved!

At that time I had "let go" yet another employee. This one had changed into a bikini and was sunbathing outside when I arrived from an outside job. It was "too lovely a day to work," she explained.

After talking with the insurance executive, I consulted a woman who had managed a hotel when she was only twenty. Her genius, I had heard from several sources, was in the handling of staff.

She asked me to make a list of the wrongdoings of my employees and these included:

• Stealing (everything from photographs, to folders, to frames, to produce from my home garden, to stamps, and lastly *cash*).

• Spending most of the day talking to friends (who came around to visit when the spirit moved them, some bringing their animals with them).

• Total lack of interest in what they were doing; unpunctuality; slowness; competitiveness with me (the hormone kind). One woman would become furious if a male customer ignored her and criticize him nastily the moment he left.

• Hiding mistakes, being rude to customers (one helper said triumphantly, "I made her cry!"; another burst into laughter at someone who was handicapped).

I liked all these employees or I wouldn't have hired them. All were exemplary for the first two weeks.

Well, the hotel manager gave me some good advice and I now have rather good luck. *Now* I know employees must: Make more money for me than their wages cost; free me to bring in business; create an atmosphere in which *I* am entirely comfortable; and create an atmosphere in which the customer is entirely comfortable.

If they fail in *any* of these areas, then they must go. I may like them, be related to them, owe them, feel guilty—but they must still go. As I now decide this in advance, it's no problem at all.

One pregnant employee, as an example, slowed down so much during her pregnancy that I was forced to say, "I'm sorry, but the baby has begun to dominate my life, not just yours. I've got to find someone whose mind is on her work."

Years ago, I couldn't have done that. I'd have just suffered along.

I have no prejudice at all against hiring pregnant women, of course, I've seen how agonizing it is for a woman to lose a job just when she needs the money most. When Michele became pregnant, she continued to work until she was in her last month and her dedication to her job did not falter. She had an open invitation to pick up my account again after her baby was born, and she did.

Honesty is the Best Policy

The hotel manager told me a story I have not forgotten.

One of her brightest employees was continually absent because of migraines and this young woman was also her personal friend.

She called the employee to her office and said, "I have the greatest sympathy for you, and our friendship will not suffer from what I have to say. As an employer I can't afford to hire someone who puts in as little time as you do. I don't want

to hear about your migraine headaches again during work hours, but if you want to see me at home, I'll find you a good doctor.

"Meanwhile, if you're absent again during the next thirty days for any reason, you'll have to find another job."

"And that," she told me, "was the end of the migraines."

Two months later I found myself saying to an employee, "I notice you took the retouching pencils home with you. I am *not* interested in the reason. I want you to go home now and not return until you've replaced everything you've taken from my studio. If you have them back by tomorrow, you may start work again. Never again take anything without my permission and if I say no, I don't want you sulking."

I fully expected outrage, sulks, even tears. Instead I got an immediate apology and a promise that while she had intended no theft, she would never borrow from me without permission again.

You can tell your employees how you wish them to behave, insist on punctuality, accuracy, etc. It's your business and they are employed to help *you.*

When Worst Comes to Worst: Firing

There's nothing more painful for an employee than being fired. Try to make it easy. Somehow try and get the message across that it would be *so nice* if he would just quit without your having to make him do so. Most employees don't take the hint!

If you work with an independent contractor it's simple to say that you will be cutting down the hours soon so he should get some additional customers. But when I had regular payroll-type employees it was more difficult.

My initial hints always started with suggestions that he was out of place at the studio, he could get more money elsewhere and should! When this didn't work I'd mention that I could not afford help, I planned to discontinue hiring *any* help soon. Then if he didn't start looking for another job, I gave him a day after which I wouldn't need him.

Only occasionally need an employee be given immediate notice and one reason is stealing. Never mind what excuse you think of, just get whoever is stealing *out of there.*

People who steal rarely do so from need; they steal because of hidden hostility or envy or insecurity. Therefore never antagonize a thief because such people can be spiteful. Instead, find some tremendous financial crisis as an excuse to "not be able to afford" the person's services.

When an assistant is definitely hurting the business in any other way, forget about giving notice. Get rid of him instantly, even if you have to pay for time not worked.

Rudeness to a customer is always unforgivable, so is disloyalty to you or your business. On one occasion I noticed that a particular customer was very short with me, unlike her usual manner. I looked up and saw my assistant wink at her with an approving grin. I didn't ask what had happened between them to cause the sudden unfriendliness because I could see a long, defensive argument ensuing. I did, however, know what to do about it. I called the employee that eve-

ning and told her that I wanted to run the studio alone for awhile, so she should look for another job.

Excuses, Excuses

It's hard not to feel guilty when firing any other kind of employee, but if you've laid out the rules of conduct and the kind of work you expect when you hire, just explain why it isn't working out.

"I wanted someone I could depend on, and you've been late four times this week."

"I needed someone who is accurate with figures, and it's costing too much to keep doing things over."

"I'll have to find someone who can work faster."

If the employee has been *impossible,* don't expect him to be fond of you when you let him go. Thus, it's unwise to keep him on to train a new employee. You'll be surprised how the new employee will become less than sure of you once he has listened to a few gripes. One disgruntled former employee came back to visit and talked for only five minutes to her successor. In that short time she managed to tell her four or five things she had found impossible about the job! Can you imagine the damage she would have done if she had had a whole week to fill her with negative thoughts!

Once an employee has been given notice, it should not be possible for him to come into the studio as freely as before. The sudden hostility of an employee who has been fired can make him do dumb things. I've had employees return to perform little acts of vandalism and their last days can be full with them, too.

One, as an example, took out several pages of a book I was writing and apparently just threw them away!

To keep her from doing something spiteful, I had sent her to the copy shop and asked her to have them run off two copies of the book!

There are a few laws that govern an employee's rights when being fired. You can, in California, tell someone not to turn up for work tomorrow and pay them right there what you owe them. But if they do turn up the following day not knowing they are to be fired, then you have to pay them something, and if they start work that amount increases. As all laws have a habit of changing, look yours up if you have any doubts, and don't listen to an employee who says he knows them. Check it out yourself.

TIPS

Using Your Employee's Talents

Don't overlook your employee's specific talents.

When I found Michele was a whiz at makeup, I was able to rent her services to models when photographing their portfolios. She can transform a pretty woman into a gorgeous one in a few minutes. I can charge $30 for this service.

A young man, Steve, had a beautiful speaking voice: while he worked for me, the telephone answering machine was programmed to say, "I am Steve, I am a machine that answers the telephone at Thwaites Photography. Please do not hang up . . ."

Donna, on the other hand, had a talent for figures, so she did my banking, bookkeeping, and prepared my end-of-the-year records for the accountant.

Christine had a knack for knowing what pictures would appeal to the public. She could choose a picture I had dismissed as "ordinary," and sure enough, customers would "ooh" and "aah" over it.

It's also fun to see your employees develop in directions they themselves hadn't considered for their careers. An introvert suddenly becomes the one who handles the customers best; the college dropout finds that photography should have been his major.

The older employee, too, will start expanding his interests. *Having* to deal with so many aspects of business at once (the bane of the small, understaffed studio), is what gives your employees a chance to "find" themselves.

Five Time-Saving Tips

1. If it's going to take longer to explain something to an employee than to do it yourself, do it yourself. This doesn't include training, but simple tasks that sometimes take elaborate explanations. Would it be easier to tie a shoelace or to tell someone how to do it?

2. Instead of telling an employee something, show him. How should a new employee deal with a customer? Deal with that customer yourself, and let him listen in.

3. If you're a competent typist, type your own letters. You don't need to dictate them.

4. Let your employee write directly to the customers, when the letter is simple. Just say, "Write to so-and-so and say I can't make it on Monday. Will Tuesday be OK?"

A friend of mine wrote to the Queen of England and received a reply, "Her Majesty, the Queen, has asked me to thank you . . .," etc. We can do the same thing!

A secretary can write, "Jeanne asked me to say she can't make it on Monday. Will Tuesday be OK?" If you write the letter yourself, you may have to make it longer and more personal.

While on the subject of letters I have only had one employee who arrived able to write a simple letter that conveyed what it was supposed to. Most write in a way that has to be decoded by a spy, and use phrases like "with regard to" when "about" would do as well; e.g., "I am writing to you with regards to your order which you placed with us by telephone . . ." instead of, "About your phone order . . ."

If you can't write a "good" letter, you're probably trying too hard. A photographer doesn't have to be an English teacher; just tell your correspondent exactly what you want him to know and don't couch it in expressions you never use ordinarily.

5. If your employee has a job to do, let him do it. Don't breathe down his neck.

The Apprentice

Advertise, pass the word, and tell job hunters that you're not hiring now but need an *apprentice*. I know a businesswoman who worked herself up to tremendous fame and wealth and never hired anyone. All her workers were apprentices and she always had more applicants than she needed. Not only did she *not* pay her help, she charged them for their accommodations on her property!

I, too, have more applications than I could ever handle.

In return for doing the odd jobs you need, you'll teach your apprentice how to run a studio and/or be a photographer. No money is exchanged.

Advantages:

1. The help is free!
2. Apprentices have the money not to need payment and are usually classy, personable types, a real asset to the look and style of the place.
3. They're crazy about your work, or they wouldn't be there.
4. An apprentice (at least in California) does not need to be covered by workmen's compensation insurance. Check your own state laws.

Disadvantages:

1. If you're already busy, do you have time to help someone during work hours? Do you enjoy teaching, in any case?
2. Most enthusiastic would-be photographers may produce little of real value to the studio. You want him to put forty frames together. He wants to take pictures, so he sulks and takes two days to do a half-day's work.
3. Because apprentices are often students, they might quickly realize they can miss days or even hours without losing, in this case, even a grade. They can get very lazy unless you drive them. The way out is to insist on the same disciplined conduct you would expect from any employee.
4. I've had trouble handling apprentices because I select them with care and like them so much, I spend most of the day talking to them and so get even less work done than when I'm alone! If I were paying them I'd not do that!
5. What do you plan to do if an apprentice is injured at work? Hopefully, your liability insurance covers him. If it doesn't, it comes down again to the question, would you be worth suing?

Workmen's compensation insurance is a state insurance that protects the employer if an employee is injured. You have to be careful not to ignore this. Even if an employee signs a waiver that won't hold you responsible for his injuries on the job, he doesn't have the right to sign away what are known as his unalienable rights.

If someone is injured while working for you and has signed a waiver like the one above, you can still be sued if he's injured. The waiver is, in fact, useless.

The reason that an apprentice doesn't have to be covered by workmen's compensation is that he isn't considered an employee under California law.

Someone who has worked for you would also be more likely to know of your assets if he cares to bring a civil suit. It's too late to wish you had kept your mouth shut about your Palm Springs property when you're faced with

a court order not allowing you to sell it until after the outcome of a personal injury case against you.

Ten Tips for Employers

Expect trouble if you hire:

1. An applicant who makes *any* derogatory remark about people he or she has worked for or photographed, or in any way puts down the public from which you make your living.

2. An applicant who wears attire that offends you in any way. (If someone can't dress well to apply for a job, imagine what he'll think up for an ordinary workday.) A young woman might apply for a job with a dress slit below her waist. A young man came in wearing cut-off jeans, sandals, and several days worth of beard. These would be great subjects for a photograph, but not for office help.

3. Someone who is not personable. Your customers shouldn't have to draw your assistant out. You need someone with charm.

4. Someone too young. I've made this mistake. You can't expect most teenagers to cope with the public in all its moods or have the forward energy you need. As an only employee it's not a good idea, unless you stumble onto someone who is unusually mature.

5. Someone who has another job (such as a student) and can give you only his least productive hours. I've had my share of sleepwalking geniuses who are "fitting me in."

6. Someone who does something in the "trial" period that is irresponsible and something you wouldn't dare pull on an employer. In judging someone else's actions, ask yourself, "Could I have done that?" Your employee should be sensitive to what is "okay behavior" by your standards.

I hired a carpenter full time when I moved into my new studio. After he had been working three days, he asked for an advance, as he had "no money." The implication was definitely that he needed money to eat, but in fact turned out to be money to go skiing! He took two days off to go skiing. When he returned, I let him work off the advance money, then fired him and told him why.

7. Someone who is closely related to a person you really care about, unless you are *certain* the friendship won't suffer if something goes wrong.

8. Someone who keeps talking about another studio's work. Often it may be someone out of town, "My dad's pictures . . ." If you use someone to "front" your studio he should talk about *your* work.

9. Someone plainly unqualified for the job. You can teach a skill to someone with an aptitude for it, but not to someone who has no aptitude for it.

10. Someone who is stronger than you are, in the sense that you'll find yourself being dominated by this person. If he is unable to take a secondary role, then you're asking for trouble by keeping him on.

Who is Making the Money?

When you find one month that your help made more than you, don't panic. It's usual! Sometimes that will happen.

A retired electrical contractor told me ruefully, "My employees *always* made more than me."

"Individually or collectively?" I asked.

"Individually!" he said cheerfully. "But I could fire them and they couldn't fire me."

He closed his business because he couldn't figure how to make more than his employees!

There is a certain time of the year when we may well make less than someone who works on salary, and it becomes a choice of losing a good employee or taking the loss.

But be careful that you're not working *just* to meet your payroll, and if that payroll overpowers you, you must find a way out. The answer may not be to fire, but to cut your employee's hours.

When business is slow and the money just isn't there, my workers always like the shorter hours. I have, of course, warned them when they were hired that they might not have as much employment from me in February or March. As they are independent contractors and taking in other work anyway, it gives them time to add other jobs. They usually don't do that, however, but spend the time with their families or catch up with work at home.

In my early studio days, I would give each worker a choice, either quit for awhile, or work and be paid late. One young woman always continued to work through March, and in April there was always enough money to settle with her in full.

A major cause of businesses folding is a top-heavy payroll. No matter how sentimental you may feel about an employee, keep your own interests uppermost.

Mechanical Employees

Why pay an employee $3,000 a year to do a job that a machine which costs $1,500 could do? At the end of the year the machine is still working for you, whereas the employee will need another $3,000 or more for another year's work.

The machines that work for us can be taken either as a tax deduction all in one year, or be depreciated over a certain length of time.

Some mechanical employees are: a good typewriter (get one that will provide you with a typewritten page that almost looks printed, so you can make your price lists and advertising copy yourself); a computer; a paper copier; a machine to answer your telephone; and a machine to address envelopes.

Look at the ads; go to office supply stores; study the catalogs.

18
Do You Need
Professional Assistance?

The Photographer

Many owner-operators only take on as much work as a single photographer can handle. They'll turn down weddings and other jobs, sometimes generously recommending another studio.

Others, like me, will hire a photographer for a job the owner can't handle. If we return to the comparison of a photographic studio and a restaurant, it's like hiring a short-order cook to fix the breakfasts, and cooking the more exciting food yourself.

I never need photographic help with portraits or commercial work, but I can't always handle all the weddings and weekend jobs. You can't tell a bride to choose another day, but you can tell someone who wants a portrait to wait until tomorrow.

It's frustrating to have several inquiries for the same day and then a couple of weekends without a job, but certain days are more popular than others. They are chosen to dodge college final exams, take advantage of the weather, and sometimes to ensure a three-day weekend when their anniversary rolls round.

Nor can I be certain of the trends. Some years I have few double bookings; others it can be an endless problem trying to chase down suitable photographers.

Large studios sometimes keep several staff photographers and it is from them that I've learned how the studios are actually run (never did get a straight answer from an owner!). When a staff photographer or a receptionist tells you that business is booming, you can believe it.

Hiring a photographer is no different from hiring other help, so go back and read Chapter 17 if you haven't already! In addition, you must expect photographic competence and professional trust.

Photographic Competence

You are responsible for the work that comes out of your studio. If you hire a photographer and he goofs, you're the one the customer will blame, not him.

Many large studios train their personnel or recruit them from university

299

photography departments in art schools and then send them to seminars to polish their salesmanship. (They learn how to take pictures that sell.)

With me it's a little different because I'm trying *not* to produce a "franchise" look, a look of a picture identical in style to every other portrait studio.

Here's how I go about hiring a photographer. Any who apply for a job must provide a contact sheet of recent work. I don't want to see carefully selected pictures blown up to 8x10s; I want to see the level they're at.

When I decided to use my son Daniel as a backup photographer, I gave him the camera and told him to run a roll of black and white through it and pretend it was a wedding. The result was hilarious but very good. He used me and our dogs as his subjects. A dog jumping for a stick was a bridesmaid catching a bouquet. I, at the typewriter, was a bride cutting the cake. We were arranged into a family portrait with the cat . . . and so it went. What he had done was much more difficult than photographing a wedding where people, not animals, are the subjects.

A test like this can tell you a lot about a photographer's ability. When a photographer isn't interested in "auditioning" his work, don't hire him.

Very often the photographers I hire are actually commercial photographers who have kept away from photographing people. They're frightened of getting into weddings, portraits, etc., and I have to talk them into trying. A test, such as I gave Daniel, gives them confidence.

If a photographer has the basic skills required, we look at his pictures together and talk about whether each picture could have been improved. I wonder if: he made too rapid a judgment; he moved too slowly to catch the action; or if a slightly different angle would have made a difference. I also look for extraneous details that should have been cropped out with the camera or removed by hand, arrangements of people that look awkward, and so on.

I bring out my work and critique it as harshly . . . to show I'm not setting myself on any pedestal.

Remember, most of these photographers are already experienced; they have other jobs. What you'll need to do is to get them to stretch a little so that they're producing not just to their standards, but yours also.

Here Comes the Bride . . .

Next step is a wedding, with a photographer accompanying me to watch how I work. It's important that his style resemble mine sufficiently for a customer to feel the pictures were taken at the same studio. I don't pay him when I take him on this job. Some photographers want to come to several weddings before they work on one alone.

(In seeking a photographer to hire, I wouldn't expect a beginner to be able to photograph a wedding. It's a difficult, one-time event that can't be retaken if something goes wrong. So a professional, perhaps someone who has just moved into town and needs some business, would be my choice in an emergency.)

I prefer a photographer who accompanies me on a wedding to be watching and learning, not taking pictures. If he uses his camera, then I pay for the film and it becomes mine. That way I make sure that I'll be the only photographer selling pictures to the family!

But he should take a back seat. If he's taking pictures, he may not ask any member of the wedding party to pose just for him. One photographer agreed to this, and then approached the bride and asked if he might take additional portraits of her alone. She refused, and he stalked off and went home!

The following week he came to the studio and complained about the bride's lack of cooperation. I reminded him he had violated his agreement with me.

He replied, "I wasn't going to sell the pictures; I would have given her them."

You can see how tight a rein you must keep on the photographers you hire. If she were getting free pictures from him, why should she buy mine?

Once I'm happy with the way a photographer deals with people—his manners, his organizational ability, his competence with a camera—I try to find a simple job that he can work alone. Such a job might be an awards presentation, where the only photographs needed are a record of the individuals accepting their awards, or an anniversary party, where a few photographs are needed of the married couple cutting the cake.

If he handles that well he graduates to a wedding.

The Photographer's Assistant

I always send an assistant with a photographer on his first wedding, someone to help arrange the groups, remind him of pictures to be taken, and generally give him confidence.

Even an experienced photographer may request that he take someone with him to "help." If he does, then I provide the assistant; a woman who has worked at the studio is my usual choice.

If he wants to take his wife or a friend I say, "no." A friend can be a distraction and I feel that he's really dating at my expense. I also remind a photographer that this is a job and not a party for him, so he's not to drink any alcohol until he has completed the photography—whether or not the bride's family ask him to help himself. If he's asked to help himself to the food, he may do so if he doesn't miss good shots while he's at it.

On location commercial jobs, I sometimes take young photographers with me as assistants, and most will do it for the experience; I don't have to hire them. If they make a real contribution, I might take them out to dinner or give them a gift. When I have an unusual job, I'll always look around for someone to accompany me, not just for the companionship or help, but because I know what it would have meant to me to pick up such experience for nothing.

One such recent job was to take aerial pictures. When I heard that it would be a three-seater plane, I invited a young photographer, who jumped at the chance. I justified his presence by having him put film in my case as I completed each roll!

If there is heavy carrying to be done, I also take an assistant with me, again using a photographer who might like the experience. If he's really working, rather than standing around and watching, then he gets paid; the customer eventually gets a bill that includes his time. Occasionally, a customer will provide an assistant when I tell him there are ladders and heavy tripods, etc., I might need help carrying. Sometimes I need help in setting up the pictures.

Assistance by the Hour

I pay photographers two-and-a-half times what I currently pay my office help, plus enough to cover the cost of the gas on out-of-town jobs. They also have the option of taking 33 percent *less* per hour plus 10 percent of the gross on the orders for reprints that come in later. I want them to do well, so I often advise them not to ask for the percentage but to take the higher hourly charge on wedding photography, if I know the young couple is on a very tight budget.

A photographer who is merely acting as an assistant to me is paid the same as office help whether or not I ask him to take a few pictures.

A photographer is paid when I'm sure the job has been done well; I've seen the pictures. I make it clear in advance that I won't pay for an unsatisfactory job and that if it costs me money to make good an error, the photographer will be charged with that cost up to but not beyond what he is paid by me. I'm really grateful to be able to take in extra jobs, so I'm not hard on a photographer. I only enforce this if the complaint is due to actual negligence. Most photographers are so grateful to get this outside work that they readily take the blame for their errors and ask for another chance.

Whose Cameras?

Apart from the film I provide (which is turned back to me), I also require photographers to carry back-up equipment and I lend them cameras and strobes if they don't have enough. Most working photographers have at least one medium format camera and one 35mm. If they only have 35mms, I try to persuade them to use one of my Mamiyas. But if they insist on the camera they're accustomed to using, I agree; I wouldn't want to take an important job with a new camera.

When I can't photograph a wedding myself, I offer to take the bridal couple's portraits at another time. Sometimes they want to do this before the day of the wedding; more often the day after, or even a couple of weeks later when they return from their honeymoon. After the wedding, a bride doesn't have to be so careful with her dress; she can run over the hillside, lounge in the grass, stroll down the beach. Some of my best-known wedding pictures weren't taken at the wedding at all!

In Case of Emergencies

If I receive a request at the last minute to photograph an event, let's say, a wedding, I might have to hire a photographer whose work I've never seen and whom I have never met. If I can't contact any of the photographers who have worked for me before, I get on the phone and start calling: any photographers who have worked for me but who are already booked for that time; newspaper reporters and photographers; camera store owners; amateurs whose work is good—almost-pro; and any people who might know of someone who is a pro or semipro freelancer.

As soon as I contact a photographer who can handle the job, I let the cus-

tomer know that I can provide a photographer, but I'm not familiar with his work.

The customer invariably says, "What would you do if you were me?"

I reply, "I'd go for it. This photographer will do his very best for you. He has good equipment, I'm providing the film, and if the pictures are taken very simply, you'll at least have a professional job. If you depend on friends, you may not. But by all means, encourage your friends to take pictures as well."

One such emergency involved photographing a bishop who was visiting the area. That time I had to provide a photographer in minutes. I sat my Mamiya at 250th second and f/5.6, set the automatic flash so that the pictures would be correctly exposed, and sent Michele to do the job. I told her to stay within ten feet of the person she was focusing on. What I did was to convert my camera into a fixed-setting camera and the pictures were good.

Because she had never worked as a photographer before, I persuaded her to do the job for nothing (because it was terrific experience), and we charged the customer only twice the cost of the film and processing and for any extra pictures he bought.

I feel that it's a mistake to turn away any job you ordinarily could handle, because you're just feeding it into another studio. In a highly competitive area like ours, I just can't afford to do that. However, I would gladly send work into other studios if they would send some back to me! I know portrait and commercial photographers who specialize and make such an arrangement.

Is the Honeymoon Over?

I have had some problems with photographers I've hired. For instance, on his first wedding for me, Stan's pictures were good except that twenty blank exposures showed up at the tail end of a particular roll of film. He was using a 35mm camera and had not rolled the film on to the spool correctly and it must have suddenly caught and started advancing. Fortunately, the pictures weren't even missed by the family, as they had been taken during the reception. He had taken a lot of pictures and done an excellent job otherwise.

Stan admitted that he had been trying to get an extra exposure on each roll by letting the film leader catch on one side only before he snapped the camera shut. I now warn photographers using 35mm, not to risk doing that, though it is a common practice.

One photographer used a wide-angle lens to photograph a wedding although I had specifically told him not to. I had noticed he liked the wide-angles because he got more depth of field and didn't have to focus so critically.

He denied it, "I used my 105mm."

I was surprised that he thought I couldn't tell a picture taken with one lens from another and stormed, "Don't snow me. I'm a photographer!"

The customer didn't know what was wrong, but rightly didn't like the pictures, and I discounted them heavily and promised a free first anniversary portrait. As their marriage ended a few months later, I never had to deliver!

Bernie, a photographer I used once, started drinking the wedding champagne, and his judgment and decorum disappeared. One complaint was that a

grandfather who had not left his home for ten years wasn't on the end of the group picture! Another was that when he was asked to photograph the cutting of the cake, he complained that he hadn't finished his lobster dinner. He forgot he wasn't a guest, though he had been asked to join the guests at a table.

I never hired Bernie again, though he had done other jobs for me without a hitch.

One photographer mistook the bride's brother for the groom in the initial part of the wedding and so we had nine pictures of them together! Fortunately, the mother of the bride was delighted.

Another job came in without a problem but only because the bride's cousin went to a bar forty-five minutes before the wedding was to start. He had dropped in to get a drink for the bridegroom, who was a bit jittery, and mentioned this to the bartender.

Lou, the photographer I had hired, looked up from his beer and asked for which wedding, and the cousin explained. Lou leaped to his feet, "Oh, I thought that was tomorrow!" he said and rushed out. The cousin only understood the reason when he saw Lou carrying a camera in the church.

I heard all about this when the bride came to pick up her album and could only be grateful that someone had suggested that particular bar to buy the drink.

The pictures were actually very good, but I never hired that photographer again, because this was the third time he had *almost* blown the job. Luck doesn't hold forever.

A very talented young photographer, Dick, suddenly produced a very incompetent job. I quickly stepped in and took extra portraits of the couple, which calmed them down. Their complaints were that Dick just followed them around in a daze. As a result everyone else also stood around and the group pictures took much longer than expected. When anyone asked Dick what pictures he wanted, he replied, "What would *you* like?" as if he had never photographed a wedding before.

Dick's explanation was that it was so oppressively hot that he couldn't think. He thought the pictures were coming along all right but agreed when he saw them that they looked as if a not-very-talented amateur had been taking random snapshots.

I learned from this that I must speak to a photographer every time he goes out on a job, instilling into him how important it is to do each job with the same enthusiasm and eagerness to please as the first.

It was oppressively hot for everyone that day—no excuse for the photographer to be sloppy.

Can You Trust Him?

You don't need and shouldn't hire a photographer who is going to start a studio in competition with your own. I won't even apprentice someone who plans to start his own studio in my area. I merely tell such applicants to take my next photography class.

I don't have any compunction about hiring a photographer *already* in busi-

ness who doesn't have a job for the same day. There must be a professional understanding, however, that he won't discuss his own studio on the job; he will act like a member of mine.

The difference between a person already in business and one about to start is a matter of ethics. When someone has discovered that it isn't easy to bring in business initially, he will be grateful for the extra money and also act in a way he would like me to act if the positions were reversed and I did a job for him. Someone who hasn't found this out is much more likely to drum up some business for himself on the spot. After all, he might figure, "I need the money more than she does."

This has been a major problem with studios who hire freelancers. The solution is to limit the opportunities for a photographer to get between you and your customer by sending someone you trust along with him and not to rehire anyone who tries it.

I should digress here as to whether you yourself would be wise to take a job offered from another studio.

If your work is specialized, or you have become or hope to become, established as a photographer with a very individual talent, don't do it unless you're starving. On the other hand, if your studio is geared to a more general type of photography, it's just another job and will result in quick and easy money.

The difference is in how you want the public to perceive you. It would be pretty stupid of you to hope people will consider you *the* portrait photographer in your area, and then hire out to a studio that is doing much more mundane work. But if your main purpose is to bring in as much money as you can as quickly as you can, you have nothing to lose. If you do these jobs, then just go through them as professionally as you can without drawing attention to the fact that you have a business of your own.

Studio Salesmen

The most valuable employee you could have is an expert salesman, someone who is able to talk a customer—any customer—into feeling that he is getting a real deal even at premium prices, by hiring you to take pictures he didn't know he wanted.

If one of your employees turns out to be adept at bringing in orders, turn him loose to do *just that*. Pay him a minimum wage plus a high percentage of the gross as an incentive, and raise your prices to take care of this added expense.

It's not easy to find such people to work for small studios, but one owner told me that he had been lucky enough to do so. A woman he hired as a receptionist soon suggested that she become a saleswoman. She could talk customers into buying the fittings off the walls.

He admitted that he would let *any* of his other staff go before this woman.

His payment scale was to give her 25 percent of all orders over $300, and 15 percent if she fell below that mark. If she could work an order over $1,000, she got a bonus.

Good salesmen are money-oriented and look to big-business for their jobs. However, a married man or woman who wants to stay in a particular area be-

cause of a spouse's job, or a woman who wants to work part-time because she has children, may well be the salesperson you're looking for.

A studio salesman can also be paid commission only, no wages. This makes him most useful and economical because if he doesn't deliver, you aren't out of pocket. In addition, he should also be an independent contractor; a payroll employee would be required to earn the minimum wage.

This kind of employee should be someone of enormous energy and self-motivation. Together you should set up a list of what he's going to sell—not just your photography, but what aspects of it. He should be well versed in what you have to offer, your style, and be able to explain why someone should hire you over the other person. He should know the package you've prepared inside out; what to say, what not to say.

This "package" should consist of business cards, a brochure, perhaps a price list, some photographs of the kind you hope the customer will hire you to take, and possibly a free gift to the person as a thank you for listening to the presentation.

Let's say you are a commercial photographer and you decide to employ someone to visit construction companies and architects' offices. Your representative's package should include architectural and on-site photographs, both exteriors and interiors; black-and-white 8x10s; and transparencies, color prints. To give the best impression, he should also be tastefully dressed . . . look like a successful business executive.

When considering what commission to pay such a salesperson, realize that only if he makes enough to cover his energy and time spent on the job will he stay at it. Fifteen percent on orders brought in and perhaps 10 percent of repeats would be minimum. Thirty-three percent on the first order might sound high, but could be worth it. You could also work a bonus system; raise the commission sharply if he can bring in an order over, say $500, or pay a bonus.

Your salesman does not, of course, have to work for you exclusively, but should have sufficient incentive to put you ahead of his other clients.

Decide what you hope he will earn; $200 a week right away? That is $1,333 worth of business (if he's getting 15 percent), leaving you with $1,133—out of which all other overhead expenses should be paid—and a good profit.

Thirteen-hundred thirty-three dollars may seem too high for just one job, but it isn't too high for three or four. So you set him a goal of three jobs per week, perhaps three or four architects to visit each day, and each package he sells should gross $450 minimum.

As the jobs accumulate and the 10 percent commissions come in on reprints, he'll be doing a lot better.

An Embarrassing Admission

Although I've tried it twice, I have never employed an outside salesman who did a thing for the studio, and it was entirely my fault.

I hired a woman first and then a man and expected them to work out all the details themselves. It was obviously beyond them, and they just spread my name without much effect! Neither earned one penny in commission!

One major problem was that both these people were not able to get to the top executive in any company, something I seem to be able to do quite easily! They allowed themselves to get stuck with people who like to put other people on hold. They were too laid back to be persistent!

I still feel that there is a great deal of money to be made if you can find the right kind of person to *sell* the studio. If you have the organizational ability to coach someone through the initial stages, there's no reason at all why it shouldn't pay off handsomely.

Pitfalls to Watch For

1. Your salesman must be honest.

2. You must be fair. This person shouldn't be worried about getting his full share.

3. Regular meetings must be set up so that you can keep an eye on the operation.

4. Be certain that you aren't liable for any accidents that might occur. If he's an independent contractor in business for himself, and not working for you alone, he'll then be responsible for himself.

5. He should be a talker: articulate, fun to be with, mentally quick.

6. He must reflect your style when he approaches potential customers.

7. He must put in a certain number of hours selling for you. If he is not self-motivated, you'll find he may not do any work for days at a time.

You may be able to find a marketing firm that will "sell" you, but this is very costly. Such a firm will undertake to make you well known. I spoke to a man (unfortunately, just retired), whose business was making people famous. He looked at my work, said there would be no trouble making me a national name, and told me who to phone about it (another of his profession). He said it would be expensive. As I have done so often in my life, the more I thought about becoming famous, the less I liked the idea (all that *work*), besides which I wasn't sure how much money "expensive" would turn out to be. No guarantees, of course. So I passed!

If you'd like to take that walk to fame, phone any marketing expert and get the ball rolling. You'll at least have taken the first step.

Two Heads Can be Worse than None

A self-made millionaire once said, "Never take a partner, except from your immediate family. Sooner or later, there's trouble. Pay a good employee anything you like, but don't make it a legal partnership."

A major cause of business failure is the partnership. It *seems* an ideal arrangement because you'll have someone to share the work, the financial burden, all responsibilities. You've chosen a person you can really trust, why shouldn't it work?

To embark on a partnership without solid experience in business, however, is much like a fifteen-year old embarking on a marriage. Quite simply the odds are heavily stacked against success!

Your expectations of your partner will be high, or you wouldn't have decided on this kind of an arrangement. But expectations and the real thing differ (again, consider why many marriages fail). Your partner will also have expectations of you as unrealistic as yours are of him. Put any personal relationship under business pressures this way and it too may crack. Something as private as how one partner spends his private time and money (when the business has slowed down drastically), can become a reason for the other partner to develop ulcers.

Partnerships most likely to succeed involve people who have known each other for years and whose relationship cannot easily be dissolved. They have already ridden out, on a personal level, some of the inconveniences which a partnership will now spotlight. There will be few surprises! You already know David likes to sleep till midday and that Janet becomes belligerent when proved wrong.

A till-death-do-us-part husband and wife may be such simply successful partners; parents and children are another example. The commitment beyond duty is already there! Siblings may also have a better than average chance of succeeding in partnerships, provided they don't insist on including their new marital partners into an existing business partnership. You married this person, your sister did not. You may feel you'll love your wife forever, she may give the marriage two years at the outside.

When a partnership succeeds it can also be because of the exceptional ability of just one of the partners to keep the business running on an even keel no matter what the provocations. This person may be a genius at personal relationships, at making financial decisions that are both mutually rewarding and comfortable for his partner to live with, or a man or woman who is able to move forward with energy never expecting anyone else to come close to the hours or speed with which he works.

Or a partnership may succeed when one person is extremely talented but has no desire to handle anything but the job at hand (perhaps take photographs). His partner is delighted to have freedom to organize the business, just so long as he is not expected to do too much photography. It will not succeed if one partner provides the talent and has to do the organization as well, unless his "sleeping partner" has bankrolled the entire operation. In that case the longer he stays asleep the better, when he wakes and wants to know every little detail, the balance may be upset.

Setting Up a Partnership

Once you decide to go ahead with a partnership, the first thing you must decide is how the money will be divided. One way is to split the profit (fifty/fifty; seventy/thirty, etc.), after the bills have been paid; that's the way we did it. Another way is to pay each partner a certain salary and bank the rest under the partnership.

You are *both* liable for all bills and if one partner disappears or runs up large studio bills, the *other* may end up paying if he alone has money.

As for check writing, in a partnership the senior partner could have the sig-

nature on the account (our way), both partners could sign a check to make it valid, or either partner could sign a check.

In a good partnership, there's a definite understanding of what will be done with the money that goes back into the business. These matters should be open to discussion.

In a partnership, up-to-date accounting is a must. You can't just throw your papers in a box and look at them again when the box is full, the way I do now! Like a marriage, a working arrangement will form, one that makes sense and is easy. But if each partner leaves certain bookwork to the other partner, and actually no one does it, things could get out of hand.

There must be some arrangement to handle the partnership through times when one or the other is unable to work. You should talk to a lawyer to be sure that your own interests are being protected.

Learning by Bitter Experience

The only time I had a partnership it was a disaster. At first it was fun to share all the responsibility, but eventually I went around wailing about the losses I had suffered, and I found that many of the businesspeople I admired had also been stung. I got no "you should have . . . ," just sympathy. They had been there before.

My partnership started well, but guess who ended up doing all the work and who ended up with the money? When I found out what had been going on in my name, I ended it quick and it took some time to cover the checks written without my agreement, signed with my name (from funds that were not there). My credit cards had been taken from the mail and used. A final blow was to receive a bill for the paint used to paint *his* house.

(The reason I picked up his bills, run up in the studio name [my name] was that I don't believe in crying over spilled milk. I wanted to be rid of the whole mess, and though I started a lawsuit against him, I felt I would never collect—even with a judgment in my favor—and would merely have more bills to pays [legal fees]. So I settled his debts [$2,700] which had been in my name and put the problem behind me.)

My partner (I'll call him Harry) had experience preparing ad layouts, so we were branching out beyond photography. Watching him work with rub-on letters and paste-ups has made it possible for me to make professional looking copy . . . as I describe in Chapter 10. So the experience wasn't an entire bust!

One major mistake I made was not requiring him to "buy" into the partnership. If I had there would have been no partnership; he had no money! Another was not to check the stories he told me. If I had I would have found a long history of alcoholism.

My husband had once commented on partnerships and the difference between American partners and English. You'll notice I completely forgot his good advice when it came to taking on a partner myself.

"Partners should have different skills and both should have equal financial investment in the company. Even so, one partner will usually resent that he is doing all *his* kind of work and think he would be better off alone.

"In England, if you find partners with separate skills, they'll give up their wives before they'll give up each other! In the states, Americans are encouraged to be both competitive and independent of others and so aggressive partners start resenting each other right away."

He told me of two examples of clients who had initially succeeded in partnerships, quarreled, parted, and failed when they went it alone.

Both partnerships were a combination of someone who knew the business (in one case, an engineer; in the second, a construction man), and someone whose talent was public relations. One partner appeared to be doing nothing but spending money and having a good time but in fact was bringing in business in a way that the hard-working and highly skilled executive could not. Yet the partner who brought in the business was useless without a reliable and knowledgable person to carry out the job.

When these partnerships broke up, neither of the partners could make it as successfully alone and none of the four men found the same tremendously lucrative business arrangement elsewhere. All four went from being near-millionaires to $30,000-a-year jobs.

Ideally, a photographer should choose a partner who is *not* a photographer. I was on the right track in finding an ad man, but I should have found one with some money who was not a drinker. A business manager would be ideal, expanding the business base as well as getting someone to share the load.

If your partner is a photographer, you could choose one with a different specialty and double your business. However, there's always the chance that you might not be as comfortable as with one in the *same* field.

A partnership can be arranged by a simple verbal agreement between two people. The moment you have introduced someone as your partner, then the partnership exists. It can also be dissolved easily. If one partner merely publishes a notice in the newspaper that the partnership is over, it's over.

Walking Hand in Hand

There are people who, for various reasons (lack of self-confidence is one), will not undertake a business without a partner.

"I can't do it alone," one woman said, "I need someone else there, even though I know I am the one who will do the most work."

If you are such a person think your partnership through. Instead of "This has *got* to work," say "It will be great if it works, and if it does not . . ." At least have a plan which if you dissolve the partnership will not leave you financially crippled or without a positive gain as a result of the partnership years.

In my own studio partnership it was easy, because I personally owned the business to start with. When I broke up the partnership, I therefore retained what I had always owned and as he had contributed nothing of commercial value, there was nothing to split.

When I went into partnership with my older son and his wife, however, we were starting an entirely new business. Again there were no problems when we dissolved—this time because we're the kind of family who finds it easy to share.

Each partnership situation is different, as each marriage is different, de-

pending as it does on individuals who bring out different qualities in each other.

But if you don't want to have to go to court to resolve your differences at some later date, be as certain as possible *now* that you have considered how you would proceed if the relationship reached a point where you would want out.

If you're going into a partnership with someone you haven't known all your life, you should check into his background—even pay a professional to do it. Twice, I've been "taken" financially, (the other time I lent money to someone). Both times it was because I trusted people who "seemed" all right, and each man had a background of irresponsible behavior I could easily have discovered if I had checked.

And if you feel uneasy about the person you're going into partnership with, don't do it. I know a lawyer who pulled out the day before a partnership was to be signed. Two days before the signing, at the party to celebrate the agreement, he discovered that his future partner was an out-of-control drinker who became nasty when he had had too much. He knew he would never feel easy about him again and told me he gave no excuse for pulling out except that he had changed his mind. This caused a rift in their friendship, though not a permanent one.

If you suspect your partner is other than upright, don't speak to him about it immediately, no matter how much you feel that it's the sensible thing to do. If he's honest, he'll be rightly upset, at least for a while. If he's dishonest, he'll cover up. You have no choice but to first follow up on his behavior yourself, and if it does seem that he's violating some part of your agreement or is dishonest, then your only hope of recovery is to surprise him with it. In that case, you'll probably need professional help, although often an experienced business friend can tell you what to do next. I reacted from panic, without consulting anyone, but I managed to do the right thing. I moved the remaining partnership money (remember, he owed me; I didn't owe him) into my personal account, told him the partnership was over, and then changed the locks on the door.

There was some drama in the lock-changing. I asked for the keys back and he refused, sneering, "You'll have to change the locks." Of course, he knew I wouldn't know how to do that and it was late afternoon, too late to call a locksmith, as businesses were closing. But with growing unease I phoned my son Michael, then a teenager, who was at our home thirteen miles away, and asked him to somehow purchase some door locks and find his way to the studio. He rushed to a hardware store and bought the locks and hitched a ride into town, and two hours later the locks were new. I found out from a friend, the owner of another business in the same building, that Harry was back at 7 a.m. the next morning trying to break in. He said that he had left his keys at home and my friend told him to phone me from his office, at which point Harry left.

An interesting thing about this partnership of mine is that personal friends who knew us both had difficulty believing that he had stolen anything. Even when faced with the evidence in black and white, checks he had signed with my name, they couldn't or wouldn't take it in. You see, Harry *looked* honest! It was a lonely feeling for me.

TIPS

Time Equals Money

If you're charging $40 an hour (or $80 or whatever) as a photographer, you're not actually earning $320 every eight-hour day. Some of the time you're a clerk, a darkroom assistant, a janitor, and some other people.

If you bring in a $400 job by visiting a potential customer for an hour, you're now worth more than a photographer, and you might consider spending more time on promotion.

Keep your mind on these figures and yourself fresh to do the tasks that you, and only you, are qualified to do. Many small businesses have collapsed, not because the owner didn't work hard enough, but because he was always working.

At first, hire someone to do the job you don't have time for. If it's a one-hour job, hire someone for one hour. Next give up darkroom work. A darkroom assistant is worth only about one-fourth or less of what a photographer can get; you can't afford to tie yourself up doing a job someone less expensive could do.

The lab we use becomes our employee now, to be hired and fired in the same way as a darkroom assistant in our own darkroom. If you don't have enough printing for a full-time darkroom worker, then a lab is the answer. In paying by the piece we're not burdened with carrying a worker who won't be working to full capacity all the time. We can also bypass the additional paperwork and expense required of an employer by the government.

When tasks pile up, hire assistance for the job that costs the least. You don't have to be rigid. If business is slow, it may be cheaper to do the larger black-and-white printing jobs yourself.

Five Tips on Hiring a Photographer

1. Try not to hire someone who does not admire your studio, its style, and its method of operation. E.g., a photographer who is capable of excellent work may be openly contemptuous and even a bit embarrassed to be representing someone he feels is not as talented as himself. If he does not have the sense to know that your style is important to your customers, they like it and are willing to pay for it, then he is not a worthy representative of you.

2. Do not overlook the photographer who wasn't able to go it alone in business because of a handicap. Scars such as burns on the hands, etc., do not impair a person's ability to use a camera but may impair his ability to make a living by dealing with the public, who are often insensitive and veer away from people with deformities. Such a person may have a safe salaried job during the week, but really enjoys making some extra money with his camera over the weekends.

3. A photographer working for you will work best if he likes you and feels free to be creative. Find some way to let these photographers know you like them personally and enjoy their work.

4. Have a postmortem on all work, turned in by a photographer, take

the time to criticize, praise, and discuss how some pictures could be bettered. It is exciting to see someone reach to his real ability under such objective help. It will also help your studio if his work is exceptional.

5. Avoid hiring a photographer who can't grasp the difference between good photography and bad. Let's say one of his pictures would have been fine if he had waited for the person in the foreground to move (or moved that person). If he doesn't see that, when you point it out, he has a problem and it may not be curable!

Thirteen Money Matters for a Partnership Agreement

I'm sure you can think of things to add to this list but it will show you how important it is to sit down with a lawyer and tie up the partnership so that all partners are aware of what they are getting into, and of their specific financial responsibilities to the business.

1. How much money is being invested in the business by each partner?

2. In what proportion will the profits be shared?

3. If each partner's investment is not equal, how will the partner who is putting in less make up the difference? One way might be for him to get a lesser share of the profits, another to contribute an automobile or other costly item he may already have, for partnership use.

4. If possible, it would be wise for each partner to place in a joint savings account a certain sum of money which would not be withdrawn except:

• At the dissolution of the partnership.

• If one partner left the other in a sticky financial situation, e.g., absconded leaving debts unpaid.

• With the agreement of both partners before the dissolution of the partnership.

A third person's signature, perhaps a bank officer would be needed before *any* withdrawal could be made. When deciding on this third party be sure that you will not be left without any access to your account if he should leave town.

5. Will each partner draw a salary for personal expenses or take a percentage of the profit or gross for that week or month?

6. If one partner gets sick or is otherwise unable to work, does his income remain the same? When he is on vacation is it the same? What if he takes an extended vacation?

7. Insurances. Will there now be a need to change existing insurance policies whether they cover equipment, liability, health?

8. Overhead. An agreement should be reached on basic overhead costs, how high the company can go on these, and who will be responsible for seeing that they are not rising beyond that limitation.

9. Ordering. Who will be responsible for ordering office equipment, supplies, and products for sale? Must the other partner give his approval of each order?

10. Equipment. Will the partners retain personal ownership of existing equipment (cameras, typewriters, etc.) that will be used in the partnership?

11. How much of each partner's home expenses will be legitimately charged to the business? Telephone calls, travel expenses, and entertainment of customers would be some matters to discuss.

12. Who will be responsible for the keeping of business records.

13. Should either partner feel free to take on outside jobs?

Some of these items you may prefer not to put in writing as they would be too restrictive. Certainly they should all be discussed.

What Are Your Partnership Expectations?

Irritation can develop between two people who have to work together. It can grow out of all proportion and eventually destroy their relationship. Sometimes only one of these people feels the annoyance and the other will be shocked when confronted.

"You are always so *negative* about my ideas!" one business partner might suddenly explode at another.

"I was just trying to see both sides of the question," might be the reply.

In a small business, particularly an underfinanced small business, every little thing your partner does can become annoying if you let it; if you let the irritation build up, you might suddenly overreact and damage the relationship which brought you together.

One way to prevent this happening is to sit down and discuss what your expectations of the other are before the problems crop up. Best of all make a list of your expectations of the other, what you think may go wrong businesswise, where you think your strong points are and where your weaknesses. When you bring your lists together you may be surprised.

Here are some suggestions for your lists:

1. What type of customer do you anticipate will be attracted to this studio? (Upper income, blue collar, etc.)

2. What merchandise, if any, do you expect the studio to sell? (Albums, frames, photo T-shirts?)

3. When do you expect the initial investment to generate a profit?

4. How long would you be prepared to retain the partnership without showing a profit? When should you call it quits if things are obviously not working out as planned?

5. How many hours a day do you plan to devote to the business? How many should your partner? At what time will you start and quit?

6. Would you object to your partner taking two hour lunches? Do you plan to do this yourself?

7. If the business is successful do you feel you should expand into other fields? If so, which fields?

8. If your behavior is beginning to irritate your partner, how would you like him to tell you about it? Would you be prepared to consider changing?

If you feel reluctant to bring up any of these matters then you are missing a very good chance to save your own money. When a partnership dissolves it is usually a big financial setback; if you are going to break up anyway, it is better to find out right now that you'd be better off alone.

Here's an example of a simple image which took neither talent nor imagination. I never exhibit it at a size larger than 8x10, and yet it gets more attention than 16x20s around it.

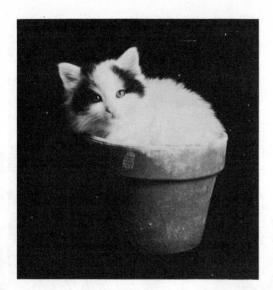

The Blooming of Henry *was an Easter present to my son Daniel. Henry was his new kitten. This series sold even before a show opened.*

My own favorite horse picture is of Bay Abi, a stunning Arabian, whose personality is as much fun as his looks. Because the wind is blowing his mane, making his neck look thick, I was requested not to use the picture in Horses of the West. *Reluctant to leave it out altogether, I made a bas-relief of the picture (positive and negative image on film sandwiched out of register), and used that as the frontispiece. I prefer this version, which had its day as the cover of* San Diego Poets, *now that the restriction on using the picture has been lifted. If a person balks at a picture being used, don't insist. Invariably he'll change his mind.*

I have a huge collection of dog pictures—dogs of every breed imaginable performing, eating, playing, growling. I happen to like dogs, and dog owners are good candidates for pet portraits. I knew this puppy was a purebred, as he was at a show, but it was several months before I could identify the breed (Schnauzer). Meanwhile, the search had made me a lot of friends among the breeders.

Like horses (and other carefully bred animals), dogs must be photographed so that they are shown as fine examples of their breed. Dog breeders might smile at a cute picture of a mongrel, but the photography will not impress them because he is a mongrel. This English Setter looks like a very good English Setter, which is why Setter owners buy the picture and want their own dogs photographed by me. One person bought it at an exhibit and later wrote to ask that I send her an 8x10 print of every "good" setter picture I had. She paid for them sight unseen.

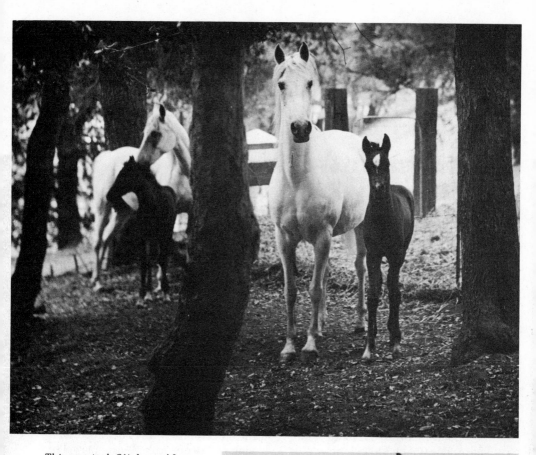

This one took 3½ hours! I was trying for an effect of seeing double, which was the impression I got when I looked at these two mares and their babies. The tree in the foreground helps the mirror illusion, although it breaks conventional composition rules.

Horse photography takes patience, and fortunately, the owner, Dottie Sewell, has plenty. When this moment happened, it was pretty exciting.

Horse lovers adore this picture. They can tell the animals are lovingly sharing a mouthful of grass, not fighting over it.

19

Investments—How to Get Really Rich

On the matter of investments two thoughts keep coming to mind:

1. It's impossible for a photographer to make a *real* fortune out of his business—unless he has a prepaid contract with a Saudi sheik or some other exceptional good fortune. A photographer has to make his fortune through outside investments.

2. How should we invest our sometimes meager savings to make a "killing," when money experts aren't consistently wise in their advice?

Here's yet another field where there are no definitive answers. Advisers just say, "Go out and buy *that* and it will be worth ten times as much in as many years." Here's a field where we're simultaneously faced with the advice: "Be cautious!" "Be daring!"

Someone who just made a killing in the stock market will say, "I couldn't have done it if I hadn't gambled," or "I just listened to my broker," or "I played it safe and won." So which road do *we* take?

There are, however, some general rules, some ways of looking at investments, and from these you can make decisions with some intelligence.

As for my own investments, I have:

1. *Always* invested any single sale of $1,500 or more in a piece of land, stock, or a solid business asset. I do not use such money for day-to-day expenses. For instance, from the first part of the advance on this book I bought a computer!

2. *Always* made a very large profit on my original investment, many times the original cost, when I've purchased undeveloped land (land without buildings).

3. *Always* lost eventually in the stock market, though at times I have shown a tremendous profit. I just don't know when to sell out and sit back.

4. *Always* found it impossible to sell things that I own which have greatly increased in value. I'm so pleased to own the expensive item that I just hang on to it. For example, my son's piccolo was bought for $32, and turns out to be a $900 piccolo. He doesn't play it (his hands got too large), but I hang on to it for a rainy day, which somehow I never quite reach. Similarly, I can't part with jewelry, paintings, or antiques.

5. Never regretted spending a large lump sum on what my children call my

"toys." These toys are expensive typewriters, good cameras, and other equipment I use often.

Thus, for someone like me, a successful investment will have to be in real estate, though the psychological rewards of buying *things* make them good buys for me.

Make a list of possible investments for yourself, and judge where you can "cash in" and where you would not. Many people can't part with land. They just hold on and live like paupers to come up with the mortgage payments, always buying more, but never selling. Only their heirs will benefit. Other people will cheerfully sell something that has been in the family for generations.

Let's say you're a judge of horseflesh. (There are many investors, however, who advise not to invest in anything that can go bad [food], or eats [animals]!) However, you decide to invest in a horse, the horse turns out to be worth much more than you paid for it; could you capitalize on that investment? Or, will you think of the horse as a pet and refuse to part with it—have it trained for shows, breed it regularly, etc.?

When you make your list, you're also weeding out areas where you will lose interest rapidly. Rental housing isn't for you if you're going to find it a bore to handle tenant's complaints and the cleaning and painting needed from time to time and/or between tenants.

Take a minute right now to make that list and then read on, taking notes as you go. At the end of this chapter you should have a good idea where the money that will set you up for life could come from (if you'd let it).

Thoughts on Investments

1. An investment must appreciate. The reason not to keep your money in a conventional bank account is that money depreciates. Even if you keep money in a simple passbook savings account it becomes worth *less* as prices inevitably rise. If it will cost you 8 percent more to buy what you need next year and your money is in a savings account that pays $5\frac{1}{4}$ percent, you're actually losing $2\frac{3}{4}$ percent on it. If your money is in a bank account where you're paid no interest you're losing a full 8 percent.

Even if a high interest account gives you a better deal, let's say 8 percent that will keep up with the cost of living, you're still not making anything on your money. You can do better elsewhere: land, precious stones, antiques, gold, etc.—that is, commodities that can be depended upon to increase in value beyond money in a high interest account. The purchase must, however, be made in a market that isn't currently inflated. (Unless you're thoroughly familiar with the market trends for that item. Then you might be able to buy when the item has multiplied in value recently, because your inside knowledge tells you it will go even higher.)

If you know specific trends for the item you're buying, and you're reasonably cautious, you've got a great combination for making money. The adage "the grass is greener on the other side of the fence," applies here. So, if you hear of other people making a fortune buying and selling dogs and you yourself only know the market in cats, where the profit is not so great, buy cats! (If you have

an excellent investment advisor who is an expert on dogs, this advice would not, of course, apply.)

2. In looking for a good investment, try for something that will increase in value in your lifetime; e.g., forget the piece of land without any sign of life if you're buying property, even if this is the only land you can afford.

3. Always initially consult a real estate agent when buying land or housing, yet never take for granted that he's telling you the truth! What you want to know from a real estate agent is:

● Is this investment in line with others of the same quality in the same location? (If not, why not?)

● Will the owner (or buyer) be prepared to "deal" (dicker over the price)?

● If you're selling the property, is the realtor himself buying it? If so, you can do better elsewhere. The exception to this can be if he is building on several lots in the neighborhood. Sometimes a realtor or contractor will buy up all the vacant lots in a road and build on them simultaneously. It costs less in the long run to have the roofers and the cement contractors come out and work on several jobs. If this is the case you might get an excellent price on your lot by holding out for it, say, a few weeks before construction is to start. He may be prepared to take a smaller profit on the final sale because he has so many units to sell.

● If it's undeveloped land (no houses), where will the water come from? Check what he tells you.

I could add to the list above, but there would be no end to it. I'm sure you'll quickly find out how useful a particular agent is in handling a sale or purchase. You'll also see that you can sometimes do much better with someone else to negotiate for you, but that you must watch very closely to see that you're getting just that, the best deal.

Never let a real estate agent work on your emotions to tie up a deal ("I've worked on this sale for three weeks"), and *always* get agreements in writing. If one says to you, "I won't charge full commission on this," get it in writing and date this agreement. Only *then* say "thank you."

4. The more money or investments you have (the more you are worth), the more ability you have to borrow. This is called leverage. You can sometimes borrow money "against" something you own; at other times your mere ownership of the thing will enable you to put through a business deal. To another businessman you're someone who can be forced to pay what you owe, because you have assets. If he's going to stick *his* neck out, he wants you to be equally responsible.

5. When you have a few investments, you'll find doors will open to you if you're also the kind of person who appears trustworthy. You'll be invited to invest in other people's companies and even get partnerships offered to you. You don't have to accept these offers, but there are many businesspeople in need of reliable colleagues.

Even if you're closemouthed about your affairs, the word will sometimes leak out when you buy and sell. It's difficult to do business without someone knowing about it, and talking about it.

6. A form of investment is allowing one's customer to charge, rather than to demand payment right away. You are now a "money lender!" You're lending your customer money and the money owed on his account is legally yours. Thus, you

must get some return on your investment—more than what you would get if you had that money in the bank—and this is usually collected as a service charge, or the highest interest allowed. Rather than being overjoyed when the bill is paid in full at the first rendering, you can even be disappointed!

In about 1981 the major credit card companies became disturbed because too many customers were settling their bills in full, instead of leaving part outstanding (on which interest could be charged). The fee we now pay for our bank credit cards was levied to make up for us paying too quickly!

I don't suggest you allow your customers to have accounts (I don't unless I have no choice), but money lending is a profitable kind of investment if you handle it impersonally and efficiently.

7. The wise investor keeps a certain amount in a savings account to tide him through emergencies. You should not have to touch an investment until it has matured. If you're investing your emergency fund outside a bank, then that money should be readily available and one sure place where you can liquidate your holdings right away is in the stock market or gold. If you're buying stock, be sure to *sell* when you get a profit. Don't just sit there staring at the stock market report until the stock falls (as I do)!

8. Remember that the greater the risk, the greater the profit. If you want to turn $100 into $1,000 overnight, then you're going to have to risk it at something like a poker game, slot machine, craps, horse racing—places where you can lose it all.

9. If you sit looking at one pot it will take forever to boil. If you have several on the fire, all put there at different times, you'll find the first one is puffing away while you're filling the last. Similarly, you're better off with several investments instead of concentrating all your energy on being disappointed with the performance of one.

10. I've found it helps a lot to think of money in terms that relate directly to myself. A thousand dollars to me means a month of living comfortably. You may need more or less; there was a time when I figured I could live on $200 a month if my rent and utilities were paid! So every time I make $1,000 clear, that is one month of "freedom" I'm buying myself.

So if I invest, say $2,000 and it becomes $10,000, now I have ten month's freedom, but if I lose $1,000 then I have merely lost one month's freedom!

You can always play these games yourself to make your investments more fun. I have found big-time investors who do the same thing.

11. Experts in a field know things that we don't, and you should get to know an expert in each major investment field. Remember that people who invest your money—stockbrokers, realtors, goldsmiths, antique dealers—make a commission out of every purchase you make and so they will talk about their specialty for nothing. They tend to lose interest if they think you have very little to invest, so make up some story about Aunt Daphne's will and how you're shopping around for suitable investments! Their first question *always* is "How much money are we talking about?" and I would suggest you be talking about $10,000 (or more), to get their attention and if you in fact have $1,000, then you could say you want to invest just a part of your inheritance. In all fairness, I must say that this isn't *always* the case. Occasionally, you'll run into a sales-

man who seems as interested in your $100 as someone else's $10,000.

I must also admit that I never bother to lie, but I also *never* give information about money just because someone asks me. If someone asks how much I have to invest, I might say, "Let's start at the bottom, what is the least I could invest at one time?"

Also keep your ears open and your opinions to a minimum when people who you know are successful discuss their investments. I mentioned to a friend that someone I knew to be wealthy—but didn't know was *that* wealthy—announced that he and his wife had paid personal income tax one year in excess of $500,000. Naturally, I didn't tell my friend who I was talking about and since he was from another state, he couldn't have guessed.

My friend replied, "How disgusting of him to talk about money in front of you!"

To which I answered, "People have always talked about money in front of me, whether or not they have it."

People who make big money often talk about little else! I have one friend who calls me from all over the world and tells me how the dollar is doing there, as if I could use the information! I encourage him to tell me these things though, because it's fun to fantasize that I should move my millions on a certain day from Hong Kong to Brazil!

If you're the sort of person who doesn't stop someone from talking about his money, it's amazing what you'll hear, and some of it you may be able to use, if not now, at least one day.

Real Money

I refer to money that far exceeds one's projected lifetime expenses as *real* money; a distinction could be made between the rich and the *really* rich. This is a goal that many people reach within their working lives, and some people take only a few years to achieve it. So it's possible, with caution and a solid income, to accumulate enough to enable you to put your feet up when and if you wish.

To be *really* rich is relative, and it's no one else's business if we want to set our sights on enough money to keep ourselves and our heirs in summer cottages.

If you don't know how much money you want, think about what you like per month ($1,000, $4,000, $10,000), and from that figure on how much you're trying for per year. Try not to have as your goal certain personal possessions (the Rolls Royce, the yacht, the private plane), but instead an income you'll no longer have to work for and that will keep you relaxed and happy!

Remember that the self-employed can provide their own pension plan (when you start earning $20,000 a year more than you can spend, talk to an accountant about that). Where your investments pay off is that they are part of your self-created pension.

"For the first time in my life, I can afford to do *anything*" a customer who has retired from government service told me.

"How did you do it?" I asked.

"I invested a little every year and then when we retired we started liquidating our real estate holdings. We do it when we need money. I figure we can go on

this way until we are both 120."

Another customer has retired from three government jobs. This didn't happen by accident; he thought about it in advance. He's a doctor but he didn't want the weight of a private practice and felt he could do as well if he worked for the government and retired from each job as soon as he was eligible. Doctors in private practice would be astonished to hear that he just bought a partnership in a casino in the Bahamas . . . his pensions went into investments during his working years; he lived on his salary.

Living for now and not for the future is how to get to old age in good shape, but it's not smart to ignore your old age. If you plan to keep at the photography until you drop, that's one thing, if you don't, you should do something about it now.

Protecting Your Investments

I suggest elsewhere that medical insurance isn't necessary for people with small incomes. If you have $50,000 saved though, that can be depleted in weeks due to an illness that requires you to be hospitalized. Even 20 percent of all hospital bills (the usual amount a patient pays on most hospitalization insurance plans) will quickly reach hugh sums. So once you've some investments, you'll have to spend money to protect them, insuring against any eventuality that will evaporate them. At this time—if you haven't already got one and if you feel you need help—find a business manager, either a financial consultant, accountant, or lawyer. This person must be *trustworthy*—if there's the slightest rumor of dishonesty surrounding him, go elsewhere; *reputable*—get a successful businessman's recommendation; and *compatible* with you. You don't need an advisor who's a pain to deal with. There are equally talented people who are pleasant.

If you're married, you must also protect your holdings from being depleted in the possibility of divorce. A lucrative investment shouldn't have to be sold prematurely, but that is often what happens when a couple splits.

However happily married you are, you should face squarely that the odds against your marriage surviving are not good! A sorrowful fact is that all married couples were once happy. If you do stay together, that's terrific, but you still lose nothing by deciding in advance—and tying this up with a written agreement—that your joint assets will only be split in a specific way if divorce day comes.

I strongly believe that both husband and wife should work to help support their families, keep separate bank accounts, and feel totally independent financially. If there is a breakup, one person doesn't feel left behind as the other, the breadwinner, goes on with his or her life.

It can also be devastating to a person who builds a business, only to see it sold and split in a divorce. One man I know had been salaried for eight or nine years and saved to start a small service business. His wife helped him, but was quickly tired of the long hours he so gladly put in and the fact that their homelife was negligible, and so decided on a divorce. All their money was in the business and it was ordered by a judge to be sold four years after it had opened. My friend gradually became a suicidal drunk and lost several years of his life pulling himself together.

He told me he had achieved his life's ambition, to own that particular business, but now he knew he would never have the optimism to do it again. I had one of his old ads on file; it was, I told him, "Too beautiful to throw away." I showed it to him to try and persuade him to start again. He was so sad when he saw it, tears came to his eyes, but he shook his head, "I can't start again. Something in me has gone."

You can also protect yourself against such losses by investing in a way that splits can be made without forced sale:

• Future studio income could be split until half the capital value of the business at the time of the divorce is paid off. The photographer in the marriage would keep the business.

Buy only acreage that can be split into equal parts (this must be legally possible, check the local zoning laws).

• Buy two of everything, even if you have to buy them one at at time! Buy two rental housing units, two plots of land, 200 shares of a kind, etc.

• Buy alternately for each of you. She wants to buy General Motors shares for $2,000; next time he gets to buy the $2,000 lot. On paper you agree that these two investments would be considered equal in the case of a future property split, when she would get the shares and he, the lot.

I'm not a lawyer but I would take these ideas to one and see if something can't be worked out that seems reasonable. I'm sure you'll grant that just having the agreement will be some kind of security for both parties.

The major areas where the man in the street, even the photographer, can invest and turn up a larger-than-savings-account profit are real estate, stocks, and gold or silver.

Real Estate

Real estate investment is divided into unimproved land—without buildings, fences, etc., and improved land.

Unimproved Land

Unimproved or undeveloped land, if bought with some foresight, will invariably increase considerably in value the moment it increases at all. The value rises when one person is willing to pay more than it is *now* worth. A piece of land is worth very little until people either want to live on it or make it into a business asset (farm, dig oil wells, etc.). When they do, they'll fight for it.

Location

To find an area that is bound to make that "jump," go to where the houses stop and where the land looks pretty and if you can afford to buy, do.

If you're buying land that will probably become *residential* property in the future:

1. The land with a view is the most valuable. Hillside properties are worth more in residential areas than flat land.

2. If the roads are in, a lot on a hill is worth more if it is *down* from the road.

The building problems are greater if the lot is above the road (requires digging into the hillside), and many people don't like walking *up* to their property. Below the road, a house can be built where you come in at the middle floor.

If, however, you're buying where the probable future of the land is *commercial*, then flat land is worth more.

It's usually pretty easy to guess whether a property will be more likely to go commercial or residential if you keep up with the news in your area. You can't help hearing which areas are opening up for commercial use and which aren't. This is one very good reason to invest close to home, at least with your initial ventures.

You might have to go ten miles or more out of town to afford a lot, but you'll find one eventually—if you're persistent. *If possible*, find land that's already subdivided, or which can be subdivided (there are no ordinances against subdivision), and remember that one-acre or smaller lots, rather than large spreads, are more in demand and thus, get better prices per acre. Even in our land boom in California, people couldn't move their eighty-acre unimproved properties, and some are still stuck with them.

When buying land, water is important. If the developed area close to your land spreads, as you expect, where will the water come from? If it's plentiful or already being piped in, you have no problems. But if not, then there may eventually be restrictions in building. There may *already* be such restrictions, so check that out. If there are trees on your lot, there must be water underground, so well water will be available. If not, find out what the county plans are for bringing water to that area.

This is not the time to talk with a realtor but the local planning department. These are usually conservative people, government servants not apt to make wild statements, and with nothing to gain if you buy one lot or another. If you're told something sounds like a good deal, it probably is.

Points to Ponder

1. The sale price of the land will help the county assessor value the property for taxes, so it's worth a double effort to bring the price down!

2. An older owner will probably accept less than a younger one (if only because that owner knows he paid $100 for that $40,000 lot; a younger one paid $4,000)!

3. Any owner who needs cash will or should come down a lot for a cash offer. Offer as much as 25 percent less. If you aren't represented by a real estate agent, and the owner is reluctant to sell for less, point out that a quick sale will enable him to invest the money right way and make up the difference in price. Many owners don't realize that in dealing with large sums of money, they're losing considerable interest on that money by waiting months for the right price.

If the owner doesn't agree to bring the price down at first, be patient. He may change his mind when he has spoken to friends. If it's a slow market you can wait; if not, you can come up a bit. If either of you are represented by a realtor, he'll push for a quick sale. That's what he's taught to do, rather than wait for the optimum price. Thus, it's to your advantage as a buyer not to offer the full

price asked initially, unless it's a real steal and someone else will go for it.

4. It's customary (and will be required if a real estate agent is involved), for an interested buyer to put up $500 or more to show his good faith. The agent usually holds that check; the owner, an escrow company or bank could do so, too. This gives the buyer the inside track to negotiate with the seller. All this means is that once you've handed that check over, the seller may no longer negotiate with anyone else as long as you're counteroffering and he's counteroffering within the time each of you specifies. If the deal is dropped, you get the money back. If you buy the property, it goes toward the sale.

When I bought my studio, someone was negotiating with the property's owner, and he had till a particular day to counteroffer. I told the owner I would pay his full price if the deal fell through. He called me one evening and said, "He had till 6 p.m. today to bring in a counteroffer. He isn't here, so if you still want the property, it's yours."

You can see how narrowly you can miss a good thing. I'm sure that the man who was late realized that when the zoning change went in three weeks later and the property went up $15,000 right away. This particular M1-zone (industrial), was changed to CN (light commercial) upgrading it.

You're also probably wondering why the owner didn't wait three weeks to sell. I think he didn't then understand the implication of a zoning change or that he thought the city council would decide the other way.

5. If the owner is willing to carry a mortgage on the property, you can also offer to pay less than the interest he's asking, even if you come down below the market rate. Whatever he offers, try for at least 1 ½ percent lower (at first). Many owners get quickly tired of trying to sell their property and will settle in your favor on these small amounts. If he wants 13 ½ percent and you offer 12 percent, it sounds like a negligible difference, but it's in your favor if he agrees. If you think you're getting a good deal, he might figure you'll be less likely to pull out when the sale is being put through escrow.

6. Insist that there will be no penalty for paying your mortgage in full before the due date. It may be that interests will drop and that you'll be able to remortgage at a lower rate.

7. Also, it's sometimes worth paying a ½ percent more to get a fixed interest loan, one that won't fluctuate with the prime rate.

I have a friend who has such a loan at 6 ½ percent. Her bank has offered her 20% off the principal still owed if she'll pay it off!

One couple that has remortgaged their home says they'll have $200 per month *less* to pay, but it will take several months before they break even because there are some heavy closing costs involved in remortgaging.

If your mortgage isn't a large one, a few thousand dollars, figure out or have someone do it for you, what the saving in your mortgage will be. You may not actually be saving money. It's generally considered smart to remortgage if you can get a drop in interest of 4 percent or more.

8. A seller might be reluctant to take a mortgage, and you may have trouble getting other financing. But if he thinks he'll get his money in two or three years, he may change his mind. What you have to decide is whether you could come up with the total owed in that time. Sometimes you may just be a few hun-

dred dollars short of your price, and this kind of arrangement will enable the sale to go through.

9. If your offer on a property is refused and you don't feel you can afford more, or that the property isn't worth it, wait awhile and see if it sells.

Right now a neighbor is kicking himself because he didn't accept an early offer for $75,000 cash on his home. He didn't even note the name of the person who offered it. He wanted $89,000, and has had plenty offers at that price, but only if he would carry a mortgage. He would gladly accept the $75,000 cash offer now, and if that person knew this he would be able to buy the property at *his* price. He should have kept in touch.

9. When a seller has refused your initial offer and contacts you later to accept it, you can *probably* work the price down a bit. "I don't have $11,000 now, but could possibly come up with $10,700."

10. Eventually, the houses will move out to your vacant land and as the buildings go up you'll be inundated with too-low offers for it. If you can, *wait,* because the more houses that are built, the more valuable that land will become. At this point, the longer you wait, the more you'll make, so wait, if possible, until prices level out and then sell.

11. I have talked of $40,000, $10,000, etc., but you can buy for much less, depending on where you live and what money is available in your area.

Improved Property

All the points I have made under unimproved property apply here, except that you probably can't buy any land with buildings for less than $10,000. In our county, you'd need $75,000. In buying buildings there are other pitfalls.

1. No matter what a realtor tells you about a house or building, if you have personal friends who know *anything* about property, have them go over the place before you buy. Architects, builder/contractors, structural engineers, people who own housing, and do-it-yourselfers who are builder-hobbyists are people to ask.

2. The exception to this would be if you're sure that the land is worth the price with or without the house. Sometimes no one wants the expense of demolishing a rickety building on a property, and the land may be virtually useless as is. If you can buy the property, and have the building demolished, you'll find a whole different group of people willing to buy. These are the people looking for a vacant lot. They didn't realize they could *make* a vacant lot.

Be sure that you can demolish a particular building—check with your planning department. You will, of course, need a permit in most townships and all cities.

3. There's a saying that there are three considerations when buying a house: location, location, location.

A man who owns several apartment buildings tells me that if you don't have the stomach to chase tenants for their rent, to listen to their complaints, and see your property destroyed, buy quality buildings in quality neighborhoods and charge high rent.

"I rent beautiful apartments to people who can afford to keep them up, and I

have always made a lot of money," he said.

4. When buying a house or any building, consider what you will have to put into it, "the hidden costs."

I was about to buy a house for a studio when an architect friend told me that it would need a new roof. To me it had a beautiful roof, but a few weeks later I saw the "for sale" notice had gone and there were workmen putting on a new roof!

These are a few hidden costs you might run into: roofing, painting, landscaping, repairs, electrical work, fencing, plumbing, and foundations.

Most cities require that buildings be brought up to code when they change hands; some of that cost should be carried by the seller. Sellers here are required to have the building inspected for termites and made termite-free before the sale goes through. This doesn't necessarily mean that they have to repair damage that the termites have already done.

If you think you'll buy a house without termites, don't look in San Luis Obispo! The owner of a pest control company here told me there wasn't such a thing! "All the houses in San Luis have termites," he said cheerfully. "If you get rid of them today, they will be back tomorrow." So for $75,000 here you get a cheap looking house *with* termites.

When I bought the studio the place looked just fine to me, yet I had the following hidden costs. Some of these were required by the city; some I just hadn't noticed:

Complete rewiring . . . A friend was shocked at the state of the wiring in the house and thought it so dangerous that he turned off the current. Our lighting consisted of candles for a while!

New driveway . . . The city required this, as I would be using the location as a business.

Landscaping . . . The previous tenants had left large piles of wood around the property, dumped concrete, etc. This had to be cleared and a real garden put in, fruit trees and flower beds being a major priority of mine.

Clutter . . . I find it difficult to destroy, remove, and throw away anything, so this was hard for me. There were three hideous sheds on the property that everyone else decided should go, and so they did.

Repainting . . . My idea! Because the building was off-white, it gave off such a glare that outdoor portraits had to be taken elsewhere. Customers couldn't open their eyes facing the building, the only way I could backlight the pictures using sunlight.

All this cost about $6,000, although I was as economical as I knew how to be and I had to take out a bank loan to pay for it. However, the same architect friend who had pulled the plug on our lights assured me that for every dollar I spend I was adding $3 to $5 dollars to the value of the property, something to remember. This isn't true, however, of improvements that aren't generally needed. You may not be able to add $10,000 to the price if you have installed a $3,000 hot tub!

The Stock Market

How is it that we hear so much about other people making money on the stock market when all our friends have lost? I've done both; won and lost. I finally pulled out for good—at least for awhile!

What other photographers spend on clothes, vacations, and automobiles, I spend (spent) on stocks. I refused to liquidate. If the market went down, I bought; if it went up, I bought.

The most fun about the stock market, when correctly used for investment, is: you don't do any work, you just phone someone and send him a check in seven days; you can bail out immediately—you don't have to find a buyer; you can double money quickly; you can buy on margin (that is, borrow on money already invested to take advantage of a good buy); and you can sell out entirely and start again in minutes.

You'll need a good broker; one who understands what you look for in buys. I wanted a quick turnover, but it took years before I found the right broker. I didn't like the cautious ones. Women are usually good with money and always a good bet in a field overpopulated with men, so here's a time where it's smart to be sexist.

Money Managers

There are organizations that are in the business of investing money for others. They're like stockbrokers and sometimes *are* stockbrokers, and take a commission on each deal. But they buy and sell stock, bonds, gold, other commodities, and also have a money market account that pays interest (where you keep your money when it isn't invested elsewhere). The initial investment is usually quite high, (e.g., $20,000) but there are some firms that require much smaller initial deposits. Ask around and read what you can. Your bank manager may be able to advise you of a few reliable companies. Your money can be moved from one investment to another and all you have to do is telephone to say "buy" or "sell."

You can also hire an expert who will merely tell you what to invest in and when. If that's the kind of adviser you want, you can, of course, watch the various financial programs on TV and follow any advice given. Other people are paying for the same advice.

The advantage of such advice is that some people deal with money and market trends every day and hear the gossip. There's no insurance though, against bad advice. Most financial advisers have made a number of serious misjudgments and some small investors get put out of business because of them. Those people I've met who have done consistently well moving money from one investment to another actually make their own decisions. They just buy what seems sensible and cheap and if it goes up, they sell!

Gold and Other Good Things

It's possible to buy gold and silver themselves; you don't have to buy the stock. There are various management firms who will invest your money in gold, sell it for you, and take a commission. You can also buy gold across the counter. Many coin shops sell gold and silver coins that are of value for the gold and silver they contain; they're in too bad a condition to be sold as valuable "coins." If you hear someone talk of "junk" gold or silver, that's what he is referring too. Certain jewelers, too, buy and sell bulk gold and silver.

You can also buy precious stones, works of art, and other items that inevitably increase in value. People who know good from lousy art make a great deal of money in speculating on its value.

The secret is to buy when the item is down and sell when it goes up—not as simple as it sounds except to people who check prices frequently and cash in without waiting too long. If there's a knack to this, it is to buy and sell *against* the trend. When the public is excited about something, don't buy. The real deals are already elsewhere.

If you're going to buy items that have value and which you plan to sell, then you must protect them. The usual place people keep such valuables is in a safe deposit box, which is much cheaper than an insurance policy.

When you buy gold, silver, and other precious metals, the quantity you buy is not important; it's sold by the ounce. But in buying diamonds, for example, you're better off buying a very good single stone than many small ones and naturally, you can't just presume a large stone is good or even real; you must have an expert authenticate it. The prices rise more steeply on quality gems, so $10,000 spent on one hundred $100 diamonds won't do as well as a single $10,000 diamond. If you have friends in the business, discuss all these matters with them and ask advice if you need it.

Invest in Yourself

When you realize your studio is here to stay, you've ridden the more difficult paths, and aren't in such a blue funk all the time, then is the time to invest in your studio. Your studio is, of course, you. You're giving yourself the rewards of your labor by working in the most beautiful conditions with the finest equipment. Nothing is makeshift; it's what you always wanted.

Initially, stay cautious because you must differentiate between what is an investment and what is money down the drain.

I'm not speaking here of buying memberships in spas, clothes, and other luxuries—however much fun that sounds—but of adding to the studio in a way that increases *your* actual value.

Thus, investing in yourself is like buying stock, only you're the company selling the stock. You take the profit, all the dividends, and add to your worth.

These investments can be in:

Equipment

This doesn't include equipment that someone has talked you into, but that special item you've always wanted and suddenly have the money to buy:

- A Hasselblad, Nikon or any camera you've wanted but never actually owned. How about one of those passport cameras that take two identical pictures at once? How about a 4x5 view camera or a perspective-correcting lens?
- The best studio lights money can buy.
- The finest camera bags.
- An IBM or other superlative typewriter.

- A computer, not a $200 computer, but one that can do everything you'd need it to do; a printer for it.
- A copy machine.
- A refrigerator and/or freezer just for the studio.

Studio Improvements

These include a new floor, a new roof, new curtains and/or cushions, new furniture, special shelving that exactly fits your requirements, matching file cabinets, a new paint job, a new building added on, an additional bathroom, a new sign, the most comfortable chair you can find.

Accessories

Entirely new stationery (well designed, and printed on high grade paper), new price lists, new display albums, an entirely new exhibit (beautifully printed and beautifully framed), a tool box with quality tools.

In all these investments you'll see the money is not just spent and enjoyed. The results remain there, working for you as well as giving pleasure.

In Closing

Life is supposed to be fun. The most exciting people to be with are the creative ones—the ones with stars in their eyes who dream of changing the world, and often do. When a businessman/photographer appears to be creatively driven, he's doing it right!

Photography has long been considered an art and it's up to us studio photographers to show the public that we, too, are artists—not just a lower, lesser form of photographer!

A successful photographer doesn't get so wrapped up in the business side of his studio that he forgets his public, which is more impressed that he has chosen photography to make a living than in what he makes a year.

He doesn't bore people to death with how much he wants, or gets per picture, or talk of his income or how he's doing, relative to the photographer next door. If he talked that way, he'd appear insecure. Would you be more impressed by a doctor who told you how much he made per operation, or by one who said, "Last year one of my patients was paralyzed from the waist down; this year he's playing tennis."

If you have to talk about money, complain! Complain about taxes, prices, and overhead—just like the very rich!

Talk about your exhibits, the interesting jobs you do, even the difficulty of certain photographic situations, but don't talk "income" money. Just drop the habit and you'll automatically put yourself on a level above those who haven't.

We professionals can't keep up with every change as not only new cameras and films flood the market, but new kinds of cameras and new emulsions. All around us there are innovations in our world; sometimes better, always fascinating.

The successful photographer is part of this change. He isn't frightened by it because he knows he must let new ideas, styles, and materials into his studio. Members of the public are already noticing that their pictures are more fun than many pros'; that their equally expensive cameras can enable them to get what they want, not what their neighborhood photographer tells them they want.

Many greedy studio photographers have already lost public respect for our business; the more-likely-to-be-*successful* studio operator understands the long-term effect of what he does. He'll do what is reasonable and honest, rather than take advantage of his customer.

He doesn't boast of how he has "taken" someone on a job, a commonly heard claim if you listen to photographers when they loosen up.

The successful photographer is always competing with himself; not just getting by with something that his customer will accept. He'll take the extra time to get an unusually beautiful picture, even if his customer doesn't know the difference between one technique and another.

Photographers who are successful didn't get that way by accident. If you respect your customers, are grateful for their business, and give them the very best photographs you can, the public will be grateful. Believe me! Then follow this up by running a very efficient business *moneywise*, and put away something of what you earn to start the accumulation of a nest egg that will support you in your old age.

It's a tremendous achievement to have created a business out of nothing and the public knows that. They want to feel that they, too, could do it; that there is a place for the stubborn individual who wants to be his own boss.

Nothing goes well all the time, so when a problem comes up—even a mammoth problem—remember, you are not alone. We've been there and will be again; bad luck and trends hit us all. But *mostly* things do go as planned. For every piece of really rotten luck, there are *dozens* of good ones!

Eventually, of course, you'll be able to enjoy the disasters. You'll laugh and your friends will, too. People don't want to hear what went right; they want to hear what didn't.

"I got the building all lined up, and the model posed just right on the steps, and then I fell off the ladder . . ."

"Then there was the time I dropped my camera into the swimming pool . . . !"

Now isn't that much more fun than remembering how much you used to charge per 8x10?

INDEX

Other Books of Interest

British Journal of Photography Annual—This outstanding yearbook contains more than 160 color and black & white photos, articles on the history, techniques, and current trends in works by photographers from around the world, and a section filled with chemical formulae for mixing processing solutions. 222 pages/$24.95, cloth

Developing the Creative Edge in Photography, by Bert Eifer—How to turn average pictures into striking photographs using Eifer's step-by-step techniques on how to see photographically, create mood and emotion, and use the camera's 15 creative controls. 220 pages/$16.95, paper

How to Create and Sell Photo Products, by Mike and Carol Werner—Over 30 sets of instructions for making and selling products featuring your photos, including clocks, greeting cards, calendars, posters, and more. Packed with ideas on what to make, how to make it, and how to sell it. 330 pages/$14.95, paper

How to Create Super Slide Shows, by E. Burt Close—A sensible guide for using simple equipment and minimal expenses to create interesting, entertaining, even profitable slide shows. $10.95, paper

How You Can Make $25,000 a Year with Your Camera, by Larry Cribb—Scores of profitable jobs for freelance photographers available right in your own community, with details on how to find and get the job, necessary equipment, what to charge. 194 pages/$9.95, paper

Photographer's Market—An annual directory with thousands of listings of photo buyers—periodicals, advertising agencies, galleries, stock photo agencies, book publishers—with names/addresses, pay rates, submission requirements, and sales tips for getting the right photos to the right buyer. 576 pages/$14.95, cloth

Sell & Re-Sell Your Photos, by Rohn Engh—Takes you step-by-step through the process of selling your photos by mail, using the right techniques for each market. Plus advice on taxes, recordkeeping, marketing, and sales tips. 323 pages/$14.95, cloth

The Travel Writer's Handbook, by Louise Purwin Zobel—Packed with tips on getting background information, taking salable photos, doing on-site research, getting freebies and tax benefits, plus advice on how to sell to U.S. and foreign markets. 274 pages/$8.95, paper

The Wildlife and Nature Photographer's Field Guide, by Michael Freeman—Filled with practical tips, beautiful illustrations, and step-by-step instructions for capturing elusive animal and nature subjects on film, including equipment, lighting, map reading, building blinds, and habitats. Plus film exposure and filter charts. 224 pages/$14.95, cloth